Talking to Myself

CHRIS JAGGER

Talking to Myself

CHRIS JAGGER

AUTHOR'S NOTE

I first started on this memoir in 2006 and each morning I began with a brief diary entry. I have kept these in, both as a diversion and because they tell a parallel tale running alongside the account of my life. I have included a good deal from childhood years because I usually find those pages most interesting when reading other biographies.

Since I pretty much conclude the story with my move to Somerset in 2000, I thought that would be a good cut-off date, so the diary touches on my life here. I have always written things, but never anything this long, as you have to shut yourself away and it's quite different to going out and playing a gig.

As for my remembrance of things past, I haven't submitted completely to a chronological tyranny, as episodes in your life overlap, or prompt digressions and reflections – and that's the approach I've taken in setting them down.

I hope the book reads as if I'm talking to myself and you're listening in.

Chris Jagger
Mudgley, Somerset, 2020

DEDICATION

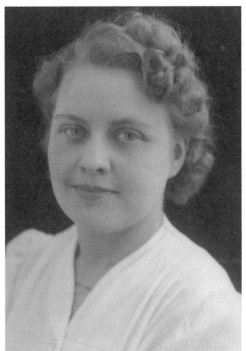

*A young
Eva Scutts.*

Boys seldom realize the dedication our mothers show in carrying us for nine months before we appear as small people. Thinking about this after my mother Eva died, I wrote a gentle song called 'You Carried Me', thanking her and reflecting on the hum of being inside the womb, surely the safest and cosiest place ever, before I emerged on 19 December 1947.

Dr Thompson delivered me at home, as my mother didn't want the fuss of going into hospital. After all, she'd already done that with my brother.

CONTENTS

Chapter 1 **HOMES** 13

Chapter 2 **AN UNCLE IS A FRIEND** 26

Chapter 3 **SHORT TROUSERS AND GRAZED KNEES** 39

Chapter 4 **TEENAGE YEARS** 54

Chapter 5 **DOWN WITH SKOOL** 68

Chapter 6 **GET OUT OF JAIL FREE CARD** 94

Chapter 7 **THE THEATRE, DARLING!** 104

Chapter 8 **'SCUSE ME, WHILE I KISS THE BLONDE** 121

Chapter 9 **EXIT STAGE RIGHT** 143

Chapter 10 **MOTHER GANGA** 168

Chapter 11 **CULTURE SHOCK** 194

Chapter 12 **A SLICE OF COUNTRY LIFE** 204

Chapter 13 **LET'S MAKE RECORDS** 221

Chapter 14 **YOU KNOW THE NAME BUT NOT THE FACE** 236

Chapter 15 **LA HOMBRE** 253

Chapter 16 **IN BLACK AND WHITE** 277

Chapter 17 **"DRESS SMART CASUAL"** 294

Chapter 18 **GUITAR INTERLUDE** 310

Chapter 19 **MUSICAL REBIRTH** 332

Chapter 20 **MUSWELL HILLBILLIES** 351

PREFACE

The only sport our father refused to teach us boys was boxing. Pity, as it may have come in handy. 'It's a mug's game,' he concluded, and he was probably right. He had boxed at university and in the army, and one time entered the ring at the Dartford fairground with 'Bruiser' Harris, or whatever, to go a full round for a fiver – good money in those pre-war days. He'd watched others attempt this and saw them stopped late on with a sneaky punch or trick, so he took on the challenge and won the prize money. But it was the last time he entered the ring.

I guess you gotta know when to fight and when to run, and without sounding like a coward, I have usually been a better dodger than a fighter.

Having a famous brother might land you in trouble, so you have to roll a little with the punches, realize it's okay to be 'normal' and not resent others' success. To achieve some pride, you must work for it and use what God-given assets you possess. I was fortunate in having a stable and loving upbringing and that's the best gift a parent can give. My joke is that I'm a late developer and at 70-plus years, I'm still learning.

CHAPTER 1
HOMES

My mother was instrumental in finding our first proper home in Dartford, Kent, in 1946, partly thanks to her best friend Joan Brice, whose family was in the building trade and had done well in the boom years between the wars. Joan owned a second-hand MG soft-top and the two would drive round town, their hair fashionably bobbed like a couple of flappers, turning heads.

Joan's brother Johnny kept pigs and was three times 'world stock car champion'. Mick and I were taken to see him driving at Catford Stadium, crashing his way to the front of the pack in his souped-up jalopy. It was very exciting. Bumpers and fenders would be hanging off by the time the cars crossed the finish line. I knew Johnny's son Tony, who later drove in Formula One for Frank Williams and tragically died in a small plane piloted by Graham Hill as they came in to land at Elstree airfield in thick fog. The papers were full of tributes to the former world champion Graham, who had a wonderful career, but alas Tony never fulfilled his promise, only living fast and dying young.

I remain friends with Joan's daughter, the actress Diana Quick, who was at school with my brother. She is a real talent and I see her whenever she appears on stage. Her family had a Thirties house right on Dartford Heath and we loved going there for parties, especially as they had their own projector and showed Mickey Mouse cartoons. However, Diana's father was a dentist and would later treat me, something I dreaded. In those days they would give you a gas mask and tell you to count to ten: 'One, two, three…*zzzzzzz.*'

SEMI-DETACHED

Our house in Denver Road was a pebble-dash semi on an estate of smartly named streets such as Chastilian Road, which sounded grander than it appeared. Still, in the immediate post-war years, buying a house was heady stuff and my mother definitely meant to get ahead. Before that my parents had rented a flat on a road called The Brent, on the old Roman Road, opposite the secondary school where my father had taught history. Since this is where my brother first crawled around, above the Eagle Cafe on the old Roman Road, maybe it should have a plaque stating 'M. Jagger lived here. *Today's special: egg, chips and beans*'.

The earliest memory I have is of lying in my pram outside Denver Road, as in those days you would be left out in the sun when it appeared, at the front of the house, presumably on the assumption that nobody would want to steal a baby, no matter how beautiful. When the wind blew from the east, the washing had to be taken in, or else it would be covered with a fine layer of cement dust from the cement factory on the river at Northfleet.

Rumour has it that I was quite a handsome lad, arriving at a difficult time – that is, a few days before Christmas. While everyone was goo-gooing over my funny face, my brother apparently appeared and remarked: 'Is this what all the fuss is about?' Perhaps it was the combination of not being the new one and boyish pique; he was, after all, coming up to five. Whatever, four and a half years isn't an easy span to bridge at that age. He was born a Leo in the warm summer and I a Sagittarius in the dark mid-winter.

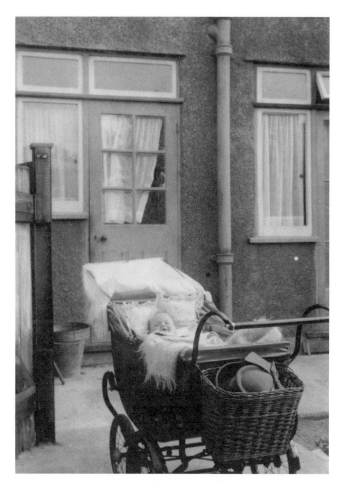

Back of Denver Road. Note the hat in basket!

WHAT'S YOUR NAME?

We still had ration books until 1954 and my parents lost a week's worth in dithering before registering me as Christopher – which turned out to be among the nation's favourite names, alongside Michael. My brother was always called Michael or 'Mike' and never 'Mick', which was chosen later at school by his mates, no doubt. At that time 'Mick' was also slang for any Irishman. My father shouldn't have had any grounds for complaint. His mother had christened him 'Basil' – rather posh – but playing football as a lad, his team mates rejected it, reverting to

the simple and affectionate 'Joe', which alliterated to his surname and it stuck.

My first year also saw the birth of the National Health Service, so I have been lucky enough to know it all my life. Exotic fruit was appearing on the horizon and once, when I was given a banana, Mick quipped, 'I never knew what that was when I was young.' Just shows he has always been jealous of me.

SHADOWS OF WAR

Conditions were easing after the war compared to Mick's early days, when a major concern was where the next bombs might drop. Mum had briefly taken my brother north for safety, to Greenfield in Yorkshire, where our paternal grandparents lived, but it was so quiet that she soon returned, adding, 'They didn't even know there was a war going on up there.' Like many others, she disliked the damp and smelly air raid shelter at the bottom of the garden, retreating instead with my brother under the stairs or, in an emergency, under the kitchen table, hoping for the best. His earliest recollections are thus of bombs dropping and flashes in the sky, which must have given him some good ideas for songs.

During the Blitz, Dartford was in the firing line because German bombers would fly up the blackened outline of the Thames Estuary and drop their loads on the numerous engineering works in the area: J & E Hall who made refrigeration equipment; Vickers who made the casing for Barnes Wallace's dam-busting bouncing bombs; and nearby, Woolwich Arsenal. My uncle Horace worked at 'The Arsenal' during the war, sometimes on one-off prototype torpedoes or other warheads. He started as an apprentice and later went on to run a small business re-boring engines. One wartime Saturday afternoon, Horace emerged from his workplace to find the other huts entirely bombed out and human remains scattered

about like dolls' limbs. Shakily, he climbed onto his bike to cycle home, returning the next day as normal.

The Woolwich Arsenal had a football club that later moved to north London, and only recently I learned from Mick that he follows them because of Uncle Horace. They were known in my day as 'boring Arsenal' and I came to support their arch-rivals Tottenham, but seeing as Mick followed Horace's whim I shall have to forgive him.

Our small kitchen was heated by a coke stove and one day I chucked a glass of water down it to see what would happen: shocked by the cloud of steam rising fiercely in my face, I had an early science lesson.

There were plenty of friends and I was a popular enough lad. Around the corner was 'Auntie' Eve, whose son William was a pal of Mick's, and it was in her garden that he famously fell into the fishpond as a toddler. William's father had been a Spitfire pilot and in the living room was a silver-framed picture of the hero, along with a model of the plane he flew. Like many, he never returned from a mission.

STREET LIFE

The coalmen and rag and bone men made their rounds on horse-drawn carts, the only pollution being the occasional droppings that people scooped up to spread on their roses. Curtains might twitch if the horse deposited outside, so you had to retrieve it before your neighbours did. There were few cars in the street, so we played a lot of games there, footer and cycling while the girls skipped and chalked out hopscotch. Once some tough lads slashed the tyres of my tricycle, but overall Dartford was a safe place to grow up.

Nearby lay 'the sandpit', a massive crater where a V-1 flying bomb had fallen at the end of the war, shaking foundations and

shattering windows but causing little other damage. These 'doo-dlebugs' were dreaded, because when the engine cut out at the end of their trajectory, there remained only an eerie silence and a fear of where they might land. Dad told us that daredevil pilots would fly alongside the V-1s and try to tip their wings, to crash them into the sea. Mick once climbed the sandpit railings with his friend Michael Spinks and slit his hand open, requiring a number of stitches. The wound was proudly displayed. More sinister for me, when I was aged around seven, my best friend Jimmy Sinclair was killed there, drowned in quicksand, an event that gave me night-mares. We still went there of course: danger was always an essential element of kids' play. And what better friend and protector can a boy have when growing up than a big brother? At the time, of course, I was unaware of his kindnesses, when he picked me up or held my hand to keep me safely by his side. I felt only the simple bond that connects two children and took it for granted. When I became more independent, I would pull away from that control and no doubt he was only too glad to be rid of the responsibility. But when I look at my two youngest grandchildren, separated by fewer years, the care and attention shown by the three-year-old to his smaller brother is wonderful to behold (although, of course, they might have a vicious fight the next instant).

The eldest son has and always will have higher status than his siblings. The eldest is special, and my father likely wanted him to follow a profession, even teaching. Mum had wished with all her heart for a girl, and all she got was me, so my mother and I doted on each other and always showed our affection openly. Not once did my father display any preferences between his sons, treating us as equally special. Many years later, as I stood next to him at a social gathering, an old colleague approached him. 'How's your son?' he enquired, to which Dad smiled and replied, 'Which one?

I have two.' I cannot imagine the trouble I must have given my parents – and my brother – over the years. But in 2006, as my father lay in hospital at the end of his life, I softly sang his favourite lyric of mine, 'Whispering wind, follow me to/ arms that are loving, a heart that is true', and he gave me the most beautiful smile in the world.

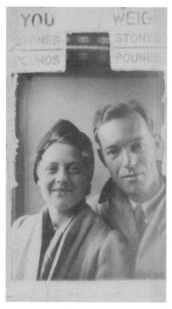

Eva and Joe in photo booth before kids spoiled their fun.

I went to the local Wentworth School, modern and purpose-built. There was no preschool or nursery, you just reached the age of five and were left at school for the day. By the time I joined the Infants, Mick was already in the Juniors. I was sent off one day with a message for his class, who were then standing outside to view a partial eclipse of the sun through pieces of smoked glass. To me, it was incredibly grown-up, and I guess that's what an older sibling gives you, a glimpse of a world more advanced than your own.

Earlier, Mick had attended the Maypole School, an old-fashioned place across the Heath – an experience I was spared.

The artist Peter Blake, whose family then lived close by, has told me stories of the nearby mental hospital and running the gauntlet of the in-patients, 'loonies', as we called them. They were housed adjacent in a gloomy Victorian edifice with tall chimneys and long corridors, and we imagined unspeakable horrors committed in there. One summer holiday, Mick worked there as a porter and was quite shocked by what he saw. That short stint was the only job he ever took apart from a holiday job, selling ice creams from a bicycle.

The Maypole School came replete with old-fashioned punishments, such as rapping knuckles with a ruler if questions weren't answered correctly. Mick hated it and was pleased to transfer to the bright new surroundings of Wentworth. All my friends lived near by and I was happy enough at school, though I did little work there.

Mick and I shared a room in Denver Road, which led to many disputes, as most parents will understand, and my mother was keen on finding a more spacious place for us to grow up in, and so we moved a few miles across the Heath to the small village of Wilmington, surrounded by open spaces and farmland. The place was more middle class and imaginatively named 'The Close', and boasted detached 'old-fashioned' houses that were much sought after. The land for the development had been chewed out from surrounding farms so our back garden included gnarled old apple trees, of which I became very fond. They were once part of a larger orchard, now separated from us by an easily climbed wooden fence, and in the autumn we would roam and 'scrump' – that is, steal – apples, including the small rosy Worcester and the Cox's Orange Pippin, for which Kent is famous (if you shake one, you should hear the loose seeds inside the core).

Round there were great areas for 'camps', little pieces of territory

where our gang could indulge our fantasies and hang out smoking Woodbines and Park Drives – though our gang only comprised three of us: me, a lad called Patrick, and John Freeman, who lived at the top of The Close and was for many years my closest buddy. We also built a tree house camp, covered with an old army tent, and an underground one, reached by a tunnel. We lit the latter with a paraffin lamp, which was quite dangerous in retrospect.

The other side of the orchard, which lay in a pretty valley, was a steep slope of wilderness and the site of an old country house, Monk's Orchard, which I can only recall as a wreck. We boys would throw stones at the windows, though I was never happy to see the glass crashing to the ground and the once proud edifice further reduced to crumbling ruin. Still, all that has now gone, the orchards buried under the M2 motorway and the area shrunk into a chequerboard of tarmac and service-industry premises.

Around a dozen apple trees stood in our garden, around which Dad incorporated a special 'exercise circuit'. I believe the idea originally came from East Germany. You would run round the trees and do six press-ups followed by squats, then chin-ups on a bar jammed in the branches of two adjacent trees, a walk along a thin plank, then maybe six star jumps before starting again at the beginning. I think Mick still does a version of this before going out on tour and no doubt he is a lot fitter than I am. Instead of squat presses, I dig the garden and sweep the floor.

Comic books then were full of the exploits of daring Tommy (British) soldiers – with the Germans being thoroughly whipped at every turn to cries of '*Donner und Blitzen!*' In play we would re-enact something similar in a disused army camp on the Heath and there were countless war movies shown at the cinemas, with Dirk Bogarde, and Jack Hawkins in his duffle coat, brimming with self-confidence and selflessness. The women spoke in

understatement. They only ever cried one or two tears and the men, never.

Another feature of comics and films were cowboys and Indians. We loved cap guns and loaded up the coiled strips of paper, dotted with gunpowder, to fire off multiple rounds – the smoke smelt good, too. The TV showed the noble sheriff Wyatt Earp along with his limping friend Chester, who we would imitate, as well as Doc Holliday. No matter how many bullets a renegade had taken, Earp would be fine after he'd been 'patched up' by the Doc. Of course, some boys would be 'Injuns', and enjoyed inflicting torture on the 'palefaces'.

When we went for a walk in the woods, Dad might say, 'This looks like Injun territory', and we all had to tread noiselessly as though we were trappers. We loved such recurring phrases as 'White man talk with forked tongue' and 'There's a stage leaving at sundown, see you're on it'. Another TV favourite was *The Cisco Kid*, as it brought Mexicans into the equation and the villains were great, too.

My main passion, however, was not slaughter but the comedian Norman Wisdom, who combined slapstick comedy with singing and dancing, plus amazing stunts, most of which he performed himself. Nan, my mother's mother, would take me to see his films at the Granada or the tiny Century, a picture house on Lowfield Street long since closed. It's hard to watch those films now without squirming; but then, Wisdom, ostensibly a man, was really a boy in sentiment and stature. American Danny Kaye was another post-war stalwart whose films I never missed.

Doris Day was my ideal pin-up – what a gal! I fell in love with her in *Calamity Jane*, and the image of a tear-away team of horses crashing over the prairies while she stood in her buckskins and thundered out 'Oh! The Deadwood Stage is a-headin'

on over the hills' was awesome on the big screen. That number was the inspiration for the first time I sang in front of people, in primary school at around seven years old, jumping up in a class assembly and belting it out with gusto. I guess I imagined I really was on top of that stagecoach.

Days other ditty, 'Secret Love', I saved for more solitary moments, except that it too bursts into a loud operatic bit. We were once asked in class what kind of music we liked and I very knowledge-ably replied 'Film music', only to be put down by the teacher who said that it was an inferior genre, presumably to the 'proper' stuff.

GUNPOWDER, TREASON AND PLOT

Aside from Christmas or your birthday, Guy Fawkes Night was the best night of the year. Even if the 5th of November did start out as an anti-Catholic festival, it's probably the closest we come in England to having a 'national day'. Like many kids, we made a 'guy' out of old clothes stuffed with cushions, complete with a sin-ister face, which we put in an old pushchair to parade around the streets asking passers-by to give 'a penny for the guy'. The whole endeavour was to raise money not for charity but for fireworks, some of which were actually manufactured on Dartford Heath in old Nissen huts. There were cheap penny bangers that went 'phut' and better sixpenny ones reserved for special explosions, as well as jumping jacks, which could be placed behind girls you fancied to wake them up. Boys have funny ways of saying things.

You could also light the fuse to a banger outside an enemy's house, ring the bell, then retreat to watch. Rockets were set off from empty milk bottles and spinning Catherine wheels usu-ally fell off their fastenings so you just kicked them around. Near Denver Road there were many old bombsites that were perfect for bonfires, when everyone came together from the neighbourhood.

Combine that with baked spuds and you had the perfect night out, even if it did usually rain. Sadly, Bonfire Night has now been supplanted by the Americanized version of Halloween.

DIARY, 2006

Writing this, I am perched in a room on top of the barn in Mudgley, where Kari-Ann teaches Iyengar yoga, the grandchildren run around when it's wet outside, and I have made some recordings. When we first moved here in the year 2000, it was the first building we renovated as the roof had collapsed, and we lived in a yurt tent inside the barn for some six months, with an outside cold tap and a gas ring. Now the November sun has kindly filtered through the windows after many days of heavy rain.

Mudgley is within artillery range of Glastonbury Tor in Somerset, my adopted county, one I am glad to call home. And home is a hard place to find in these days of wandering, rootless people. Not so many years back, this hamlet (there are only about ten houses) would have been populated entirely by locals who were born here or in the neighbourhood. Now the connection to the land has been severed and people zoom about the world selling vacuum pumps or dealing in cocoa futures before retreating back to their rural boltholes to wield the strimmer. This was fairly recently a chicken farm, and they were jammed in here like worms in a bucket in the bad old battery-hen era of the Seventies.

ON REFLECTION

Many years later, after my parents had died, their house in Richmond upon Thames stood empty for some while – and though it was never a childhood home, it retained many memories. Eventually, it was sold and the time came to clear everything out. As anyone knows who has done this, it's a time-consuming process. The kitchen drawers contained a collection of ordinary

utensils and, as I held each one, my mind filled with cherished memories of their daily use: a corkscrew, an old whisk, a bone-handled fork for carving that had likely been passed on by Mum's own mother. Simple items, always used, never replaced with improved versions. Together they represented a lifetime of preparing food, cooking and caring for my brother and myself. They all belonged together and it seemed sacrilege to break them up and take them to the Oxfam shop to be sold individually. Then there were the boxes of letters. Which ones to keep? It was a long task and I painstakingly went through everything on my own. At one point, I had to sit down and write a country song instead. It's a slow one:

I've taken all the pictures from the walls,
And stacked up all the boxes in the hall,
I read through all the letters,
That reflect all the love
That came to you both
From one and all.
Life is an ever-changing circle
Returning to the root from where it came,
And if I shed a tear or two when I'm leaving,
I know life will never be the same again.

CHAPTER 2

AN UNCLE IS A FRIEND

Uncle Cyril, the eldest of my mother's four brothers, presented me with an ancient wind-up gramophone and a few heavy 78rpm discs when I was around ten years old. These I played alone in my bedroom, singing away merrily and amused by the clockwork turntable slowing down or speeding up, depending on how much it was wound. There was one operatic song – 'Watchman, What of the Night?' – that I could sing note for note. Another was 'The Moon Hath Raised Her Lamp Above, (to light the way for thee my love, to liiiiiiiiiight the way), which also tickled me.

It's quite surprising that my parents didn't suggest some musical education. But like many girls of her day, my mother had been forced into piano lessons, so she made sure not to impose them on us. In any case, we didn't own a piano. Uncle Cyril, who had been chief engineer on the P&O shipping lines sailing east, owned an amazing pianola, and his wife, Elsie, played. You could produce 'programmed' music by pumping treadmill-style pedals connected to perforated paper rolls loaded in the instrument's front, and by this ingenious means the pianola would then 'operate itself', the keys lifting and falling as if by magic. However, Elsie played it properly, when she wasn't knitting or chain-smoking.

Apart from Uncle Horace, my mother's other surviving brother was Etheric, who was very kind and rather religious. The missing uncle was Percy, who had moved to Australia and died there in his thirties. Before emigrating, Percy would sometimes preach atop a soapbox in Dartford town centre, which so embarrassed Mum that she would cross the street to avoid him. He was quite musical and strummed a guitar, as we discovered from a photograph.

Uncle Horace owned an upright piano for singsongs round his house. He was a great character – every family should have one. His son Roy was a few years older than my brother and a bit of a tearaway, with his motorbike, fags and rough friends. I think Mick borrowed records from him at one point and the two of them shared an interest in model trains, too. Roy had a large set in his attic with a spread of rails, numerous points and signal boxes, which were later passed down to Mick for his own collection.

Horace would always hand us boys a half-crown each and utter from the side of his mouth, the instruction: 'Here, put this in your pocket.' One of his jokes was that he was supposed to have been christened 'Maurice' but that the vicar was 'hard of hearing'. At family get-togethers we would sit around munching crisps until Horace slyly took my brother and me into a back room to offer us a drop of cider. Unscrewing the ceramic stopper from a dark brown quart flask, which gave off a gentle fizz, he would warn us, 'Don't tell yer mother.' In his twilight years, he came to Somerset and loved sipping local cider and looking out at the rolling countryside with Glastonbury Tor in the distance. Horace was the holder of the family history and told us tales of his mother and the family, many of which are in this book. I think he viewed Mick and I as suitable repositories for these stories and quite rightly valued oral history from days gone by.

In his later years, like most of my relatives, Horace moved down to the Kent coast near Margate and dutifully looked after his wife Gladys, who was confined to a wheelchair for many years. She always had the attention of us children because she had 'chocolate éclair' sweets and other goodies hidden down the side of the chair and among her floral dresses. She lived well into her eighties but, once she had passed on, Horace took off 'Down Under' to see

Australia and all the cousins he had missed since he left aged six, as the family had emigrated there in 1912.

Horace was in Sydney during a Stones tour and Mick told me that Horace called him up one morning, opening with his usual patter: 'This is your oldest relative…'. Mick told him to come by for lunch at around 1.30, as he has a tight schedule. Notwithstanding, by 11.30, Horace was knocking at the hotel door, his usual incorrigible self. He loved coming to see my band too, and was buried in his Rolling Stones tie aged 97. I had arrived to see Horace in his hospital bed just a few minutes too late and told the nurse that he had gone. He was still looking forward to being 100 and visiting Mick in the West Indies. His last words were: 'Is that it then?'

PARTY TIME

As with many families of the day, get-togethers would feature parlour games, charades and some hugely embarrassing dancing with female cousins. (Mostly, they made a fuss of me, which I'm sure I enjoyed, not having any sisters.) Nan would sing 'Abide with Me' in her wavering voice, which, we were assured, was a fine one in her youth.

My mother had a sweet voice too but would frequently have to refer to my father when she forgot the words, an important asset for a singer. Dad would then begin crooning and Mum might comment 'Joe, you're flat' – but he would carry on regardless. One of his favourite musical duos was the evergreen, if corny, Flanagan and Allen, who had a wartime hit with 'Underneath the Arches'.

I found Bud Flanagan's autobiography in a second-hand bookshop recently. His was an interesting story, beginning with hard times as a Jewish lad on the streets of London's East End. A little while after Dad's death in 2006, I was sitting in his house alone and wrote a song for him called 'The Photograph', including the

lines 'Some say that you sang flat/But I shouldn't worry much about that'. When I later recorded it, I made sure I was flat, and guitarist John Etheridge added a flat note too!

While at school, a teacher had ridiculed my father for his inability to hold a tune and that struck me as cruel. Everyone can, in their own way, sing, and being embarrassed in front of his peers must have been painful, particularly when his own father was headmaster of the small Greenfield school in Yorkshire and played the organ in church. So Dad, like Mum, had little musical education. Conversely, Mick and I weren't offered it, but one way or another we taught ourselves. As Jimmy Page once remarked, 'What I liked about the guitar is that it wasn't taught in school.' Perhaps lessons would have put us off in the longer run, while finding our own routes has made it more personal. In any case, we wouldn't have been studying Howlin' Wolf or Chuck Berry.

In primary school, I scribbled the classic essay on what I wanted to be when I grew up, opting for 'ryner' (runner), singer or 'cemedan' (comedian). It's amazing that music, humour and sports are still the things I love most – and in later life, I used to wonder why I had abandoned singing so soon after declaring that ambition. The answer is obviously puberty: when your voice breaks, you become self-conscious. Singing wasn't seen as a talent worth encouraging at big school. Better that you were good at Latin.

ROLL OVER, BEETHOVEN

For many years, the only music that came into our lives was via the wireless, which Mum liked to listen to around the house. There were plays and classical works on the BBC Home Service, but our set was usually tuned to the Light Programme, which played chiefly dance music such as *The Billy Cotton Band Show*, with Vera Lynn on vocals.

There was also a good deal of jokey stuff, from such comedians as Arthur Askey, Ted Ray and other wartime favourites who seemingly had an unlimited timespan. Then there were presenters, such as David Jacobs and Sam Costa, who disliked any rock & roll, with the exception perhaps of Cliff Richard or Tommy Steele, both of whom started out okay but then slithered into a morass of middle-of-the road slush ('The Little White Bull', anyone?). Those DJs survived into the Sixties to comment on music that obviously wasn't their cup of tea in the first place. Jacobs famously chaired the TV show *Jukebox Jury*, whose jurors included all five Stones one week. The generation gap was huge and the band treated the whole show as one big joke in their usual cruel manner.

COMEDY STUNTS

By the dawn of the Sixties, Kenneth Williams and Frankie Howerd ruled the comic airwaves with all their camp nuances and funny voices. So that was one field, then, where being gay was all right. Men like my father would refer to feminine men as 'nancy boys' – which was less rude than the usual 'queer'. Women, though, found sexual innuendos and suggestive comments particularly amusing in a period when men were pressured into behaving 'normally'. Strange to think that, years later when we grew our hair long and were ridiculed, we were often asked, 'Are you a girl?' As though that was the worst thing you could possibly be.

Unmissable on the airwaves was *The Goon Show* with Peter Sellers and Spike Milligan, which was the beginning of zany humour as far as we were concerned. Led by Dad, who remembered some sketches verbatim, we would all learn the silly voices (and, that being a good mimic is one way to become popular). Tony Hancock then became the king of radio comedy, his situa-

tions being more existential and consequently more advanced, or so we thought.

Mick and I occasionally performed sketches in the living room, with our parents as audience, and once did a Bernard Cribbins routine called 'The Hole in the Road', which was basically laughing at the laziness of the working classes, just as they did in the film of the day, *I'm All Right, Jack*, sending up the unions. On Sunday afternoons, it was a patriotic duty to listen to the Forces Request programme, when privates from BFPO 30 in Hamburg would write in to request a tune for their fiancée Doreen in Wapping whom they were marrying in six months' time. This was during the washing-up and after Billy Cotton's show, which also included comedy sketches. Much later, I began collecting old 78rpm records from those times and it's amazing how most of the wartime songs are cheerful and happy. I guess people didn't need to be depressed.

After all this excitement, Mum would go for a rest and Mick, Dad and I would depart with our cocker spaniel Jinks for the obligatory walk to Swanley or Joyden's Woods, whatever the weather. One attraction of this was stopping on return at the only place open on a Sunday, a sweet shop run by two old boys, where we filled little white bags with goodies. And sometimes we visited the site of a Roman settlement, Lullingstone Villa, and might hunt about for some tessellated pavement, small chunks of tiling that we would illegally bring home. Holding such an ancient piece of pottery in your hand was magical.

VOYAGES WITH MY FATHER

Dad was keen for us to have an education, but sensibly realized that we wanted fun too, so trips to London were sprinkled with both ingredients. He would joke in a northern accent, 'You must have some culture!' And since he was a historian, he took us to

sights like St Paul's Cathedral or up the Monument, erected to commemorate the Great Fire of London, its height being equal to its distance from the pudding shop where the blaze started. One time we ascended Big Ben with the guide, a Mr Simpson. He reeled off various facts and figures, the number of steps we were to climb, the height of the tower, the number of pieces of glass on the clock face, the weight of the bell and how many pennies were placed on the pendulum to adjust it to the exact time. The bell struck 12 while we were standing there. I later saw Peter Sellers taking off the very same Mr Simpson on the *Parkinson Show*, so he made an impression there too!

After the 'culture', we might stop at the Cartoon Cinema in Victoria where they showed non-stop Mickey Mouse and Tom and Jerry, and finish at Lyons Corner House for some basic nosh – 'tea with lions', as Dad would say. A special treat was going to Schmidt's in Charlotte Street, perhaps the first proper restaurant that Mick and I ever went to. They served chicken, which was a big deal. You entered through an unimposing front door, followed a narrow corridor past diners, descended a few steps, round a corner, up more steps and along another passage before they found you a table. Manned by scurrying waiters, with armfuls of delicately balanced plates and stained uniforms, it was a warren of inter-connected houses, and was busy because it was cheap.

My father always had to watch his money, and would collect spare change in old jam jars to take to the bank for a rainy day. At Christmas he would shop carefully, and our best presents were German Schuco toy cars, the wind-up ones. (Mick once received a red convertible with a steering wheel and a horn that actually worked – a classic.) Schuco developed a strong spring system so that their chunky racing cars could go extremely fast, which seemed fantastic. Dad bought them at Gamages, a department

store in Holborn near the Central Council of Physical Recreation office in Bedford Square, his base for paperwork. He was always looking for a deal and once suggested to a salesman that Schuco made a cranked key, as the existing ones were too hard for small children to turn. They took his advice, introducing the cranked key the following year, and so he was given a free one!

MUM, A DESCRIPTION

My mother was quite petite, about 5 feet 4 inches tall, fair skinned, outgoing and vivacious, and enjoyed dancing and meeting her friends. She had the security of four elder brothers who spoiled her and had returned with her aged three back to England from Sydney, Australia, where she was born. Her father stayed put and the later realization that he would never return must have affected her. My nan brought up five children on her own and lived through two wars in difficult circumstances. Nan was finally offered hot water in her council house in the Seventies but, as she'd made do without it all her life, she didn't bother with it.

Leaving school at 14, Mum worked for a while in a music store in Bexleyheath and got along fine, enjoying the newly released records and the radiograms for sale, but she wasn't really settled in herself and left; a pity, as the connection might have come in handy later on! Instead, she was taken on as a hairdresser's apprentice and, the current fashion being for bobbed and crimped hair, there were likely many locks to sweep off the floor. Somewhere I still have the iron clamp that would be put on a gas flame before curling the 'Marcel Waves' that were then de rigueur for budding flappers. Hats were added at an appropriate angle and the look was complete. With her slim figure and pretty features, Mum must have had many a local admirer.

One such was a policeman, but it didn't last and he inadvertently left his dinner jacket at Nan's house. When Mum met my father, they were due to go to a dinner-dance but Dad had no dinner jacket, so – without letting on, of course – she lent him the one hanging in the closet. It was an oft-told story accompanied by much laughter, and when I first heard it, I remember being pleased that my father wasn't in the police.

DIARY

Why do I live in Somerset? Although I was raised in Kent, I do feel an affinity with this county, partly because apples are so important in both landscapes. Here in Mudgley, we are fortunate to have local cider maker Roger Wilkins, who dispenses bonhomie close by in his barn, whatever the season. In the extreme cold, you may be lucky to taste some 'hot', served from an old white jug that cheers you immediately and then you are free to start talking nonsense.

To serve 'hot', you should gently warm the cider, then add a good tablespoon of honey and brown sugar, a small sprinkling of ginger powder and a slug of gin. Serve immediately.

DAD, A DESCRIPTION

Dad stood around 5 feet 9 inches and had a fine physique; he boxed and ran cross-country for Manchester University – receiving his 'colours' – and he remained fit all his life. His hair thinned very early, so I never knew him with a proper mop and his ageing seemed very gradual to me because he remained vigorous and active. He occasionally smoked when young, as all men did then, but drank only 'socially' because to abstain would have been rude.

After graduating, Dad taught history in Bedford and then rode his motorbike south to take a post at East Central School in Dartford, where the pay was better. His interest in sports must

have made him a popular teacher coaching the teams, and after war broke out in 1939, he was drafted into the army as a private. You might have thought that a university-educated sportsman would have been trained up as an officer but this was not the case. He told me that on a cross-country run organized for the recruits, the poor squaddies were collapsing all over and Dad had the temerity to inform the commanding officer they weren't fit enough for such strenuous efforts. For this he was duly reprimanded. But he knew what he was talking about and, although a respectful man, he would speak up if necessary, despite others' seniority; he was an independent thinker.

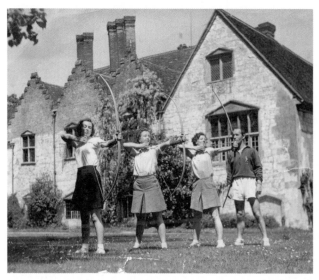

Dad with Amazon warriors at Bisham Abbey, a sports centre outside London where ordinary mortals enjoyed the ancient buildings and grounds.

Thankfully Dad was sent back to teach in Dartford and employed by the forces to improve the fitness of young conscripts. Classes would take place in draughty drill halls and local barracks of an evening, and I suspect, left to his own devices, Dad began formulating ideas on how to both instruct and retain the attention of his students. His approach was always to make things interesting and entertaining in order to achieve better results.

Like all those in 'reserved' occupations, Dad doubled up in the Home Guard, as a gunner. He told me that on their first practice they lined up the distance and trajectory for their shell and banged out the target straight off. They were told off for this, as the target took a lot of work to re-set!

After the war, Dad enrolled as a mature student at Loughborough College, then, as now, the premier college for physical education in the country. Due to a shortage of instructors, he was asked at one stage to teach the classes himself. The one time he became really annoyed after my brother became famous was when he was described in a newspaper as a 'PT [physical training] instructor'. He had campaigned for so many years to have this description changed to Physical Education (PE), to differentiate it from the mindless military-style drills that were previously the norm.

Dad's early upbringing was in Greenfield, a small village on the moors east of Manchester. He told me that if you tossed an apple core into someone's garden in the morning, the news would get back to your mother by day's end, and being a school-teacher's son, he was subjected to much ribbing by his peers. At home, his mother ruled the roost and was very strict about attending church, where Granddad took the choir. Grandma was proud of her maiden name – Fanshawe – that went back 500 years there, so she said. She even gave it to Dad, as his middle name.

The village school that Granddad ran is still thriving to this day and I took Dad back there in his old age. The woman head was delighted to meet and hear his stories, and we were pleased to see the school still thriving.

I didn't know Grandad well but remember once going for a walk together and he had a 'turn', which we left him to get

over. The dizziness was a legacy from the Great War, when he had served in the artillery and, like so many, suffered from shell shock. Yet he was one of the lucky ones. A telegram was delivered to Grandma one day reporting that he was 'missing', usually a euphemism for 'dead'. He had gone 'over the top', that is, and on his return scrambled into the wrong trench and was still very much alive.

Granddad first became a student teacher, instructing younger children when all ages were taught in one large room. He then progressed to proper teacher and finally to headmaster without ever gaining a proper qualification. He didn't play music in public, with one exception. In Lancashire, they had 'wakes weeks', when everyone took their holidays from the factories simultaneously, usually boarding the train for the seaside town of Blackpool. There, as Dad told me, you lodged in a boarding house where they provided your breakfast and evening meal. No matter if it was pouring with rain, you left in the morning to roam the streets or attend singsongs or dances. At one event, the pianist failed to show and so, prompted by his wife, Granddad came to the rescue on the joanna, likely with some hymns or popular tunes such as 'She's Like a Rainbow' (da da da da da da da).

A distant relative of my father, even named one of his sons Johann Sebastian Jagger, so he must have had a sense of humour.

UP NORTH

Grandma grew up outside Sheffield, in the small town of Eckington – home to Renishaw Hall, a fine country house and the seat of the Sitwells of literary and artistic fame. Dad was best friends with Stanley, the gamekeeper's son there, and together they had the run of the grounds, playing in the woods, climbing trees, collecting birds' eggs and having a rare old time. He even played

cricket there, as Sir George Sitwell boasted his own pitch and Dad was drafted in as a lad.

When my father was approaching 90, Mick and I took him on a trip north to Hadrian's Wall and en route visited Renishaw. The owners were absent but luckily the custodians welcomed us in and we enjoyed a tour of the house followed by tea and cake in the dining room. We admired the pictures and the photos by Cecil Beaton, and the fine furniture. Dad's old friend Stanley was still alive and the two had a final reunion after some 60 years. Dad asked Stanley how he was and got a blunt reply, 'I'm not well, seeing as you ask.'

My parents were born within a week of each other in April 1913 and met when they were coming up to 30 – so with the Second World War ongoing, they decided to get spliced. They first met at a dance at The Bull in Dartford, as both shared a love of dancing and music, which shows how it brings people together. I reckon a man couldn't meet or touch a woman in those days, except when stepping out. You would soon be found out if you were clumsy or had two left feet and word would get around (for ladies did not care to have their dainty toes trodden upon). Even worse was if you refused to dance and were a 'wallflower', as my mother called the men who just stood watching. Clearly, Mick follows in Mum's footsteps.

CHAPTER 3

SHORT TROUSERS AND GRAZED KNEES

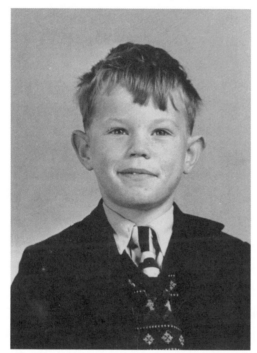

At Wentworth Primary School.

I spent most of my youth playing football and cricket. I was an avid reader of Charles Buchan's *Football Monthly*, with its tinted pictures of the day's heroes, such as Billy Wright and Danny Blanchflower, in action poses. Wrighty was the England captain and Dad had his check jacket hanging in a cupboard for many years, until Mum threw it out. I think he'd left it behind after a coaching session. Today you would put it on eBay.

I collected cigarette cards and indecipherable autographs: Johnny Haynes of Fulham and England, a stylish player of his era; young Bobby Charlton who was already losing his hair; the mouthy Brian Clough; and our big hero Jimmy Greaves, who we called 'Graves' for some reason. While at Hulme Grammar School

in Oldham, Lancashire, Dad had played football opposite Walter Winterbottom, who later became the England manager – so if we wanted tickets for England at Wembley, it wasn't a problem. Sometimes, we watched from the Royal Box, but I never imagined that many years later I would watch Mick on stage from the same vantage point.

I went with Dad to most London grounds, the nearest being Charlton Athletic, but also to West Ham, a cramped but friendly ground, with the best banter and songs. Arsenal had a swanky place with art deco stairs leading to the director's box and – most impressive of all – individual towels in the loo, monogrammed with the team's gun logo. But my favourite venue was Tottenham, as the Spurs were by far the most exciting team of the era, winning the League and the FA Cup. Double in the 1960 – 61 season. I once went to a mid-week game with Tony, a school pal. We took the train together to north London and the ticket office directed us down a long, dark corridor until we emerged blinking from the players' tunnel to the jeers of the crowd, who were waiting for the teams to appear. We perched on the trainers' bench: one minute you were 2 feet from Dave McKay's muddy boots, the next straining your eyes to catch the action on the far side of the pitch.

At Wentworth School, we religiously carried the goals and equipment in a crocodile every Wednesday to the pitches on Dartford Heath and played under the eye of Mr Mills. Aged 11, I was picked for the Dartford Schools team, playing at left-half. Our centre-half was Colin Dwyer, who we all rated and, many years later at a gig, I ran into his sister and learned he had achieved the mighty heights of playing for Welling Town in the Southern League. Not that 'amateur' football should be sniffed at. Dad had played for the Bedford Eagles before the war and was once

surprised to find a fiver lodged in his boot before a game. He was advised to keep quiet about this 'boot money'.

For 15 years during the Fifties and Sixties, Dad worked for the Central Council of Physical Recreation (CCPR) – quite a mouthful. This was a government quango set up to organize sport in Britain, then largely in the hands of cheerful amateurs driving round the country to run courses with equipment stuffed in the boot of their cars. Our garage at Wilmington was a treasure trove of gear: old leather medicine balls, volleyballs, heavy leather footballs with laces, boxing gloves, cricket bats and balls, stumps, foils and fencing masks, javelins, discuses, shots, hockey sticks, baseball bats and balls, shuttlecocks, tennis rackets, weights and a canoe strung up on the beams. Against the back wall were boxes of cooking apples, wrapped in newspaper, so there was a curious mixture of linseed oil, leather and rotting fruit in the air, much to Mum's displeasure.

The canoe was strung up in the roof, an early kit one which I helped Dad construct, glue up and cover with canvas; and I was featured in some shots for a book on canoeing that he wrote for Faber & Faber. Together we went on expeditions and I loved every minute of them: from assembling the aluminium screw-top tins that Dad had collected from the chemist and filled with tea, sugar and biscuits, to pushing off from the bank, paddling downstream, and camping out when the evening air became heavy with mist. Our best trip was down the River Wye when I was about 12. I'd never seen such beautiful countryside as those sloping valleys in Wales as we drifted along the rippling current, with the occasional salmon jumping across our bows and the trees waving their branches at us from the grassy banks where the Hereford cattle chomped on the lush pasture and the poet William Wordsworth had

wandered, penning his famous lines on Tintern Abbey, further downstream.

We used a Percy Blandford folding double canoe, which could be taken on a trolley in the guard's van of the train. Beginning at Hay-on-Wye, we made our way past Hereford to Ross, camping en route. There were a few minor rapids and at one point we were caught in a whirlpool that almost sunk us, but Dad steadied us by bravely clutching at some plants on the bank. They were nettles!

We also paddled more local rivers, like the Medway and the Cuckmere in Sussex, which ends at beautiful Peacehaven. There, we fished off the bridge while the grayling ghosted underneath us. I had a brilliant childhood and never wanted it to end. I hated the idea of growing up.

Some trips I didn't make, such as the journey that Dad and Mick made to the Brussels World Fair in 1958. They hitchhiked there to see such wonders as the Atomium, a stainless-steel construction with connecting spheres, resembling a magnified iron crystal – all very sci-fi at the time. Mick took off with his blue duffel bag over his shoulder, all so grown-up, while I stayed home with Mum. He must have had a great trip as he was into Isaac Asimov stories, which I occasionally picked up to fathom through.

Another of Dad's pastimes, which he kept up for many years, was teaching learn-to-swim classes for adults. Like most amateur sports bodies, this was all done gratis. Once I recall him being chuffed that an 85-year-old woman had finally conquered her fear of the water and could now do a length or two. On the other hand, my mother refused to swim, so no success there!

There were holiday courses a-plenty. I went to one at Aylesford Paper Mills, where the Finnish team had trained for the 1948 Olympics. Nobody had heard of saunas then, and the Finns had built their own there, a spacious wooden cabin that we were free

to use after the day's session. I also went on football courses where I was usually the youngest and sometimes just had to watch. One coach was the Lancastrian Jimmy Clarkson, who Dad liked to imitate. To teach us the offside rule, Jimmy had trick questions like 'Where do you 'ide on a football field?' I've actually heard him quoted on TV by pundit Jimmy Hill, another pal of Dad's. Although the sport was still very competitive, the coaching methods were not so formalized as now, and there were closer ties between professionals and amateurs.

After the FA Cup Final in May, footer finished and cricket and tennis commenced. The house in Wilmington had a narrow driveway boxed in by two walls with a garage door at the end: a perfect 'net', with a wicket chalked on the garage door. Mick and I would practise there with a tennis ball – although not knowing when it had actually hit the wicket led to some arguments. The usual method of our settling these disagreements was 'matchsticks' – that is, the batsman holding the bat by the blade and attempting to hit the ball with the handle. Of course, it was hard for me to keep up with a brother so much older, and probably pretty tedious for him, though I suppose Mum would lean on him.

There was a rich tradition of Kentish cricket players, such as Alan Knott, formerly at Erith Grammar and probably the best wicket-keeper England has ever produced. (Mick actually played against him at school-level, although Knott was a bowler then.) 'Deadly' Derek Underwood was local and took nearly 300 wickets for England while England fast bowler Graham Dilley attended Wentworth School after we had left.

DIARY

The sun is shining though my window again, praise the Lord, but the fields are still wet and saturated and the stream in the bottom field is

running full: I couldn't cross the ford there in my wellies. A more imme-diate problem than remembering what happened 50 years ago is my impending trip to the USA. The Stones are embarked on a tour there and God knows how much longer they will go on. I suggested to the Daily Telegraph a trip to Nashville to pen something nebulous for the travel section. But one problem is that Charlie Hart, who is organiz-ing our gigs, told me that we have one at the 100 Club in London on 24 November, the day I need to be in Nashville!

I was so anxious about it last night that I had a dream we were playing, not at the 100 Club but at a new purpose-built auditorium in Camden. I was shown round the state-of-the-art place, which could hold a few thousand, but then I was told I would be playing in the basement, a pokey hole (like the 100 Club). Not that I don't like the 100 Club. Normally I would be happy to play such an illustri-ous joint, where every good band (and some crap ones) has performed over the past 50 years. It's just that I would also like to make some money before Christmas, as God knows it's dead after that. I am try-ing to draft in Ben Waters, a fellow musician and piano player, to cover for me.

OUTSIDE BROADCASTS

Associated Television's *Seeing Sport* was a weekly 5 o'clock pro-gramme that aimed to encourage outdoor interests among schoolchildren. My father, always looking for new opportunities, became involved with the programme in the Fifties, and because it was produced independently rather than by the BBC, he was paid a decent fee for those times. The show was fronted by Peter Lloyd, a blazer-wearing chap exuding bonhomie, who always had a suitable expert on hand to answer his relevant questions – and this was all done on location with outside broadcast (OBS) trucks, quite innovating then.

My brother was pretty good at shimmying up rocks, soon understanding the techniques of climbing, and he can famously and fleetingly be seen in a *Seeing Sport* segment shot at Harrison's Rocks in Kent, when the instructor John Disley lifts up Mick's shoes to show the camera what he's wearing. Mick and I were involved in the programme at various points and, though I was quite young at the time, I can remember the camping and canoeing episodes. That was our first introduction to TV.

One holiday, my father and I went walking up Mount Snowdon in North Wales – the highest peak there, but you can basically stroll it – when he decided the 'pig track' was too boring for us. Instead, we ascended directly up the scree, on the side of an escarpment to Crib Goch, the ridge above. On the top we met proper climbers making their way, so for safety's sake he borrowed a rope to tie round my waist, as there was a sheer drop on the far side. It was always good fun going out with Dad!

John Disley was a great pal of Dad's and to us he was a hero, having won a bronze medal in steeplechase at the 1952 Helsinki Olympics. He had a small cottage in Capel Curig, in the mountains of North Wales, and since he left its key under a rock, all fellow climbers knew how to get in. John began the sport of orienteering in the UK and, along with steeplechaser Chris Brasher, founded the London Marathon – which from humble beginnings and not much support has emerged into the major event it is today. Initially, John Disley was faced with major objections from the authorities to the running of the marathon, but after a 'fact finding' mission to New York, which had held its own hugely popular marathon since 1970, all protests disappeared. It turns out the Metropolitan Police came for a jolly, and were whisked away immediately by the NYPD; our boys in blue had such a fantastic time there that, when they returned, they fully supported the idea!

THE FLICKS

I was a notorious tease and liked to see how far I could push things, so sometimes Mick would bribe me to be good – and I had to be doubly good if he deigned to take me to the cinema in Bexleyheath for the Saturday morning kids' show. We would take a trolleybus and meet his friends outside the ABC cinema in the high street. So exciting! But it wasn't just going to the pictures, it was the freedom of being out there on your own and, in those days, the only chance you had to see cartoons, which were doubly amazing on the big screen.

You got a badge and there was a compère and a song for the 'ABC Minors' and hundreds of screaming kids. If it was your birthday, you could get up on stage for a cheer and a present. One of my brother's friends did that, even though – Mick assured me – it wasn't actually his birthday, and I was amazed at the audacity. I was so innocent, I'd never even heard a swear word until my friend John Freeman said 'bloody' one day. I remember him stepping on ants, too, and I made him stop because I thought it was wrong to kill things. So maybe I wasn't just innocent but also showing early signs of Buddhism.

WE'RE SHOPPING

Mum never learned to drive so shopping was a big deal if Dad wasn't around with the car, as everything had to be lugged back on the bus. Women always took their baskets with them and, apart from brown paper bags for special things, there was only old newspaper for wrapping goods. Spuds were chucked in paper at the greengrocer, where they served the queue very fast. You had to have your basket at the ready while they lobbed weights onto the scale to work out the price per pound. One butcher was avoided because he had been known to stick fat under his

scales to short-change customers – and during rationing every ounce counted.

The grocer delivered on Saturdays in a small round-top van, one custom that has recently returned – as has buying clothes on approval. There was one outfitter well known to Mum, where she could buy clothes 'on appro' and take them back if they didn't fit. She did that quite a bit for us both as it meant we didn't have to come with her.

One store in Dartford retained the ancient pulley system for payments, which fascinated us as young kids. The assistant would take your money, put it in a screw-top metal container overhead and pull a cord that sent it whizzing to the little glass booth of the cashier, who did the accounts and sent the change back the same way. Assistants weren't always trusted with money and that's the reason, some claim, for the strange prices – say, 19 shillings and 11 pence for an item, instead of £1. That meant the assistant normally needed a penny change, whereas they might have been tempted, if nobody was looking, to slip a pound note into their back pockets with no one the wiser.

NAN

My nan, my maternal grandmother, always had a pocketful of sweets when she saw me. They were a currency between us. She had sucky sweets, toffees and liquorice, chocolate, chews and aniseed balls, black jacks, fruit bonbons and peppermints. During the war, confectionery had been rationed, so she made up for it later; nobody had told her it might be bad for your teeth.

After we moved to Wilmington in around 1956, I remained at Wentworth School, so I had to get there each day by two buses, sometimes three. Returning home, I would change at the Orange Tree pub, where Nan would meet me, God bless her, to have a

natter and load me up with sugar. For this she would walk from her house, maybe 400 yards on her dodgy knee, but she never complained. I loved her because she spoiled me. She was small and always wore a hat – which, when visiting, she was prone to leave on. 'Take your hat off, Mother,' Mum would admonish her; to which the reply was usually 'No, I'm not stopping.' Fifteen minutes later, the same conversation would be repeated but she seldom took it off, especially if her hair hadn't been 'done'. Then Nan might announce, 'I'll walk to the church,' as the fare was slightly cheaper from there. The received wisdom was that if a bus had 'gone up', there would be one soon 'coming down'. The important things were never mentioned, like 'Why didn't your husband come back from Australia?'

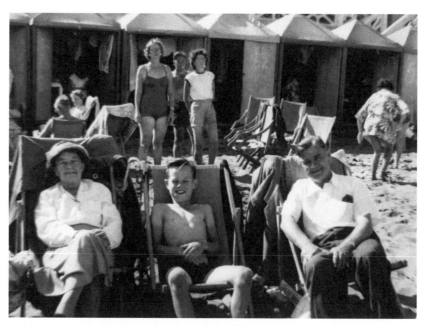

On the beach at Broadstairs Kent, Nan as always in hat and Uncle Cyril.

A FAMILY MYSTERY

My maternal grandparents emigrated to Sydney in 1912 and my mother was born in the suburb of Marrickville a year later. Sydney has the ocean all round with wonderful beaches, sunny skies and good food. My grandfather was a boat builder from Kingston upon Thames and soon found work in Sydney, far from the ghastly carnage of the Somme. He had apparently been a 'good catch' for Nan, a handsome feller who liked the company of ladies, and she had married him when 'with child'. But in Oz, Nan sorely missed her family – she was one of 12 children – and after three years there, she resolved to return.

Her usual excuse to us was that it was 'too hot', but I suspect there may have been another reason. I mean, why leave your husband and book a passage home in the middle of the First World War, when German U-boats were active and there was rationing in Britain? My grandfather worked with the Admiralty, so must have been aware of the dangers to shipping on the long route home. He was supposed to follow on, but procrastinated indefinitely. Many years later, sitting in what had been his office on Garden Island and looking out at the fine expanse of Sydney Harbour, I thought: 'I wouldn't swap it for Dartford Creek, either.' But that was to be the last my mother ever saw of her father.

Next door to the Marrickville house stood a large pub, where they kept chickens in the garden to supply bed-and-breakfasters, and my uncles would sneak in there to cadge eggs, eventually coaxing a hen into their own garden. They would then take eggs to their grandmother, walking the few miles' distance. One day, they had the bright idea of bringing the hen instead, so they took her along in a brown paper bag. When they arrived, however, there was a deadly silence. They were led into their grandmother's bedroom, where she had just passed away aged 102 years.

So they stood there wondering what to do next, holding the hen in the bag. Whenever Horace told me this tale, tears of laughter would roll down his cheeks.

THE LONG WAY HOME

In 1916, Nan and her five children boarded the SS *Rotorua*. Loaded with 6000 tons of produce and 238 passengers, the steam ocean liner headed via the Solomon Isles towards the rising sun and the Panama Canal. For the four boys it was a great adventure. Horace told me: 'We always called England home and as young kids we were quite excited about returning. For the trip we all had to have our ages reduced, as over-12s were full fare. Cyril and Percy had their passports altered, even though Cyril had his fifteenth birthday on board. One of our activities was to go up to the skylight over the dining hall. We'd get string and a potato, stick matchsticks in it and dangle it down in front of the diners!'

Horace recalled the stokers coming up from below to be inspected by the doctor. 'Then they would sit on top of the hatch playing the old mouth organ and singing songs, so we kids would gather around to listen.' He still remembered the song they sang:

Bill on the big ship,
Shovelling the coals on the fire,
Down in the stoke hole making the flames
Leap higher and higher.
He died in the autumn and left his Mariah.
Poor old Bill, I'll bet you he's still
Shovelling the coals on the fire.

And this is one that Nan would sing:

My master grinds an organ.
He leads me by a chain,
And when I've picked the pennies up,
The people laugh and laugh again (ha-ha).
Although I dance and caper,
At times I am forlorn.
I wish I were in monkey land,
The place where I was born.

After the *Rotorua* finally arrived at Plymouth, the passengers dis-embarked, and Nan continued to Southampton. The ship was being tailed by a U-boat, which sunk her in the Channel, and there she went down with all the food and goods destined for the deprived home markets.

Initially, my grandfather sent money home but that soon dried up, so Nan raised five children by her own means, which must have been tough. No doubt her boys were soon bringing in wages. She made extra money by running up clothes as a seamstress, and she was a milliner too, making fancy hats for women.

My grandfather died in Sydney in 1963, a year before my brother first went there, touring with the Stones. It was only on his deathbed that Mum sent him a letter, saying she forgave him. It was a letter that took her 50 years and much thought to write but no doubt a crucial one for him to receive. It's hard to understand a father not wanting to see his daughter, no matter the distance and the years passed, and it's sad that there was no reunion.

Mum refused to return to Oz, even though Mick sometimes suggested it. Dad would have liked to emigrate there to advance his career, or alternatively to Canada or the USA – but my mother absolutely refused to discuss the matter and remained in Kent.

CONCERTINA JACK

An earlier family mystery concerned Mum's grandfather, aka Concertina Jack, a Kentish baker by trade who played the squeeze-box round the pubs. He fathered 12 children but then inexplicably took off on an Australia-bound sailing ship, along with his 70-year-old stepmother, who worked her passage by looking after children on board. Uncle Horace surmised the reason was 'either money or woman trouble, probably the former'.

Jack certainly proved to be a 'rolling stone', rising early to make bread, playing around local pubs, and in the summer off picking hops and entertaining the families of an evening around the campfire. Like Jack, I enjoy bread making too, and I'm glad to see a resurgence in the old skills, and see them handed on through the family.

Mick and I knew Jack's son, unsurprisingly known as 'Concertina George', who stayed in Dartford and ran a bike repair shop among other things.

Many years later, in 2005, I seized on the story and wrote a tune about Jack. With this suitable excuse, I took off with my band Atcha! to Mick's chateau in the Loire in France and recorded an album in the old stables there. Mick arrived a few days later, so I enlisted him to add to the vocals in warbling about our old ancestor.

VALEDICTION

Families are often a curious mixture of influences but our upbringing was very grounded. A father with a steady job and a mother at home looking after the family is unusual today. But it was sometimes quite lonely for Mum, as Dad was always working and determined to get on – and his dedication was manifested in those he had taught. Many a time we were shopping in Dartford as a family when strangers would approach him and thank him pro-

fusely for the help he had given them. My mother would see what was coming and, knowing Dad's patience, move off with me in tow. I was nonetheless impressed! One former pupil wrote to me after Dad's death and told of the simple manner they dealt with miscreants then in PE. The class would form two lines and each remove a slipper, then the naughty boy would run the gauntlet through the line.

DIARY

Upon my soul, another sunny day. This project must be blessed. Sheets of water are still lying in the fields and shimmering in the morning light. Numbers of duck rose there yesterday and even if no one else enjoys the floods, the birds do. Dad arrived last night, so that will be a good chance to try to remember times past with him – though sometimes he thinks he's speaking to Mick not me, so the information's accuracy will be another matter.

The phone just went and it was Arabella Churchill from Glastonbury, wanting to cancel Kari-Ann coming over to take her through some yoga poses. The other night I was chatting to her and it seems we have the 'fame' thing in common, she being the granddaughter of the most illustrious Briton of the 20th century. That might have some drawbacks. Something of a rebel when young – as Winston was, in a way – Arabella founded and now runs Children's World, a charity providing entertainment for kids in the developing world and at Glastonbury Festival. She's married to Haggis, who among other things is a juggler. She told me that she had come down to Glastonbury Tor recently, when someone sitting in the grass muttered aloud 'Never surrender!', the old Winston quote. She was quite flummoxed. But that's one thing about these associations. A journalist comes up to you after a gig and asks, 'Is it a disadvantage being Mick's brother?' To which the answer has to be, 'Only when journalists come up asking, "Is it a disadvantage…".'

CHAPTER 4

TEENAGE YEARS

My brother passed the 11-plus exam and was admitted to Dartford Grammar. I believe that he was a 'borderline' case and so interviewed by the head, as to his suitability. The headmaster, 'Lofty' (on account of his short stature), asked what Mick liked to read and he apparently replied 'encyclopaedias'! Personally, I remember him chiefly reading *The Eagle* comic or *The Schoolboy's Pocket Book* (which I guess was a kind of encyclopaedia, as it listed all the names of the longest rivers, highest mountains and so on). Like all such books, it was carefully preserved with a thick cover of brown parcel paper, onto which you proudly wrote your name with a fountain pen.

Mick took *The Eagle* and then handed it to me once he'd read it, although I really preferred *The Beano* and *The Dandy*. *The Eagle* was a bit highbrow, and boasted Dan Dare on the front, eventually in amazing colour. Dare was a modern hero who fought the Treens in outer space and, with his mate Digby, outwitted the evil forces of the Mekon. But I was still more concerned with the Bash Street Kids and Dennis the Menace.

As a present for passing the 11-plus, Mick was given a new bike, something of which I was immensely jealous, as I'd never achieved that status. It was a blue Raleigh with drop handlebars and a leather saddle which I later inherited, like many a hand-me-down item brothers receive. Now I receive them from my kids!

Bikes were important as they offered massive freedom to explore. The usual rendezvous was on the Heath, in an area that featured a series of 'humps and bumps' that was originally created for tank exercises during the war. They were graded in three different heights, the smallest used by tots on their tiny bikes,

the steepest by the flash kids with bull handlebars, hooters and no mudguards.

In my last year at primary school, I rode my bike there from Wilmington, across the Heath, which involved crossing the main A2 London to Dover road, a busy route even then. At weekends my friends and I would take long rides out to country places such as Horton Kirby, in the pretty Darenth Valley, or to Swanley Woods and the racing track Brands Hatch, where Dad had shown us a place to climb over the fence and get in for free.

We loved the motorcycle racing best, the racers roaring round Paddock Hill Bend at death-defying angles, their white scarves flying in the wind. Those were the days of Phil Read and John Surtees, kings of the Norton, while Stirling Moss and Mike Hawthorn dominated the racing cars with their snorting Jaguar D-types and ERA cars. Some years later, at secondary school, I joined the printing club and forged press passes to get into the paddock area with my friend John Freeman, who owned a reflex camera, and we wandered about taking snaps as the machines were revved and finely tuned by the petrol-heads. John later fulfilled his ambition to become a top professional photographer.

On a more intellectual level, Mick brought home a paper-back one day called *The Hidden Persuaders* by the American writer Vance Packard, so I read it too. Written in the Fifties, the book envisioned a world of advertising, marketing and sinister manipulation that has all since come to pass. Along the way, Packard touches on the notion of built-in obsolescence – and the cynicism of it was quite shocking to a young lad such as I. No doubt my brother took it all in too, and perhaps it has some echoes in the song '(I Can't Get No) Satisfaction', still the Stones' most seminal song and a critique of the consumer society.

Mick also came back with *The Tempest* once, and I was impressed enough by the famous speech 'Our revels now are ended…' to learn it by heart. The curious thing is that verse committed to memory so young can still be remembered, while plays I later learned I cannot recall at all.

HAIL! HAIL! ROCK 'N' ROLL

A major event happened when Dad took us into Woodyers, the music store in Dartford, and bought a record player; not a dark-grained radiogram like Uncle Cyril owned, but a basic single-speaker Phillips covered in red and cream vinyl. Two 78rpm discs came with it, the Mantovani hit 'Charmaine', a sugary confection of strings, and my brother's choice, 'Singing the Blues' by the American Guy Mitchell, rather than the Tommy Steele version. More interesting records followed, including 'Lucille' by Little Richard, 'Hound Dog' by Elvis, 'Rock Island Line' by Lonnie Donegan, and 'High School Confidential' by Jerry Lee Lewis. Then came Larry Williams' 'Short Fat Fannie', 'The Great Pretender' by the Platters, 'Yes Tonight Josephine' by Johnnie Ray, 'Searchin'' by the Coasters and 'Hang Up My Rock and Roll Shoes' by Chuck Willis. The last title appears particularly pertinent in hindsight. The discs would clatter off the spindle and drop one at a time onto the turntable, later slipping and groaning until you relieved the weight and turned them all over to hear the other side.

Soon 45rpm records appeared and, being less prone to break, could be carried around much more easily. One seminal 45 was 'What'd I Say' by Ray Charles and this comprised of 'Part One' and 'Part Two' on the other side. As Part One faded out to the cries of 'More!' from the Raylettes, the trick was, with the record arm retracting, to flip the disc before the needle automatically came down again on the vinyl, thus ensuring continued

listening. That was the first time an electric piano, a Wurlitzer, was heard on record.

These records must have made a huge impact on Mick, ditto the movies *Rock Around the Clock* and *Jazz on a Summer's Day*, which gave him his first glimpse of Chuck Berry. He was already knocking about in a skiffle group with some local lads – Dick Taylor, later of The Pretty Things, was involved at one point, too – but they never rehearsed at our house, preferring Alan Etherington's at the top of the road, or Dick's house. It was all above my head and I guess my brother was pretty secretive about it as I can't remember him even singing much at home.

The big game changer was a tape recorder, an expensive item that Dad worked on, as he 'knew a fella' employed at Thorn Electrical where he might get a good deal. Come Christmas a Ferguson reel-to-reel appeared as my brother's 'big present'. This was transformative as it enabled his friends to share music for free, like an early Napster. Few rhythm and blues enthusiasts could then afford LP (long-play) records, as they were hard to obtain, pricey and often had to be imported from the USA. The tape machine ran at three and three-quarters of an inch per second or, if you were miserly, one and seven-eighths but then the sound was pretty crap. This was the means by which all the blues artists – Howlin' Wolf, Muddy Waters, Little Walter and Jimmy Reed – were first ingested and copied around, the foundation of The Rolling Stones.

ALMOST GROWN

Saturday morning was the time to catch the bus to Dartford and check out what was going on. The fashion of the day was for drainpipe trousers and pointed shoes, beloved of the Teddy Boys – not that Mick or I ever followed that path – but the style filled my father with horror. I remember a heated argument one

morning, when Dad was absolutely resolute that Mick would not wear his winkle pickers into town. That was about as cross as he ever became, for Dad never shouted at us or raised his hand. Mick was likely heading for the Carousel coffee bar, where you went to hang out and meet girls.

There was also a school of dancing above Burton's the tailor's, which he might have gone to once; dancing was a mystery to me and I recall trying to work out a printed diagram with footmarks and arrows on how to do the new craze, the Twist. 'Imagine you're drying your backside with a bath towel,' it added helpfully at the end. Mum was enthusiastic and no doubt Mick has inherited much from her light feet and love of movement. I remember her teaching me the Charleston one day and I have never forgotten the moves, though her attempts to show me how to waltz weren't so successful. She always spotted the time signatures in music and when I played her a tune from my 1994 record, she immediately said 'slow foxtrot' and demonstrated how to do it.

The first record I ever purchased was on my brother's instructions. I was going into Dartford and he passed me the money for the 7-inch 45rpm single of Chuck Berry's 'Little Queenie', saying: 'Listen to the B-side and if you like it, buy it.' Obviously, he wanted his money's worth. I went into a small store on Lowfield Street, where they spun the flip side for me while I stood listening in the small pegboard-lined booth. Suddenly I was a critic, which was rather daunting. The B-side was 'Almost Grown': not typically Chuck, as it has a doo-wop vocal backing, which was slightly outdated even then, so I was in two minds. I handed over the six shillings and four pence, however, and, carefully placing the record in my saddlebag, rode home. Later, I discovered that none other than Etta James and a young Marvin Gaye performed the back-ups. As for 'Little Queenie', that tune was also to prove

pretty successful for the Stones; I recall at the end of a show in London's Lyceum theatre before Christmas 1969, when a large backdrop of the Queen was unrolled during the number. That was right before they went off into exile, so we got the point. In Chuck's twilight years, I got to open some shows for him across Europe and at the Hackney Empire in London. As he only played a short set, the contribution that pianist Ben Waters and I made was quite important for the evening's entertainment. Chuck's guitar playing was patchy by then but he still sang great, quite softly and with real feeling.

HOLIDAYS IN THE SUN

The standout event for our family was the great summer excursion. First, as our relatives did, we went on the usual seaside jaunts to the Kent coast and to Devon, but a big change came when Dad bought a Dormobile, an early camper van. It was a conversion of a Bedford van with sliding front doors. The seats folded down in the back to serve as beds, and the makers claimed that, with the tiny headrests, it could carry 13 people – thus becoming a bus and exempt from VAT, or purchase tax as it was known then, a dubious but ingenious claim which appealed to my dad's thriftiness.

Dad took the train to Folkestone on the Kent coast to collect it and drive back, but not quite home, leaving it in a nearby village and taking a bus for the last leg. He then suggested that we all go on an outing to Horton Kirby and, as we walked unsuspectingly along a small lane, he pointed out this attractive vehicle. We agreed it was nice. 'Shall we take a closer look?' he asked – whereupon he produced a key and opened the doors, to our amazement and my mother's laughter. A new car was a big deal, then as now, and we certainly had our money's worth from it. Apart from shipping hockey players across London and rock climbers to Snowdonia in Wales, it took us on our first foreign holidays –

then, in the late Fifties, something reserved for the rich and a few adventurers.

LA BELLE FRANCE

Our first journey was meticulously planned and needed to be, what with all the petrol coupons to keep the cost down, the green card carnet, the passports, insurance docket, maps, ferry tickets and of course AA wallet containing the highly regarded GB sticker. Just as we now shall have to do after the ghastly 'Brexit'.

The motor was packed to the gills with spare parts in case of a breakdown, with a Blacks of Greenock tent for Mick and me, green cotton anoraks and an Optimus stove that you would prime with methylated spirits – which gave off a great whiff and a blue flame – before pumping up petrol into the shiny steel vessel, whereupon it roared into life.

The first morning we rose at 4am, drove to Newhaven on the south coast and boarded a boat for Dieppe. The Dormobile was swung up onto the deck of a cargo vessel, which then departed, and an hour later our passenger ship set off, passing the old freighter halfway across the choppy waters of the Channel, where I was seasick. We were reunited in the picturesque port of Dieppe and stayed in a small *pension*, as the trip had taken the entire day. The bar there (children were never allowed in a bar in Britain) had table football, which we hadn't seen before – and it was so much fun, we blocked the goals to allow ourselves more time on the game.

Driving across the French countryside, I naturally read out all the billboards, as I was at that irritating age. I also used to tease my brother mercilessly and had invented a word for him – 'Dop' – which I was banned from using. Then, lo and behold, we saw an advertisement for a shampoo called 'Dop'. They had stolen

my word! While the French whizzed past in amazement in their Renault Dauphines and Citroen DSs, we took time out on the roadside to brew tea – the locals could not be trusted with such an important undertaking – and if we saw another GB plate, there was much waving. We seldom stayed in campsites, deemed 'too boring' by Dad, so before evening drew in, the great search would commence. We would turn off the main road and scout down little lanes looking for an appropriate field. Then we would find the farmer to ask permission.

The ritual went like this: Dad would take a highly embarrassed brother along and request in his best parlez-vous, '*Est-ce que c'est possible de faire le camping près d'ici, monsieur?*' Usually they said '*Mais oui*', and we would pull into the chosen field, often to be observed by the local children, who on one occasion presented my mother with a bunch of flowers – how innocent those days were! Sometimes the farmers would shrug their shoulders and look puzzled. They would ask, '*Anglais?*' and for some reason my father would say, '*Je suis d'Ecosse* (I'm from Scotland)', just to be different.

En route we made friends, returning to the same places in following years, exchanging Christmas cards and becoming pen pals in those days when you had to work hard to keep in touch. Some incidents went into family folklore, such as the time we camped near Perpignan in the mayor's field. The only catch was that there was a horse in it and one day – luckily we were out – it gave a solid bang with its hoof to the tent, distorting the 'A' pole. Dad tried to straighten it out but ever after there was a bump in the tent and so the story was re-told to whoever asked, 'Why is that pole bent?'

We played *petanque* and swam in the warm Med at Juan-Les-Pins, camping behind the beach among all those smart French people. Dad talked to everyone and easily made friends, so one night our parents were invited to dine in an adjoining tent. He

appeared, probably in his khaki shorts and a green shirt after combing what little hair he had, only to find the French host in full evening dress – in a campsite.

We loved the thrill of foreign travel, the different people and language, the food and the markets. What a way to shop, *en plein air*, with all the goods displayed in the open, often by the growers, with plentiful tables of fresh vegetables and cheeses. And they actually invited you to taste things for nothing. Free! More chance that you bought something, of course, but that never happened in England.

Bro and I. We were always fascinated by rivers and their multi-layered currents, and could spend hours watching and exploring the banks.

Dartford town still had weekly livestock sales when I was small but they were cleared out for a more modern market, with vendors arriving from afar to ply their patter. (Dad and I used to go and listen, fascinated by how well their technique was thought out.) But the variety of French produce was superior to what we had in Britain. Mick and I usually gravitated towards the shiny knives on display, which were not expensive, so we checked our French francs, quite chunky coins at the time, and bought one each. I still have a knife he bought there, as I find it hard to part with ancient relics. This was all very good for our education in the French

language, particularly as my brother went on to study it at A-Level. He's very fluent now and can even get by in patois when required.

As the first trip was so successful, the following summer was earmarked for the Breton side of France but, encountering a lot of rain, we headed south to La Rochelle and camped among the pine trees within easy reach of the beach. However, the breakers rolling in from the Atlantic didn't have the heat of the Mediterranean, still relatively unspoiled when we first went there.

VIVA LA ESPAÑA

On the third trip, my brother was around 16 and we ventured further afield, to Spain. This was much longer on the pre-motorway roads but it was exciting to visit a new country. Spain had stood still under Franco and was much more backward than France at that time. We waited for hours at the border, finally passing the fierce-looking Guardia in their shiny hats and pompous uniforms, and arrived on the Costa Brava in a resort called Tossa de Mar. At the time, it barely boasted a three-storey dwelling but now it's a sea of concrete towers. We rented a small villa from a friendly family and my brother even had a holiday romance with one pretty girl, while I was left to wander around the back streets of the then-picturesque town. I went into a bar alone for a soda, whereupon two policemen seated there challenged me for my passport and brought out their automatic weapons. As I was only 12 and still on my parents' passport, I quickly left, a bit shaken.

Dad took us to a bullfight in Barcelona, a bit gruesome for a 12-year-old. There was a large party of US sailors in uniform, one of whom fainted at the sight of blood and had to be passed over the crowd's heads. I have never felt the urge to go to another. Mick bought a Spanish guitar and on the winding pass leaving Spain we stopped and posed in our sombreros for Dad's Brownie, with me

holding up some castanets. Many years later, the press got hold of this picture and I was snipped out of the frame. I was most offended.

Mick ducked out after that holiday and it was never quite the same again. We went to Italy, which I loved – especially the ice cream – and drove across the Alps, which was wonderful if rather slow in the old Dormobile. It was almost impossible to overtake and we would often have to stop to cool off, opening the bonnet and topping up the radiator water, as the engine was really too small for such a journey. Those long tunnels had yet to be built.

The classic duo on the pass as we left Spain. I think he is holding down an E chord?

Arriving at the Med, my father liked nothing more than to lie on the beach and then swim off to a floating raft, lie there and then swim back. He loved eating peaches from roadside stands and just relaxing; after all, he worked damned hard the year round. On the other hand, Mum didn't swim, she only ever paddled, and with her fair skin stayed out of the sun. The Italian owner at one *pensione* tried to give her extra pasta at dinner to make her figure fuller, like the Italian 'mamas', but she wasn't interested! Dad would eat anything you put in front of him and appreciate it. If we left food on our plates he might say, 'They're starving in China.' I keep that in mind to this day, even about the 'chippy bits', a phrase I invented

when small for the remnants stranded on the plate, which none-theless should be finished off.

DIARY

Rain coming in from the west with some heavy showers but it will brighten up later, we hope. Soggy fields and rivers running high, it's November for gawdsake! I went to Bristol Old Vic last night to see an old friend, the actor Gerard Murphy as Falstaff in Henry IV Part 2. He was his usual bumbling good self and stood out from a sea of medi-ocrity, as any good old Citizens Theatre boy should. Some of the acting was amateur, and wooden at that, and the costumes looked like they'd been run up from Auntie Flo's curtains. I first went to Bristol Old Vic in 1966 for a Tyrone Guthrie production of Lear. Richard Butlin, then the art master at Eltham College, took me there. The theatre has since been modernized and taken over the warehouse next door, so there is more space but less charm.

11-PLUS

Before comprehensive schools, the '11-plus' was the exam that basically decided the rest of your life, and mine was no exception. My friends didn't pay too much attention to it and expected to go to the local secondary modern. I was a little unnerved by the 'intelligence test', a mystery to me. I was convinced I would fail and duly did. Only around 15 per cent of pupils passed on to the grammar, not a high percentage, and I wasn't one of them. The question was: what would happen next?

My father knew about local education from teaching in these schools and had a low opinion of the secondary moderns – West Central being the sole choice. Most kids left there aged 15 to work in engineering or clerical jobs. Dad thought, perhaps mistakenly, that I could do better than that and so had to pay for my educa-

tion: no small thing, as his income was really too slim to afford such a luxury. I was shipped off to that most British of institutions, the 'prep school', where you are groomed to enter something altogether better and distinct from the rest of society: the 'public school'. (This, I should explain to any non-Brits, isn't 'public' at all; it's actually private, just to confuse you.)

I entered Merton Court School in Sidcup wearing my little red cap with its yellow cross, and needless to say I hated it, particularly as they made you work on Saturday mornings. Games followed in the afternoon, homework on Sunday, then it was back to school on Monday. Abominable! There were new subjects to master, such as geometry, algebra and – worst of all – Latin, which most boys had already studied. I struggled with it and was constantly rescued in my homework by Dad, who already had the experience of getting Mick through his O-Level Latin, in his words 'a touch-and-go affair'. I recall Dad being a big fan of Latin grammar. 'Ut ['so that'] takes the subjunctive,' he would repeat.

I didn't manage to scale the same heights and struggled with the declensions – and with Mr Bentley, a short, balding guy to whom teaching small boys was obviously a bore. We sat at ancient oak desks full of holes and covered in penknife carvings, polishing the wooden benches with our short flannel trousers. The class was small and with nowhere to hide, quite unlike primary school. Copying from the next boy was difficult and the only things I enjoyed were the games.

I was quite small for my age and became a wing-forward in rugby. Leading the team was one Anton who was prematurely tall – around 6 foot – and just ran solo through the opposition like a knife through butter. If he was felled by a half-dozen opponents, he might offload the ball to his henchman, Briggs, another toughie who we all looked up to. It was a similar pattern in foot-

ball, although size wasn't so important there. We won every game bar one and I managed to score five goals in one game; it was the last proper footer team I played for.

The prospect looming at the end of prep school was the Common Entrance exam – which we swatted up on – and soon I was taken to nearby Eltham College to check my suitability for entry there. I was left in no doubt that this was a significant moment in my life, and I can still recall Dad driving us up the wide avenue. I was put into a cupboard that housed an enormous grandfather clock and given a paper to complete against the background of its constant ticking. I had a fear of exams but, likely as my father was paying, I passed okay. I do know my admission was all set up with the help of the PE man there, John Linscott, whom my father knew and turned to for advice. The catch was that I had to become a boarder.

I arrived there at the beginning of the term, accompanied by my parents and Mick, who proved his then-left-wing leanings to another boarder by declaring that 'public schools should be abolished'. If only they had been before I started.

Merton Court prep. I am the giant, back row, right, but managed to score five goals in one match!

CHAPTER 5

DOWN WITH SKOOL

Being packed off to live with droves of other boys and ruled over by an antiquated system of rules and masters in black gowns is not what a young boy massively looks forward to. It separated me from my parents and my brother, something I didn't realize fully until more recently when I was talking to Mick about it. It changed the chemistry at home for, although he was coming to the end of his time under the family roof, it prematurely curtailed our relationship. I would have followed him to Dartford Grammar had I taken studying a little more seriously, but I was left to repent at my leisure. Like many middle-class children, I was spoiled at home and one thing I will say for boarding school is that it makes you appreciate your parents times ten.

My mother arranged all the necessary outdated grey suits, ties, shirts, pyjamas, shoes and socks, and ticked off the endless list as if I was joining the army instead of moving 15 miles up the road. These were all duly inspected and two grey flannel suits found to be of a slightly different shade, for which letters were exchanged and replacements eventually found at even more cost.

We slept in draughty dormitories on old iron beds with itchy blankets and hospital corners, and got splinters in our feet from the floorboards. Many of the pupils were day boys and so, come 4pm, departed for home and all the comforts there: armchairs, TV, toast and jam and the freedom of coming and going as you liked. We were made to do our prep in the draughty classrooms under supervision, as if you hadn't had enough of that scene.

Eltham College in south-east London was originally founded for the sons of missionaries and, by coincidence, my two best friends there were sons of missionaries, namely John Newbigin

and David White. Dave's father was a church minister in South Africa and had spent time in jail for helping a black family, while John's father was then secretary to the World Council of Churches in Geneva, later becoming the Bishop of Madras. So I had a good political education from them regarding the apartheid system and the CND (Campaign for Nuclear Disarmament) movement.

I can't report that I was constantly bullied and buggered at school; mercifully I didn't come across much of that. There was a fair degree of wanking but that's fairly normal when lots of boys get together and are exploring their sexuality in such an unnatural environment.

'Willie', Mr Wilson, was my first form master. He was a short, grey-haired Scotsman with a wooden leg and bad teeth. Naturally, he was a bachelor, but then many masters were. They all wore black gowns and, on our first morning, he occupied himself in attending to his tatty example. He called one boy forward and sent him out to the nearby village to buy a needle and thread and, on the boy's return, proceeded to sew up his gown until the lesson ended.

I was spared Latin and took German instead, something that has stood me in good stead. We learned declensions and prepositions by heart in songs, for Willie was fond of a good tune, particularly German drinking songs. Off-duty masters would walk past the classroom to hear us banging them out as if it were the Hofbräuhaus in Munich. Our German books were ancient, often written in gothic text, which made them particularly incomprehensible, and some featuring the exploits of Anton, a fair-haired Aryan youth who did everything perfectly. The same can't be said of most British schoolchildren – then or now – but I might have learned more without such distractions as Dartnell holding up his semen-covered hands to show the rest of us how virile he was.

A general snigger would go around as Willie's back was turned while he scraped on the blackboard. He would spend the next ten minutes trying to get to the bottom of the matter and various boys, usually innocent ones, would be put in detention. If you argued he would shout, 'Quiet, boy!' and 'Take the rough with the smooth, laddie!' One 'joke' of his was to stand on your foot with his wooden leg. When you protested, he would counter, 'Funny, I cannae feel a thing!' For one horrid year, he took us for both French and German and, arriving in class, he might have forgotten which one it was, so naturally a boy would tell him the wrong language. Then, halfway through the lesson, he would realize he'd been 'done' and fly into a temper, handing out detentions before switching languages.

Willie sometimes fell asleep in class, snoring loudly, but would then come to and repeat the question he had asked previously. By this time, boys would be out of their seats, with various ink battles raging across the room, so more detentions were handed out. He also had a penchant for the poet Schiller and we learned by heart 'Der Handschuh' ('The Glove'), an 18th-century poem, some of which I still remember. Willie made us act it out in class, which – being a romantic ballad describing a chivalrous scene in the medieval French court – was hugely embarrassing.

If this sounds like a tale by Molesworth in one of Geoffrey Williams' hilarious parodies, well, it was – right down to the school dinners or, as our hero has it, 'the piece of Cod which passeth all understanding'. Many years later, I had the idea to make a musical from the Molesworth books and we even approached Mr Searle, then in his nineties and living in the South of France, and he gave us his tacit approval. Of course, they made films from the St. Trinian's romps that he drew and I guess it's more appealing having sexually aware young schoolgirls getting into scrapes

rather than spotty schoolboys breaking windows with catapults, but I digress!

Once a week, we had a bath, when the male teachers would wander round chatting to us. (I wonder why?) We displayed our clean knees to the matron – as new boys, anyway – and washed with Wright's Coal Tar Soap, which was supposed to be hygienic. It certainly made good ammunition for soap fights in the vast washroom. Once the yellow stuff had been thoroughly soaked and mashed, it was ready for action – and a solid splattering of it was pretty painful. If you missed, it went all over the mirrors and floors and then there was hell to pay, if you were caught. Masters prowled the corridors on the lookout for such activities, loving to discover you and administer justice.

The standard punishment was 'rounds' – circling the field in front of the school a set number of times, usually in the rain and when it was inconvenient. If you exceeded a certain number of rounds a week, you got the cane. This sounds drastic but mostly boys preferred it, as it was over and done with quickly and it didn't hurt that much. (At least you got to keep your trousers on!) The worst was to be 'gated': then your weekend leave was cancelled, and there were only two a term. There is nothing so dull as a boarding school on a chilly November weekend.

At Eltham, I filled the 'home void' with – you guessed it – sport. The school boasted large playing fields, which being so close to central London was pretty amazing. After lessons, when the day boys departed, there was compulsory 'exercise' for the boarders unless you had something ghastly, such as a violin lesson in a tiny room off the spiral stone staircase, from which emanated the horrible sound of bows scraping resin-coated string.

I TRIED AND I TRIED

Football was outlawed, so I was drafted into rugby and we lined up for tackling practice, and as I seemed to have the knack of that and catching the high ball, I was made fullback. In those days, you were positioned like a sentry far behind the team, and when the muddy ball was hoofed your way, you caught it and booted it immediately into touch, preferably before the star player from the opposing side had hacked you down and slammed your face in the dirt. (This is all 'character forming'.) If the ball was 'loose' you had to dive on it, after which everyone else piled on top and you were crushed at the bottom. When you finally emerged, some master would call, 'Well played, Jagger!' and you would retreat to your position, licking your wounds. Americans cannot understand playing this game without helmets, shoulder pads and the like.

I once scored a try and a watching master shook his head and chided me for leaving my position. Rugby was akin to the First World War, where it was a mark of distinction to gain 5 yards of muddy ground even if you lost it a minute later. It confirmed my suspicion that this was merely training for going off to run the Empire or fulfil the whims of generals on the battlefield.

The last game I ever played was at the Oxford seven-a-side competition in front of a proper stand, where an Irish side crushed us and went on to win the competition. During the game I realized that every one of those fervent Catholics could run faster, tackle harder and kick further than anyone on our team. The game was up. I recall the captain, John Willis, later a big name in TV – trying to raise morale with a kind of prophetic ranting in the half-time huddle, with the steam rising from our exhausted frames, telling us we could win it, although we were some 20 points adrift. Had we been an Inuit hunting party out to spear a whale in the frozen North, our lives would have

depended on it – whereas to lose against Colfe's School wasn't the end of the world.

I once ran down the touchline to the cries of 'Up the Stones!' from the captive boarders, who were generally obliged to attend. John Willis was lucky enough to be a day boy. His playwright father Ted was a Labour peer and had famously written the TV series *Dixon of Dock Green* about a regular bobbie (cop) on the beat, which always began with that memorable line delivered by Jack Warner: 'Evening, all.'

After a game, we sometimes retreated to John's palatial home in nearby Chislehurst, where I met some of Lord Willis's political friends, including Richard (Lord) Marsh, who was in charge of the railways, then sensibly still nationalized. John had a birthday party at the House of Lords where we pressed flesh with the prime minister, Harold; also present was the Chancellor, George Brown, who practically fell out of his limo onto the pavement on arrival, being slightly the worse for the demon drink.

John wrote for the school magazine, and in one piece included a description of wallowing in the bath after a rugby match and turning on the taps with his feet. Impressed by his candidness, I realized that such personal observations could form part of a story or essay.

Like others, I was often told to have my hair cut, though it was quite short. This was a big deal at school, and over-long hair was almost a hanging offence. Take my mate Draper, who for some reason was nicknamed 'Sue'. (He also had a great collection of Coltrane and Miles Davis records and read Beckett.) He was once told by the head to get his sideburns cut in the middle of a school dance. Why did a stuffy headmaster come to the dance at all except to make sure the boys weren't lusting after his daughter Rachel, of whom many stories were told? I was once summoned

to his study for a bollocking about the length of my hair, and I told him that he was victimizing me because my brother was in a rock & roll band! Taken aback, and respecting the British code of 'fair play', he laid off me thereafter.

Porteus was a lonely figure who taught the occasional Latin class and was universally disliked by boys and masters, poor fellow. Short, balding and bespectacled, he marched about with his nose in the air. Chief of his detractors was Mr Chambers, nicknamed 'Whockie' (a version of his initials), who taught history and economics. He was a portly bachelor with dirty suits, a waddling gait and thick glasses, but his pupils liked him, particularly as he moaned to us about the head, especially when we reached sixth form. His teaching method was to perch directly in front of us on the front of his desk and ramble on about whatever subject caught his fancy, be it in the news or something that had attracted his attention. He was in the mould of the historian A.J.P. Taylor, and well aware of Taylor's wide-ranging lectures, which were shown on TV. So his view and thus our view of history was more mature than the course really demanded. From time to time, Mr Chambers would remember that we had to look at the curriculum and swot up on the Disraeli cabinet or – marginally more interesting – American history. He was similar to the teacher in Alan Bennett's *The History Boys*. I suppose he treated us as adults, so we responded to that respect.

DIARY

A journalist is arriving today to speak to me about 'Stu', or Ian Stewart, for so long the glue that held the Stones together. Stu originally played the piano with the band, only to be dismissed by Andrew Oldham because he looked too Neanderthal – perhaps the unkindest cut of all. But Stu saw that the band were going places and so nailed his colours

to their mast, becoming the band's roadie and organizing all the equip-
ment, both important tasks that he combined with playing piano on the
band's tours. Always a real one, none of those electric things!

MUSIC = TORTURE

At Eltham, the only music approved of was classical or religious,
the hymns sung during morning chapel, at evening prayers and
on Sundays, when we had to go to morning church and evening
chapel. As our sacred singing wasn't too hot, the head decided the
boarders would practise on Saturday mornings after prep, which
served to make a hated master even more detested. (Including
practice, we reckoned we had to sing about 30 hymns a week;
and let's face it, most are dreadfully Victorian and pompous.)
So, as revenge, we decided that at one Sunday evening chapel we
wouldn't open our mouths – and there was nothing he could do
about it.

One master we particularly disliked was the moustachioed
Shuttleworth, who was a snob; he drove a Lagonda and had a
'recording club' at which acolytes could play with his Ferrograph
tape machine, which was actually rather good. An ex-Navy man,
he took boys sailing, and once I actually went on a weekend course
with him on the Thames, where the boys served the 'officers' break-
fast and ran chores for them. Although I did get to sail a little,
which I loved, it was all very dodgy. At evening prayers he always
chose the hymn 'For Those in Peril on the Sea'. Since he had a
pronounced lisp, we would sing, 'For those in pewil on the BBC',
trying to keep straight faces all the while.

Once a week, we also had a 'music appreciation' lesson,
which was an opportunity to daydream. I once brought in a
Charlie Mingus record – *Blues & Roots* – which lasted about 30
seconds on the turntable before being removed. Of course, every-

one in the school knew about The Rolling Stones by then, though nobody had seen them play. The order of the day was Cliff Richard, Marty Wilde and other lads from the stable of Larry Parnes, the manager whose business strategy was to re-record the latest singles coming out of the USA with a succession of pretty-boy frontmen.

THE DAILY GRIND

The school day was regimented by a series of bells starting before breakfast. They were controlled by two brass buttons next to the grandfather clock in the hall, a job performed by boys according to rota, and situated in a cavernous hall above which were balconies running to the various dorms. First, was a single ring, then five minutes later two rings and after another five minutes' lapse, three more rings – by which time you had to be out of your dormitory and in the queue for the dining room.

Often boys were running late, so a relay would be run with one boy outside the dorm warning those still struggling to dress, and the bell monitor shouting up to the gallery about imminent rings (which might be delayed in return for later favours). One time-saving operation was to remove your vest and shirt together at night, with the tie still in place – so that in the morning you could switch back in two swift moves, before running down the corridor while jamming your feet into your shoes. I still do this sometimes for speed. After inspection, we would move off to lumpy porridge and rubbery fried eggs with greasy fried bread. The food was pretty disgusting but you ate it or else went hungry. We sat at long trestle tables, covered with grease and polish, in equal quantities and with various horrors – such as raspberry jam – smeared underneath to catch you unawares.

We had no TV at school but there was a cinema club run by the boys, bringing in such black and white classics as *Some Like It*

Hot or an Alfred Hitchcock movie to be run on a 16mm projector. We had endless ping pong and pool sessions and I joined the printing club, chiefly because it was housed in the school tower and no masters could be bothered to climb the steep steps. We tinkered around with an ancient press making letterheads and forgeries while smoking fags. I later discovered that some Jaggers in the North country had run printing presses – it was a sizeable industry in past times.

My buddy John Newbigin was a brainy lad and popular, as he could doodle cartoons during class, thus amusing us during boring lessons. We remained in touch and he has worked with film producer David Putnam and been special advisor to Chris Smith in the Department of Culture during Tony Blair's government. I once confessed to John that I couldn't have got through those awful school years without his friendship – and I guess that's something else you learn at boarding school: to appreciate comradeship and mutual support.

John recently reminded me of an incident when he and I visited my brother on a weekend at the small mews house he shared with Chrissie Shrimpton, near Marble Arch. The doorbell rang and, since no one answered it, John wandered up to the front door to open it. Standing in front of him were John Lennon and George Harrison, saying they'd come to visit Mick. After a hesitation, he blurted out: 'You'd better come in, then.'

'SOMEONE DONE HOODOOED THE HOODOO MAN'
– Junior Wells

The well-worn magnetic masterpieces of reel-to-reel tape accompanied me to school and were played in the studios of older sixth-form friends, who allowed me into their private worlds. This was a welcome relief, as you could toast white bread

on their gas fires of a dark evening, spreading it with Marmite while discussing the merits of Jimmy Reed or Howlin' Wolf. Only sixth-formers had studies; all I had was a tiny locker for personal things that was private to me. A lad called Farmer played tunes by ear on the piano and was popular with the boys, but in the school's view this was of passing interest: proper music was classical and written down. Farmer was a bit like my friend Ben Waters, who told me that when he was at school – much later – he was locked out of the music room during the lunch period to stop him from practising on the piano, the only thing he was any good at! After I left school in 1966, it took another 20 years or more for The Beatles to be accepted by school music departments. They were considered quite 'clever' and worthy of study. It took considerably longer for the Stones to appear on the curriculum.

THE SCENE

I was 15 years old and already well primed in blues and R&B when I first saw the prototype Rolling Stones perform in 1963. The venue was a Soho dive called The Scene in London's Piccadilly on a Wednesday night; Dad had lent Mick the family Triumph Herald to drive up to town. (Borrowing the car was always a big issue between my father and brother, as any parent will know.) We passed through the West End with Mick humming the Jimmy Reed song 'Bright Lights, Big City' – appropriate enough – then parked up and descended into a small basement. I was left sipping lemonade while Mick went off to get ready. The opening act was billed as 'Dave Green's R&B Band', which slightly confused me, as the line-up was more akin to a 'trad' jazz outfit: indeed, there was a great deal of debate at the time about what constituted this particular genre. Dave Green

was in fact an old horn-playing jazz man who, wishing to keep gigs in the book, had added 'R&B' as an appendage.

The Stones then came on and fulfilled my expectations. This was exciting stuff and I was swept up in the spirit of the performance. Keith Richards was see-sawing on the edge of a postage stamp-sized stage with his f-hole Gibson, dark hair protruding from under a black French beret, while blond-mopped Brian Jones stood opposite, both complementing each other's styles, adding vocals and cranking up their Dartford-manufactured Vox amps.

Looking every inch a student (which he was) in his brown corduroy jacket, Mick barely had room to wiggle on the spot. There was no Bill Wyman or Charlie Watts then as they hadn't yet joined. The drummer's name was Tony Chapman, a fair guy with a quiff who I've never seen since. Dartford lad Dick Taylor was on bass, while Ian 'Stu' Stewart tinkled away on the ivories, sounding good but looking somewhat out of place, with swept-back hair that dated from an earlier era. Charlie likely had another gig that night, perhaps with bluesman Alexis Korner. It all sounded great to me as they ran through the many tunes I was familiar with from records and tape.

THE LOW SPARK OF THE HIGH-HEELED BOYS

Mick was relaxed about it so I took everything in my stride too, although of course it was quite a new experience for me. After the gig, we dropped off at a dilapidated terraced house in Edith Grove, then an unfashionable part of Chelsea, where Mick rented a room. Brian and Keith lived there too; lads loose in the big city, having a whale of a time, always broke and on the scrounge from visiting girlfriends or whoever walked through the door. But as the senior, and already a father, in name at least, Brian was a bigger presence, particularly as Keith was so shy.

Records and guitars were strewn around the scruffy flat, so it was a place where tunes and ideas could be worked on and a good base from which to prowl around the city. We left though, as Mick delivered me and the Triumph Herald back home in the early hours.

I visited Edith Grove on other occasions and was intrigued to actually see the place reconstructed in the Stones exhibition in London in 2016. I could remember Brian seated on the floor analyzing an Elmore James solo, copying the exact little traits that added up to the whole picture. Brian even gave himself the name 'Elmo Lewis' at one point. There were no instruction videos then; you had to deconstruct the arrangements to discover what was going on. Although seemingly quite straightforward, the blues has many little added bars and inflections, giving individual players their identities. Many early blues artists were illiterate and had to rely on their memories. The better educated mainly confined their studies to the Bible. As Blind Willie Johnson sang, 'Mama taught me how to read. If I don't read, my soul be lost, nobody's fault but mine.'

'CAN BLUE BOYS SING THE WHITES?' – Viv Stanshall

I'd met Keith occasionally when he came to our house and he was always very polite. His mother, Doris, and our mother were friends, often crossing paths in Dartford while shopping and no doubt discussing their sons. Keith had attended Sidcup Art College aged 15 but didn't stay too long, preferring the guitar to the easel. Many years later, I heard a funny story from one of his tutors, Rose Hilton, a well-known painter and the widow of artist Roger Hilton. Keith decided to play a trick on her and contrived to lock Rose in a storage cupboard, where she remained for some hours before another staff member heard her shouting. She laughed about it later.

On the way to one Stones gig, I stopped off with Keith in the Archway Road, north London, to visit his granddad. His grand-dad was a lively figure and Keith's inspiration to play, as he gave him his first guitar. There was a strong connection, partly as Keith lacked a father figure. It often happens that a predilection in a family skips a generation, which was clearly the case here.

In those early days, pivotal venues – as many know – were the Ealing Club and the nearby Eel Pie Island Hotel. In 2000, I put together a three-part radio show for the BBC on Alexis Korner, who initiated the British R&B revolution, and it's a fascinating story. Mick gave me a great interview, relating how Alexis took them under his wing and got them up on stage (and also how he once had to help Jack Bruce onto a bus with his double bass!). Charlie Watts was informative, too, describing the moisture that would drip from the roof onto his snare drum. He would rig a cloth over his head, but as it became wet itself, the drips would begin again, and in those days the snare was calfskin, so it went very dull when damp.

Alexis brought so many future stars up onto the stage. They were inexperienced, but he endorsed their talent and gave them the confidence to perform: the likes of Mick, Keith and Brian; Paul Jones and Eric Clapton; Eric Burdon, Robert Plant and many more. Alexis proved that white boys could sing the blues, which until then was considered just absurd. Alexis had rebelled against his father and in turn he made sure those younger than him would receive encouragement rather than censure. Once the Stones had formed properly, they cemented their reputa-tion by refusing other players the chance to come and jam with them, as was more the norm in the old trad jazz days, when all you had to do to join in was bring your trumpet onto the stage to blow.

DOING THE CRAWDADDY

After my early sighting of the Stones, I contrived to get to Richmond to see them again at what was known as the Crawdaddy Club, run by the band's then-manager, Giorgio Gomelsky who, like Alexis Korner, was an émigré to Britain and was following his passion, later managing The Yardbirds among others. The venue was the Station Hotel on a Sunday night, sometimes following an afternoon gig in Soho at the Ken Colyer Club, a tiny basement off Charing Cross Road. With the band packing out Richmond and the landlord threatening to close it down, the show moved to the nearby Athletic Ground, a roomier if less attractive venue.

Richmond was a good focus for the band, being just outside London but retaining its own identity, so it proved to be a great place to build up a following. At the Crawdaddy, there were definite favourites the Stones played each week: Bo's 'Diddley Daddy', Chuck Berry's 'Around and Around', Slim Harpo's 'I'm a King Bee', the ballad 'You'd Better Move On,' and 'Can I Get a Witness', Marvin's Gaye's first hit record. The Stones were first and foremost a dance band, so the mod crowd liked to show off their moves and few stood around just watching. This was tough for me, as I didn't know how to dance and was too embarrassed to ask anyone, particularly the older girls – although Chrissie Shrimpton, Mick's girlfriend, would push me onto the floor and I'd give it a shot. Most musicians won't or don't dance; I guess they are too busy playing for everybody else. Many years later, the band were playing at Wembley Stadium and I was there in the Royal Box. I'm not keen on these massive gigs and felt a little disconnected, so I stood up to dance and get the old body going. 'Sit down!' called a voice behind me, and I thought about it for an instant – then carried on. It's supposed to be rock & roll after all.

The highlight of the Richmond scene came in 1964 when the Stones played at the Athletic Ground for the National Jazz and Blues Festival – one of the first in the country. This event later morphed into the Reading Festival. Top of the bill was Acker Bilk and his Jazzmen, dressed old-style in bowler hats and striped shirts with armbands. Unfortunately for them, this music was already well past its sell-by date. While Acker played outside in the damp drizzle to a few diehards, the younger fans, me included, packed into a large marquee, where electric guitars and drums replaced clarinets and trumpets.

It was a home crowd for the Stones and the others, including Cyril Davies, The Yardbirds and Long John Baldry. I loved the Cyril Davies Band as Cyril played the best blues harp around. He looked an unlikely frontman with his cheap suits and comb-over hairstyle. He was a panel beater by day and he had little time for niceties. Mick once asked him how to 'bend' notes on the harmonica and he replied, 'You get a fucking pair of pliers and fucking bend 'em.'

The Stones came on to a rapturous reception, proof of how far they had come in such a short time. Fans were hanging on to the tent poles and climbing precariously to the top. The 'in-crowd' there knew the band was going to the very top, too; it was a given, nobody in that camp doubted it for a second. While many bands disintegrate or fail to capitalize on their early popularity, the Stones maintained their steady rise, in the early days primarily by refusing to 'go commercial'.

Making records was therefore a hard card to play. Many thought the debut single, a cover of Chuck Berry's 'Come On', was too mainstream and only just saved by the bluesier B-side, 'I Want to Be Loved', the first self-penned track they cut. Of course, there was competition: The Pretty Things, for example, had a great

following. But the Stones had that extra 10 per cent. And they happened to be in the right place at the right time.

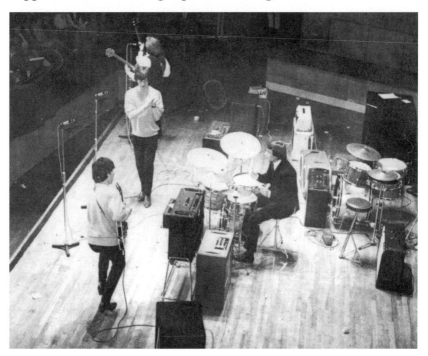

Early shot of Rolling Stones; probably using Vox AC30 amps made near Dartford. No foldback speakers then so impossible to hear any vocals I expect.

THE BOYS FROM THE POOL

Although I can say I saw The Beatles perform, I can't say I heard them. The Stones were on the same bill as The Beatles at London's Albert Hall in 1963 when the Fab Four topped the bill and the Stones opened up as 'brightest new hope'. I witnessed the continuous outpouring of teenage sexual excitement as John and Paul attempted to make their voices heard over the screaming fans. The band looked helpless, like puppets on a tiny stage. There were no stage monitors then for the musicians themselves, and in fact I believe that the band broke up before sound systems became in any way near to what they are today.

Mick and I were walking around the circular corridors there when a bunch of girls spotted us and stormed in our direction, so we ran away very fast, with Mick laughing his head off. Later, I asked the elderly doorman what was the best act he'd seen there and he answered, 'Undoubtedly Liberace.'

I remember a gig in the Seven Sisters Road – in Tottenham, north London – which was an 'all-nighter' and quite exciting as the band didn't play until the early hours. I perched on a rickety structure near the stage with manager Andrew Oldham and songwriter Lionel Bart, the Jewish cockney and writer of such memorable tunes as 'Living Doll', performed by Cliff Richard. Lionel was a loveable rogue who at the time was rising high on the success of the musical *Oliver*, which he developed with director Joan Littlewood.

DIARY

Went to Nashville and saw the Stones perform, so needed to write something for the Saturday Telegraph. *The piece went in straight away, but I prefer to read it in print after a while because if I go to buy the paper and read it immediately, I always see the faults. The trip was fun but tired me out, especially with changing planes and waiting for hours at Newark Airport for the flight home. I looked for a place there to lay my weary head but there was none. Finally, I spread out some newspapers over a vent on a ledge and had just nodded off when a black guy woke me and asked to see my boarding pass. He was from a charity called Outreach and was rounding up bums to take them back to NYC [New York City], as they weren't welcome out there! I thanked him and tried unsuccessfully to go back to sleep.*

Most of the homeless people were black.

Back home it's damned cold and wet and we are readying for the Christmas onslaught and our birthdays. Mick has followed me to

Britain and asked us for dinner, but I don't think we'll make it back up to London this time.

REGENT SOUNDS

Andrew Oldham is credited as producer on a number of the Stones' records, and I remember being at the tiny Regent Sounds Studio in Denmark Street, London's version of Tin Pan Alley, when the band was recording 'Little Red Rooster'. As the song was winding down with a fade-out, Andrew was waving his hands in a circular motion, and I thought, 'Oh, that's what record producers do!'

Regent Sounds was a poky little basement studio, for sure, but it did the trick. When Stu said 'Rooster' was good enough to be a single, Charlie, who was leaning against a wall, replied, 'Why not?' I think it was the only blues tune ever to be a British number one.

Glyn Johns was the engineer on that session and helped develop the Stones' sound. He was the first to record a demo of the band earlier at IBC Studios, which became a complication when Andrew Oldham did a deal with Decca, so Glyn returned to IBC and told them the band had decided against 'going commercial' and asked if they could they have their tape back. He paid the £50 and was free of any further complications, a smart move.

THE WONDER OF STU

Stu (Ian Stewart) was an integral part of the Stones from the off, first playing and then road-managing. Bands spend far longer travelling than playing on stage, so a reliable driver and wheels are crucial. Stu drove everywhere in his VW van without bothering to look at a map. When loaded up and ready to move, he would jangle a large bunch of keys and pronounce, 'Shall we?' Amps and guitars have to be kept in top condition and, apart from Bill Wyman, as

far as I'm aware, none of the Stones knows one end of a screw-driver from the other, so that was another important responsibility.

With his jutting chin and shy, fluttering eyes, Stu was widely imitated by the band. Brian, Keith and Mick would take him off mercilessly, but he bore it all in good humour. Everybody really loved Stu but he did have quite conservative views, once opining to me that 'The Beatles were the worst thing that ever happened in British music' (I took it with a pinch of salt). I guess Americans would call him a 'good ole' boy'. After he died in 1985, many of the music biz's biggest stars – among them Eric Clapton, Jeff Beck, Pete Townshend, Keith, Mick, and Ronnie Wood – turned up to his funeral to say goodbye. It was a poignant moment.

INTO PRINT

While the Stones were playing their Richmond residency, I was approached by a journalist and asked to write a story about the band, a sort of 'day in the life' piece. It was the first thing I had written and I received a fiver for it when it appeared in a teen-y magazine. A while after, I was summoned to appear before Andrew Oldham who, with Keith at his side, took me to task about not obtaining their permission for the article. They even demanded a cut of the money. I guess the last comment was a joke, but it was a definite shot across the bows and quite daunting for a 16-year-old. I finally forgave Andrew when I heard him say recently in an interview that Mick and I should sing the 'DJ Blues' on stage, as he really rated this song from the *Act of Faith* CD, put out by my band 'Atcha!', on which Mick had sung with me. I sure stored that one up.

CLUBLAND

Escaping the clutches of boarding school at weekends, it was easy enough to get to London to explore. So, with school friend Ricky

Hopper, I would take the train to see the sights. Getting into clubs wasn't a sure thing at 16 or 17, as you were technically under-age, but that didn't stop us too much.

Our favourite haunts were the Flamingo or the Whiskey-a-Go-Go in Wardour Street, where stylish young black dudes danced wild steps to blue beat and ska rhythms. We shuddered at such competition, so mostly watched from the side. A regular act was Georgie Fame and the Blue Flames, whose extensive line-up included Ghanaian conga player Speedy Acquaye and guitarist John McLaughlin. Georgie often played extended solos on the Hammond organ, jamming for long periods, a regular jazz thing, and it really got people excited.

Ricky Hopper and I would then stroll up to Les Cousins in Greek Street, which stayed open real late, and sip coffee while lesser folk acts that had been waiting patiently finally got to play as the punters were falling asleep. (Earlier in the evening, you might catch the stars of the scene such as Bert Jansch, Davey Graham or John Renbourn, who we all loved, as we were into folk music, too.) Finally, rousing ourselves, we tottered off to Charing Cross station and boarded the early milk train back to Dartford.

Screamin' Lord Sutch was an early rock & roller to make an impression on me and I first saw his band at the echoing Eltham Baths. Sutch had the best musicians at the time and modelled himself on the American act Screamin' Jay Hawkins. I caught up with him 40 years later at a Brixton Academy gig, along with the diminutive Wee Willie Harris, who dyed his hair pink and yellow. I wanted them to appear in a show I had conceived called *The Last Rock & Roll Club in the World*. I wrote a treatment for the idea but not long after our meeting Sutch took his own life, putting the kibosh on that.

As leader of the 'Monster Raving Loony Party', one of Such's questions was: 'Why is there only one Monopolies Commission?' He stood for parliament against then-prime minister Harold Wilson, with a top hat and cane in hand. He was a great British eccentric and I reckon he should have been made a member of the House of Lords, thus becoming Lord Screamin' Lord Sutch!

Graham Bond did the rounds, mesmerizing on the organ, alongside Jack Bruce and a host of other great musicians. Ricky and I would go to the nearby Bromley Court Hotel where, in a small back room, I first saw John Lee Hooker, his foot slapping a piece of hardboard. Solomon Burke appeared, at the Black Prince in Bexley, and afterwards we chatted to him, snazzily dressed in a shiny blue mohair suit and gelled hair and bragging about picking up girls. Chislehurst Caves was another local watering hole where I saw bands like The Yardbirds with Eric Clapton, playing in the damp atmosphere while we wandered round in the gloom amid the echoing sound and your girlfriend held tight to you in case they got lost. The caves had been dug out from the chalk over centuries and provided a good shelter from bombs in the Second World War for the local population, among other things. They were akin to the Dene Holes, also found in Kent, vertical shafts, some around 60 foot deep, and dug for chalk from early times which my dad took Mick and I to for exploration with a stout rope, which was all very exciting.

PERFORMANCE

Laurie Yarham, a school mate from nearby Peckham, was more streetwise than me, so I blame him for my first and worst bit of publicity. We went to the Lewisham Odeon for a big party night and between acts there was a competition for a Mick Jagger lookalike. I didn't want to enter but was with a bunch of friends

who wouldn't take no for an answer. Being a bit of a mod, Laurie gave me a Purple Heart – an upper – and then I didn't care anyway, especially as the prize was your choice of LP. I jumped on the stage, mimed to a Stones track and won. It would have been lame if I hadn't. Some weeks later I got my LP – James Brown's *Live at the Apollo*, which took some getting hold of – but I also got my first-ever press coverage, and the clipping followed me round. (Once filed, it's never forgotten.) I didn't harbour any pretensions of being in a band myself; I just did lots of listening, a good education in itself.

It was with Laurie that I smoked my first spliff, in Brixton, where we paid five bob (25p) for a pre-rolled jumbo joint of black hash. I was told that in the early Sixties hash was sold on market stalls in Brixton as the police had no idea what it was – and what did they care anyway?

FIVE-FOUR-THREE-TWO-ONE

For the mod crowd, the main weekly TV show in London in the mid-Sixties was *Ready Steady Go!* with Cathy McGowan, an icon of the scene. Broadcast live every Friday evening, it was Mary Quant skirts, Vidal Sassoon bobbed haircuts, tight trousers and bright shirts. Donovan appeared almost every week, along with Sandie Shaw, and the Stones, whenever they could – though they had a busy touring schedule, running round every cinema in every county town. What marked *RSG!* out was that it was the first to use 'ad lib' presentation, so artists could be themselves instead of conforming to a manufactured image. This suited bands like The Stones and The Beatles, who loved playing live and chatting away freely. The audience, too, 'did their own thing' and were recruited from the London clubs for their moves and clothes.

One year, *RSG!* held a Mod Ball at the Empire Pool, Wembley, where the stage moved around the large floor space. Unfortunately, due to a lack of organization and security, the band were mobbed and the live transmission shuddered to a halt. It was very entertaining, though, as I watched on with Paul Jones from Manfred Mann. My mother always wanted to get hold of Paul to treat his acne, which was pretty bad. This was partly because Mum ran a sideline in 'Beauty Counsellor' products, an early range of creams and treatments marketed directly, not available in stores nor laced with nasty chemicals, and aimed at the more 'mature' market. And because Mum was popular but not pushy, she did okay with them. I would often be dispatched to deliver said products around the vicinity, and even Mick would tout for business with the mothers of his various girlfriends.

ROCK & ROLL TOURS

Leaving the dilapidation and traffic of Edith Grove, Mick and Keith took a flat in Mapesbury Road, north London. It was Number 36: I remember, as I made notepaper at the printing press in school for my brother – though I cannot imagine him writing a letter with the hectic lifestyle they led. This place, with a rather damp English whiff, was their base when touring with Bo Diddley in a fantastic show, their first package tour, headlined by the Everly Brothers.

Bo had a sidekick called Jerome who played the maracas, two in each hand, which he showed Mick how to use – he put them to great effect in the Diddley-inspired version of Buddy Holly's 'Not Fade Away'. Jerome was immortalized with the tune 'Bring it to Jerome', and I just thought at the time, 'What a brilliant name!' Jerome stayed at Mapesbury Road and slept across two chairs; that was something I had never seen before and I was impressed! On

that tour was 'The Duchess', who came on stage in a shimmering white sequined dress with bouffant hair and playing a Gibson flying-V guitar with loads of reverb. Wow!

Bo sported wide check jackets, heavy glasses and strange home-made guitars, one of them square; he was definitely different. (Years later, I had a blue check jacket made in the same style.) The last time I saw him playing was at Dingwalls in Camden in the Nineties, with Wilko Johnson and his band backing up. Wilko knew every one of Bo's licks, but he was a little nervous, as he hadn't even met him beforehand. When Bo arrived on stage, Wilko asked if there was a setlist. Bo replied, 'We'll start with "Bo Diddley" and take it from there.' 'What key?' asked Wilko.

Charlie and Inez Foxx also toured with the Stones; they had that great hit 'Mockingbird'. Charlie was as lanky as a basketball player and a great mover while Inez boasted a towering beehive hair-do, a style later popularized by Amy Whitehouse.

I'd always loved the Everly Brothers and I got to hear close-up the same harmonies that I'd first heard on the 78s. A few years back, I persuaded Mick to sing a couple of those old numbers at his birthday party. I think families singing together have a special sound, and I thought ours was pretty good too; but after we finished the second tune, Mick's son Lucas asked, 'Can we have the football on now, Dad?'

Eventually, Little Richard was added to that bill, as the Everlys weren't quite doing the business at the box office, and he sure livened up the proceedings. I'd never witnessed a singer whip up the crowd like that. He would jump on his grand piano and dance around; then, as the crowd bayed for more, he would go into the front rows, stripping off his shirt and driving them even crazier. 'Security' at gigs didn't really exist then, apart from ex-servicemen with berets and medals at the stage door. But as

I stood at the rear of the stage one night, the theatre assistants, dressed in long brown coats, decided enough was enough. 'He's not getting away with it tonight,' they declared and grabbed hold of the microphone lead, commencing a tug-o'-war with Richard. In the end, he put the mic down and went into the crowd anyway, literally losing his shirt.

Naturally, the public didn't know Little Richard was gay but it was obvious to everyone on the tour. 'Ain't I pretty, I am the greatest,' he would say as he bumped into me on the theatre staircase and eyed me up. For him, it was a great revival of his career, as he'd already made the rock & roll circuit in the USA a decade before. The last time I saw him perform was in New York at the Bottom Line, when I went with Mick and Jerry Hall. He was still amazing and had the entire crowd singing a funk version of 'Itsy Bitsy Spider'. He would begin one of his hits and suddenly stop after a minute, saying, 'We got a lot of shit to get through', before moving on to something else.

On the Stones' second countrywide tour, they headlined for the first time on a bill that included the Ronettes, Dave Berry with his weird mic moves, the Swinging Blue Jeans, Marty Wilde and a 'comedy compère'. (On the early packages they often had jugglers and magicians, a legacy from the music-hall era.) I went into the band's dressing room one night and Mick and Keith each had a Ronette each sitting on their laps. One of the perks of the job, I guess. What else would you expect to happen after singing 'Be My Baby'?

CHAPTER 6

GET OUT OF JAIL FREE CARD

Alongside the emergence of my brother as a rock & roll star, I too was freed from the confines of boarding school and became a day boy after my O-Level exams, which went okay – apart from German! The tedious trip to and from school via bus and trains also ceased after passing my driving test and I felt like the luckiest guy in the world when Mick gave me a brand-new maroon Morris Mini for my 17th birthday. This was around the time that 'Satisfaction' was released in the USA and, although I hadn't seen much of Mick, at least he hadn't forgotten about me. In the post, I also received a copy of the US single, which had no spindle hole; you had to buy a plastic triangular section specially to insert and play the thing, as they were used for jukeboxes too.

I had learned to drive with a creepy guy in a mac in his Ford Anglia with a sloping rear window screen, and soon I was king of the road, driving to school and parking up around the corner. It was around the time that pirate radio stations began operating, challenging the BBC monopoly of the airwaves, so I could commute to the sounds of 'Rescue Me' by Fontella Bass and 'SOS' by Edwin Starr.

During the summer, the main game was cricket, but it was run by a clique I didn't like and so I took up athletics, eventually becoming captain of the school team. In cricket, you must wait to be selected, but if you throw the javelin farthest, you're in, and I had one great advantage as Dad was my coach.

A silver cup was awarded to the champion at the annual sports day, when you could enter four events. So, apart from the spear, I chose the triple jump, hurdles and pole vault. The last didn't feature in inter-school athletic competitions and few were willing to

risk it as you landed in an old sand pit and used a long piece of unyielding aluminium. You would run up with as much speed as you could muster, jam the thing into a slot, swing over and hope for the best. By this route, I accumulated more points than the flashy boys who won the 100- and 200-yard sprints with the whole school screaming, so I walked up to claim the cup two years running. I enjoyed the solitary discipline of running out with a javelin to train after school, drilling it into the ground along a marked line, and pretending I was a hunter in a primeval forest, probably the more useful origin of such activities.

We had just a few black pupils in our school; one was Ajegbo, a popular boy from Ghana, with an amazingly strong and lithe physique. He won the Wimbledon junior tennis and was coached by Whockie. With his tennis contacts, Whockie took us to Wimbledon on the final Saturday of the championships, to watch the men's and the mixed doubles, which he maintained were superior to the singles any day. Whockie was also keen on the ballet and took us to Covent Garden – and in return, some of the dancers came down to play cricket matches, once bringing Rudolph Nureyev in tow.

I played basketball, and one year a tall American lad joined, providing a solid injection of talent. Poor guy, he was practically a one-man team. We did our best to assist but he was streets ahead of us in technique and savvy, winning us many matches and showing us how it should be done. Basketball was actually one of my father's pet sports; he coached the game, wrote a couple of books on teaching it and would take Mick and me to such US army bases as Chicksands, where they boasted swanky shining courts with see-through backboards and tall black servicemen to dunk the ball into the net. It was impressive. They ate steak and ice cream in the canteen and even the Coke was shipped from

America. My brother was keen on basketball, too, and played for his school. I had one solitary game for the London Schools representative team. I came on as a substitute and ran around until I was dizzy, managing to make one jump-shot attempt, whereupon some towering guy just slapped me down. That was another level.

DIARY

An amazing morning in Mudgley. Finally, the rain stopped and we had a very clear and cold night. Consequently, there followed thick frost across the Levels. There are little ripples of frozen ice along the rhyne (local dialect for 'ditch') at the bottom of the field and crunchy shards of icicles; everywhere the eye catches the prisms of light.

Last night there were fifteen in the house and barn, all our five boys and friends from Muswell Hill. This must be the last day of the holidays so it's good to have a crowd.

I have come across some passages I wrote when Mick was going to do an autobiography, reminiscences knocked out on an old IBM typewriter. Perhaps it was some of them that stopped him from bothering? They're fairly fragmented, so I'd better have a proper plan when I really start back.

Alan Yentob may stop by today en route to London. He has an amazing baronial edifice near the Quantocks. I received Charlie Hart's live recording from the 100 Club yesterday. Sounds okay, though a little rough. Where to with the music?

THE GUN

I was useless at art, and lessons were taken by a dour Scotsman called Mr McKay, but he did know about the distant relation of my father's, Charles Sergeant Jagger. Charles had sculpted the Royal Artillery Memorial on London's Hyde Park Corner, a massive thing. Charles had been a soldier in the First World War and

brought a sense of realism to the monument that was lacking in previous eras. His brother David was a painter too and Mick has managed to collect some of their artworks, including a maquette of the gun and a painting by David, which is a nice connection between brothers in an earlier age.

McKay retired and our new art teacher, Roger Butlin, was more interesting. He was particularly into theatre design and, later realizing teaching was not for him, went on to design sets, initially for the Greenwich Theatre. It was Roger who gave me an introduction to the Hampstead Theatre Club, my first proper job after leaving school.

THE PLAY'S THE THING

At the end of the spring term came the 'house plays' and one year a sixth-former produced *Rhinoceros* by Ionesco. I liked this 'theatre of the absurd', where you took everyday events and wrote the dialogue like a soap opera, then you added bizarre elements which made the audience look at the characters' reactions; thus, in the mediocrity of mundane chatter, a rhino passes by like an apparition. The effect is both funny and disturbing.

I discovered a one-act play by Ionesco called *The New Tenant* and got the nod to produce and direct it for the school 'house competition'. The plot is rudimentary: a bourgeois gentleman is inspecting an apartment he wishes to rent, meticulously taking measurements of each wall and noting them on his pad, while madame concierge moans about the previous tenants. Two removal men appear, bringing his furniture and possessions, and he directs their positioning until the entire stage is totally packed and there is no room to move. ('The street is jammed with wardrobes, they are filling up the Metro, the whole of Paris is full...') The prospective tenant asks for the light to be switched off and that's the end.

It was great listening to the audience's comments on leaving: 'That was a load of rubbish, wasn't it?' and 'What did it all mean?' Unfortunately, that was the first and last play I ever directed – but I enjoyed the whole scene, the lighting and organizing the props. At one point, we wheeled on a Victorian loo in great style – I played one of the removers – and received the standard instruction: 'Over there.'

I worked fairly hard at my lessons – I had to since my father was paying, and I couldn't let him down – and I even won a school prize one year. However, it was accepted that, during the lower-sixth year, you could have an easier time after the rigours of O-Levels, and this enabled us to get involved in such extramural activities. In my view, that's a good thing. School shouldn't be just swotting and exams.

Bit part in Macbeth. It's fun murdering people.

My participation in the standard school play was limited to playing First Murderer in *Macbeth*, who nonetheless delivers a nice line – 'The west yet glimmers with some streaks of day, now spurs the 'lated traveller apace to gain the timely inn' – before helping in the bloody dispatch of Banquo. All great fun – unlike the English master, one Mr Barnard, who adored the period pieces of Gilbert and Sullivan. So witty, he said; plus he could play the leads, to show how it was done. I shied away from those – I've never really liked musicals – but at least I was spared from taking a female part. That was the fate of some boys, Barnard vigorously defending the practice because it happened in the Bard's day.

Ελλάς

In the 1965 summer holidays, I decided to go travelling with school friend Ricky Hopper and my local pal John Freeman. We took the Dover to Ostend ferry on our way to Greece but, realizing that it was nigh on impossible for three boys to hitch a ride together, we decided to split up, each travel alone and meet in Athens. But where? The only place we all knew was the Parthenon – you can't miss that – so the rendezvous was duly arranged: 10.30 every morning after arriving; fingers crossed. Such was life before mobile phones.

I stuck out my thumb and made slow progress through Germany, where my basic Deutsch came in handy. It was my first visit there, and I had never before seen the huge articulated trucks and the autobahn system. In Munich, I was unable to find a place to stay when a young man took me down many narrow streets to a doorway, where we knocked and it was answered. I turned around to thank him, but he had gone. I will never forget such simple generosity from total strangers. I hitched a long ride through Austria and Yugoslavia and ended up in Dubrovnik, where I was

impressed by the ancient city next to the sea, all I had dreamed about. But I still had to get around Albania, then a closed communist country. (It wasn't until the Nineties that I finally got there.) I took a ship bound for Athens but, wishing to save funds, I disembarked at Corfu. From Igoumenitsa on the mainland, I started to hitch the road to Athens – a crazy idea – over arid mountains on dirt roads with little traffic.

A truck driver picked me up in his ancient Volvo and did his best to seduce me. First, we stopped on the top of a mountain pass and went into a large *cafeneon* where everyone was eating sheep's heads – presumably because they were so cheap, you didn't want to transport them. Their brains were a delicacy and the eyeballs, too; but when you've finished, it looks like there is more on your plate than when you started. Thinking this would do the trick, the driver then stopped on the road in the middle of nowhere for some al fresco sex, but I managed to fight him and his moustache off and he eventually gave up, dropping me off in a scruffy village. I went through a small town called Trikala where a bunch of kids threw stones at me, so obviously tourism wasn't a lucrative industry there.

At last I reached Athens in triumph and at the appointed time the next morning climbed the steep hill to the Parthenon. What perfection, what grandeur – the Erechtheion, the porch of the Caryatids – but alas no friends were there; no Plato or Aristophanes to keep Socrates company.

I found a tiny whitewashed room in the steep narrow alleyways of the Plaka and the following morning, with renewed anticipation, I again ascended the heights of the Acropolis. As the sun heated up the steep steps, I scanned the tourists for a face I knew, but to no avail. I was spending precious drachma, so on the third day I decided not to pass through the gates of the precinct. But as

I approached the Propylaea, wondering what my next move would be, I heard Ricky's voice from a bench. I could have kissed him! We waited another day for John, but there was no sign of him so we boarded a boat for Crete.

I couldn't have had a better companion than Ricky as he was a classics scholar, was familiar with *The Iliad* and could read Greek – albeit the ancient form, which is far divorced from what's spoken there now. I once persuaded him to make an attempt at conversing in Ancient Greek, and watched the perplexed faces staring at this fair-haired boy with blond curls speaking a strange yet familiar language.

In Crete, we stopped off to see the ancient Minoan city of Knossos, much restored by Sir Arthur Evans, and then headed to Phaestos, which we loved. Here we met two English girls from Ravensbourne College of Art – close to where we went to school! – and since they were headed to a beach near Agia Galini, we followed them and hung out, camping rough and relaxing after our arduous journeys. They were just a little older, so they turned their noses up at the idea of 'relationships' with us, we being mere schoolboys, but we did all get amorous one night when we went to a local wine festival and events turned rather hairy. The entire place was rip-roaring drunk, and the lorry drivers' idea of a good time was to climb into their cabs and career through the narrow streets swerving across the pavements. We found a way back along the beach and through the incoming tide, with the girls clinging to us for safety.

I loved Crete and resolved to return to this ancient kingdom between Europe and Africa, which had been civilized as long ago as 2500 BC. (They even had running water and toilets in Knossos.) But now came the long haul back to Blighty. We returned by boat to Piraeus, in a leaky old tub called the *Heraklion*, which sank the following year with the loss of 200

lives. I ate some pork on board, developed food poisoning and learned two lessons: be careful what you eat on a ship; and if you are sick, choose the leeward side. I slept on deck with the peasants and chickens and, on arrival, we had to fork out on a hotel for me to recover, draining our slender resources.

After a couple of days' groaning in a run-down garret in the old port, I opened my eyes to see Ricky coming in. With his fair skin, he'd gone red as a lobster from sitting in the sun, and I laughed so much that I realized I was fit enough to travel.

Along the Peloponnese, one guy with a motorcycle sidecar picked us both up, which was crazy, and another gave us a lift in his old Volvo, taking us to have lunch with his mistress before dropping us off. We slept at the site of Mycenae as it was late and deserted – the legendary city ruled by Agamemnon before he went off to fight the Trojan wars – and walked around it all alone.

Skirting round the Gulf of Corinth, we arrived back at Kerkira – or as most people know it, Corfu, the name the Venetians gave it. We tried to sleep on the beach there but gun-toting police put a stop to that and our remaining 'drachs' went on a hotel. From there, we took the ferry to Brindisi in Italy, and eked out a bare existence across Europe, sleeping in railway stations and managing one meal a day.

Across Greece we'd enjoyed sitting in a basic *cafeneon* where they bring you a clear glass of water without any request; then looking in the kitchen and ordering moussaka or the large *fasolia* beans, and *horiatiki* salad with feta cheese, and *galaktoboureko* puddings, the creamy custard delights. (Then, of course, there was yoghurt and honey – which I had never tasted, as this was the mid-Sixties and British food was far from exotic.) I'd been intrigued by Greek music, managed to decipher the alphabet and spoken some conversational phrases. I once asked a guy what the Greek word

was for 'waiter' and he thought for a second – then just thumped his fist on the table. This is the place for me I thought; the land of Aristotle, Homer and Melina Mercouri.

When we finally reached home, we found that John Freeman had met a bunch of American GIs in Yugoslavia and had such a good time, he didn't bother to travel any further. I couldn't really blame him.

MY BASIC BEAN RECIPE

Soak a large pack of giant white butter beans overnight, the longer the better, changing the water if you like and rinsing well. Bring to the boil and then simmer slowly or place in the oven in a crock to slowly cook. It takes a while, and when they are softish, fry up lots of garlic in olive oil, and I mean lots, and transfer the beans, adding salt and pepper and simmer slowly, adding some stock if you have it, or a little water just to keep them moist. Add a squeeze of lemon and handfuls of chopped parsley. It's a simple but tasty one and it's good to cook quite a lot to enjoy them the following days in salads or put them in a soup, if you like.

CHAPTER 7
THE THEATRE, DARLING!

The final year at school is a funny one as you are growing up so fast yet still surrounded by a school full of young kids and teachers who look increasing irrelevant. Most students looked to go to university, not because that's what they had their hearts set on but because they didn't really know what to do otherwise and it was a safe option, especially as back then there were no tuition fees and you could obtain a grant.

Mick had taken a course in economics and law at the London School of Economics, the prestigious college in central London, and for that he could easily travel from home, but he dropped out of that scenario once the band became professional. Art teacher Roger Butlin had encouraged me into the theatre and he too was soon to leave teaching to fulfil an ambition to be a set designer, first at the nearby Greenwich Theatre. He took me to watch a performance of *The Flying Dutchman* at Covent Garden, the first opera I ever attended, but we were mainly there to look at the set by the legendary Irish designer Sean Kenny, which consisted of an enormous hydraulic platform that tilted at different angles – enough to make the performers quite seasick, but very impressive. So it seemed a good idea for me to take a course in theatre studies, and there were just two places to do that in the country, Manchester and Bristol, so naturally competition was high. My exam results were okay – not that impressive, but enough to gain admission to my dad's old place, Manchester, and knowing him, he likely called around the department there to see if that might help.

The summer of '66 was hot, England won the World Cup and everybody was feeling good. The Stones played a crazy show at the Albert Hall with Ike and Tina Turner and The

Yardbirds (who at the time boasted Jimmy Page and Jeff Beck on guitars). There was a stage invasion, with Stu and others fighting off the fans while the band tried in vain to continue. It was all a chaotic blur.

I had said my goodbyes at school – and one master was almost tearful that I hadn't made a 'prefect', so I guess I must have disappointed them. I took a break and travelled alone to see Corsica, which was hot and mountainous, meeting up with a young French guy, and we hitched around the island eating breakfasts of bread and chocolate, and sheltering from the hot sun under shady fig trees full of fruit. For a change it wasn't the Brits the locals hated, but the French.

Then I started work at the Hampstead Theatre Club in Swiss Cottage, north London, as an assistant stage manager, a go-fer, making the princely sum of £10 a week, reduced to a measly £9 after deductions. Roger Butlin had introduced me to them and it was a great opportunity, as apart from the Royal Court in Chelsea, this was the one theatre in London dedicated to new plays. Run by James 'Jimmy' Roose-Evans – all curly auburn hair and camp manners – it was housed in a 'temporary' building between a library and swimming pool. My first job was to sweep and clean the stage, and I soon learned that every task is important. I helped to build and paint props and sets – the joy of theatre being they only have to look good from the front and last a few weeks, about the lifespan of my DIY. I ran around town in my Mini, hiring lights from Strand Electric in Covent Garden or borrowing them from other theatres – and once from RADA (the Royal Academy of Dramatic Art, darling) where I felt distinctly out of place among the precious students as I lugged equipment about. Before such institutions as RADA, actors would

start like me: watch from the wings, become a spear-carrier and, if lucky, catch someone's eye.

The first production was set on the Russian front during the Second World War, and I worked the sound effects on a Revox tape recorder, hitting the start button with a shaky hand, and hoping the tape wouldn't snap. I assisted on the lighting board, separate dimmers that had to be faded out on a count, sometimes balancing them with a wooden stick and other tricks. Now it's all done automatically.

MURDER MOST FOUL

A play on the assassination of John F. Kennedy followed, Michael Hastings' *Lee Harvey Oswald*, and this combined dramatic action with TV footage from the event; my job was running the 16mm projector from a knocked-up platform above the foyer. The lights would dim, the theatre doors open, and I would get the thing whirring.

On the opening night, we were expecting important people: the critic Harold Hobson in his wheelchair, and producers who might want to transfer the show to the West End, thus helping the theatre's finances. But there was a glitch with the projector – its 'exciter lamp' had bust – so it was panic stations. (This lamp is part of the means by which a projector 'reads' the soundtrack and channels it through the speakers.) I managed to tape a small torch in its place, so I got extra brownie points from Roose-Evans. He once stopped me in the foyer with, 'I hear you do a very good impression of me,' and gave me a wry smile, bless him. I saw the sequences of JFK's motorcade, and the subsequent shooting of Oswald by Jack Ruby, so many times that I knew every frame backwards.

A highlight came when Robert Bolt wrote a play for the theatre and Sarah Miles played the lead. (Everyone fancied her after her

performance in *The Servant* with Dirk Bogarde.) Leo McKern, with a rambunctious manner, large mottled nose and gruff voice, also appeared there. He was later to play *Rumpole of the Bailey* in the TV series written by John Mortimer.

Across town, I had seen Maggie Smith, Robert Stephens and Nicol Williamson perform, and they were so brilliant, their timing so perfect and effortless, I wondered how I could possibly aspire to such heights. Meanwhile, the jobbing actors at Hampstead were appearing for peanuts – hardly more than I was earning – and after removing their greasepaint, they disappeared down the Tube to mundane existences in damp flats and lonely bedsits.

I was fortunate in that I could stay in my brother's apartment, Harley House, on Marylebone Road, not far from the theatre. At the time, Mick was mostly away touring in the USA and so gave me the use of a back bedroom. The place had high Edwardian ceilings and a great sound system. The front of the house had a vista of Marylebone Road, with a long corridor connecting to the main sleeping quarters at the back, with a view of Regent's Park. The building chiefly catered to doctors and lawyers, so it was an elegant pad, with a uniformed concierge to keep an eye on things. The furnishings were more modern – this being the Habitat, Terence Conran period – and a stainless-steel Arco lamp was bent on a curved piece of steel over a low, square mirrored table, with folding-down sides that housed little compartments.

Occasionally, Mick's girlfriend Chrissie Shrimpton took me to such glamorous watering holes as The Scotch of St James, where the trendy young things drank miniature bottles of spirits diluted with ginger ale or cola. They played Wilson Pickett and 'Reach Out' by the Four Tops for stars like heartthrob singer Scott Walker and Lulu, perched on banquettes looking very cool. Chrissie would drag me onto the dance floor, which I dreaded,

but she liked to have fun and it was safe enough to be seen out with me. The fashion scene was also taking off, with Carnaby Street in its infancy and, on Old Compton Street, John Michael, which sold French-style suede jackets in green and brown with metal buttons, all very mod. There was a coffee bar there called Act One – Scene 1, where the Stones would meet up with other faces, wearing Cuban-heeled ankle boots, as did The Beatles, and trendy girls sported Courreges silver boots, Mary Quant skirts, and berets in pastel colours. John Stephens supplied tight trousers that made your balls ache, and that split when you bent over, but they looked great. There was also a little Hungarian shirt-maker in Savile Row who made shirts to order, in bright colours with double fold-back cuffs. The details were always important. If you were really cool, you smoked Benson & Hedges and lit the fag with a gold square Dunhill lighter.

DIARY

Clear skies at last after the night's rain. Yesterday I went to the late Joe Strummer's place in the Quantocks, to plant trees. It seems that the day before he died, right before Christmas, Joe had signed the deeds for an adjacent field and ordered 1000 mixed trees, mainly ash and oak. So a posse was raised to support his widow, Lucy. Digging into the red soil brought everyone together, including a group from Manchester, who had obviously been big fans of Joe. After some three hours there were about 500 trees planted, staked and protected – complete with little mulch patches – so we went in for some excellent grub. The Manchester mob stayed outside in the rain, sitting round a huge bonfire drinking, while the women and babies were inside watching TV. Damien Hirst appeared, bringing some huge tins of lasagne that he'd made. He looked well, so obviously the new regime of abstinence is working, but hardly said anything. Still, it was strange to be in Joe's house without Joe, so

I went outside and sang some tunes, wiping the rain from my guitar from time to time. However, the Manchester mob weren't too interested, being of a much younger generation. I don't know any Happy Mondays songs.

MIND THE GAP YEAR

There was a huge divide between the music and theatre worlds, which left me with a question: did I really want to go to rainy Manchester, to read theatre studies and Shakespeare? To the dismay of my father, I decided to forgo this opportunity and, consequently, my gap year has arguably lasted until the present day. At the age of 19, I turned my back on academic study, which is crazy when you consider it only takes a few years of your life and would likely have led to so much else. I would probably have ended up working in TV, which might have been fun and eased my money troubles, a far more sensible move for the brother of a Rolling Stone.

I guess I was intoxicated by the London lifestyle and the exploding scene of the Swinging Sixties, with women, music and drugs (though I had only really smoked grass). By contrast, Manchester was a square place, with students in donkey jackets trailing off buses in the rain, looking spotty and unhappy. I chickened out and nobody really sat down to talk some sense into me. But no wonder my head was turned by what was going on. My brother had also failed to finish his course at the LSE. Do your own thing was what mattered.

But what was my own thing? I still didn't know.

IVORY TOWERS

As an antidote, I went off to Cambridge to visit my old school pal Ricky Hopper. Maybe I was feeling guilty about not

attending university myself. At least this would give me a glimpse of the student experience.

Ricky had been awarded a scholarship in classics, at Jesus College, where he occupied some ancient rooms up a winding stone staircase. At night, a medieval security service, the 'beadles', were on patrol and locked the gates at midnight. We hung out together and after a while people assumed I was studying there. One undergraduate suggested I come into lectures anyway, as nobody would notice.

Still, I was having a musical education. I first witnessed the Jimi Hendrix Experience at the Dorothy Ballroom in Cambridge one dark Wednesday evening. The power trio wandered on then hit us with, among other tunes, a reworked version of 'Wild Thing' that made the hair stand up on the back of your neck. 'Hey Joe', Jimi's debut single and originally a folky tune, had a major reworking and what Jimi did to it was amazing. It was as if he had just landed from Mars, as obviously nobody had heard of him before. I had met model Linda Keith when she first went out with Keith Richards but didn't realize that she was instrumental in bringing Jimi over to London. As there were only around 30 people in the audience, it was no problem afterwards to get into the dressing room and introduce ourselves; and over the next year or two I became well acquainted with Jimi, who was always pleased to see me.

On a basic level, Ricky sang vocals with a band known by the strange moniker of 'The Pineapple Truck', and that led to my first proper on-stage appearance; he got me up with him to sing on songs such as the Four Tops' 'Same Old Song' and the Sam & Dave duet 'You Don't Know Like I Know'. My voice must have been pretty weak but you have to start somewhere. We opened at a small college for blues man Alexis Korner, who was as encouraging as he always was with youngsters. I didn't take it seriously, though.

Another group I connected with was called 117, which, if you're interested, is the smallest possible length of the longest side of a Heronian tetrahedron (that's a triangular pyramid, whose sides are all 'rational' numbers). Thus began a friendship with keyboard player Charlie Hart and drummer Johnny Sheriff that has lasted to this day. The band 117 played spacey psychedelic tunes with catchy titles like 'Venusian Sunshine'. A fast-talking student named Pete Rudge managed the band and, sensing a possible entrepreneurial opening myself, I wangled a session for them through my brother.

The band first rehearsed at an old factory in Clerkenwell, London, where Mick came to see them. He enjoyed it enough to arrange a session at Olympic Studios, where the engineer Glyn Johns was sceptical about this amateur band of undergraduates playing weird music. Mick went for it, though, and even joined in with the vocals, but nothing transpired and the tracks have since disappeared into the ether. Meanwhile, Pete Rudge made the most of the opportunity and later managed tours for the Stones, then The Who and Lynyrd Skynyrd, setting up his own management company.

Pink Floyd started in Cambridge – where Syd Barrett and Roger Waters grew up – and I first met their close friend David Gilmour there when he was in a soul band called Jokers Wild, which included his brother Pete. David was always softly spoken and considerate and remains so to this day, still keeping in touch over the years. There were many other bands around the pubs and clubs in Cambridge and a good folk scene, too.

On the romantic front, James, the singer from 117, had a partner called Debby – a fun girl – and her flatmate was Phillipa who, after some serious courting, I persuaded to become my girlfriend. She was very pretty, with auburn hair

and freckles – and quite innocent. It was in their house that I first took acid, with 117's drummer Johnny Sheriff (LSD was still legal then, although mine wasn't very good quality). We messed around after everyone had turned in, then Johnny left and I attempted to go to sleep but couldn't. Phillipa was in bed already but for my amusement she recounted blood-thirsty tales of the Scottish MacDonald clan and their battles with the McClouds – she was a MacDonald – as well as other gruesome legends. So I was sat up in bed more awake then ever and slightly freaked out.

Ricky and I would sometimes pop round to the bedsit of one Jonathan King, who had begun his foray into pop music with the hit tune 'Everyone's Gone to the Moon'. He later discovered and produced Genesis and 10cc, among others, but his career came to a shuddering halt many years later when he was jailed for a period of seven years for seducing young boys. Naturally, we knew he was 'queer', as we said then, and he was briefly entertaining and well connected.

The photographer Mick Rock, a lovely guy, was also on the scene and his love of music would lead him to taking portraits of Lou Reed, David Bowie and Queen – and he certainly had the best name for the job. Mick had a great sense of humour and we went around his to score quid deals of hash!

Much later, in 1974, Ricky came across a young Kate Bush in Welling, not far from where we both grew up. He brought her to the attention of David Gilmour, by then a star, and, together with EMI, they nurtured her talent slowly, helping her to avoid the pitfalls of childhood fame. To her credit, I have heard Kate acknowledge the job that Ricky did for her – and I too am indebted to his influence. He had strong opinions about music. He was very early to recognize Dylan as a great poet and to

understand that a song by, say, Buddy Holly was just as good as anything created in the past.

I also met Danny Russell in Cambridge and he remains a friend. Danny heard the Tibetan Rinpoche, Chögyam Trungpa, speak in Cambridge and decided to follow him through thick and thin, initially to Scotland, to Samye Ling, the first Buddhist monastery in the West, and then out to Bhutan. (The King of Bhutan had shot the Queen's brother with a bow and arrow, so she sent for Trungpa to come and assist her in her meditation.) Danny hitchhiked out to Calcutta and then on to Bhutan where, he told me, he was the 16th foreigner ever to travel there. I recommend Trungpa's books; they are the best explanations of Buddhist thought, and *Born in Tibet*, his account of leading Tibetan refugees out of his country while avoiding the Chinese, is an incredible story. I recommend his 'Wisdom of Shambhala' books, too. He has a brilliant grasp of English.

DEDICATED FOLLOWER OF FASHION

Back in London I met Jay, a working-class Chelsea lad with long hair, a dose of acne and a great deal of style. He knew the scene pretty well and persuaded me to go into business with him, making clothes. I knew next to nothing about it, but he was streetwise and had dealings with shops such as Granny Takes a Trip, at the unfashionable end of the King's Road, opposite the World's End pub. With the enthusiasm of youth, we struck out. The game was to find suitable materials, decide on a style, get some nice women to sew things up for us and sell on the goods to unsuspecting punters.

One favourite haunt was Kensington High Street, which then boasted a variety of old-fashioned department stores with rolls of materials, such as Pontins, where in the basement we discovered bolts of old floral crèpe. It was like the Seventies TV sitcom *Are*

You Being Served? The blue-rinsed ladies, wearing perms and rustling stockings, led us long-haired lads into dark storage rooms to rummage among the remnants, which we bought at the best possible prices, haggling away. We delighted in our discoveries – prompting in Jay a particularly high-pitched laugh when pleased, while he swished the hair out of his eyes.

Some rolls of cloth had been sitting there since the war. But as we were making 'exclusive' items, it didn't matter that the material was 'end of line', quite the opposite. We also bought floral Indian bedspreads, then a trendy design, and turned them into ghastly tunics, one of our stock lines. However, selling to retail shops wasn't easy; the competition was fierce and the profits small. It was better, as ever, to sell 'direct', so we targeted rock & rollers. They had money and liked clothes.

For our commercial enterprise, Jay and I enlisted the help of Carmen, a dark-haired beauty and sometime girlfriend of pianist Georgie Fame, who opened her little black address book for us one rainy afternoon. A number we duly copied was that for Eric Burdon – or so we thought when we called him. He asked us over to a small concrete ground-floor flat in west London, where the door was indeed opened by Eric. Eric Clapton, that is. I can't recall if the visit was a success but it was certainly funny. Slowhand can be a serious chap and – since we obviously didn't want to admit to our mistake – we had to keep straight faces.

Various women known as 'outworkers' stitched up the clothes we had for sale for a modest sum, and one was Karen Astley. Visiting her basement in Ecclestone Square in Victoria, Jay and I were sitting there chatting away when a lanky figure clattered down the staircase, ducked his head in and gave us a glowering 'Who asked you in?' look. It was her boyfriend Pete Townshend, whom she later married.

But our best customer was Jimi Hendrix. He loved wearing crazy clothes; in fact, the more outrageous the better. We went to see him one afternoon in his flat and, after showing him our merchandise, sat around for quite a while drinking tea and smoking joints, as you did in those days. When he disappeared into his bedroom, I found a Robert Johnson record and put it on the turntable; and on Jimi's return, he was pleased to find young white kids digging this obscure stuff. Still, after all the hanging out and chatting we thought, 'What about the sale?' We didn't want to be pushy, so we thanked Jimi and were ready to pack up the clothes lying on a chair when he asked, 'How much do you want for them?' 'What, all of them?' we hesitantly replied, then went through each item in our elevated state and came to what seemed a fair price. Jimi produced the pound notes and we fell out into the street. What a fine gentleman! Obviously, Jimi dug it in London, where he stood out, especially with his crazy hair and clothes, and he enjoyed the little eccentricities in the language and the humour. I guess after being turned down in his own country, it was vindication for his chosen style and direction.

I know Jimi wore some of the clothes; some he maybe gave to pals who dropped by, as the money seemed secondary back then. We also sold items to his drummer Mitch Mitchell and bassist Noel Redding – who became quite good friends – and we got a kick from seeing them on stage in outfits that we'd helped to create.

The culmination of our Hendrix experience was the one-off jacket in which Jimi appears on the front cover of the US pressing of *Are You Experienced* and the rear sleeve of the US version of the double album *Electric Ladyland*. The photo was shot in Kew Gardens, west London, by photographer Karl Ferris. An Irish girl called Julie created the piece. Until then, she'd drawn swirling psychedelic designs on silk ties, some of which were sold at Hung

on You – a bespoke boutique run by Michael and Jane Rainey in Cale Street, off the King's Road – which the Stones frequented. The boutique's exclusive and expensive speciality was crushed velvet jackets with a striped lining and a hidden 'dope' pocket. Jay suggested that Julie make something more interesting, a silk jacket perhaps, so we commissioned her for this altogether more ambitious project. The finished article boasted puff-sleeves and beautifully coloured eyes on either side of the breast, each containing two pupils. It was like a living person, a sensational work of art. So, naturally, we took it to Jimi, who squeezed his skinny frame into it and was delighted. He paid £60 and I understand that it sold some years back to the Hard Rock Cafe, for $12,000.

With Jimi Hendrix, fitting jacket at Saville Theatre London.

Julie made two other similar jackets – one for Mick depicting Judge Block, who presided over the famous trial of him and Keith, and the other for John Lennon – and someone told me they thought them the best pieces of psychedelic clothing from the Sixties. Many years later, Mick's daughter Lizzie sauntered into his chateau in the Loire wearing his painted jacket; having appropriated it, she was now returning it. And not long after that, when the show 'Exhibitionism' was organized in Chelsea, they wanted to include the jacket in the costume display but nobody could find it; it had disappeared again.

DIARY

A balmy night walk out with the dogs. The moon is beautifully bright, clouds passing over, then full beam. In fact, it's brighter than when I came out around 7.30am, when the fields were still dark and Venus was shining in the southern sky. How well you can pick everything out in the soft silvery light of the night, too – subtle and sensuous – yet all are in bed and know little of such delights. Hunting is never so good when the moon is full, however; better a darker evening.

Tonight I cooked up the woodcock I had found on the track above Wells. It seems there had been a shoot there, as I saw a tractor and people on top of the hill but never heard a shot. Yet the tiny and colourful bird was warm when I picked him up, with hardly a mark on him. I stewed him alongside some pheasant I had, so ate leek and potato soup and game stew before an apple crumble after. Delicious.

CHELSEA ANTIQUE MARKET

One source of inspiration for our fledgling business was the Chelsea Antique Market on the King's Road, where Ulla Larson worked on the first floor. Ulla was a wonderful character with great style and eclectic origins in Sweden, Hungary and Germany. She

had been in Berlin during the Fifties and had great stories from that time. Her look and the clothes she sold there were a wonderful concoction of old silk dresses, waistcoats and cast-offs from the Thirties that you might find in a jumble sale in a draughty church hall in Guildford for ten pence. An Australian called Verne owned the place and he allowed me to buy some old silk waistcoats – they must have been well over 150 years old – at knockdown prices. I still have a couple. Anita Pallenberg and Keith were regular visitors, in fact half their wardrobe came from Ulla; so was Jane Rainey, who remains a great friend. With her dark hair, Celtic looks and infectious laugh, she had fantastic fashion sense and could carry off the style like no other. She was among the first to take Mary Quant dresses to the USA, and wore them at receptions her father, Lord Harlech, held in Washington as the British ambassador there in the fashionable days of JFK and Jackie.

Jane's great friend (Sir) Mark Palmer started a model agency called English Boy, which was the first of its kind to feature long-haired, disdainful debs' delights in all the latest garments. Mark had been a page boy at the Queen's 1953 coronation as his mother was a lady-in-waiting; it must have meant a lot of standing around. Mark asked if I wanted to join the agency but I said no, thinking modelling was too cissy. Had I agreed, I would have met my wife-to-be Kari-Ann Moller, who was a great friend of his and had joined English Boy when it began to take on females. But then, I dare say, she would have been far out of my reach.

One pub still in the King's Road is the Chelsea Potter, where Brian Jones would hang out with photographer Michael Cooper, who had his studio right around the corner. This was a tiny space but somehow it all worked – and it was there that he shot the cover of *Sgt. Pepper* and numerous other sessions (including *Their Satanic Majesties Request*, the Stones' own 'ver-

sion' for the psychedelic era). The Beatles montage and homage to their heroes was largely down to art dealer Robert Fraser. Paul McCartney was toying with the idea of Amsterdam hippies Simon and Marijke designing the album sleeve, but Robert was adamant that Peter Blake was the right choice – and so it proved to be. The fact that Robert failed to negotiate a decent deal for Peter, who even had to seek permission to reprint his own work in a book, is easy to condemn in hindsight. But at least he *did* the deal, and it has brought many people to see what else Peter has created over the years.

The Baghdad House was a favourite dive on the Fulham Road, serving all things Arabic; all falafels and couscous, quite exotic then, which you ate reclining on large embroidered cushions, probably bought from Thea Porter's shop in Soho and wonderfully comfortable. You might linger there with copious amounts of mint tea and rinse your hands with rose water. The place was something of a black hole where people disappeared and failed to emerge for hours, falling asleep in the basement after a meal and a few joints, nobody thinking to wake them up. In the corner there was a regular oud player, who gently plucked the strings of the Turkish lute. Abbas ran the place while Valerie waited on tables, very slowly. Unlike many regular restaurants, they had no aversion to long-haired men and women in long frocks.

At the time, people also used to drop Mandrax, a hypnotic tranquillizer then prescribed as a sleeping pill, and just a half would relax you enough – although I disliked them. You could easily spot people on 'Mandies', as they might suddenly tumble down a staircase then pick themselves up at the bottom, amazingly with no harm done. Franco, a handsome long-haired Venetian lad, once ordered dinner at the Speakeasy in Margaret Street, and when it came, he just passed out, plonking his head in his food.

The 'Speak', as it was known, was an easy place to get into, as musicians were generally welcome there. I have no idea why. The place was full of roadies, too, and girls waiting to be picked up. There was live music, and I saw Hendrix and Pink Floyd play there, as well as Bob Marley and the Wailers on their first British tour in 1973, after they made *Catch a Fire*. I went with Keith and Anita, who were great fans, and it's funny to think that there was so much debate about whether Marley was really reggae or not! Keith Moon was also a regular at the Speak, as were Lemmy, the Small Faces and Rod Stewart. Even though the food was terrible and the drinks expensive, it was the industry watering hole of choice.

Another dive I occasionally visited was the Split Coconut in Earl's Court. This was open later than the Speak, until around 5am, and you might bump into David Bowie, who lived around the corner. It was basically a late-night café with booths where people smoked joints without any hassle, much as they subsequently did in Amsterdam. A friend of mine, Jon Newey, told me that when he went for the first time and pulled out his papers and weed to roll a spliff, he was confronted by the Jamaican owner who told him: 'If ya want ta smoke, ya gotta buy it off me!' Which he was only too happy to do. Presumably the police had been bought off in that neck of the woods.

CHAPTER 8

'SCUSE ME, WHILE I KISS THE BLONDE

Jay and I made a memorable journey to Sweden in 1967 when Jimi Hendrix was touring there. The idea was to cover our expenses by buying Swedish army coats and bringing them back to sell during the cold winter. We drove my Mini onto the ferry to Gothenburg and took a little hash with us, but as we approached the customs post I panicked and swallowed the lump I'd stashed in my mouth. So the drive to Stockholm was interesting, with the road like a rollercoaster of black velvet in the quiet, dark night and me feeling very queasy. At least they still drove on the left then.

Jimi's band were both surprised and pleased to see us. We saw them perform three times in one day, some kind of a record in itself. The first gig was held at a fairground in the afternoon, playing in front of the big dipper. Next was an evening club date, then on to a late-night joint where Jimi played again until around 4am – drums and bass as well, I think, and the line of blondes outside his dressing room was impressive, too. He may have had a short life but it was certainly a full one.

It's funny to think that some 40 years later, I was a guest in Wrocław, Poland, for the 'Thanks Jimi' festival. A Guinness World Record is attempted there every year for the most people in one place playing 'Hey Joe' live on guitars. (Jimi didn't write that song, it's attributed to Billy Roberts, but it sounds like he actually lifted the tune from another artist named Niela Miller.) I played a tune of mine, 'On the Road', to the large crowd, solo, and then a version of Jimi's 'Little Wing' with the house band. I thought to myself that I was probably the only person there who ever actually saw Jimi play; then I remembered that Eric Burdon was appearing too, and he was a good mate of Jimi's,

particularly as The Animals' bass player Chas Chandler produced the early records. During Eric's number I toured the crowd with my camera and took hundreds of shots of all the guitar players, who posed for me laughing and having fun. It was all quick-fire shots and I used them years later pasted in the booklet of a record.

'EVERYBODY'S MAKING LOVE, OR ELSE EXPECTING RAIN' – R. Zimmerman

My life in London was becoming increasingly irrelevant. What exactly was I going to do with myself? It would be the classic case of the super-successful elder brother and the younger dissolute one if I wasn't careful. Youth may have its excuses but after the flush leaves the cheeks, people are less likely to indulge you or give you their time. I came to meet some influential figures, which was great, but after the initial introductions you are on your own. There were many peripheral dudes on in the scene then, often with money, who liked to hang around bands and be associated with the glamorous lifestyle. Some were upper-class dilettantes who took up photography to meet pretty girls, some drove fast cars and dished out drugs, becoming the victims of their own excess. I didn't want to go down that road.

John Lennon usually had a quick comment for any situation, and might make a joke at your expense, and the Liverpool humour is very sarcastic. The Beatles referred to my brother as 'your kid' – as in 'How's your kid, then?' – which took a little getting used to. I spent one late night in John's company in a Chelsea pad, along with John Dunbar, Marianne Faithfull's husband, who ran the Indica Gallery. Lennon was intrigued with Dylan's 'Ballad of a Thin Man', and the eerie and rather long tune was spun many times on the record player till we were sick of it.

Paul McCartney would refer to Mick as 'the prince of pop', and the relationship between the two bands was one of both rivalry and friendship. Paul lived not too far from my brother, in a large detached house in St John's Wood, a smart area of north London. One day, I knocked on his door and was asked in and shown round. He had an artist-in-residence there, colouring in the wallpaper in swirling patterns. (Paul was also a buddy of Klaus Voormann who had drawn the *Revolver* cover and, being close to art dealer Robert Fraser, began a good art collection, which he presumably still has.) Paul asked if I wanted some food, so we sat in his dining room while his elderly housekeeper lady served us two veg, meat and gravy on nicely warmed plates. It was rather like a superior school dinner – and before Linda came along with the veggies.

Ringo Starr was the down-to-earth one. Mick once took me to a Christmas party in Ringo's large house in Stanmore, some miles out of town, and he was a good host, though there wasn't much entertainment. Eric Clapton wanted to jam, so he asked if there was a guitar around that he could play. Ringo pointed to an old Spanish acoustic languishing in the corner, which wasn't quite what Eric had in mind. That was the first time I met Ringo's wife Maureen, who later became a friend when she was with the Hard Rock Cafe's founder, Isaac Tigrett.

One band that regularly visited Harley House was the Small Faces, always chirpy and ready for action. I went to the Stax Show at the Hammersmith Odeon with Steve Marriott, Ronnie Lane and Ian 'Mac' McLagan, where some fans asked us for our autographs. I told them I wasn't in the band. (At the time, I was sometimes embarrassingly mistaken for Peter Noone, who fronted Herman and the Hermits and was a huge star.) The girls didn't buy it and one replied smartly, 'C'mon, we know you're one of the Small Faces!'

The Stax Show was the best I have ever seen, period. The curtains drew back to reveal Booker T. and the M.G.'s – Donald 'Duck' Dunn and Steve Cropper, with Al Jackson on the drums – laying down 'Green Onions', the soul anthem of a generation. After one more warm-up tune, the all-star cast was then introduced: first the pretender to the throne, Arthur Conley with 'Sweet Soul Music', aided by the Bar-Kays' horn section; then Eddie Floyd with 'Knock on Wood'; the Wicked Pickett with 'In the Midnight Hour'; and Sam & Dave with 'Hold On, I'm Comin''. Next came Rufus and Carla Thomas and the headliner, the fantastic Otis Redding, with 'Mr Pitiful' and all those wonderful songs he sang before his untimely death in that plane crash.

The Small Faces were also close friends with Pat 'P.P.' Arnold. Previously one of Ike Turner's Ikettes, she had jumped ship from the iron grip of Ike, who ran his troupe like Diaghilev did the Ballets Russes. I had seen them when they toured theatres and cinemas across the UK with their soul revue: the pounding rhythm section, Ike's spiky guitar, the kicking horns, the shimmering Ikettes with their sparkly dresses and straight brown wigs – and of course the star of the show, Tina herself. Although she was having a torrid time with Ike – which we didn't know – it was a hot show that I had witnessed close-up from the wings, and I preferred their act then to all the later power ballads that brought Tina so much success. Pat Arnold saw there was a chance for her to grab something for herself and, with the support of Andrew Oldham and Mick, she disappeared into hiding at the tour's end. Despite Ike's efforts to locate her, he had to leave Britain without her – a blow to his show, as Pat was the Ikettes' main singer, the other two being there mostly for decoration.

Pat rented a small mews flat north of Marble Arch, and one evening I went over to visit, armed with a Billy Preston LP that

I particularly liked. She was knocked out by it, and after a little dancing around, we fell into her bed. She sure knew a lot more than I did about the joys of lovemaking. We did enjoy each other's company but I think I was embarrassed to be seen out with her because of the comments of other musicians, which were probably meant in fun, but I didn't have the confidence to deal with it. She even asked me to come with her on holiday to Spain, but as I had little money and wouldn't think of her paying, I didn't go. In fact she was only a year or so older than me, but she already had two children back home and had done a whole lot more living than me.

I didn't meet Tina Turner until many years later at a garden party. She was sitting demurely in the garden and I didn't want to go over and bother her. Then one of her minders approached and said, 'Tina would like to meet you', which is the right way to do it I guess – like meeting the Queen!

I was at the Hampstead Theatre Club for seven months or so, and during that time Chrissie Shrimpton had packed her bags and I too had departed Harley House staying with my girlfriend Julien, who was well educated and exotic, as her father came from Ceylon. She had a regular day job on the *Daily Express* and was so very kind to me, introducing me to a lot of people and taking me out to dinners. I still popped round to Harley House when Marianne Faithfull became la belle dame and held court, in a more bohemian and literary style. She was better read than I was in the likes of Shelley, Byron and Keats. She could quote Wilde's 'Ballad of Reading Gaol' by heart, and would leaf through books on Botticelli and Beardsley.

Marianne also enjoyed the company of more folky types – especially The Incredible String Band (ISB), who were hugely popular at the time. Her favourite tune of theirs was 'Painting Box', which

she later recorded. I was already an ISB fan and had been to many of their gigs. They caught the spirit of the times with their quirky songs, often in a modal form, using strange instruments; and they explored other cultures and styles while somehow always remaining Scottish.

One evening when Mick was away, Marianne needed an escort for dinner with the poets W.H. Auden and Stephen Spender. It was arranged by the Labour MP Tom Driberg, in a private upstairs room at the aptly named Gay Hussar in Soho. I had studied Auden at school, so to be sitting opposite him was quite unnerving. His face was long and angular, furrowed with deep lines, but he was very entertaining. Later, I became friends with Spender and his daughter Lizzie. I had the naïve audacity to write a poem about the occasion and sent it to her, and she in turn forwarded it to the great man. God knows what he made of it, but I suppose poets must encourage young men to write verse, bad or worse.

Another visitor to Harley House was the film producer Donald Cammell, who was in the process of working through the script for what would become *Performance*. The fast-talking British film industry 'consultant' David Litvinoff would often join him, too, and they would rap through dialogue for the film's gangster scenes, as Litvinoff was from the East End and had associations with the unscrupulous Kray twins. Litvinoff was very Jewish, very funny, gay and a massive Bob Dylan fan. We got on pretty well, though he did take a swing at me one time.

DIARY

Dark, wet and windy. I do feel more centred, and no doubt taking two of Kari's yoga classes this week has helped. Can finally look forward to the Glastonbury Assembly Rooms do next month to play at the 70th birthday party of John Michell [the late seer, numerologist, phenome-

nologist and philosopher]. I spoke with Jerry Hall last night and was a little embarrassed to hear that she is contributing £600 to the events costs. Bless her. I had booked Ben Waters, as the date was the Sunday. But now it's been moved to Saturday he can't do it, so I've been searching around, wondering what to do. The penny finally dropped yesterday when I called up Charlie Hart who first declared he couldn't make it but has now offered to play bass. So, should have Robin on the fiddle, Les on the drums and Dez from down here on guitar. Relief all round.

Spoke to Steve Winwood, but he can't come, as he's due in New York for the opening of a Scorsese movie about the blues. With Eric et al. going, I've done with the celeb invitations.

ALAN KLEIN, MAN ON A MISSION

The Beatles also stopped over at Harley House, and I remember when John, George and Paul arrived to meet with Mick in 1967, after the sudden death of Brian Epstein. The Beatles were naturally quite shaken up and needed a manager, and were consulting my brother about Alan Klein, who had been looking after the Stones for a couple of years. 'Who have you got working for you now, then?' Mick asked. In his laconic way, John drawled 'Not sure,' and, turning to George, asked, 'Is Deirdre still there?' There were a couple of secretaries running The Beatles' empire!

At the time, I think Mick was reserved about recommending Klein to them because it was relatively early days. Later, he told me that John had called him again to talk about Klein: Mick immediately asked, 'Did you sign?' 'Yes,' John replied. 'Well that's it, then.' Further down the line, the Stones would come to sue Klein. It would prove to be a pretty bad move for The Beatles, too.

Often in a big successful company or business, which is what the Stones became, the extended family becomes involved. This has its advantages and drawbacks, as I was to discover.

I met Klein and his nephew Ronnie Schneider at Olympic Studios; he quickly sized me up, asked what I did and, since I didn't have a job, found me one. That was his style: put you on the payroll and there would be plenty to do. As a family member, you could be trusted, and probably paid less than outsiders, at that.

There was some interest in acquiring a recording studio, as the band were spending a fortune at Olympic, so I was to connect with commercial property agents to look at suitable buildings and report back. It was quite fun roaming around dilapidated cinemas and boarded music halls ripe for development, reporting back to Ronnie, who I liked. (He later went on to manage US tours on behalf of Klein, overseeing the box office receipts and starting the 'there are no comp tickets' trend!) My job lasted only a few weeks before petering out. The band had lost interest in a studio after all, and my £40 a payroll dough bit the dust. The Stones never completed this project in the end.

One of Klein's business methods was to invite the interested party to meet him in his central London hotel suite, to arrange agreements or contracts. In the next room, a secretary would be listening in to the terms and typing them up. She then brought in a contract for both to sign, job done. The art dealer Robert Fraser described Klein as shooting multiple bullets at a wall, knowing a few of them would hit home.

Robert ran an art gallery in Duke Street, Mayfair, and operated in a high-octane world. Through his exhibitions I came to meet Peter Blake, Jann Haworth, Richard Hamilton, Jim Dine, Andy Warhol and Roy Lichtenstein; later, Keith Haring and Brian Clarke. Robert was a trailblazer for works that few thought serious at the time, let alone worth the money they sold for then. He was hugely influential on the scene in general and on me

personally, as he was always filling in gaps in my education – of which there were many – and freely sharing his extensive knowledge. He was great friends with Keith, Mick and Marianne (and his fellow Old Etonian Christopher Gibbs, he of interior decoration fame), and brought me into his circle – though many a time I had little idea what was going on, particularly if it concerned drugs, as I was still quite innocent. Robert loved to eat out at Chez Victor, an old-fashioned French place in Soho, and later, after he followed me to India, we often went to Indian restaurants together.

I did incur his wrath one time, though. The artist Colin Self once showed up at his flat at 23 Mount Street, where I was staying, and asked for the drawings that he had left there. I let him in and he duly collected them. But when Robert returned he was mad with me, because he was contesting the drawings' ownership with Colin. Artists were always complaining of the high fees Robert charged for representation and sales, but really, nobody did it better at the time.

I AM THE WALRUS

Harley House had its own small private drive and Mick had a couple of cars parked there, though thankfully he was never a car maniac. Keith had a nice blue Bentley and Mick a white Bentley Continental, which he described as being for 'coked up duchesses', plus an Aston Martin DB4, which was a heavy vehicle, as driven by James Bond. The most useful car, though, was a 'Radford' Mini Cooper, a plush conversion with an eight-track tape machine and record player – so, good sounds!

One night, I was at Harley House on my own and had an acid trip on me that I intended to drop before joining friends in South Kensington. Taking the trip, I climbed into the Mini, figuring

I had time to reach my destination before the effects came on strong. As I motored gently down spacious Park Lane, I relaxed and switched on the record player, which held a few vinyl 45s, and on came the opening bars of 'I Am the Walrus', a strange tune whenever you might listen, but now it exploded my consciousness. I believed I was a blood corpuscle pushing along an artery, moving a little jerkily but with a singular purpose and in no danger of crashing into the other corpuscles around, which was just as well. Reaching Hyde Park Corner, which sensibly had no traffic lights then, the cars all floated around as if by magic and I headed out west. Unfortunately, I couldn't find my address and only became orientated when, with some relief, I recognized a cigarette machine on the corner of the street.

HAPPENING TIMES

I was renting a room in South Kensington but really I was just treading water. There were a lot of new and exciting events happening, as it was the beginning of the counterculture revolution. The 14 Hour Technicolor Dream at Alexandra Palace (Ally Pally) was one of London's first 'happenings' – like glorified village fetes for 'heads', with amusements, music, light shows, dance and poetry and a long list of acts to raise money for the *International Times* after they were raided by the police. (The Establishment and the police were desperately trying to close down what they considered to be 'subversive movements'.)

A helter-skelter stood in the middle of Ally Pally and we would climb to the top, roll a joint and float down on mats to crash in a heap with each other (John Lennon was there, and I wonder if that's where he got the 'Helter Skelter' song from). Pink Floyd headlined the event, though I must have missed their 5am appearance. The usual suspects were all present: Arthur Brown, Graham

Bond, Ginger Johnson and his drummers, The Soft Machine, The Pretty Things and The Move; poets such as Barry Fantoni and Michael Horovitz; the Exploding Galaxy dance collective and my Cambridge friends from 117.

Brian Jones liked to check out the action and, while I was taking the air on the steps outside, he arrived in his Roller with fellow traveller 'Stash', Stanislas Klossowski de Rola, who was always on the fringes of the action around the Stones. As a 'prince', Stash dressed suitably flamboyantly and wore a lot of jewellery; tall with long dark hair, he certainly lived up to the reputation of having the famous artist Balthus as his father. They were sporting the style of the time: crushed velvet, flared trousers and floppy Biba hats with feathers stuck in the band.

With Brian, I wandered around the event for some time, saying hello to everyone. The scene was quite egalitarian; there were no roped-off areas for celebrities in those days. In the early morning we emerged dazed from the huge building to sprawl on the park's green banks, where the party carried on.

The Roundhouse in Camden, previously a railway engine house, had recently re-opened as a venue. Then little more than a vast open space and usually freezing cold, it had an almost cathedral-like atmosphere and somehow belonged immediately to the hippie fraternity. Although it hosted many bands, we primarily went to hang out and have fun, whatever the act. I went there on one of my very first acid trips and, my head in a daze, found it pretty confusing. Luckily, I ran into the lanky American psychedelic guru Steve Abrams, a long-time advocate for legalizing pot. Steve immediately realized my situation and, ushering me outside, hailed a cab and took me back to his mews house to act as my guide and mentor. He knew just what to do, from the gentle music on the hi-fi to laying out books of

illustrations, and also gave me practical assurances to make me feel safe.

Steve showed me that it was only my mind's perception guiding me through the trip: it was the way I was viewing the world and I could change that. Acid is simply giving you a mirror on your own hang-ups and fears (barring the Alfred E. Neuman 'What, me worry?' types). Back then, many people 'experimented' with drugs – that's to say, they were interested in the effects on their psyche – but it didn't mean you had to continue using them until you became damaged or hooked. That's the danger, but it's no different with tobacco or alcohol, two drugs that many hippies looked down upon and for good reason.

ARTISTIC LICENCE

One excellent hangout was the Arts Lab in Drury Lane, where you could eat in Sue Miles' restaurant, watch a play, then crash on the mattresses downstairs, where they showed all-night movies; people went to sleep or made love there – and it was considered normal. The place was the baby of Jim Haynes, an amazing American who had lived in Edinburgh as a student, later running the Traverse Theatre there and kick-starting the Fringe Festival along with fellow American Jack Henry Moore. Jack ran a prototype video project at the Arts Lab and the place influenced many people, such as Michael Kustow, who went on to run the Institute of Contemporary Arts (ICA) in Pall Mall, where I later performed in my first play.

Although short-lived, the Arts Lab was a pivotal centre for creative people whatever their medium, and gave openings to David Bowie and the actor Steven Berkoff, among others. John 'Hoppy' Hopkins was a leading light there, a small but dynamic man who was so instrumental in the scene, and his girlfriend was

Suzy Creamcheese. At the Lab, they would screen underground French movies or D.A. Pennebaker's *Don't Look Back*. Then a gang of us would have a bowl of delicious porridge with cream and walnuts at around 5am before emerging bleary-eyed and legless in the bustling Covent Garden fruit and vegetable market, where the porters, trundling their noisy and heavy iron trolleys across the uneven cobbles, would shout rude remarks about the length of our hair or lust after our skimpily dressed female friends. There was also a greasy spoon café open, and you might risk that if you needed a pick-me-up.

The *International Times*, co-founded by Hoppy and Barry Miles, became the house organ of the London counterculture and was always a fount of information, opinions and discussion. John Lennon made contributions to the paper, as he was a friend of John Dunbar – it was in Dunbar's bookshop basement that the *International Times* started, and through him that John met Yoko – and Paul McCartney helped out, too.

Hoppy and Joe Boyd also co-founded the UFO club on Tottenham Court Road, in December 1966. You descended the stairs into an underworld of altered consciousness, practically the birth of London's psychedelic movement. I once took my brother there to see Pink Floyd but it was a bit too far-out for him, I think. We all loved the Floyd's founder, Syd Barrett, who for a time was lodged in a flat in nearby Earlham Street, in the heart of the West End, above Cambridge Circus, surrounded by theatres. One day, Ricky Hopper and I went there to see Syd and Pip Carter, who was a roadie for the band, but we didn't bump into Kari-Ann, also a sometimes visitor of Syd's. I wrote a short piece for the music paper *Disc*, predicting that the Floyd 'could develop in a big way', adding that 'their first single "Arnold Layne" is starting in the right direction.' I also mentioned their lightshow and equipment,

important factors in their success, as later was the input of Storm Thorgerson from Cambridge, who did the graphics and record covers with Aubrey 'Po' Powell.

At the UFO club, Mark Boyle ran the unique light show with Peter Wynne-Willson, dropping onto glass projector slides drawing ink that expanded and bubbled under the heat of the lamp, thus creating random effects. The operator fed the colours in with a syringe, getting covered in the stuff in the process as it was all done in the dark, and sometimes the entire operation caught fire. Another innovation was to project strobe lights, operated manually, and all the exploding colours on the screens behind the stage certainly elevated the performance; indeed, the musicians just cast shadows on the backdrop. Mark also did lights for The Soft Machine, assisted by Joan Hills.

I loved Arthur Brown; he employed special effects and is justifiably famous for his hit single 'Fire', from which he received little income. It was and remains the highlight of his act – the flaming headpiece and demonic dancing backed by the cathedral of sound coming from Vincent Crane's Hammond organ. The Hammond was a feature of many bands – Graham Bond's and Brian Augur's, to name two – but these were heavy items to lug around and almost impossible to manoeuvre down the steps of a dark basement. Those in the know, and with enough readies, invested in a 'split' instrument, converted by specialist Bill Dunn, who chopped the thing into two sections to make life easier for the roadies.

The Soft Machine – Kevin Ayers, Robert Wyatt, Mike Ratledge and Daevid Allen – were just as popular as the Floyd, and played some wonderful music. They always had great guitarists: Andy Summers at one point and latterly John Etheridge. Tomorrow, with Steve Howe on guitar, were always

playing round town as well and were very popular; they had a hit with 'My White Bicycle' and a single called 'Revolution' a year before The Beatles' song of the same name.

The UFO club was forced to shut after Hoppy was busted for cannabis possession and sentenced to nine months in prison – a draconian sentence – and in its place came Middle Earth in Covent Garden, with Jeff Dexter acting as MC and spinning great records. Many bands played there, including the madcap Bonzo Dogs, The Pretty Things, Roy Harper and Captain Beefheart from the USA. The Byrds with Gram Parsons famously appeared there in 1968 and my brother went, but I missed that one. The police twice raided the place, on one occasion dismantling and taking away a device called 'the trip machine'.

'IT'S A REAL HOLOGRAM…WELL, ALMOST A REAL HOLOGRAM' – F. Zappa

One memorable night, I went to the Royal Albert Hall with Suzy Creamcheese to see Frank Zappa and the Mothers of Invention, a favourite band then as now. The place was packed, as you would expect. The defining moment was when jazz keyboard player Don Preston climbed the steps to the venue's renowned organ, found the light switch and blasted out the chords to 'Louie Louie', which brought the house down.

I had previously seen the Beat Poets. Allen Ginsberg at the same venue read from 'Howl', which was amazing, and I have followed his poems and notebooks ever since. I had no idea that you could just stand up and read in that intense, slightly manic way and entertain so many people; it was definitely different from the poetry we had been studying at school, such as the rather considered verses of Thomas Hardy and John Masefield. The last time I saw Ginsberg was in 1995, and I chatted to him backstage but by

then he wasn't too well. As if by magic, once in front of his audience, he came alive, an inspiration to another generation, freely answering their questions. 'Be a good secretary to your own consciousness' was one good piece of advice.

The Establishment's vendetta against the counterculture culminated when, in league with the *News of the World*, the police descended on Redlands, Keith's house in Sussex, to arrest Mick, Christopher Gibbs, Marianne, Keith and Robert Fraser in February 1967. Much has been written about this episode, but it illustrates the lengths that the authorities were prepared to go to in order to curb the influence of the younger generation. Never had the old order been challenged in this way before. That the police should dedicate their resources to breaking into private property to investigate personal affairs is overstretching the powers of the state. It must have affected my parents even more than it did me, for they were completely outside of the scene.

This pursuit of the Stones became a witch-hunt and Robert Fraser was the worst casualty, being sent down to Wormwood Scrubs for six months. A Stones single was cut in the aftermath of the arrests, mockingly entitled 'We Love You', and, as Mick and Keith were detained at the time, I remember being at Olympic Studios when Paul McCartney sang all the backing harmonies on it. He was amazing at double-tracking his voice, and the sound coming from the massive speakers was like a mix of the two bands, united against the oppression to which they were being subjected.

The authorities hadn't reckoned on public opinion, however, and there was much protest over the arrests. When Brian Jones was later busted for cannabis, I went to Fleet Street along with many others, including Jeff Dexter and Caroline Coon from Release, to demonstrate outside the *News of the World* offices. Release was an office set up to counter the regular arrest and harassment of any-

one with a joint on them by the police who wasted countless hours on this rather than chasing down criminals. A great debate began about cannabis and – can you believe it? – they are still having it in the UK to this day.

DIARY

Spent yesterday clearing up the junk in the barn. Lots of donkey work needed if we are to rent this place out for weekends to make money. Don't know what the prospects are for me making any through writing. Sent a story about birthdays off to the Kentish Times, *but Melody there informs me that there is no budget for a regular contribution. Have heard nothing from* The Telegraph, *not even that they got the last thing I wrote on airports, and heard nothing from Ted at the* Mail on Sunday. *I wrote about my son Robert and the attacks he had when it came to the pressure of the A-Level exams. Maybe it's best left as it is.*

I had a call from Pete Townshend's PA yesterday and she thanked me from Pete for the message of support I left on his machine after he was accused of looking at child porn. He was surfing the net and checking out how easy it all was, so I chose to believe his story. She said I was one of the few people to ring.. I don't know the ins and outs of the case but I do know Pete and take his side.

There are so few gigs coming in, the rental is imperative. I shall need about six grand more to finish the annexe so as to make it comfortable there. The costs for the running of this place are mounting so cannot see another way through. Of course, I could write my book.

THE LIFE OF BRIAN

As a founder member of the Stones, Brian had been the one on the phone looking for the bookings – and having done that myself, I can tell you it's not easy. He was also key in choosing the setlist. Very early on, an advert in *Melody Maker* announced the

band as 'Mick Jagger and The Rolling Stones', probably at Andrew Oldham's suggestion, so Brian protested. The next week, the ad said 'Mick Jagger, Brian Jones and The Rolling Stones', which was really silly, so they went back to the name that has served them so well since 1962.

Not long ago, I discovered an old acetate (a studio demo) with the Stones being very silly and playing kazoos over standard numbers like 'Old Folks at Home' ('way down on the Suwanee River'), and in the middle of this farce Brian is trying to impose some order. 'How does "Worried Life Blues" go, Stu?' he asks at one point, Ian Stewart being the most experienced in the blues department. There was a tradition of blues-jazz numbers being handed down and the Stones lapped it up from Stu like hungry cats.

Brian was the first musician I had heard play slide guitar and I thought, 'What's that? It sounds amazing!' He owned a green f-hole Gretsch that he tuned open – some think green is an unlucky colour for a guitar – and he would sway his head to and fro, making his long blond hair move from side to side as his left hand travelled up and down the neck. The first time a slide was used on a British record was in Brian's distinctive contribution to 'I Wanna Be Your Man', a not-too-memorable Beatles tune covered by the Stones. But it did the trick, largely down to the gritty sound swamping the entire track.

Sometimes, Brian would switch to harmonica and he could blow it pretty well – which was useful if Mick was singing, as blues bands traditionally have a dedicated harp player. In fact, he could turn his hand to many instruments, including the sitar, and that likely gave him problems in the end, as he didn't improve his guitar skills enough to keep up with Keith, who was totally dedicated to that one task. One of Brian's toys was a Mellotron, a pre-synthesizer and a very expensive plaything for the dilettante.

This monster of a thing contained banks of pre-recorded tapes, which slotted into position when you pressed the keys, the drawback being a delay in the 'tracking' (which was fine in a slow tune like 'Strawberry Fields Forever'). Mick had one in his Harley House flat and guests would mess around on it when sufficiently stoned.

While Brian was in the forefront of arranging and running the band, he fell behind when it came to writing the tunes, particularly as he lacked a collaborator. A similar situation happened with The Beatles: John and Paul took all the writing credits and George had to fight his corner on his own. Brian was quite shy off stage. People comment on his unpleasantness, but to me he was nothing but polite and generous. Still, he did like to get stoned, very stoned, which led to him becoming detached from the others. Once, in 1967, I was at Olympic Studios when the band were working and Brian dropped in before travelling out to the Monterey Festival in California. He just wanted to 'be there', I guess, but it felt like he was basically checking out from the Stones.

The only record Brian released outside of the band was *Brian Jones Presents the Pipes of Pan at Joujouka*, a somewhat obscure album made in the Atlas Mountains in Morocco and subsequently released through the Stones' own label. I lost touch with him after he left his flat in Courtfield Gardens and moved to the country. He bought a house in Sussex, the former home of A.A. Milne, the children's author who created Pooh Bear. There's a lot of debate as to what happened there in 1969, but for sure Brian had become entangled with many low-life characters who were sucking him dry, and he ended up paying with his life. This was way before people understood or had proper procedures to deal with drug dependency.

Anita Pallenberg, who went out with Brian before she became Keith's partner, told me that he was the most open-minded member of the band and could talk to her in German. She also loved his musical ability, which she thought has been overlooked. Anita lined up Brian to make the soundtrack to the film *A Degree of Murder*, by the then-little-known German director Volker Schlöndorff, the tale of a girl (Anita) who kills her abusive boyfriend with his own gun. Brian enlisted help from Jimmy Page and the pianist Nicky Hopkins, among others, recording at Olympic. Anita particularly liked one outstanding piece on which Brian played cello.

The last time I saw John Lennon was at a farewell party that Mick threw before the Stones left for France in 1971 after the tax fiasco. (Hit by the cost of suing Allen Klein, and owing 90-odd per cent of their year's earnings to the taxman, they had no choice.) It was held in a rather straight venue by the Thames in Maidenhead, and John was there, dressed in a white boiler suit with Yoko Ono. At one point, with his typical Scouse humour, John started humming 'Satisfaction' at the table, only changing the lyric to 'I can't get no…sanitation.'

The evening was a little too formal and the management uptight, so in the end Mick vented his anger and deliberately put a chair through a window. Nobody tried to stop him, or said anything: they just looked on. Leaving Britain must have brought up a lot of feelings for him.

THE MYSTERIOUS YEAST

Sat on a table in my brother's apartment was a large 3D map of Asia, called an Aero Map, with the mountains and geographical features pressed out in relief. Marianne liked to dream of faraway places and outline various trips that she and Mick might make,

and she showed me a book called *The Road to Oxiana*, written by Robert Byron and finally published in 1937. The book documents his journey from Venice across Central Asia, where he rode horseback, meeting the nomads and unearthing remains from the days of Gohar Shad, a queen who ruled in a relatively enlightened period. Travel writer Bruce Chatwin described the book as 'a sacred text, beyond criticism'. For me, it was more of a Lawrence of Arabia adventure and provided an opening into the ancient culture of Central Asia.

After the US tours, Mick would return from New York having pillaged the record stores, and he had eclectic tastes – not only blues and soul albums but also world music from across the globe, Balkan ensembles, Turkish orchestras and the sounds of India, from vocal music to folk tunes and classical sitar and sarod. I liked listening to these and caught concerts in London by Ravi Shankar and Vilayat Khan; the music took you out into another space and called you hauntingly from afar. The concert violinist Yehudi Menuhin introduces one of the earliest Shankar LPs and tells us of the tanpura, or 'inevitable drone'. Yes, it was this that had me and my pals hooked, not the Maharishi or another saint, but the chanting musicians who didn't bother to do things like change key – for we had to tune into the 'Om'. But what was the 'Om'? Surely, I had to investigate?

On 25 June 1967, during what was later to be called the 'Summer of Love', The Beatles closed the first-ever worldwide live broadcast TV show with 'All You Need Is Love'. I sat down to watch it on my own (along with 350 million others around the globe) in the South Kensington flat, thinking, 'This must be the peak of the scene, the pinnacle of the flower power era.' It was a crowded studio, the black and white dress of the string and horn players contrasting with the multi-coloured clothes of

The Beatles, all relaxed and perching on stools. On the floor in front of them sat Mick and Marianne, and the camera panned off from the back of the jacket that Jay and I had made for him. The event was a culmination of all that the Sixties stood for, yet I felt a chill isolation myself, detached from the whole spectacle. After the broadcast, I went out in the street to discover that my Mini had been broken into and all the belongings that I had recently moved out of Harley House had been stolen. It was then that I decided to go travelling, and to make it simple by going alone without any encumbrances. I figured I'd seen the best of the swinging Sixties and was glad I stayed around for it, but I was out for some adventures of my own and sought wider horizons than the well-worn streets of London town.

CHAPTER 9

EXIT STAGE RIGHT

Filling a small rucksack, I announced that I was off travelling and to expect a postcard in some months. Mick gave me a $100 bill that I stashed away somewhere safe and in due course lost on the long and dusty road. In hindsight, it's extraordinary how many tens of thousands of Westerners, some still in their teens, were taking off halfway round the world without the back-up on which today's Wi-Fi-enabled gap-year students can rely.

Ye Hippie Trail.

I bought a rail ticket as far as Athens because I had no wish to repeat my hitchhiking trip across Germany. However, my 'ticket' was simply a handwritten piece of paper giving me leave to travel from London's Victoria Station to the Greek capital, a curious document that few could understand. In Germany, a railway official snatched it from me, leaving the remaining part in my

hand. Henceforth, I apologetically presented the two sections to anyone interested.

After many days of dirty travelling, I was happy to be back in the familiar surroundings of Athens. In the Plaka, overshadowed by the Acropolis, I rented a room from a small woman dressed in black called Kyria Anna for a small sum – five shillings (25p) a night – and wandered round the alleyways shielded from the hot sun, meeting locals and foreigners alike. One was an American black guy called Stanley, who was followed by an adoring mongrel dog and we soon became close friends, even with the dog. Stanley was a free spirit who took me under his wing, teaching me some Greek and telling tales of his own trip to India, a while before. We visited Aegina and Hydra, where Joni Mitchell and Leonard Cohen had strummed their bouzoukis in the shimmering light, drinking retsina and avoiding the cruise ships that occasionally called in.

Fellow traveller Stanley and faithful mongrel in Athens.

Trail snaps from left to right: The 404, 'Mighty Quinn' on dodgy Afghan B-road. Turkoman yurts by wide river. Wild man on Bay of Bengal. Durbar Square Kathmandu. Myself with Uzbek cap and robe in stripy green, Tashkurghan, Afghanistan. The chillum maker in Kathmandu. Anthony and I at a deserted Taj Mahal.

There were few other tourists then, especially in the springtime. Stanley told me to relax and enjoy these balmy days, so we took a short island-hopping trip to Amorgos in the Eastern Cyclades, riding there on small fishing boats. 'India will always be there,' he

said knowingly, as we headed up the coast on a small motor boat. Around the headland, however, we met with fierce seas and, as we were sitting in the bow of an open vessel, we were swamped with every successive wave hitting the boat. At the top of every crest, the horizon revealed an endless onslaught of white tops as the propeller turned in the air, before we crashed back down into the watery abyss.

Holding on for dear life, I thought we would likely drown – there were no life jackets – but the Greeks sat stoically in the back, their sun-baked faces staring straight ahead. Finally, we reached a small harbour and jumped thankfully ashore. Within minutes we were sitting in a café overlooking the sea, drinking ouzo and crunching on fried calamari, the waters below all calm as though it had been a dream. The wine-dark seas of the Aegean can turn into such a many-headed monster, you can believe in the tales from *The Odyssey*.

ISTANBUL... CONSTANTINOPLE...

After several weeks, I took a boat from Piraeus to Istanbul – gateway to the East – and sailed through the Dardanelles to the bustling capital of Turkey. This was altogether different from Greece and where you said goodbye to all things European, so I went to the souk and bartered away those clothes I thought I wouldn't need on the trip ahead, trading them for more suitable new items. This lasted a couple of days and there was little hurry to the trading, just plenty of coffee and chat with merchants who lived to meet people and do business as they had done with traders going back to Marco Polo.

The long-haired ones slept in large rooms, sharing their stories and dope. During the day, they hung out in the pudding shops eating sweet rice with cinnamon on top, waiting for funds from

home or arranging travel to India. Istanbul was a shady place, as documented later in Billy Hayes' book *Midnight Express*, and I was careful to steer clear of trouble. After the customary sight-seeing around the Topkapi Palace, the Hagia Sophia and the Blue Mosque, I took a bus out of town heading east. Apart from a mad Turk drawing a knife in a sleepy town – I think he fancied a girl I was travelling with – not a lot happened. She was just a companion but I realized that, while it might be chivalrous to protect a lady, it wasn't a good idea to travel with one.

'BE HAPPY FOR THIS MOMENT. THIS MOMENT IS YOUR LIFE.' – Omar Khayyam

From Tabriz I went to Tehran in a bus full of pilgrims. On the road, we became stuck in a muddy puddle, whereupon a loud wail of prayers was offered up while the wheels spun round, finally catching hold, and we emerged and all gave more thanks to Allah. A crowded and dusty place, Tehran was teeming with the Shah's secret police; there were spies everywhere. I wanted to go to Isfahan with its blue palaces and wished that I had, but instead I found a car ride with a Sikh travelling east. On the way he sang sacred songs and showed me some basic exercises to keep myself awake on the long road; I paid him some petrol money, so it was a fair exchange.

We reached Meshed with its twin-domed mosques of turquoise and gold glittering in the sun and, after stopping in a turquoise-seller's shop, where a basketful of the blue stones cascaded onto the counter, I was drawn to walk towards the domes. As they came fully into view, an imam in flowing robes spotted me, shouted something and, picking up a handy stone, chucked it in my direction. This infidel got the message and beat a retreat, determining to move on as soon as possible, taking the bus further

east along the dusty road to Herat in Afghanistan. The Persians could not believe anyone would willingly travel to that poor country. Some miles from the frontier the tarmac stopped, becoming a rutted track, and we were unceremoniously deposited at a shack that marked the border.

AFGHAN HOUND

After the usual inspections – checking how much film you were carrying, admiring your wrist watch and so on – I boarded a ramshackle but gaily painted Thirties Chevrolet bus and sat next to the driver as requested. He offered me something to chew – I guess it was betel nut – and we were off for what was scheduled as a day's ride, although I was sure the distance didn't merit so much time. After a few miles on the tarmac, the driver swung the wheel left and we began careering over boulders and depressions while the passengers bounced gaily up and down in their seats – all smiles, as they were no doubt used to it.

Soon we approached a *rabat*, or small settlement, surrounded by dun-coloured mud walls and, after the engine was switched off, all that remained was the cackle of the passengers and the bleating of goats. We remained there for some time, loading the bus with an assortment of livestock and passengers before retracing our route. The hens with their minders went onto the roof. There were other detours, but eventually we reached Herat by nightfall.

DIARY

A bright Saturday morning. Last night, cooking at the Aga, for the first time I realized it brings back almost subconscious memories of our mother when we had one; making food is such a crucial part of your upbringing and though I get bored with it, it almost brings her tangibly closer.

I took out some venison from the freezer and set it by to marinate, leaving it on the table in the lean-to. As I went to bed, Orca was sitting in there so I left her, all innocent, and in the morning she had devoured the piece that she had caught.

CENTRAL ASIA

'Our camels sniff the evening and are glad' – James Elroy

Herat was quite filthy but charming. I sat on the verandah of the shack where I was lodging and watched the *tongas*, the one-horse traps that served as taxis, running up and down on their errands. The horses' heads were crowned with red plumes and they trotted past traffic cops on their pedestal, paying no attention to their commands. Men strolled hand in hand and dust blew everywhere (which is one reason they wear turbans piled high on their heads). I visited the tiled minarets that Robert Byron had written of, just outside the town, and where Gohar Shad held court in the 14th century with artists, philosophers, musicians, poets and architects. Indeed, the prototype for the Taj Mahal was built here and for ten years Gohar was the de facto ruler of the Timurid Empire, which extended from the River Tigris to the borders of China. (Unfortunately, she was beheaded in her eighties, which seems a bit unfair.) Bruce Chatwin claimed that hippies had wrecked Herat, but his experience of the place was similar to mine. 'To cross the Afghan frontier, after the lowering fanaticism of Meshed, was like coming up for air,' he wrote, going on to quote Byron: 'Here at last is Asia without an inferiority complex' ('A Lament for Afghanistan').

Personally, I was crippled with the runs, the curse of the Orient. A German 'head' recommended I take some opium for it and handed me a piece, which I swallowed. I lay on my cot for a few days staring at the ceiling, drifting in and out of dreams, until I

fully came to and realized the medicine had worked. The German had disappeared but in the meantime two English public school-boys had pulled into town. I'd met them in Tehran, where they had offered me a lift in their car, driven out from England, a rare thing indeed. They detoured to see the Caspian Sea, so I had told them I'd meet them in Herat, such were the arrangements then.

I showed them the Byron book I'd taken with me and they were suitably intrigued about my quest to reach the River Oxus – or some call it the Gozan, or the Amu – that flows north into the remnants of the Aral Sea. In Afghanistan, it marks the border with Turkmenistan, then under Russian control. Together we planned to take the route north from Herat, instead of the usual trail south via Kandahar and Kabul, but were told that this was forbidden without permission. 'Where can we obtain a permit?' we asked, to which the answer was 'In Kabul' – some 600 miles away.

Notwithstanding, we set out on a bright morning in their Peugeot 404 estate on the road to Mazar-i-Sharif. No proper map was available, unless we returned to Stamford's in London's Long Acre for it, so we had to make do with a very basic item bought in the bazaar, showing only the main towns connected by a spindly outline and with no physical features whatsoever. When we came to a junction, we had little idea which branch to take; it was largely guesswork. There were no signposts, not that we could have read them, and only a few jeeps and trucks on a dirt track that stretched across an arid desert.

Amazing fact: the Mighty Quinn, as we dubbed the 404, was totally reliable, and though we might have been killed at any time, we didn't so much as have a puncture. At night, we slept under the stars after cooking a basic meal, which no matter how disgusting, could be improved by the addition of soy sauce. One evening, I looked up and saw on a hill above a horseman with the usual rifle

slung over his shoulder, complete with a rose sticking out from its barrel. He sat motionless, looking down on us. I turned away for a moment and when I looked back, he had silently disappeared. Luckily for us, he decided to leave the infidels alone.

Driving through a small town one morning, the 404 was surrounded by the usual contingent of urchins running alongside when someone invited us to breakfast. As we had already eaten, we said no thanks, but it became apparent that the governor of the province was asking us 'officially'. Soon we were seated on a dais in the garden of his house, eating white sheep's cheese and drinking hot tea, all set out on a clean tablecloth, much as Robert Byron might have done all those years previously. The governor enquired where we had stayed the night and on discovering we slept out, he warned us against it. 'Is it because there are brigands?', we asked. 'It is not good to stay outside,' he repeated. However, with the foolishness of youth we preferred the cleaner earth to a vermin-infested hut, were such accommodation on offer.

We passed through every village in turn as the road twisted across the barren landscape, and never saw another car, as the area was officially closed to foreigners, even fresh-faced English boys. Outside one small town, a policeman flagged us down. He inspected our passports, commencing at the back and, reaching the upside-down photographs, turned them around and handed them back. Standing in front of the car, he noted down the number plate on the back of a cigarette packet, then climbed into the front seat, indicating for us to drive on. We wondered what trouble we might be in, but in the main street he held up his hand to stop and directed us into a tea shop, where he paid for our refreshments. After the dust of the road, it's wonderful to wash your hands in the tiny sinks and relax, drinking tea. Such kind people!

We reached the ancient ruins of Balkh, the oldest city in the world and once the rival of Babylon. The home of Zoroastrianism and formerly a centre of Buddhism, it is where Alexander killed the king and married his daughter, Roxana of Bactria ('You don't have to put on the red light'). Genghis Khan sacked Balkh twice and now it is a khaki-coloured ruin, such is the progress of man.

THE CHARM OF THE OLD BAZAAR

We stopped in Tashkurghan and visited the famous souk and walked through rows of beautiful garments and hats, all in their own sections and embroidered in tribal fashion as they had been for hundreds of years. The light filtered through the roof's broken slats to the floor below, where the vendors sat cross-legged among their garments, sheepskin caps, camel saddles and curved steel knives: a medieval scene, now alas all swept away with the wars subsequently fought in that country. I bought a green striped Uzbek robe and matching cap, and wore them, too.

Suddenly the spell was broken as we slid onto a black modern road, all designed for speed and comfort. The small villages and towns were bypassed, and soon we found ourselves in Mazar-i-Sharif itself, something of a modern city even then. In one roadhouse we came across a Russian engineer plotting new roads. Like the Romans and later Hitler, the roads were driven through before the subjugation of race and culture could begin – although it was some years before the Russians invaded with their tanks. Now the Chinese are doing the same thing; beware strangers bearing gifts.

Our attempt to reach the Oxus was thwarted by soldiers, who turned us back. Undeterred, we found a side track and finally gazed at the muddy river. Then we turned towards Kunduz, where the Americans were to attack the remnants of the Taliban in 2001.

An earlier traveller had told Byron 'Go to Kunduz and die,' refer-ring to the scorpions and bad conditions. We attempted to view the giant Buddhas of Bamiyan and the lakes of Band-e-Amir in the centre of the country, but a bridge had collapsed in the floods and the water was too deep for us to cross. Had we known the Taliban would blow up the Buddhas, we might have found a way.

The capital Kabul had none of the charm of Herat for me, although I recall walking up to the British Embassy there – built like an English country house – and standing on its green lawn. (Methinks the security has changed a little since then.) In the bazaar I had some pyjamas made for a small sum. The tailor was finishing them off when I arrived for collection and he asked if I wanted a smoke. A small boy was sent off for a piece of hash and, on his speedy return, the tailor removed a piece of charcoal from his iron with small tongs and put the *charas* on it; we sucked up the smoke through a straw. He then replaced the charcoal and continued to iron my pants with a large smile, as we were both rather stoned.

The food was basic, though one amazing treat we had was sheep's milk ice cream. The ice to make it came all the way from the Hindu Kush, mountains and the freezing mixture was crushed in a turning metal container by the vendor. We sat down to eat it and a thousand flies rose from the table. In a minute or so, the delicacy had collapsed in the sun. I met one Baluchistan tribesman with a traditional handlebar moustache, swathed in ammunition belts and carrying a rifle, who realized I was an English *sahib*. If I came to his village alone, he said, I would be killed instantly; but if I came as his guest, then I would be treated like a king. Such are their fierce traditions.

Kabul in the early summer is hot and dry as it stands at some 6000 feet above sea level, a fact you soon realize when you take

the long and winding road down the Khyber Pass into the plains of the Indian subcontinent. Every turn of the road reveals another abandoned fort or station where some poor homesick Tommies or Pashtuns fought a skirmish across the barren landscape. You drop down and down into the unrelenting heat and stench of Peshawar, the ground parched dry awaiting the monsoon.

PAKISTAN

People can go mad in the pre-monsoon period as the barometric pressure rises. We shacked up in a large old bungalow, complete with a hand-pulled *punkah* (a large rattan fan), but unfortunately no *punkah-wallah* to work it. Instead, we dipped ourselves in the roll-top bath and then, covering our bodies with wet towels, lay on the beds underneath the gently rotating electric fan to get some respite from the heat. In the evening, we emerged for a mango lassi – the fruit was in season – and you have never tasted anything so good.

As the British decamped at this time of year to the hill stations, we too retreated to the cooler north and Muree, where the *mem-sahibs* would spend the season in an Eastern version of Tunbridge Wells. We went further north into Pakistani Kashmir and the Khagan area, an alpine region of high valleys and snowy peaks. The Khagan Valley was badly hit by an earthquake in 2013 and it is hard to imagine a place even poorer than it was then. The road gave out and so we parked the 404 and walked on, joining migrating herdsmen moving to their summer pastures and travelling in convoy. At the head of the procession strode the tribal chief with his large billy goat, the horns adorned with silver cones and his neck covered in tassels. The rest of the goats followed, then the sheep, the children and hens, riding on the backs of donkeys. The women bore large iron pans in which they baked their bread when they stopped for the midday meal by the banks of the river. It was a Biblical scene.

We climbed up to a well-known beauty spot, a lake cradled in the hills, but all was not sweetness and light. We ordered tea after which followed an extortionate bill, but when we protested, the bad-tempered retainer pulled out a rifle and threatened to blow our heads off. As there were three of us and one of him, we grappled with him, took away the gun and emptied the shells, before beating a hasty retreat down the mountainside with rocks flying and bullets whizzing over our heads!

We wanted to travel into Indian Kashmir but, in order to do so, we would have to come way down south to the plains, then cross into India, only to drive back north into the mountains according to lines on a map.

Lahore is Pakistan's second city and, with famous gardens and a university, is very cultured and a teeming place. I went to the telephone exchange to make a rare call home and witnessed row upon row of women operators pushing and pulling cords to make and break connections, as you might have seen in movies from way back. It's right on the border with India and the scene of the most horrific carnage, after the British carved out 'Partition' in the most botched manner under Louis Mountbatten in 1947.

We ate at the busiest restaurant I have ever visited. On arrival we were shown to a table as it was being cleared, while underneath it a man was sweeping the floor. We sat down and were handed the menu, ordered pretty much immediately and were served in five minutes. The second we finished, we were handed the bill, and as we put down the money and rose, the table was being cleared, the man was sweeping underneath and more people were waiting to sit down. No labour shortage there!

Along the way, we encountered well-to-do Pakistanis confessing, 'We wish you were still here,' as many of them had done well under the British and disliked Partition and all that it did to the

subcontinent (which had occurred a mere 20 years previously). Right until the last day before Partition in 1947, nobody knew if Lahore would be in India or Pakistan – and whatever the British did there, the worst was their hasty division of the territory, the legacy of which still haunts Kashmir.

INDIAN KASHMIR

A travelling Muslim merchant who we had encountered on the route invited us to stay in his house in Srinagar, the capital of Kashmir, where the winding streets are lined with beautiful old carved wooden houses. Eventually, we found his abode close to the centre of the old town, and he received us warmly and fed and watered us. It was so very kind, something you cannot imagine happening in Britain. In the shadows of the stairwell, you might catch the briefest glimpse of women scurrying to and fro on their daily chores; but they hurried away, drawing veils over their faces. It's a man's world there. We were presented with 'tiffin' boxes for lunch when we went sightseeing to such beauty spots as the Shalimar Gardens – perhaps, along with Venice, the longest-running tourist attraction on the planet. In AD 1610 ce, Emperor Jahangir largely created these Mughal pleasure grounds for his wife – in the Persian style, with shimmering trees reflected in lakes and canals – although there were gardens here some 1500 years earlier.

The three of us rented a traditional houseboat on Lake Dal, and many had names like *Little England* or *Maidenhead*, a relic from the days of the Raj. Ours was no exception, with floral curtains and pictures of Windsor Castle and the Queen hanging on the walls. It was all rather strange. Before Partition, these boats would have been taken by people running the Empire or a tea plantation, travelling on P&O lines to and from the Orient, but now

scruffy hippies had come instead. The Kashmiris couldn't fathom it. Previously the British had maintained a strict demarcation between the natives and themselves, but here was a new breed more like gypsies; not come to impose their own views but more to explore and investigate their world.

Kashmiris were used to tourists and made all the usual souvenirs, cleverly painted papier mâché boxes with cunning secret sliding sections, and women's shawls decorated in swirling Paisley patterns. (Paisley is in fact a town near Glasgow where the fabric was produced, the pattern being of Persian origin.) The hopeful vendors paddled across to the houseboats in the morning, holding up their wares as stoned hippies looked out with bleary eyes, explaining that they didn't want a shawl for their grandmother – which of course only increased the vendors' persistence. 'It is my duty to sell you this shawl,' one pleaded with me. On a later visit to India, it saddened me to see displaced Kashmiris trawling the beach in Goa, trying in vain to sell their wares, as very few tourists visited their country then after so many religious battles. The sight of khaki in Kashmir constantly reminds the population that it is an occupied territory, and the British are partly to blame for that too.

Kashmiri hash is celebrated by discerning palates, and reportedly mixed with opium, which gives it a very dark and potent aroma. We went to a smoke house in the valley where a few locals were sitting around and pulling on a large hashish pipe in the centre, falling away when they had had enough. An old boy was pointed out in the corner and we were told, 'He has been smoking for 50 years!' Finally, he straightened himself up from his cross-legged position and left walking in a straight line, the first time we had witnessed the long-term effects of the drug. There, a visit to the smoke house is rather akin to

going for a pint, and like the boozers in the old working-class pubs, their patrons are seen by the middle classes as down-and-outs – which is why the association of hippies with hashish was so telling.

There I met Australian John, who liked the highly regarded local opium. John visited a dealer and became very stoned, bringing some 'O' back for later consumption. He told his friends about the quality but, when he lit up a pipe, it didn't seem quite so good. Returning the following day to complain, the dealer apologized and prepared John a pipe that did the trick; but he still gave him the same second-class stuff to take away.

After a trip to the mountains, we moved back to the plains, and following the obligatory visit to the Taj Mahal, headed to Nepal and Kathmandu. The Taj was wet and shiny in the rainy season with no tourists, somewhat melancholic.

DIARY

Last weekend was the 70th party for John Michell and a heap of work. My architect friend Steve Wilmoth came over from San Fran with his wife and their daughter plus friend from France, so we put them all up. Many kids too – John, Rob, Anna and Julian Gordon-Watson with Ursula. Julian is an old pal of Kari-Ann's, a real country man and a great character who loves me singing old Hank Williams tunes.

Kari-Ann was down to sing 'Hey, Big Spender' in an amazing dress once belonging to a busty opera star, so she had to stuff up the bosoms. She rehearsed the song with Dez on guitar, changing the words from 'the minute you walked in the joint' to 'the minute you puffed on the joint', as J. Michell is a dedicated smoker. Another add-on was and 'Hey, crop circler', as John runs 'The Cerealologist', dedicated to such activities; this brought the house down.

Looking back, it was great fun but I had the usual worries. With the dining arrangements, there was little room to set up – so right before we played, I was yanking bits of staging from the basement for the drums to have a flat platform. Robin McKidd arrived late to play the fiddle with a dreadful cold – I didn't go near him! I asked him why he came and he answered 'I need the money!' Les the drummer showed, and we have played little together, while Charlie – who normally leads from the front – was stuck in the corner on double bass. There were no monitors so I couldn't hear myself. I broke a string on the last number before midnight and couldn't find another, while Dez had just put on new strings so he kept going out of tune and blasting out my eardrums! Most people are oblivious to all that of course and it was a wonderful evening of celebrating John with all his dear friends, reading poems, speeches and stories, and dancing. John was beaming from ear to ear, surrounded by admirers including Jerry Hall and her sister Rosie.

I have a few ideas for writing jobs floating about but either nobody commissions you or they reject you. Even having a commission is no cert either.

We have people coming to rent the place next weekend so this is a big test. I have had so much stick about this but am going through with it anyway, as the ad alone has cost £200 in the Sunday Times. *So with the £550 I'm getting, there will be but £350 for myself – and some will have to go on cleaning, etc.*

'MY RELIGION IS TO LIVE AND DIE WITHOUT REGRET' – Milarepa, Tibetan Buddhist master

Travelling overland to India had taken me six months, hence I had acclimatized in stages. On the road, the Western clothes you start with wear out and become obsolete, so you have new ones made; you sell your wristwatch and acquire odd pieces of silver jewellery, and dialogue-wise you pick up a few words of Urdu or Hindi

that work for you, such as *baksheesh* (freebie) or '*Challo!*' ('Let's go!'), and drop them into your everyday speech. The international hippie is thus born.

We drove the 404 over the pass to the hallowed mountains of the kingdom of Nepal, that mythical paradise which was quite unused to coping with an influx of foreigners. It was the closest you could come to Tibet, then a closed country ripped apart by the Chinese and the so-called 'Cultural Revolution', a Newspeak term for destruction on an industrial scale.

Kathmandu was beautiful and green; the people smiled at you despite their poverty. We had finally arrived in the Orient after all the dusty miles on the road. We sat on the steps of the crumbling temples in the main Durbar Square smoking *charas* in a chillum and watching the processions wind their way noisily past, blowing horns and crashing cymbals – all the wonderful aspects of life that we in the West had jettisoned in our rush for progress. After that long road, I was content to wander gently around the valley, the culmination being the walk from the busy city to Swayambhunath, also known as the 'monkey temple', standing on a hill of 'self-created ground' a couple of miles away across the river. On the wooded slopes live numerous apes, who cunningly send their offspring to amuse the tourists and, while the foreigners are cooing over the babies, the adults slyly pickpocket bags for food. As you gradually ascend the steps, you take it all in, and passing three huge red Buddhas halfway up, you turn around to catch your breath and admire the view. Then you approach the vast *dorje*, or thunderbolt, with an iron snake coiled around its stand, right in front of you. Behind are piercing eyes painted onto the white expanse of a circular stupa topped by a massive brass spire. The eyes face the four cardinal directions and, as with all stupas, you must circumambulate in a clockwise direction, turning the prayer

wheels set in the wall and chanting '*Om mani padme hum!*'. This you should perform at least three times.

Later, I came to know a Tibetan lama there and sat alongside the monks as they went through their long ritualistic prayers, the chanting punctuated by bells, cymbals and the famous long horns, reverberating against the walls into your consciousness like a call from a distant time. Intoning their texts, the young novice monks would look at us and burst into laughter while the elders admonished them.

You stay as long as you can, for it is such a special place – but if it is becoming dark when you go back to the city, remember that you must negotiate packs of roaming dogs. These are altogether different from the pampered pets of the West as they bare their teeth and snarl when you gingerly pass by. Bony and mangy, some with rabies, as in India, they are a painful feature of street life in the Orient. At night, they fight for their territory and howl endlessly, stopping your sleep. In Tibet, I later discovered, the dogs hang around the monasteries where they are tolerated and fed, because Buddhists believe all living things are sacred and have the same right to existence as we do.

HEAD SPACE

In town, there were two main hangouts for the heads, the Cabin and the Ling Kesar. As well as a selection of confectionery, the Cabin sold *charas* and hashish, and was licensed to do so because the owner was a Newari, from the caste that once ruled Nepal. Downstairs at Ling Kesar was a café and shop selling Tibetan items, including turquoise and coral necklaces, clothes and *thankas*, or religious hangings. Once the heads had smoked a chillum or two, they would be hungry for banana fritters and Tibetan *momo* – the dumplings they like so much – all washed

down with lemon tea. There was the usual informative notice-board telling Sam that Jake had gone to Pokhara, back in a month, as well as boots and sleeping bags for sale and an array of free paperbacks left by travellers wishing to lighten their loads. Upstairs, musicians would drop in and play, and here you could lay on mats spread out so that you could contemplate the ancient mural of the 84 *siddhas* (saints); or rather 42, as half of them resided in the adjoining house on the other side of a partition wall. Elsewhere, a great treat was the delicious *dahi*, or yoghurt, made in wide, shallow clay bowls and then set out to cool. The cane sugar rose to form a crust, which was regarded as a delicacy, quite unlike the gloopy homogenous stuff sold in the West.

Bodnath, down the valley, was the manor of the Chini Lama. He was the son of a Chinese trader who, many years back, had somehow acquired the rights for the stupa there and exploited it for all it was worth. He held court on a four-poster bed covered in silk brocades, and dealt in bells, bowls, brandy, opium, expensive *thankas* and Tibetan relics, including thigh-bone trumpets encrusted with gems. His fingers were adorned with rings, among them a gold snake with a jade ball in its mouth. I bought a brown silk waistcoat from him that I treasured for years. Around the stupa were the usual *momo* shops and Tibetans selling boots, robes and *chang*, the fermented barley beer so loved by Nepalis and Tibetans.

A bunch of heads from Philadelphia called 'the fuzzies' had set up their HQ in the vicinity and were well equipped, as most Americans are, with fridges full of fruit juice and honey, a sound system and the best *charas* around. Naturally, there were certain 'clans' of hippies but generally everyone got on well; it was very much an international scene. Stories were constantly swapped of where

such and such a character was last seen and whether he made it to Benares or was off to distant Darjeeling. Hippies were generally delayed when they ran out of funds and then had to sit and wait for weeks at the American Express in Delhi or elsewhere for travellers' cheques that took an eternity to arrive. To place a phone call back home was a major expense. You relied on aerogrammes and letters waiting at a Poste Restante in main post offices. Money was shared around, lent out to friends – and sometimes stolen, because few had any place to stash valuables except on their person.

The French hippies weren't always so happy, as they realized they had to speak English in India, which fazed them somewhat. I remember one French junkie, Geraldine, who always had ten tales of woe if you ran into her: losing her money, fighting off men, having no place to stay, being unable to find her drug of choice and so forth, all recounted in her thick French accent and without a pause. The ethos was 'If you have it, share it' – but everything has its limits.

Kathmandu was the centre for all the heads who had made it either overland or the modern way by plane. The latter faced an abrupt shock in many ways and Americans in particular found it hard to function without the comforts of home, unprepared as they were for the squalor. One hippie who flew from the USA straight to Nepal freaked out on being accosted by a desperate beggar and handed him all his cash – over $100 – whereupon the police arrested the beggar and swiftly relieved him of it, while the greenhorn wandered off with a personality crisis.

DOWN IN THE VALLEY

Before it was crushed in the 2015 earthquake, Bhaktapur was the most entire and beautiful village in the Kathmandu valley, full of wooden houses and temples all adorned with exquisite carvings,

and I was invited there by a German working on a water aid project. As he spoke fluent Newari, he was respected by the locals and was rewarded in the festival celebrating 'brothers' with a lengthy ritual in a fine old house, which I went to watch.

All the women paraded in front of the seated 'brothers', setting a small fire in front of each. Then they brought them a series of offerings, including garlands and incense, then smeared *tilak* paste on their foreheads, daubed them with oils and fed them with tasty morsels, directly into their mouths. This took place in silence among the rustling of skirts and the giggles of the beautiful Nepalese girls, who enjoyed every moment. At the end, we were all offered a simple yet delicious meal, which we ate in silence and then departed; there was no small talk whatsoever.

I stayed in Kathmandu during the long monsoon season, as it's impossible to trek out then unless you like being eaten by leeches. With an Italian guy, Franco, driving his Fiat camper van, we attempted to see how close we might get to Tibet, even though the country was closed and permits were never issued. The party included Stash – Prince Stanislas – who had appeared from London by plane. I had an American girlfriend, Ellen, at the time and Stash kindly took her off my hands, as I didn't want a serious relationship.

The Chinese had built a road out from Kathmandu towards Tibet and we soon encountered some of their soldiers. Franco, smooth and fast-talking, somehow convinced them that his passport alone allowed him to travel where he wanted, citing as his residence the Soaltee Hotel – the smartest place in town – and, amazingly, we were allowed to continue. We passed a large army barracks with huge garish pictures of Chairman Mao mounted outside, surrounded by multiple light bulbs with numerous quotes below, but when we got out to inspect them, soldiers with bayo-

nets appeared to move us on. We drove further up the mountain pass as daylight faltered and then reached a small outpost manned by Nepalese Gurkhas. They were playing volleyball on a lawn the size of your front room, only with a direct drop of 1000 feet to one side. There was no messing with them, however, and they ordered us to turn back.

Reluctantly, we retraced our route down that steep mountain road as the monsoon rain pitter-pattered on the roof in the gloom of the evening; first gentle and then increasing to huge raindrops crashing down. The van conked out as we had run out of petrol! A truck full of Nepalese workers pulled up to assist us and, recklessly, I took off with them to try to find some fuel. After we bumped along in the darkness for a while, we emerged and I was led along the tops of some paddy fields by a friendly local, who held my hand lest I fall into a torrent (for the rain was still belting down), and we reached his village. I squatted inside a low shed, watching enormous buffalo being milked, the steam rising from their sides as they chewed the cud and expressed huge quantities of milk. The grinning Nepali girls pulled on the beasts' udders and grinned at me through their gold teeth, handing me a warm cup of the fresh *doodh*.

I fell asleep in a thatched hut with the rain pounding on the roof – and when I woke in the morning I might have been in paradise. The sun shone, children were playing games outside and an old woman without teeth was propped against a tree smoking a corncob pipe while chickens clucked and birds flitted across the bushes. I found some petrol and walked back to the road to see some sappers engaged in laying dynamite to blow up a large landslide just around the corner from where the Fiat had stopped. It was a foolhardy trip – and I was not able to reach Tibet until nearly 30 years later.

FELLOW TRAVELLERS

I fell in with a group of like-minded people, among them Richard Horn and fellow American Rick Watson, and the two had a lot to talk about. Rick, a bookworm and intellectual, had been at Stanford University in California. Richard and his partner Lynn were from NYC, and on the strength of a novel he had written for the Grove Press – the original publishers of William Burroughs' *Naked Lunch* – he had drawn an advance and took off for India, intending to write his ground-breaking novel, which never materialized.

Richard was an expert on the New York scene and had met Neal Cassady, who featured as Dean Moriarty in Jack Kerouac's *On The Road*. Although still young, Richard was professorial in appearance, with a comb-over and thick glasses. A chess master, he could wipe the board with you in two minutes flat. His partner, Lynn, was fast-talking with a strong Queen's accent, intelligent and good-natured too, with an extremely thin body and frizzy hair. Between them all, they gave me a fast-track education in such topics as space travel (Rick's father worked for NASA), John Donne, William Blake, the physicist George Gamow and the Big Bang, the Grateful Dead, Ken Kesey, pre-Columbian America, Zuni Indians and lost Amazon tribes (the ethno-botanist Terence McKenna was a friend of Rick's). I had a crash-course in the tabla, too, as we had in tow an Indian musician called Sakhet, who told us many stories and of course played the twin drums. He taught me how to massage his fingers, something I have not forgotten.

Once the new hashish harvest arrived in town, I bought a kilo of the freshest and packed it into my rucksack to trade down the line. I paid the tax on the transaction to make it 100 per cent legal, the document embossed with a government stamp, leaving town with

a Scottish lad heading for Benares. When we crossed the border, a policeman noticed my visa had expired, so he detained us both in a tiny hut where it was impossible to stand up. My mate sent out for a smoke of hash, as we didn't want to break open the large stash, and we spent a rather stoned night in jail; thankfully, the only one I've ever had to endure.

CHAPTER 10

MOTHER GANGA

I had already passed through Benares, so knew a little of what to expect there. With its numerous temples and *ghats*, the steep stone steps facing the Ganges, travellers either love it or hate it. It has another name, Kashi – 'the shining one' – and a long history that makes it sacred to Hindus and Buddhists alike. The most famous temple, Kashi Vishwanath, dedicated to Lord Shiva, is off-limits to foreigners, no matter what your disguise. As a matter of duty, many Hindus with enough rupees will bring a deceased relative here to go up in smoke and duly scatter their ashes into the holy Ganges so as to break the cycle of birth and death. The smell of burning flesh pervades the air, mixed in with incense and general pollution, which has greatly increased since my days there. One Hindu I chatted to on the steps of the Ganges pointed out a nearby smouldering pyre saying, 'There is my father, burning. I have done my duty. Come, let us take cup of tea…'

My small shack of a hotel was visited by an ex-wrestler with mandatory handlebar moustache and dhoti, offering massages to weary hippies. This was cheap enough, but if you were broke, he might do it for a smoke. You would be swung horizontally onto your cot while he worked over the aching muscles, and soon be relaxed and smell of mustard oil for the remainder of the day. These were the first massages I had ever experienced; in England at the time the only place you might encounter one was in a boxing gym.

Englishman Jasper Newsome, aka Ram Giri – the name given to him by his guru – was living on a Benares houseboat with numerous other heads, including Nick (who was fond of opium) and Mataji, a diminutive Indian woman who knew a lot about sacred sites and the practices of the ascetic *nagas*. She was also a

good cook. Mataji had children but was an ascetic, too, and, being partial to a chillum of ganja, was a friend to many foreign heads. From her I heard how Baba Kina Ram became guru to the Maharajah of Varanasi, a tale involving a sadhu – a holy man – eating the limb of a charred corpse and transforming it into a silver platter of fruit. Many such handed-down stories were recounted and Indians delight in nothing more than the telling of tales, something we have largely discarded in the West. I myself was forced to recount stories I had read in W.B. Yeats' anthologies.

DIARY

The past week has been fast and furious. First, there was the dreaded weekend with the rental people. They came in a storm and left quietly. It was a strange time for me as I had Kari-Ann going over the top about the whole idea – she hated it, naturally – and was shouting at me at the same time as I was clearing up. Finally, she drove off to her sister's in Cornwall along with niece Rosie, leaving me to gather myself before the next onslaught.

I moved into the scruffy cottage and was busily stoking up the fire when four-wheel drives started pouring down the newly constructed drive, disgorging babies, anxious mothers and kitchen paraphernalia. Like the guide at the doors of some great house, I showed people round as they devoured the information then promptly forgot it. What a nightmare: people on the phone demanding directions, etc. However, once things settled down and I got used to the interruptions of 'Where is the such and such?' I learned to ignore what I could and get on with stuff. They did go out and about, mercifully, which gave me some time to have a shower.

In the end, George, who was rather henpecked and a bit of a lad, came over to the cottage and we went out for a walk, during which the staffie, Mudger, chased and tussled with a badger and lost his expensive

£20 collar. The lurcher, Orca, chased a deer in the gloaming and George was most impressed with the action – despite being admonished by his wife on his return, because he had missed the kids' bath time.

They invited me to a meal that came prepared by an Italian restaurant and I ended up chatting to him after the others went to bed. George passed out on the couch in a boozy haze. I had taken him to the cider barn earlier and I reckon he thought it was lemonade.

THE JEWEL IN THE LOTUS

Sarnath, just outside Benares, is a must-see, as it was there that the Buddha delivered his first sutras (teachings) after his enlightenment under the Bodhi tree in Bodh Gaya. Sarnath has a beautiful mural depicting scenes from the life of the Buddha, created by the Japanese artist Kosetsu Nosu.

There is much music in Benares. At one concert in the Hanuman Mandir, or Monkey Temple, sounds ran through the entire night into the following day, taking in many ragas from the evening into the morning. Each piece is associated with a time of day, and even a particular season, which gives it the special *rasa*, or 'flavour' as we might say. I sat there for hours cross-legged, not missing a beat, assisted by some speed to a friend donated. I particularly remember the famous tabla player Samta Prasad, the regular accompanist of the sarod maestro Ali Akbar Khan.

Prasad listened carefully to the *alap*, the early stages of the raga, which are very delicate and slow, appreciating each nuance as the notes delicately died away into silence. When this first passage was over, he took a *paan* – a favoured stimulant for *tabla wallahs* – from a small silver tray in front of him, tossed it into his mouth and let loose a rapid salvo from his drums, to the spontaneous applause of the delighted audience. Not able to contain his excitement, while beaming and laughing, he propelled his mouth's contents up into

the air and in the direction of the onlooking crowd! The chewing of *paan* – areca nut wrapped in betel leaf and covered with lime – was one habit of the Indians that the British hated, but it has digestive properties.

A fan in the audience asked Prasad how he came to be such a master of rhythm and he replied that, after meditating in a cave for many weeks, a vision of Mother Kali finally appeared – at which everybody nodded in appreciation, as she is the force of time itself. Bit different to rock & roll shows.

Rick Watson arrived from Kathmandu, and stayed on Richard Horn's rented houseboat. His partner, Lynn, was so excited when she first saw him crossing the gangplank that she screamed his name out – whereupon Rick dropped all the notebooks containing his poetry and a year's work into the swirling waters of the Ganges, never to be seen again. Only the pen briefly floated to the top of the turgid waters. A definite sign! Likely the I Ching was consulted soon after to see what direction we must take. Without such things as TV or radio, the I Ching is good entertainment.

I visited Calcutta with Richard Horn, and although it's extremely polluted, we became fond of the place, particularly as it boasted the best Chinese restaurants I'd ever eaten in. Calcutta still retained the original rickshaws, complete with large cartwheels and barefoot coolies pulling you along: quite medieval. Even the bicycle rickshaws looked daunting. I once swapped places with a matchstick-thin *wallah*, to his surprise, and I can tell you it was damned hard work pedalling the thing.

We met an American Trappist monk who had been there for some years and was on his way back home. He had been a friend of Richard Alpert's, Timothy Leary's associate, and as it happened, possessed a bottle of the original pure Sandoz acid fastened with a handy dropper on the top. The monk wanted some

good hash to take home, so we made a swap: the bottle for a kilo of hash. We had also become acquainted with an Indian doctor who was something of a science buff, too, and he was intrigued by Richard. The two of them talked into the night attempting to marry up Hinduism with modern physics. This Dr Prasad had a good knowledge of the Vedas – the Indian sacred texts – and Richard was particularly interested in the concept of soma, the elixir of immortality, associated with the god Indra and guarded by Gandharvas, the celestial musicians. This is all in the Rig Veda, the ancient Sanskrit text.

Dr Prasad drove an old Hindustan Ambassador car, and he offered to escort us around the sacred sites we wanted to visit. Somehow we all piled into this most versatile of vehicles for another adventure across the north of India. The doctor was good company for the brief time we were acquainted, but he vanished one night, deciding he had had enough, and we were left to continue our pilgrimage by bus and train.

THE TEMPLES OF KHAJURAHO

When we reached the famous erotic temples of Khajuraho, there were six of us: Richard Horn and Lynn, Rick Watson, Howard, a West Coast hippie, and a young Englishman, Chris Westgate, who joined us someplace I can't remember, and myself.

This ancient site contains temples adorned with voluptuous maidens in erotic poses and is now well known from art books in the West. At the time, however, Indians were often ignorant of it: for many centuries it had been overgrown by the surrounding jungle and lay 'undiscovered'. There are around 20 temples in an area of a few square miles, all built around AD 1000. None now serve for worship, except the one closest to the site entrance, which has a 12-foot-high lingam and surrounding yoni, the

symbols of the masculine and feminine. We were nearby in an old-fashioned 'dak' bungalow, one of the lodges where officials of the Raj would once have put up. Consequently, when you were taking breakfast, the waiters would ask exactly how many minutes you would like your eggs boiled, serving marmalade with the toast. During our week there, the moon became full, so we took a dose of the Sandoz acid, which enhanced our perceptions of the temples' beautiful carvings. We all marvelled at the skill of the masons from all those years ago.

In the quiet of the night, the holy site came alive as we sat in a circle, after exchanging stories and sharing our feelings. At one point, I remember climbing up a temple as far as the roof, delicately moving over the sandstone sculptures, the old rock-climbing skills coming in handy. The buildings themselves are beautifully proportioned and laid out to comply with sacred measurements. You first climb up the steps into the shaded portico, then enter a darker recess where, as your eyes adjust to the shade, the central lingam reveals itself.

Under the full moon, we were now almost unable to speak but filled with an amazing bliss and contentment, not wishing to move from our circle. I thought, or imagined, that I witnessed Rick, sitting cross-legged, levitate a foot off the ground. When I told him later he replied, 'That's what I was attempting!' Unfortunately, the effect of all this magic was too much for Chris Westgate. He appeared one morning at breakfast, beaming from ear to ear but refusing to either speak or eat. Finally, he drank a little milk, but only uttered the occasional words, such as 'It is here…all is the same…love is us,' while nodding with an Indian philosophical expression on his face. We did what we could to understand him but to little effect. After that, he departed, and we missed him, with his guitar playing and friendly conversation.

MORE SACRED SITES

Our next stop was Sanchi, where Emperor Ashoka had created the first stupa after converting to the new philosophy of Buddhism in 263 BC. He then ruled most of the subcontinent, containing some 50 to 60 million people, and had forged connections as far afield as Greece. After his earlier conquests and bloodthirsty combats, he experienced remorse after visiting a battlefield, citing the text, 'Is it valour to kill innocent women and children?' and transformed into an enlightened ruler. The three lions atop a pillar first appeared in his time and remain the modern symbol of India. Sanchi was peaceful, particularly once the tourists had departed for the day. Again, we stayed at a dak bungalow and, as the full moon rose, took a drop of the LSD. It was a blissful experience, sitting up all night with friends and under peaceful skies with the giant stupa bathed in moonlight.

Central India is mostly served by road, so you resign yourself to being shaken to bits in the stifling heat for hour upon hour. As our bus approached one small town, it became obvious that the driver wasn't willing to stop; he already had a totally crammed vehicle, couldn't take on any more passengers and didn't want a riot, so he ploughed through those waiting, waving their arms attempting to make him halt. That was pretty scary.

We reached the famous caves of Ajanta, where the rock walls are covered with paintings of the bodhisattvas (enlightened ones) depicting tales from the life of the Buddha. The site is hidden in a gorge, once heavily forested, and though previously known to wandering pilgrims, was 'discovered' by the British in 1810. Copies of the frescoes were made and shown in Britain but these perished in the fire that burned down Joseph Paxton's Crystal Palace in 1936. The colours of the paintings are now fading and you can only wonder how vivid they must have been.

Some caves at Ajanta are large but others are more like cubby-holes for the monks. I sat in one and intoned my 'Om', hearing the reverberations continue with barely any effort, as though in an echo chamber, a beautiful experience. The full moon came out in all its glory and we took our by-now-customary acid trip, an amazing one, lasting all night.

Our final ancient monument was further west in Ellora. The famous temple caves there are altogether larger and more monumental than Ajanta's – which, along with the many tourists, we found hard to handle. Or perhaps we were reaching 'sacred overload'? The grand Hindu pillars and carvings looked like the results of too many slavish workmen grafting away for years for their rulers and the glory of the gods.

DIARY

The amazingly beautiful weather continues, although there is a chilly easterly wind today. I've been digging and planting out seeds – sunflower, marigold, corn, spinach, etc. If things had worked out, I would have been in India, writing a story about the Stones' trip there, but at least my cancellation had given me the chance for this. My Indian friend Alok called from Bangalore over the weekend. He could not thank me enough, as I had arranged for him to meet my brother, and was then right at the Stones gig, waiting for them to come on stage. Mick had called him earlier and they had been out to a temple site one hour from the city – and also to see some dancing and have a picnic. I was a little envious, but said, 'How nice.' It would have been a perfect opportunity for photographs and almost enough for a story.

I can't easily see where I go with any articles; the gardening piece on planting my orchard was rejected after initially being accepted by The Telegraph *and the story on my son Robert left to go cold.*

We had been together some months on the road and yearned to find a place to rest up, so planned to spend Christmas in Goa. First, we had to negotiate Bombay (now Mumbai), India's most Westernized city, towards which we hurtled on a crowded express train, its manic energy looming large on the horizon. I had a Hindi phrase book containing such useful expressions as 'It is very crowded in here/We are jammed in like cattle/Even cattle would be allowed more room.' On one train there was a catering service, which involved ordering your *kanaah*, or meal, from a steward, who then alighted at the next stop to telegraph it forward. The food duly arrived at another station and the plates were taken off later on. All tip top!

In the Sixties, Indian cities were a mass of men in white dhotis and women in bright saris, on bicycles, rickshaws, bullock carts, the odd camel, mules, cows – and a few cars. The original Ambassador, modelled on the old British Morris Oxford, was still the king of the road, though Mrs Gandhi had recently launched the upstart Maruti, a Japanese car into which Indian families attempted to shoehorn themselves. From Bombay, we boarded a steamer bound south for Goa. It wasn't such a long time then since Goa had been reclaimed as an Indian territory; it had been Portuguese since 1510, and not a lot had changed since the Portuguese had departed. Goa was a relative backwater, popular with middle-class Indians who went drinking in Panjim's old colonial hangouts. It fell to the hippies to put it on the map and make it the overblown international resort it is today.

Renting a house on the beach for a few dollars a month, we settled into a nice routine, walking to the waterfront as the fishermen returned in their wooden outrigger boats, and buying what we could afford from the day's catch. They caught small sharks, white fish and some octopus, all good and fresh. A shallow well

in the garden supplied our water, of dubious quality. Christmas – and my 21st birthday – were approaching, and the population had increased to a few hundred hippies. I remember a big cook-up on the beach where everyone came and banged tablas and blew conches in that rag-tag way the hippies had.

As I was sitting next to the water one fine day, two fresh-faced girls walked by and held my attention: one with fair hair, the other with long curly black locks. I was rather shy about approaching the latter but Rick encouraged me and so I came to meet Vivian Zarvis from Portland, Oregon. Her real name was Vasiliki, as her parents came originally from the Peloponnese in Greece, moving to the USA before the Second World War. Her father had worked on the railroad before opening the Grand Avenue Oyster House in Portland. We were soon inseparable and she moved into our little seaside house with the rest of the crew.

OLD MYSORE

Goa was a pleasant holiday, but not quite what had brought us to India. Seeking some adventure, Rick and I decided to take a trip to the interior of what was the old state of Mysore, home to legendary kings and musicians – and from where Tipu Sultan had fired iron-cased rockets at the British in 1780. With Vivian, and Richard's girlfriend Lynn, we headed inland by bus towards Badami, which has famous caves cut into the red sandstone, and passed through amazing landscapes with abandoned temples and not a foreigner in sight. Exhausted, we bedded down in the open next to a 'tank', a kind of reservoir the size of a large swimming pool, and I went to sleep with the buzzing of a thousand mosquitoes in my ears. We'd heard there was a famous fair nearby, held on the full moon, and so determined to visit. Unable to find any transport, we began walking.

Although still January, it was warm around midday as we approached a small village and were soon escorted by the customary gang of children, curious to see foreigners in such a backwater. We asked if there was any food available, but since there wasn't even a chai (tea) stall, we were led to a shut and very dusty old shop, which must have once served travellers. The padlock was removed and we sat down with many curious eyes upon us. Rick asked if they had soda, for he was convinced that the addition of CO_2 to well water would render it safer. Water was fetched and old cylinders were eventually found, along with glass bottles with round marbles in the necks that would take the gas and, after many attempts, the luxurious drink was produced.

We gestured for something to eat, but they shook their heads. Then someone produced a plate of fried chillies and placed them in front of us. We stared at them for a while, before Rick took up the challenge and gingerly began to chew on one. His face turned a purple hue, there might have been steam coming out of his nostrils, and all the kids began to laugh at this brave attempt to be native.

Our stoicism was rewarded when we finally reached Banashankari. The scene was akin to a medieval fair: part religious festival, part celebration and showcase of all the arts and crafts from the surrounding area. There were rows of wood carvers, with their intricately carved posts and doors on display; chalk sellers, their wares stacked in pyramids with the colours gently blending from one hue to another; saddle makers; leather workers; stone masons. I had never seen such richness and diversity before. There were other attractions: a cow with two heads, boys who could contort their bodies into knots, fakirs lying on nails, snake charmers, soothsayers, people with all kinds of weird and strange abnormalities whose sole purpose was to make you part with *char anna*, or a few pennies.

We saw sadhus covered in ash with iron rods through their cheeks, holding poses like Saint Sebastian. There was a magician who levitated a small girl draped in silk fabric and passed a hoop across her body to prove it, a fine trick. And in the evening, the country people packed into a large tent to watch a musical stage version of the Ramayana and gasp with childlike amazement. Now, you would be snapping endless digital photos, but then we just looked and took it all in, as bemused by them as they were by us, for I didn't see another white face. The people were wonderful and never hassled us for *baksheesh*.

NAGA WALLAH

Rick was intrigued by one particular snake charmer and asked to buy a cobra in a basket from him. He had once owned a boa constrictor back in the USA but cobras are venomous. (Apparently, the poison sacs are removed for the purpose of charming, and we hoped this was true.) In tandem, I sought out a charmer's pipe, a *punji*, to complete the picture; one pipe provides the drone while the other is fingered to make the tune. I then had a go, keeping my eye carefully on the snake. Although cobras can sense sound, they don't have ears, so mercifully he couldn't hear my poor playing.

Not being able to stun his prey, the snake had to be fed through a hollow chicken bone, which was a grisly business but otherwise he would perish. We brought him in his basket all the way back to Goa by bus, with the other passengers avoiding us. Eventually, he escaped in our Goan house, sliding into the cavity wall, and when the locals found out, they locked themselves in their homes. Rick cut a hole in the wall and meditated in front of it; when finally the snake appeared, Rick took him into the bush and released him to an uncertain fate.

Goa was full of characters like Eight Fingered Eddie, an American hipster slightly older than us who hung out on a deserted beach away from town, but we had had enough and decided to leave for Madras, via Bombay on a plane, the first I had been on since leaving home. Before that, we caught the latest cinema sensation – Kubrick's *2001* – which the Indians found fascinating and perplexing, arguing among themselves as to whether that was really what might happen.

DOWN SOUTH: MADRAS

In the Sixties, Tamil Nadu was a dry state – no alcohol was permitted, but foreigners might obtain a 'liquor licence'. The hippies claimed them and then sold them on to thirsty middle-class Indians, so they could buy locally made whisky with faux Scottish names. The hippies then spent the money in the government-run ganja shop – the opposite of what you would find in the West.

I sought out the famous veena player Balachander, whose records I had heard in London. He received us graciously in his house, playing for us in his music room. We ate a meal with him, then he announced that he was due at a girl's school that afternoon and asked if we would we like to come. Together, we all sat on the grass in front of a large dais where seven beautiful *devis*, or young women, began to play in unison on their large veenas. It was as if you had died and gone to heaven. The veena has always been one of my favourite instruments, with four melody strings, three drone strings and 24 frets, so soulful and deep – and of course played by the goddess Sarasvati, the mother of all arts and music, who sits on a white 16-petalled lotus!

We also loved the intense wailing of the nagaswaram, a double-reed instrument with a long wooden horn, similar to the shenai as played in the north, but with more bass end and louder.

Accompanied by the mridangum drum and other noisy percussion instruments, it is often played outside at weddings and street festivals, as it carries a long distance.

We had a favourite café where we repaired for *marsala dosa* and vegetables, served on banana leaves. A lad wandered around with dal and lentils in a stainless-steel bucket, and you could take your fill of these, paying extra for the vegetables. Another joint served piping hot Madras coffee, tinged with cardamom and poured extravagantly between vessels 2 feet apart, all served to the loud 78s that blasted out a series of nagaswaram solos, which Rick likened to John Coltrane. (Indeed, the 'Trane was a lover of Indian music.) Another destination was an ice cream parlour that served fresh dates and fruit together with the dessert, which we ate beneath swirling fans.

I passed a record shop and went in and asked to listen to the latest record by The Rolling Stones, *Beggar's Banquet.* It was a good listen right enough. I was 10,000 road miles from London and light years away from the world of rock & roll. There had been no telephone conversations or any communication, bar the occasional letter from home, for nearly a year. I was out of range and heard third hand about the death of Brian Jones and the subsequent concert in Hyde Park.

On the first cut, I heard my brother sing 'I laid tracks for troubadours who get killed before they reach Bombay.' 'Was he thinking of me?' I wondered, and if not, then who? In India, I was never bothered with questions about the Stones, it wasn't relevant. But Mick and I were made in the same image, had the same roots, and that you cannot deny no matter how many twists there are in the road. I didn't see it like that when I left London. It was almost instinct. And I was proud to be independent and take the road in front of me and trust to fate.

While we were in Madras, its most famous son, known as 'Anna' – who had been an actor, writer and political leader – died suddenly and the ensuing funeral brought around *15 million* people streaming into the city, which shuddered to a halt and everyone shut up shop. We were locked in our hotel for days until it blew over. The cumulative effects of travelling combined with the sights of towering temples and sickly incense had taken their toll on me. I turned a sallow yellow hue and soon discovered I had contracted hepatitis A, hardly surprising as we drank well water and tea from roadside stalls; this was way before the fad for bottled water.

Rick tried shooting me up with strong B12 injections, but I needed to convalesce and stay put, as you turn a shade of yellow and become very weak. Fortunately, the father of my best school friend John Newbigin was resident there; Bishop Leslie, a dedicated churchman, author and father of the church in Tamiland. Vivian and I went knocking on his door and he kindly found room for us in his rambling house. I needed some weeks to recover, and Vivian did a wonderful job looking after me. As a cure, I was given a special spinach-like Ayurvedic plant – which Viv gently cooked for me every day – and I read some years later that it was being investigated by Western medicine as a way of relieving this debilitating illness. I shall never forget Leslie's kindness and that of his wife Helen. Both lifelong pacifists, after he retired they returned to England overland, using local buses. They were indefatigable.

When I had recovered sufficiently, Vivian and I headed north via Mahabalipuram and its seaside temples to Orissa, one of the poorest states in India, on the Bay of Bengal. A cyclone was developing and came in with a crash, the sea advancing about 200 yards up the beach in the strong winds. The sellers of the small cheroot-like *bidis*, who had been perched on their stalls a few feet above ground the day before, were now at water level

and serving small boats that floated along the high street, so this was a regular occurrence.

MY SIMPLE DAL/ LENTIL RECIPE

Wash the lentils in water – in India you must remove all the tiny stones – and use good quality dal. (There are many varieties, some cook faster than others.) Add water to cover and then some, along with a good tea-spoon or two of ground turmeric, and bring to the boil. Reduce heat and simmer gently for 15 minutes or so. Make sure it doesn't dry out, so add a drop more water if needed.

Fry up some onion in a pan, add a few black mustard seeds if you have them, then transfer the lentils into this pan and cook a little more, adding salt, pepper and a little water or stock. When cooked, sprinkle in a teaspoon or two of garam marsala and lemon juice, and it's ready. You can get fancier than this if you like.

MOUNTAIN LIFE

We then headed for the foothills of the Himalayas, north of Delhi, to stay in Almora, above the resort of Nani Tal with its picturesque lake. There, we rented a bungalow just outside town, courtesy of Nik Douglas who was moving out. His main interest was the art of Tantra, on which he subsequently published books; he even toured north India making a film on the subject that my brother helped to finance. While diving into the cool waters of the lake Nani Tal, I had the idea for a children's story and subsequently wrote it up, titling it 'Lal and the Lady of the Lake', and many years later I read it to my own kids.

The house was called Chilkapita; it stood alone, looking out across a steep valley that dropped to a river below. It was sur-rounded by pine trees that were robbed of their vigour by the practice of gashing the trunk to bleed sap into a waiting cup.

Life went on much as it had for centuries. Our firewood was carried there on the backs of strong Sherpas and, without electricity, all was peace and quiet. We walked the mile or two into town for supplies from the market, bargaining for every carrot and tomato.

Almora lies 5400 feet above sea level on the dusty Indian plains, in a region known before deforestation for its extensive wildlife, some of which still remains in the Kumaon area, particularly in the Jim Corbett National Park, which was named after the hunter-turned-conservationist. He was called upon during the Thirties to shoot man-eating tigers, which roamed many miles, terrorizing the villages. One beast consumed more than 200 people before hunter Jim tracked it down, taking several years, so large is a tiger's territory. We once saw leopard prints on the pathway near the bungalow, so there were still big cats about. The monkeys, however, were more of a menace to our caretaker, or *chowkidar*. With her tanned skin, ready smile and no teeth, this slight widow came most days to look after the terraced garden and to tend her vegetables, as the place boasted a spring and so was irrigated. Some days she would converse with her neighbour way across the valley by shouting at the top of her voice and waiting patiently for the reply. If their husband dies, Hindu women are forbidden to re-marry and so live a solitary life, one recourse being to convert and marry a Muslim.

A large mango tree stood directly outside the house, and this was raided before the fruit was properly ripe. One morning, I witnessed the king monkey climbing to the top to claim the prize mango. Another monkey ambushed me as I walked along to our spring; he leapt out and I flinched at the surprise, whereupon he chuckled to himself and sloped off in a relaxed fashion. They know what makes humans tick.

We sometimes stopped to see Dr Bindu, the local Ayurvedic practitioner, who was at the cultural heart of the town. He welcomed many visitors, sitting cross-legged in his reception room, where music recitals were often held. Hill people might also make the journey down to consult him about their various ailments and he treated them for free. (The nearby missionary centre was prone to hand out antibiotics to them for almost any ailment, and Dr Bindu was highly critical of that.)

The local music teacher dropped in, too. He was a small and jovial man, always smiling, and so Vivian and I decided to take singing lessons from him. It was the only formal musical education I have ever had and it has helped me enormously. We sat with him and his harmonium, singing scales up and down until we could hold a note without wavering. Gradually, we became steadier in our breathing and more confident in the exercises involving the ascending and descending notes. We learned a couple of simple songs and the rudiments of the raga, and enjoyed the personal one-to-one instruction. Towards the end of our stay, as my ear became more finely tuned, I was able to detect the small variations of quarter-notes, or *shrutis*. (These are some of the subtle tunings of Indian music, which doesn't use a tempered, piano-based scale like Western music.)

I also learned about the ragas' dominant and sub-dominant notes and their talas, or time cycles, which are not unlike the 12- or 16-bar blues. I borrowed an old harmonium from our teacher to practise with at home, and one day I was gently squeezing the bellows when a family of scorpions emerged, the little ones marching behind their mother in a troupe! On one special evening, lying in bed, I could hear as plain as day a woman singing a raga most beautifully and I listened in wonder; I found I could vary her voice myself. It was like a visitation and went on for some time before I

finally drifted off to sleep. Vivian and I were happy at Chilkapita. It was good to be somewhere peaceful, not constantly travelling, and to take stock of where we were at.

DIARY

Last day of yoga before the Easter break, and Kari-Ann still having a tough time with her foot she had injured. Was going to the last class then had a tiff and I ended up digging in the garden. One of her students is a landscape gardener and she said about my patch in front of the house, at the bottom of the slope: 'Why not put it somewhere out of the way?' Why do people think growing food is a secondary consideration and only flowers worthy of pride of place? It's there, and it's easy to get to and water.

I originally covered the area with black plastic sheets to kill the heavy thistle and nettle infestation. The veg should also clean up the soil – even if later it's used for another flower display. It should meld in with the orchard and ducks, etc., to create an interesting, rural, rambling scene. I'm not labouring to put in azalea bushes or magnolia trees.

I spoke with Mick today. He's in Bangkok, though the rest of the crew are still stranded in India. He's philosophical about the whole affair, though his PA Miranda Guinness said there was a lot of pressure on M's shoulders after the cancellation of the China leg and the SARS flu troubles. He also said he could come down here in May sometime, so I'd better start on a big clean-up before the royal visit.

WHO ARE THE HIPPIES?

The two most commonly asked questions in India were 'What is your purpose?' and 'Are you a hippie?'

Initially, the hippies had credibility, but this soon changed. The media had a field day with the danger they might pose to Indian youth. Stories appeared daily in the papers of hippies smoking

chillums in holy places, smuggling drugs, being beaten up and robbed, or suspected of being spies and having orgies. Occasionally, there were more positive articles noting that they were interested in spiritual matters and Hindu culture, taking a lead from The Beatles' visit to Rishikesh with the Maharishi. The negative vibes took a nasty turn, however, with the reporting of Sharon Tate's murder by the Charles Manson gang, with all the gory details of that cult and the dangers of manipulation through drugs.

There is the concept that Westerners craving spiritual experiences are basically psychological misfits, easily fooled – and such people are good targets for bogus holy men, who have been swindling suckers out of their savings forever. The hippies' rejection of material possessions was a direct threat to the Indian middle classes, who desperately aspired to such bourgeois goals as owning a detached house and a TV, along with a new car in the driveway. Politicians even mounted campaigns denigrating the unwashed foreigners and the threat they posed. But on an individual level, it was different.

One friend of ours, Howie, was as typical a hippie as you would ever find, a gentle American soul who had been turned on to Hinduism in Haight Ashbury in San Francisco and travelled extensively through India, becoming conversant with all the threads of Hinduism – and expert at making a chillum. He had long black hair in a headband and wore beads. One Indian engaged him in the 'Are you a hippie?' conversation and Howie talked to him for ages, explaining what he was and where he had come from. In the end, the Indian concluded, 'Maybe you are not hippie, but you are hippie-like.'

What struck those looking for a meaning to their lives was the everyday philosophical outlook that many Indians embrace. Waiting is a national pastime and, once, at a railway station,

I was unsuccessfully searching for information about an expected train. I asked a learned-looking man and he replied, 'Train may come in five minutes, it may be an hour, but certainly train will come! Let us take cup of tea.' Of course, educated Indians were only too pleased to pass on their stories of Emperor Akbar, or how the poison from the churning of the ocean of milk turned Shiva's throat blue. After all, the British had been coming to India for centuries and only been interested in making money, maintaining the status quo, playing polo and downing gin and tonics. To go 'native' was the worst sin possible, and here were these young people embracing just that. Kipling wrote all about that years earlier.

SAMSARA AND KARMA

One visitor we had at Chilkapita was Jasper Newsome (aka Ram Giri). Jasper had first come to India around 1963 and had met Allen Ginsberg and his poet partner Peter Orlovsky, coming back in 1966 to study Sanskrit, after which he basically dropped out and lived the life of a yogi. Jasper became so integrated in the language and culture that many Indians thought him from Kashmir or a remote northern state, for he spoke fluent Hindi and dressed the part in ochre robes and dreadlocks, carrying only the most basic of possessions, including his chillum and rudiments for fire making. An Oxford graduate, Jasper was a knowledgeable bird-watcher, able to identify many native species, so it was a delight to go walking in the hills with him.

Jasper acquired an extensive knowledge of the multi-layered world of India, in particular of the nagas, the ascetics who renounce all worldly possessions and aspirations in favour of emancipation. This was so totally alien to most Western concepts that his family struggled, not unnaturally, to make him return home and become

more 'normal'. He did in the end go back to the UK, but there was no doubt that his spiritual home was in the East.

Jasper built a chillum using three-parts cigarette tobacco, one-part raw country tobacco and one-part *charas* or hash, all rubbed together to make an even mixture. It was necessary for hygiene purposes that each smoker had their own clean, dampened cloth, to cool the smoke. You then held the pipe between your first two fingers and thumb, and wrapped your other hand around the back to form a chamber, not touching the stem of the pipe. Before inhaling, the participant should raise the chillum to his forehead and cry 'Boom Shankar!' to invite others to come and share, and as an invocation to Shiva. (There are many others, including 'Bam Bole!', asking Shiva to drive out fear.) The chillum is like the Native Americans' circulating peace pipe, which has a set ritual and brings people together.

I returned from Delhi, where I had gone for the Kashmiri wedding of friend Ashish and his bride Nima, and to buy a tanpura, the four-stringed drone instrument, to find Bhagvan Das and Jasper there. Bhagvan Das, formerly Michael Riggs, took a liking to my Harmony guitar and showed me how to handle it better, playing some impressive 12-bar blues. He had travelled extensively through India acquiring knowledge of devotional hymns and yogic rites and is featured in *Be Here Now*, the book by Ram Das, the guru-given name by which Richard Alpert went.

Many heads stayed on a hill above the town of Almora, nicknamed 'Crank's Ridge', and Dick Alpert had earlier rented a house there. The guru they had in common was Neem Karoli Baba who had his ashram near Nani Tal, down the mountain from us. I once stopped to see him on a pilgrimage but he didn't seem very interested, probably because he was sick of having to deal with Westerners and speak English.

This guru was named after a railway station, Neem Karoli junction, where he performed a 'miracle'. During the Sixties, there was a government drive to ensure that everyone bought a ticket for their train ride – and this posed a difficulty for the sadhus, who carried no money. This *baba*, or holy man, was discovered on a particular train without a ticket and thrown off. The signal was given for the train to leave, but to no avail; it would not budge. Finally, an aware passenger pointed to the *baba* sitting on the platform. Asked to rejoin the train, the *baba* walked ceremoniously up to the engine, tapped the wheels with his fire tongs, climbed aboard – and the train duly puffed off. Richard Alpert brought Steve Jobs to meet the *baba* there many years later – and as I am writing this on an Apple Mac, there is a far-reaching connection there!

The oldest inhabitant on the Almora ridge was Lama Govinda, who you might see in the marketplace along with his wife, a rather fierce woman, both attired in their distinctive Tibetan dress. Christened Ernst Lothar Hoffmann in 1898, he had discovered Buddhism by studying Schopenhauer in Europe, and had later been interned in India during the Second World War as a possible security threat (which shows how daft the British were). The early Orientalist Walter Evans-Wentz, translator of *The Tibetan Book of the Dead* and the stories of Milarepa, had passed on the house to him.

Vivian and I travelled a few miles north of Almora to Gauri Udyar, a holy cave outside Bageshwar, for a *yagya* ceremony of purification that a *baba* friend of Jasper, was holding, which was to be concluded with a non-stop reading of the Ramayana. There had been heavy rain falling, and it returned when we reached the cave, not letting up. The *baba*, who had a wild appearance, had been fasting for some time and was sitting cross-legged in the cave with a huge log fire in front of him, looking very sullen.

The place was exceedingly damp and even the stalactites were dripping constantly.

A small stage had been built and decorated with cloth and leaves, and soon villagers arrived with ghee (butter), flour and sugar, as well as musical instruments – a harmonium, cymbals and tablas – to accompany the Ramayana. There were numerous chillums smoked to ward off the cold and keep us in a state of trance while the rituals went on (complicated and lengthy, they also required quite a bit of sponsorship, to which we contributed). After a night in the cave, we departed in the rain and headed back to Almora to the news that the Americans had landed on the moon! Many Indians refused to believe this, surmising that as the moon was on an astral plane, this was an impossible feat; others believed it might be possible but was unlikely, while still more thought that, if they had indeed made it, it was an unwise act.

TALES FROM THE HILLS

We took another walking trip with Jasper into the hills, to Jageshwar, which boasts an ancient and exquisite complex of temples lining a woodland river basin, overgrown with thick roots and vegetation. Some of the images from there had been placed under lock and key, however, after robbers had stolen artefacts, despite it being so remote. At night, the evening *puja* is performed in the domed Devi Jagadamba temple with much rattling of the damaru – the two-faced drum with clackers, which makes a satisfyingly holy noise when you spin it – along with the conch and gongs, and the *pandits* mumbling prayers in Sanskrit, all climaxing in a grand 'Om'.

In the evening, we were invited to a large hall and, surrounded by the entire village, smoked a chillum of their rather strong dark hash, after which they pointed at us and burst out laughing. I stood

up and sang a couple of songs because you are expected to deliver some kind of entertainment after coming all that way and you can't say no. I sang something from The Incredible String Band and they all applauded!

Vivian and I were in Almora for six months, including the monsoon season. Every afternoon, the skies darkened and the clouds ascended the valley from the plains below; then it would begin to rain, sometimes all night – the hillsides turned into rivulets – and there were often landslides. One afternoon, the rain stopped and I went into the garden; I touched a beautiful flower bud and it sprang open in front of my eyes.

One night, I had a strangely prescient dream that I received a telegram from my brother and, by magic, the following day a lad came down the hill to deliver one. Mick had been filming the movie *Ned Kelly* in Australia with director Tony Richardson, and was having a tough time with Marianne. He suggested that we meet in Bali when he'd finished shooting. But before I departed, I determined to make a short trip to Kausani above the Gomati Ganga valley, which commands beautiful views of the high mountains.

Rick, Vivian, Jasper, his friend Paul and I took a taxi as far as possible and then, as the road was washed out, walked the last few miles. The rains finally cleared and we were astonished at the panorama of the Nanda Devi massif – all of it above 21,000 feet, with the peak rising to 25,500 feet – and to the west, the distinctive Trisul, a group of three peaks. They are so vast you might think you were close by, but in fact they are some 200 miles distant at that vantage point. It was a farewell to the Himalayas, the majestic mountains that tower above the world. It is said that if you sail north in the Bay of Bengal, you are actually travelling uphill, as it were, such is the gravitational force the mountains exert.

I was excited about travelling to Bali to see my brother after everything that had passed, and no doubt he was looking forward to meeting up, too, but events conspired in a strange way to prevent that reconciliation. I flew from Delhi to Singapore, where I was to obtain a visa, as Bali is under the jurisdiction of Indonesia, a Muslim country that disliked hippies with long hair. They told me I would have no admittance unless I had my hair cut short, and I went away to ponder this dilemma. I duly had my locks shorn, but still it wasn't short enough for them and then came the weekend and the embassy was shut. Meanwhile, my brother wanted to return home and the opportunity had been lost. I was stuck alone in limbo in the luxurious Raffles hotel in Singapore, and so I unceremoniously returned home too. It was a strange way to end such a long trip but maybe the two worlds collided and went off at a tangent.

Flying back to London after so long away was always going to be a shock. My luggage was fully scrutinized at customs, as you would expect, and they examined the trinkets I had brought back. Among my mementoes was some Tibetan incense made by a Sherpa woman in Kathmandu. The suspicious officer crushed a stick in the palm of his hand and was having a good sniff until I informed him of the 18 ingredients it contained, including yak dung to render it combustible. He screwed up his face and let me through.

CHAPTER 11

CULTURE SHOCK

A bin strike was in full swing as we drove along the familiar streets of Earl's Court in 1969, with my father no doubt pleased that at least I had returned in one piece as I shivered in my thin Indian cotton pyjamas. Of all the strange habits I'd acquired, the one that most horrified him was eating with my hands. The fact that your right hand must be scrupulously clean and that you only really use the tips of your fingers escaped him. As one Indian said, comparing eating to lovemaking, 'You like to use a prophylactic?' You learned solemnly in India not to use the left hand for eating – that is for other things – though it was never explained how that impacted on lefties.

Vivian soon joined me in London and, to begin with, in an act of inordinate kindness, Keith and Anita, with their son Marlon just a toddler, put us up in 3 Cheyne Walk. I arranged a concert in Keith's living room with Ashish Khan, son of Ali Akbar Khan, who like his father played the sarod. Ali Akbar's father was the famous teacher Allauddin Khan, who was also the teacher of Ravi Shankar, and it is said the line came down from the legendary Tansen, a court musician in the times of the 16th-century Emperor Akbar. That's how it's done to preserve the authenticity – so you could say that George Harrison's sitar training came all the way down from that distant past. Keith, Anita, Robert Fraser, Michael Cooper, Mick and all the guests sat around on the kelim rugs and were royally entertained, much like the maharajas of old. Keith even joined in, appearing with his Dobro – an acoustic guitar with a built-in resonator – and played some bottleneck, including the blues tune 'You've Gotta Move', later to appear on *Sticky Fingers*.

Our stay at Keith's was a short-term arrangement but luckily Robert helped out with a room in his spacious Mayfair flat, by far the smartest address I've ever stayed at. Below us was the Queen's butcher, with the royal coat of arms on the shop front, a very expensive grocer, and over the road a stationer's shop where Robert introduced me to Alwych notebooks, made in Scotland. At the time, Robert was living with his boyfriend Karma, an exotic South Indian dancer with kohl-black eyes and a lithe body. One of his specialities was *kuchipudi* dancing and, as he was giving Robert classes, Viv and I were invited too. It was great exercise – though what an Indian onlooker would have made of it was another matter. I would help out by making the odd meal and taking his Afghan hound to Hyde Park, where I once innocently let it off the lead and the crazy thing refused to come back.

LET THE SUNSHINE IN

Marsha Hunt, Mick's new girlfriend, was always a mover and a shaker. She had appeared in the London production of *Hair* and told me of a touring version then being cast by the director Patrick Garland. I knew him from the Hampstead Theatre Club – so Vivian and I went along to the auditions for the musical due to open in Tel Aviv, Israel. There were many hopefuls in the line, but we did okay and were booked for the show as chorus members; even though we had no previous experience, I guess we had lived the dream.

We flew out to Tel Aviv and met the rest of the cast, the principal players being Israeli. (The production was in the Hebrew language and we were the decoration – the 'tribe' – bringing an international flavour to the show.) There was a large black guy from the UK called George, and Brenda, a black woman from Mississippi, with whom I became good friends. Alice Ormsby-

Gore, youngest sister of Victoria and Jane, was also in the show, a beautiful girl – skinny, with lots of kinky pre-Raphaelite tresses.

Tel Aviv was a busy and modern place, quite ugly and edgy. Explosions were going off in the streets, as the Palestinians were angry after the Six-Day War in the summer of 1967, when Israel took over the Sinai Peninsula, Gaza and the West Bank. During the rehearsals in May, it was unbelievably hot, hotter than India. Vivian and I lived simply on brown rice and vegetables and the co-director, Oliver Tobias, taught me how to make Swiss muesli.

OLIVER TOBIAS'S SWISS MUESLI RECIPE

Take grapes, strawberries, mangoes, pineapple, goji berries, dates, apples, pears and any other fruit handy (but not grapefruit). Slice as thinly and small as possible. Add a spoon of mixed seeds, rolled oats and some milk, stir together and let it soak, leaving it to expand in the fridge overnight.

Oliver and his partner, Nicky Browne, were great fun, and the four of us became close friends, touring the flea markets in the Arab quarter of nearby Jaffa to find costumes for the show, eating and hanging out together. Nicky was from Newry in Northern Ireland and had been married to (the Honourable) Tara Browne, with whom she bore two sons. Tara was killed driving his Lotus Elan through the narrow London streets and 'didn't notice that the lights had changed', as The Beatles put it. Oliver had a swagger and presence that came partly from his successful run in the London production of *Hair* after his training at London's East 15 Acting School. Born in Zurich, both his parents were in the theatre, his mother being the well-known actress Maria Becker, and he spoke German, French and Swiss-Deutsch, which we engaged in after a few beers for a laugh.

The script for the show had been translated into Hebrew, and this caused many arguments among the Israeli cast over the appropriate meaning and use of words. Modern Hebrew is something of an invented language, borrowing from the Bible and ancient texts, adding new words for which old Hebrew had no equivalent. Jews from Arab lands had one word for something, a Yiddish equivalent, and possibly another way of saying the same thing if you came from Russia. There was someone on hand specifically to advise on this but that didn't prevent much shouting, which of course we failed to understand. We did, however, have to learn the songs in Hebrew and so 'Let the Sunshine In' – the show's finale – became '*Tnoo la Shamash*', while holding our outstretched arms heavenwards, naturally.

Vivian was a good dancer while I was working hard to catch up, but whatever we lacked in technique we made up for with enthusiasm. The music was directed by the American Steve Gillette, an expert on harmonizing parts, who conducted the proceedings with his Fender Telecaster – much better, I thought, than sitting behind a piano. Oliver arranged the all-important dance and movement sections: not only had he played the lead role in London, but he had directed the Amsterdam version, too, so he knew the score inside out – and it was Olly rather than Patrick Garland who made it work. Patrick was more of a Chekhov man.

The opening night was a bit flat, partly because the audience didn't know what to expect, but it livened up at the end when a couple of Israeli paratroopers jumped on stage and began dancing. The original idea for the show was conceived in the spirit of New York's ground-breaking Living Theatre company, the idea being to involve the audience in the performance and bring it out from the traditional constraints of the proscenium arch. Thus, the unconventional opening involved the cast arriving on stage in slow

motion, from a number of starting points in the auditorium. Three of us began at the back of the stalls and, linking arms, carefully moved over the audience, threading our way across the armrests. Our unexpected appearance caused initial alarm to the theatre-goers, looking up at the long-haired hippies above them. One woman freaked out so much that she had an epileptic fit and had to be carried out.

A party of us took a day trip to Jerusalem and while there visited a smoke shop in the souk. The large water pipe in the room was loaded with rather strong hashish, set alight, and then the smoke travelled rapidly up the tube and into your lungs. We all crashed down onto the rugs laid out there. After a while, another pipe was lit, and then we were ejected into the bright sunshine and narrow alleyways of Old Jerusalem, alive with noise and colour. We made our dazed way back to Tel Aviv and the theatre, but the slow-motion opening that night took three times as long to wade through. We were like sloths on sleeping pills.

We made several side trips to the desert, Jericho and the Dead Sea, as well as the Sea of Galilee, where we spent a memorable evening with the famous herbalist Juliette Levy as the bats circled her remote house high above the lake. Our favourite restaurant destination was in the Arab quarter of Jaffa. Whenever a party of us would arrive to eat, plates of delicious hummus, olives, pitta bread and peppers would immediately be brought to the table as we sat in the cool courtyard underneath a squawking parrot in his cage. We had much sympathy for the Arabs, as they were treated poorly by the Israelis, who held all the trump cards and often had little regard for them. On the other hand, we met many Israelis who sought peace with the Palestinians.

A main selling point of the show was the 'nude scene', which closed the first half. It was all rather innocent, really, but the press

liked to build it up and even managed to take some grainy photos of the event. The 'tribe members' were hidden under a huge silk parachute and, as the lights dimmed, we were to emerge and stand naked in a circle. The idea was based on an anti-Vietnam War demo that had once taken place in Central Park, New York, where some demonstrators had stripped off.

The show contained a lot of anti-war sentiment, something not lost on the Israeli public. The stalls might be crowded with maimed soldiers sitting next to peace protesters, along with right-wing groups coming to see the show for themselves. Other musicians often joined us at the end, with dancers taking to the stage with a devil-may-care attitude that was truly liberating. One night, some 'leaping rabbis', with long side locks and black hats, came to the theatre; at the conclusion of the show, they climbed on the stage and Hebrew tunes were played, the tempo inevitably stepping up until everyone was pogo-ing across the floor. It was mad. The after-show party was often confusing for the audience, who didn't know whether to leave or get involved. All good Living Theatre stuff.

The cast mounted their own protest, in the form of a sit-in, one evening. We had been filmed for what we thought was a promotion, but then the footage was used in a beer advert without our permission or any payment; and to rub salt in the wound, the ad was shown during the half-time break, as the theatre also had a movie screen. There were some lively exchanges. I probably overstepped the mark and later got the sack. Fortunately, though, the entire cast leapt to my defence; the producer had to back off and to his chagrin reinstated me.

In all, Vivian and I lasted some six months in Tel Aviv. The musical was a great chance for me to express myself, particularly away from prying eyes that might have been critical in London,

and I gained experience of the stage, singing and dancing. There is no harder work than full-on musical numbers, which, luckily, are usually over in a few minutes. You might have noticed that at the end of a routine, when the cast freezes and the audience applauds, the chests of the dancers are heaving as they try to replenish their oxygen supplies.

DIARY

Back in Mudgley after a Sunday in London and Dad's 90th; a little crazy doing that, as there will be a bigger do next month when Mick comes back. Jade and Piers and their kids came, as did our cousin Christine – but not Horace, who wasn't feeling up to it. I missed his 97th birthday the previous week, too. The next day I felt deeply depressed in the suburbs, walking to the shops with Dad: all so mundane.

That morning, Kari-Ann and our niece Rosie went through Mum's old clothes, asking what to do with each item: give to charity, someone else, or keep? They were all so lifeless on their own; slowly all the vestiges of Mum have been removed from home and seemingly from Dad, too. Whereas before he would always go on about Mum, he hardly mentions her now and, when referring to the past, avoids times when we lived in Wilmington or things we did with Mum. Or perhaps that's just my reading of it now.

SHIPPING OUT

Viv and I left Israel from the port of Haifa, heading for Crete and a holiday. As it was October, the tourists had departed and we rented a small house outside Agios Nikolaos in the east, where now huge hotel complexes cater for bulk tourism. Meeting a friendly English couple, we decided to explore on foot for a few days the nearby Plains of Lasithi, situated in an elevated area some 3000 feet above sea level. We started the walk from the house but

realized the ascent was further than we had figured, as we had no map. We asked some peasants coming down the mountain how far to the village. 'One hour,' came the answer; then after walking an hour, the answer would be 'half an hour,' until one old woman sitting on a donkey nodded and just said, '*A pano*' – further on. Large Cretan goats scattered from high up among the trees where they were grazing in the twilight, before we finally reached an old inn. Viv and I had deserted our vegetarian regime after climbing off the bus and smelling the shish kebab on the roadside that we had to try, so after a nourishing meal of mountain goat that one of the locals had shot, we arranged our bedding on the floor as travellers had done in years past.

The next morning it was misty and cold but, fortified by more goat broth liberally laced with salt and lemons, we started off along a mountain track. It was a bit like being in Wales. Vivian was chatted up by some locals who liked her Greek credentials, and they spoke proudly of the numbers of sheep and olive trees they owned. 'We know what we have to eat up here and we keep the best for ourselves,' they said, implying a certain contempt for the layabouts on the coast who made money from tourists.

ALL THE WAY TO MEMPHIS

Back in London, I met up with the American filmmaker and occultist Kenneth Anger, who was obsessed with the Stones. (When we'd been staying in Cheyne Walk, he'd appeared one day to paint Keith's front door a sparkling gold colour.) Kenneth had been trying to induce my brother to star in *Lucifer Rising*, a movie that he had been developing for years. Mick declined – he was wary, and too busy with his music – though he did say he'd think about a soundtrack; and with that intent I can recall him sitting on the floor at 48 Cheyne Walk (his house) with consoles from

the first Moog synth, cross-plugging the patches, with the result-
ing electronic sounds wafting through the thin walls of the house.
These were originally constructed from ships' timbers by a retired
sea captain, wanting to feel he was still onboard his boat, no doubt.

With shooting due to start in Egypt, Kenneth decided I would
make an interesting addition in the lead role. But since we had just
returned from Israel, that caused an immediate logistical problem
for Vivian and me, and we had to apply for new passports to avoid
the stigma. A gang of us went on the trip, including the photog-
rapher Michael Cooper, David Cammell and Marianne Faithfull,
who was cast in the role of the goddess Lilith. We were comfort-
ably housed in Giza in the famous Mena House Hotel (soon to
be modernized and spoiled), which boasted plaques on the doors
stating that 'Winston Churchill' or 'Dwight D. Eisenhower' had
once stayed there. Kenneth shut himself away in his room, no
doubt concocting numerous spells, so we were free to ride camels
across the desert and explore Old Cairo.

Abdullah, our guide, hired us horses and we rode off through
the dusty streets of Giza, with him leading the way and cracking a
long whip to clear a path through the milling crowds. It was posi-
tively feudal. Arriving on the edge of the desert, he asked me what
I knew about riding. I told him I had done a little, then he gave my
horse a hard whack on its backside and it bolted off at breakneck
speed with me hanging on for dear life. Without the usual trees
and fences, this was exhilarating if rather dangerous – so, looking
to find a way to slow down, I steered the beast towards a narrow
gulley, thinking that would do the trick. The horse had different
ideas, however, and scrambled up the stony bank as if I was the
outlaw escaping a posse in a Western movie.

There was no script for the film and I had little idea what was
required of me as lead. When I put this to Kenneth, he lived up to

his surname and stalked off in a huff, shutting himself away again and sacking me from the project. There's a lesson there – don't open your mouth – but to this day I don't think I've learned it properly. So the Egyptian idyll came to an abrupt end; and while the others ventured out in the searing heat further up the Nile to Luxor, Viv and I returned home. Marianne was in a very 'dreamy' state and I think Kenneth exploited that. Luckily, he had a tousle-haired lad with him who filled in as Lucifer – one Leslie Huggins – and I wasn't needed.

Still, I did get to the original Memphis, although no Beale Street or Sun Studio there – it was all rather flyblown.

CHAPTER 12

A SLICE OF COUNTRY LIFE

Vivian and I returned to England in 1971 and travelled down to visit my brother in his country house, Stargroves, outside Newbury, and we immediately loved the place. Mick and the band were there recording, and I met Bianca De Macías there for the first time, as she looked out from the first-floor bedroom window on the rain falling steadily to the green lawns below. Her complexion was so associated with the sun, I wondered how long such a beauty would last in the English climate. Yet she turned to me and remarked how lovely the rain was.

The mansion was a sprawling Victorian edifice set in beautiful grounds on the edge of the North Hampshire Downs, with its own gatehouse, stables, rose garden, woods, and a lake that would never fill. According to Marianne, Mick had bought the manor while on an acid trip, but that might have been her exaggeration. Back in the early Seventies, country houses were relatively cheap to acquire – people wanted the land, but not the cost of modernizing and maintaining an enormous pile.

Beneath its 19th-century turrets, the house had earlier foundations; legend has it that Oliver Cromwell slept there prior to the Second Battle of Newbury, fought on 27 October 1644 during the First English Civil War. The Parliamentarians drove the Royalist forces back to Oxford, but the battle was not decisive. As Sir Edward Montagu, the Second Earl of Manchester, remarked, 'the king need not care how oft he fights...if we fight 100 times and beat him 99, he is king still, but if he beats us but once, or the last time, we shall be hanged.'

When Mick bought Stargroves, it needed huge renovations and these were only ever partly completed. Christopher Gibbs, the Inigo Jones of the day, was handed the brief to drag it into the 20th century. Among other things, he made the old ballroom into a six-sided space and imported a grand Sicilian fireplace into the main hall. The thing always smoked badly, but it looked grate(!).

The band, which now included a fresh-faced Mick Taylor on guitar, were recording in the mobile unit when I arrived, the results of which would emerge as *Sticky Fingers*, the first album on the Stones' own label via Atlantic. Key tracks like 'Brown Sugar' had already been laid down at Muscle Shoals in Alabama, and now the band were at Stargroves to finish the job.

The Stones never had their own studio; their nomadic lifestyles pointed to something more idiosyncratic, and so The Rolling Stones Mobile Studio – basically a lorry with a recording studio built into the back end – was born. The 'Truck', as it was affectionately known, was small but perfectly formed; I recall Keith contentedly putting his feet up inside the control room and extolling its virtues as though it were a child born to the group. While the concept wasn't entirely new – Mick and I had encountered mobile studios when our father worked on *Seeing Sport* (or at least they were outside broadcast (OBS) trucks for the pictures and sound) – it provided the answer to the enduring question of 'Where do you want to record?', and it soon became popular with other rock bands, including The Who, Led Zeppelin and Fleetwood Mac.

The Truck required the best spec possible for audio recording and after, consulting with producers and top engineers, the man entrusted with the job was Dick Swettenham, former in-house service and design engineer at EMI's Abbey Road and Olympic

Studios and founder of Helios Electronics, home of the world-famous Helios mixing console. Stu took on the job of organizing the equipment and it was his baby, really. With studios, reliability is essential, as there is little point having everyone booked only for a sound module to malfunction, rendering the session dead in the water. Having a lot of gear packed into a small space that can be driven around created its own problems. Technology has made things easier, but back then, with large reel-to-reel tape recorders and a host of patching cables running everywhere, it was hard keeping tabs, especially when there were so many updates and rebuilds constantly on the cards.

The real beauty of the Truck was that it sidestepped the 'studio factor' – that feeling of being trapped on the outskirts of a town in a building which, although constructed for musicians, could become a somewhat artificial experience. With the Truck, one could open the sliding door, walk across the lawn, wander around the grounds and get a quick refreshing break from listening to endless overdubs or backing tracks.

At Stargroves, there was a high-ceilinged, wood-panelled hall, from which doors led off to various parts of the house, while a grand oak staircase led to a gallery above. The height of the space gave recordings a 'live' sound, so in many cases the instruments or amps would be dampened down – that is, surrounded with baffle boards or screens that could be moved around to isolate the sound. Nonetheless, there remained 'bleed', sound coming across all the open microphones, and particularly that of the drums. Sometimes, bleed adds to the overall sound of a track – most old records have it – but it can make adding or changing things difficult, which is why in most modern studios each track is recorded in isolation, free of background noise. Keith would drive over from his house at Redlands on the Sussex coast to record over-

dubs on the Muscle Shoals tracks. The engineer, Jeremy Gee, told me that sometimes he would show up so late that everyone else had disappeared. Then the track would roll: 'Da-da da-da-da-da da.' Midway through 'Brown Sugar', waiting for the entry point of his part, Keith would nod off, waking when it had finished. 'Roll the track,' he'd say, and Jeremy would repeat the process. Around 4am, Keith would drive himself back to Redlands and engineer Jeremy could finally go to bed.

Americans loved Stargroves and were usually introduced to the place by the producer Jimmy Miller, who found it a home from home. *Sticky Fingers* was laced with the horns of Jim Price and Bobby Keys, both of whom became good friends of mine, but Miller also brought over session players such as drummer Jim Keltner, who has played with everyone, including on Dylan's 'Knockin' on Heaven's Door'. Jim possessed a fine collection of calfskin snares and little percussion objects, sounding them off at just the right time. I introduced him to Bulmers Number 7 cider in a local pub, as well as White Label, a strong bottled beer. He loved going out into the countryside with our lurchers and having adventures. On one session – I think for trumpet player Jim Price – Ringo Starr came along too and he and Jim Keltner played together. It was a magic moment.

HORSE AND HOUNDS

In the 'gamekeeper's cottage' Maldwyn Thomas was in residence, employed as Mick's groom, though he isn't exactly the horse and hounds type. Adding a suitable 'gypsy' element to the surroundings, visitors like the aristocrat Mark Palmer would descend upon Stargroves, and they'd always spend time with Maldwyn, who would teach them all about fishing, dogs, hunting and shooting.

Mark had co-founded English Boy, one of the first male model agencies, but by the early Seventies he'd given it up and moved out of London to embark on a rural idyll, travelling across England in a horse-drawn wagon and, in his charismatic way, gathering up a merry band of like-minded friends also hoping to escape the clutches of city life. Since winter was basically 'downtime', Mark rested up at Stargroves, waiting for the spring until he could travel on. He was the first of many to ditch the London scene, having influenced musicians Ronnie Lane, Eric Clapton and Pete Townshend, among others, to do the same. They felt a connection to a more down-to-earth life, where you could enjoy the freedom to ride along the Ridgeway with lurchers in tow, chase a pheasant or a hare, get soaked in the rain and dry off at the pub over a jar and a roll-up with your mates. It was all a far cry from the pressures of the rock & roll scene and doubtless inspired a song or two along the way. Mark owned a white Arab stallion named Sagittarius, and if an unsuspecting musician arrived and admired the steed, Mark would suggest he take it for a ride – bareback, no less (not an easy thing!). Then Sag would prance over to the duck pond and buck off the rider, to the amusement of all those who were in on the joke.

HUNTER-GATHERERS

My brother and band departed – indeed, they were soon to move to France – while Vivian and I stayed on in the sprawling mansion. The Truck and facilities were then rented out to paying bands and their crews. Of course, the Mobile Studio could come to them – but if they chose to use Stargroves, we acted as caretakers, ensuring the place was kept warm, helping out with provisions and generally making people feel welcome. However, if there were no bands coming, the cupboard was, so to speak, rather bare. Being out on a

limb, we would largely live off the land, so such country pursuits as foraging for the odd pheasant or rabbit became essential.

I would borrow a 12-bore shotgun from Pete, the local motor mechanic, and with a rescue Alsatian named Fred we would head off shooting. The problem was that Fred was so keen, he would often run ahead and disturb the quarry. But we became quite good at stalking and I had no compunction about shooting a bird in the tree or on the ground, so long as I wasn't going to hit anything else. This sometimes brought us into the orbit of the gamekeeper from an adjoining estate, and it was a cat-and-mouse game to evade him. He once shot at my lurcher, Sarah, after she had run off, and I had to have lead pellets removed from her shoulder.

Benevolent friends would come down, though, bringing goodies with them to rescue us in such hard times. Oliver Tobias loved visiting and sometimes brought along his friend Rok Brynner, son of the unique Yul. Rok always carried his Gladstone 'magic bag' with him, containing such prized possessions as an instrument with which he could make a glass from an empty wine bottle. In 1972, when Oliver was filming the *Arthur of the Britons* TV series in Somerset, Viv, baby Demetri (our first son) and I appeared in one episode, suitably cast as peasants. At first, Oliver drove a tiny Haflinger around, with his Irish wolfhound filling the back of the vehicle. He ate a lot and slept much of the time (the dog, that is). Later, Oliver bought a Ferrari, which was good fun to drive around the Hampshire lanes.

My brother had a Thirties Cadillac in the garage, with a 'dicky' seat that could be flipped out of the boot to accommodate passengers, and occasionally we took it for a spin. A beautiful car, built like a tank, it straddled the entire road – and drank a lot of petrol. This prompted a tune of mine: 'I've Got the Caddy if You've Got the Gas'.

Vivian with Demetri, me and Davina Verey in front of fireplace, Stargroves.

When bands arrived at Stargroves, Viv and I would help show them the ropes and take them on country walks, where they would usually get their python-skin boots muddy and tear their expensive leather jackets on thorn bushes. Special visits were made to sacred sites not too far away – Avebury and Silbury Hill were favourites – as well as to Salisbury Cathedral and sometimes Stonehenge, where you could still walk among the standing stones back then. Vivian made all the difference at the house, cooking and making it homely, and obviously getting on well with the visiting Americans.

Led Zeppelin loved the place. But they seemingly wanted to record more cheaply, so later found a nearby house, Headley

Grange, and then drove the Truck there. (Apparently, the place had no heating, but look at the money they saved!) When they were at Stargroves, I recall jamming with Robert Plant; he was on drums and I picked up Jimmy Page's beautiful cherry-red Gibson guitar in open tuning and played it quite loudly in the hall. A door opened and Jimmy's face appeared round it to see what was going on – but I guess he didn't bawl me out because I was having fun with his lead singer. After that, they set up in different rooms: John Bonham in the snooker room, Jimmy and his amps in the living room, with Andy Johns, brother of Glyn, engineering the album that became *Houses of the Holy*.

The Faces came to record, and bassist Ronnie Lane, being a close friend of Maldwyn, received much of his rural knowledge from staying at Stargroves; they would go out fishing, travelling the Hampshire lanes in Maldwyn's pony and trap, with Ronnie doing his best gypsy/East End lad routine. The Faces used to shout at each other a lot, too. After a drinking session one night, they smashed up a life-sized white fibreglass sculpture of a ghost by the pop art sculptor Nicholas Monro, proving what philistines they were. (I don't think they paid for it, either.)

Other outfits included a great American three-piece called Sky, who were introduced to Stargroves by Jimmy Miller. Handsome lads with great songs, but they seemingly never made it commercially. Glyn Johns brought the much-covered Gallagher and Lyle to make an acoustic-based album, and Horslips, an early exponent of Celtic Rock, recorded there.

The most memorable for me were The Who, an early favourite of mine. They arrived to make 'Won't Get Fooled Again', a landmark hit for them. They had tried to cut the track previously in New York, but it hadn't worked out. So, as they wanted a live sound – which was relatively rare at the time – they decided to

try out the Truck. The crew set up in the hall as if it were a gig, which, to all intents and purposes, it was, as we watched from the gallery above.

The song opens with an undulating modulation from a synth for an age, changing slightly before the drums and guitar announce themselves. Keith Moon, wide-eyed and ready for action, was like a lion stalking his prey; Pete Townshend wound up like a coiled spring. They really went for it, as though performing in front of 10,000 people. Roger Daltrey took a good few swigs of the Hennessy brandy kept atop a speaker and spun the mic around his head. After a few takes they had the good one and proceeded to add handclaps, all the while trying to put each other off the beat. As ever, Glyn Johns oversaw the recording, and it became the first-ever song I'd heard to incorporate synth into rock & roll.

Not everyone was so enchanted by all this music, however, and an older couple that had bought a cottage on the edge of the estate fell to complaining. Poor things, they had all this great music for free. (Not that it was so loud – they must have been 200 yards away, but they claimed it was still audible.) The woman of the house and wearer of the trousers was hockey correspondent for *The Guardian*, as I recall, with little sense of humour. We tried to mollify her – parking the van at the back of the house, for example – but after she was elected to the parish council, she eventually persuaded them to ban recording at Stargroves, claiming that it was 'industrial use'. She wasn't a local villager – *they* never complained – and clearly she had a pre-conditioned idea of what she would find in the countryside. No doubt we horrified her.

DIARY

I visited stepson Arthur's new restaurant in Portobello Road, next door to the old Electric Cinema and in the same complex. The whole shooting match has been taken over by Nick Jones and Soho House. I looked into the cinema, where I had spent many a night watching Peter Lorre or Bruce Lee's early movies. The old rows of curved seats had been replaced by comfy leather sofas and huge armchairs: I would have liked one back when we went there to fall asleep, as many of the punters did in the wee, wee hours, while yet others puffed away on joints and nobody seemed to mind.

Back in Mudgley to do some more building work in between trying to get gigs and writing jobs. I desperately need some money but from where? Last night I went to Devon to leave my guitars with Hugh Manson, the custom-guitar man. Bad news: the Washburn isn't worth fixing and the Eccleshall/Grammar will cost. It has matching Brazilian rosewood back and sides, but the top is coming away. The original guitar belonged to Keith – he gave it to Mick, from whom I acquired it – but the neck was too flimsy, hence the major rebuild. I will soon have gigs and no guitar to use.

PROMENADE DES ANGLAIS

Meanwhile, the Stones had become tax exiles in France, due to the amount of money they were claimed to have earned and the over-exuberance of the Labour government in trying to grab large amounts of tax instead of keeping 'entrepreneurs' happy in their own country, using facilities and home-grown expertise. The band, and others, were forced to move abroad, the result of a policy that had far-reaching consequences.

Keith rented Nellcôte, a villa in Villefranche-sur-Mer near Nice, where the Stones were to record their seminal album *Exile on Main Street*. It was a large, rambling house on the Med, with

curious shoreline grottoes on the small private beach created by a previous owner. Now it had been reincarnated and was soon filled with musicians, technicians, helpers and hangers-on, some more useful than others.

In the summer of 1971, the Truck was parked up under the villa's palm trees, while recording took place in a tiny and extremely hot basement. It wasn't ideal, but after being chased out of their own country, the band were determined to make a good record. Mick sometimes had to fight the wall of sound that erupted from Keith and Mick Taylor's duelling as the drums and bass bounced off the walls, condensation dripping down them like in the rock & roll clubs of earlier days. The basement sessions would begin quite late, often after dinner, and continue through the night. Being the first to arrive, Bill Wyman would naturally be the first to leave, and then someone else would take over the bass duties.

Viv and I managed to travel to Villefranche to attend Mick and Bianca's nuptials. We stayed at the local *pension*, since Nellcôte was full of Keith's friends, including country singer Gram Parsons of the legendary Flying Burrito Brothers. I remember strumming a version of his tune 'Hickory Wind' to him, then confessing I'd forgotten the last verse. 'Sing the first one again,' he said – a good tip. One afternoon – for nothing happened in the mornings at Nellcôte – Keith announced we were going on a trip to nearby Monte Carlo. Gram, saxophonist Bobby Keys, Anita and several others jumped into his speedboat idly bobbing on the water. All of them were smashed and when Keith tried to pull up the holding anchor, it got stuck. As I was younger and sober, I offered to dive down to dislodge it from the rocks, and soon we were travelling full throttle along the coastline with Keith at the wheel, steering across and smacking into the waves, as he likes an element of danger. Nobody mentioned life jackets and had we overturned, there would have

been trouble. We finally reached Monte Carlo unscathed, sauntered around, took a drink and returned back up the coast.

Viv and I didn't attend the actual wedding, only the after-party. A local band played first and then a jam session materialized, with Bobby Keys and Stephen Stills guesting. Stills borrowed a black Gibson from the warm-up band's guitarist – obviously his pride and joy – and at the climax of his solo dropped it onto the hard stage, to the owner's consternation. The show was stolen, however, by Bobby, who came centre-stage and played some great rock & roll tenor horn. Good old Bobby.

IT'S A FAMILY AFFAIR

Vivian became pregnant, and in January 1972 the time was approaching for delivery – always a nervous period, particularly with a first child. Jenny, a friend of ours, arranged for us to stay in her parents' mews house in Kinnerton Street, Belgravia, just around the corner from St George's Hospital, overlooking Hyde Park Corner. This mews formerly served Wilton Crescent – a very grand 18th-century street often used in television period dramas – and Jenny's parents owned a house there, too. Her father had left Poland before the Second World War, set up in London as an industrial chemist and done well.

The hospital where Demetri was born overlooked Charles Jagger's massive Royal Artillery monument. Viv went into labour during the night, and in the early morning out came a beautiful boy. We were both so happy and in love then. After the birth the sun came up on a glorious winter's day and I walked across St James's Park to Westminster Abbey. I had been anxious about the birth and gave thanks, feeling very small in that place. A few days later we returned to Stargroves, holding the smallest baby in the largest house.

As Vivian was Greek Orthodox, we wanted Demetri baptized in that faith and arranged the christening through our friend Johnny Stuart, who dealt in Russian icons. Johnny was well connected and asked Father Anthony, the senior metropolitan bishop of the Orthodox Church in London, to perform the rite. This is a complicated piece of ecclesiastical theatre that involves the priest processing around the font with the babe in his arms, a full bath and a change of new white clothes. I believe Demetri was the last child to whom he gave this sacrament, for the archbishop retired from such duties soon afterwards.

As chance would have it, I'd already witnessed Father Anthony in action years before at my school's Sunday evening chapel service, the excruciating end of the school weekend. One evening, as we shuffled to our feet, we were surprised to witness sweeping down the aisle a black-frock-coated gentleman with an enormous grey beard, the metropolitan. When it came to the sermon, he eschewed the usual posture of leaning on the lectern and instead chose to stand relaxed and commanding centre-stage, where we could see him fully. I can't remember what he spoke about but it held us, and he was certainly heaps more interesting than most visiting tub-thumpers. Subliminally, too, it had an effect on me, as thereafter – for one reason or another – I was drawn towards the Orthodox end of the Med.

'DECK THE HALL WITH BOUGHS OF HOLLY'
Christmas at Stargroves in 1973 began with a call from Rufus Collins in London, the actor and director formerly with the Living Theatre, who I knew through Keith and Robert Fraser. He had brought the Bauls of Bengal over from India, for performances at the Roundhouse in London. 'Could they all come down and spend the holiday period in the country?', he asked

unassumingly. The Bauls are wandering musician-monks, greatly admired by the late writer and poet Rabindranath Tagore, who play devotional music with great gusto. Of course, I said yes.

In their bright orange robes, and feeling the cold, eight Bauls arrived on a damp evening and were billeted in a single room, preferring to sleep dormitory-fashion and have some good old pillow fights into the bargain. In tow was an older South Indian dancing master along with Rufus, joining my friends and parents, who were already there. The house party now ran to about 20 people – the more the merrier – but on top of that, I had a special consideration as I'd asked the local villagers up to the big house for Christmas morning drinks. (Mick covered the cost, which was about £50 – enough then for a few bottles of sherry and Scotch.) As we were the 'wild ones' up in the grand house, our neighbours viewed us with some suspicion, and I thought a bit of good PR might change that.

A few locals, including Mr Watts the blacksmith, knew of my plans, so on Christmas Eve, I toured the village to offer personal invitations to others, and found myself brushing past overgrown hedges and along dark passages to discover hidden back doors, which were opened by little old ladies I hardly knew existed: 'But I've arranged to see Mrs So-and-So,' they might tell me with a perplexed look, doubting they could come at such short notice. Many folk who had lived there all their lives had never dreamed of venturing up the beech-lined driveway to the big house, especially when the previous owner, Colonel Carden, was in residence. East Woodhay lies only some 60 miles from London, but many villagers had never ventured there either. One day in passing, I told an old boy I was off to London, remarking that I would be returning later. He pushed back his cap and with wonder uttered: 'And back

again…the very same day?' He didn't care for the place, as he'd seen it in 1932.

When Christmas morning dawned, I didn't know if my scheme would succeed, but tongues had been wagging and plans changed. Not that there was much competition in that sleepy hamlet – except from the pub, the Axe & Compasses, which in true English fashion had managed to alienate half the village. Mick's gardener Mr White had vowed never to enter there again after being told his boots were muddy, so he had to walk a couple of miles to the Furze Bush for a pint. The 'Axe' is now an estate agency.

Anyway, they arrived at the big house in their Sunday best, the men with clean-shaven ruddy faces and the ladies in their finest floral prints, stepping into a room the size of some of their cottages to be served by long-haired hippies and greeted by the dark faces of the Bauls. Many villagers had never seen Asian people, but before long everyone was mingling, some of the old boys removing their jackets and pushing up the stretchy armbands on their striped shirts to play on the snooker table, while others gazed at the colour TV – a novelty back then.

My Welsh musician friend Dave Pierce tinkled on the grand piano while the Bauls seated themselves on the floor in a circle and began to play their songs of praise to their altogether different god. Starting with long, clear notes, the sacred songs soon picked up tempo and damaru drums were whirled, tablas tapped, sarods plucked alongside the ektara, an amazing one-stringed instrument, and the sounds filled the hall. Lines were tossed from one singer to another and the chorus taken up by all, increasing the volume until unable to remain seated, the Bauls rose to dance, stamping their bare feet on the matting, their ankle bells ringing in time.

The cultural gap looked ominously wide but – caught up in the spirit and, as always, ready to shake a leg – Mum picked up a tam-

bourine and danced, aided by Mrs Jones, who ran the local shop. As the sherry flowed and laughter rang round the hall, runners were dispatched to remove half-burned turkeys from ovens in various parts of the village. However, country people aren't likely to overstay a welcome and they soon all departed, leaving only us two-dozen to our own Christmas dinner.

Numerous tables had to be arranged in the hall and, as the Bauls were used to their own food, it was an unusual Yuletide meal. My mother had brought only a smallish chicken for some reason, and a young Indian girl expertly carved it, although she wouldn't eat it. Mum insisted that everyone try her pudding because it wouldn't be Christmas without it – and the Bengali contingent were about to eat it when they discovered it contained mincemeat. There followed a lengthy discussion over whether mincemeat actually contained meat – and if not, why it was so called (most likely it was made with lard, but we didn't delve into the issue of the sacred cow). I guess my parents have witnessed a few out-of-the-ordinary situations involving both myself and my brother, but they have always coped well and taken the attitude that life is there to enjoy, so best get on with it. However, they weren't too happy about the Bauls throwing their orange peel from the bedroom windows!

My parents had also invited two of their friends, and one of them told us that, as she was standing at the bottom of the stairs, she had the sensation of a woman's ghost coming down the steps and passing her. Of course, in such places ghosts come with the fixtures and fittings. Later that Christmas evening, the dancing master with his long grey curly hair appeared, stepping tipsily down the large staircase to pick up the drumsticks and play with complete freedom on the kit set up there. 'Where is the Johnny Walker?', he asked, only to answer himself, 'That lady [Vivian] has taken it.'

DIARY

It's the Tuesday after Easter and most everything has happened here. Yesterday began nicely enough; my son Rob left in his van with elder brother John on the cushions in the back and I retreated upstairs to have a bath, although it was by now nearly 1 o'clock and the fish stew was bubbling nicely on the Aga. I had just splashed my bottom down in the water when Rosie [Kari-Ann's niece, who lived with us while at school] came running, shouting that Granddad had fallen down.

I pulled on a dressing gown to find Dad at the gate with a bleeding hand, along with Kari-Ann, who had hobbled there on crutches (after her accident), plus Demetri and my eldest grandchild, Isaac, looking concerned. A car had come from the back and Dad had fallen over his great-grandson, protecting him but hurting himself in the process, as his skin is paper-thin. We first went to Wells A&E – no good – then Bath Hospital, where we remained until 8pm. Many nurses and doctors came to see him and scratched their heads until finally the head of the hospital arrived and instructed the nurse to clean the wound and dress it! At one point, they wanted to keep Dad in hospital for 48 hours. Demetri was fantastic and a real help.

Isaac is zooming around with a multiple-shot rubber-band gun and playing with the dogs, which he adores. No call-back from Mick, and I have to speak to him about Dad's party.

CHAPTER 13

LET'S MAKE RECORDS

Front of Stargroves House.

Watching bands recording at Stargroves was all well and good, but what use was it to me if I remained an onlooker? I had the means to record, as the assistant engineer Jeremy Gee was staying, and he had become a friend; very useful, as he knew how to operate the board on the Truck. There was always downtime, when it wasn't in use and parked up and, fortuitously, I had a producer in John Uribe, who first came over from Los Angeles to record with sax man Bobby Keys and trumpeter Jim Price. John had thick, wavy dark hair, a low, wicked laugh and long fingers to wrap around his cherry-red Gibson 335. Originally from Billings, Montana, he had migrated to LA and had worked with Harvey Mandel, among others. He later contributed to *Nilsson Schmilsson*. He loved Stargroves and found it hard to leave the sanctuary. Bobby Keys, too, was to become a lifetime friend of mine; he was always supportive of my music and played on that first record, *You Know The Name But Not The Face*, and many years later popped up at the

Paradiso in Amsterdam to jam with the band on stage. He was a soulful player and always did his own thing.

John Uribe was fluent in a number of musical styles and proficient on the bass, too. Familiar with the recording process, he taught us the tricks of the trade and the standards we must reach if we were to be taken seriously. We needed material, so I called in Welsh musician Dave Pierce, who came down to stay, and we began putting songs together. Dave played guitar and piano, and it was handy having a Bechstein Grand in the hall, which he loved to hammer away on. I had lyrics and poems knocking around, plus we had a resident poet in Rick Watson who had followed me back to Britain and ended up living at Stargroves for a while. He knew a lot about the wordsmith's art and we incorporated some of his words into our compositions.

We began the search for a good drummer and found one in Mike Kellie, formerly with Spooky Tooth. The Brummie band were signed to Island Records and produced by Guy Stevens. Guy borrowed the name Mott the Hoople from a Sixties novel and gave it to Ian Hunter and his musicians, including Pete Overend Watts, also later to be a pal of mine. Guy had a little black book with band names in, and would sell you one if you paid him enough. On my return from India, I had played him some tapes of Tibetan monks – recorded in Tengboche monastery in Nepal on a Nagra machine by an American called Thom – with a view to their release. Guy rolled an enormous spliff in his office at Island and put the disc on at a deafening volume. He was quite crazy.

Kellie was holed up in a fancy pad next to a gravel pit lake near Reading that belonged to Island boss Chris Blackwell, so wasn't too far away. He was a pro, so we had to pay him enough to make it worthwhile to come over and record, and we laid down as many

tracks as possible with him as he was worth every penny. Kellie was tall and thin, his height accentuated by cowboy boots, and had long black hair; he would lean back on his drum stool and crack the skins in syncopated time. First off he was wary of us, but Uribe knew what was required and Mike fitted the bill perfectly. Like a few people around then, he was hoping for a call from Joe Cocker or another outfit to go out and tour. He later teamed up with Peter Perrett and The Only Ones, taking over the drum stool from my friend Jon Newey.

When Mike wasn't available, we used Roger Earl, who was also an asset. He was with Savoy Brown and had apparently auditioned unsuccessfully for Jimi Hendrix, later going on to success in the USA with his own band Foghat. Roger was very solid, which was the basic requirement; but one time we were recording a very slow track called 'Going Nowhere' and it was so laid back for him that Dave gave Roger half a Mandrax to chill out, and it did the trick. I met a cello player on the train down from London one day and he came and added some lines, too, a chance encounter; he was somewhat befuddled not to have written music in front of him but somehow got through it!

John Uribe showed us how to multi-track, first laying down drums and bass with guide vocals and rhythm guitar. We would overlay perhaps maracas and a shaker to build up the rhythm track, re-do the bass, and then Uribe would work magic with his guitar overdubs and all the effects he could squeeze in, often staying up most of the night to iron out little snags and glitches. All this took time but it sure showed us how to attain the standard. Finally, I would add the main vocals and we were sounding like the real thing.

None of this would have been possible without the assistance of the engineer Jeremy Gee and equipment man Stu. If Stu liked

you, then he saw to it that you were looked after. He was never impressed by star names, rather the opposite in fact; he supported struggling musicians and helped by lending them equipment and even recording them if the Truck was available. He would show up unannounced at any time and, if he liked the music, would give it a nod and disappear into the kitchen for a cuppa. He was understated like that. At one point, Stu announced that, as our project seemed to be lifting off, he was donating towards the 'bacon and eggs' expenses, as he knew we were pretty broke. What a diamond geezer.

All in, we produced around five tracks: enough, we thought, to give us a shot at a record deal. Marshall Chess, son of the legendary Leonard – co-founder of the Chess record label with his brother Phil – was working with the Stones on their recording projects, so it seemed natural to offer him the tape. (There was no consideration that the Stones' label would put out my project, as that might look too cosy.) Marshall said he could get us signed and set a time limit on it of around six months. I was prepared to wait.

OVER THE RAINBOW

To make ends meet, I took a job working at the Rainbow Theatre in north London, then run by the American entrepreneur John Morris. This was the former Astoria cinema, a huge place that held over 3000 people and boasted a Moorish-inspired foyer with a goldfish pond, as well as such other mad features like a Spanish village-by-night constructed above the stage. Now it has become a Pentecostal church and those amazing times are just a dream.

I rented a small room in the Balls Pond Road with the front door opposite a bus stop, so it was easy to get about, if a bit grim; whenever I had a few days off, I headed back to Stargroves. As in

my earlier Hampstead Theatre Club incarnation, I started out at the Rainbow as a dog's body. The sound quality was poor in the auditorium so we lashed up some basic soundproofing, jamming fibreglass rolls between chicken wire, stapling them together and placing them on the walls of the theatre. It was all done on the cheap. In the evenings, I was put on the lighting rig and one of my jobs was to run the spotlights from the very top of the theatre.

These 'super trooper' lights were powerful but also very smelly. You fired them up by touching the carbon rods together, which sparked them into life, then backed one rod up until the light was as white as possible and the fumes were racing out from the top of the vent. You then followed the singer or guitar player according to the lighting man's instructions. Of course, I couldn't leave my post during a performance, and if I needed a piss I would reach for the nearest receptacle.

The only time I had a visit there was from Dave Pierce, who brought engineer Nick Watterton in tow. Nick was a great guy; he looked after all the maintenance on the Truck and was a boffin. While watching the show, Dave picked up a stray beer bottle on a ledge, took a swig and passed it on to Nick, who took one gulp and immediately spat it out. It was my old piss from a week or more before! He wasn't so much cross with me as incredulous that Dave would actually *pass it on*.

From my vantage point, I came to see many bands and learned so much just from witnessing the top acts of the day, among them The Who, Mountain, Yes, Wishbone Ash, Osibisa, Gong, Terry Reid, Eric Clapton, T. Rex, the Faces, Frank Zappa, Pink Floyd, Heads Hands & Feet, Leon Russell, Poco, and Desmond Dekker. Backstage security was becoming an issue at that time and guests started to need passes, which were not always forthcoming. Prog band Yes did a series of shows, and backstage a big spread was

laid out – but there was nobody to tuck into it afterwards, so they either had few friends or they had all lacked passes. As a theatre worker you don't get many perks apart from seeing the show – most acts just ignore you and only deal with their own technical crews – and since these people can be demanding and quite rude, they can irk you, so there is a lot of amusing backchat on the headsets while you're waiting for the lighting cues.

WORD GETS AROUND, WHEN THE CIRCUS COMES TO TOWN

The Christmas show at the Rainbow was Chipperfield's Circus. I was manning the spots for that, and so came to know the routines and patter off by heart, from the Spanish knife-throwing hombre who used his wife for target practice to the high-wire act; from the jugglers and clowns to the showgirls – and of course, everyone doubled up on the acts. Animals still featured in those days and, as well as the monkeys and horses, these included elephants and lions. The elephants deposited the largest amount of dung on stage, but by far the smelliest poo was the lions'. There was even a tiger, and afterwards I wrote a song called 'The Monkey and the Tiger' which, though I've never recorded it, remains relevant. It's a conversation between the two animals about whether they should be in the circus, and I guess I got the cue from Rudyard Kipling, who wrote so beautifully from the perspective of animals:

The monkey, he said to the tiger:
'Soon all our jungle will be gone.
How can I tell the white man,
This was once our ancestral home?
Our days they are as numbered,
As the autumn leaves on the tree,

There don't seem to be no place,
Where we can roam and be free.'

Chorus
'So it's down on the sideshows of life.
Believe me, you needn't think twice,
Under those bright circus lights,
Down on the sideshows of life.'

One night, my friend the socialite Cara Denman invited me to a smart fancy-dress Christmas party at Christie's auction house in Mayfair. I asked Arthur the clown to make me up backstage, then jumped on the Tube, where everyone ignored me, and headed into town. I had a few tricks up my sleeve, as befits a clown, but realized once I arrived that most partygoers just liked the dressing-up and there was no acting it up, which seemed a bit tame. Many of the toffs I noticed had come as cardinals, so I went up to one (who turned out to be the Duke of Marlborough) and showed him my ring, which he briefly looked at before I squirted him with it. He was not amused. I think I was ejected after letting off a smoke bomb in the corridor.

After a while, I'd had enough of my digs and smelly London and went back to the countryside, despite no forthcoming record deal. My saviour, however, was soon riding into view in the form of Ronnie Wood, who introduced me to the Faces' then-manager, Billy Gaff. After listening to our songs, he signed me to his own GM Records.

ROCK ON, WOOD

Ronnie had always been very welcoming and friendly to me. He had two older brothers, Art and Ted, who schooled him in life,

music and painting. They could never figure out why they were so poor and he did so well, but Ronnie was always appreciative and acknowledged their assistance. I sang a couple of times with Art.

When the Faces were riding high, Ronnie bought a house at the top of Richmond Hill – The Wick – the most ideal place you could wish for: close enough to the centre of London but right next to the open space of Richmond Park and with far-reaching views of the Thames as it winds through open fields, looking much as it did when Turner painted the scene. At the bottom of The Wick's garden is a cottage where Ronnie's first wife, Krissy, lived after their divorce in the late Seventies. Later, Ronnie Lane used it. The previous owner of the house had been the actor John Mills, and the bedrooms still bore the names of his children on fancy plaques. Pete Townshend lives there now.

Ronnie had a small studio in his basement where I recorded some tracks one time with guitarist Sam Mitchell, and I recall a jam session with Paul McCartney, playing all his favourite rock & roll songs. Ronnie had set up a reel-to-reel videotape machine and he delighted in running old black and white films, particularly those of the Marx Brothers, which I had never seen. Before long, we were all doing bad impressions of Chico and Groucho, and tapping invisible cigars. Keith Moon was also a regular there, drinking brandy and ginger. Courvoisier was very much the Faces' drink of choice, and large amounts were consumed on and off stage. A pal of Maldwyn's, Danny, got the job of chauffeuring the band around but he wasn't a good choice, for often when it came to ferrying them home after a party, Danny himself was drunk!

HARD ROCK STORIES

Throughout this period, I was forging a close friendship with Isaac Tigrett, co-founder of the Hard Rock Cafe. He was also a great

pal of Rok Brynner's, and often came to stay at Stargroves. It was there that I remember us first coming up with the idea of collecting rock & roll memorabilia, which seemed crazy at the time. Initially, musicians just presented the stuff to Isaac. (An old broken guitar? Sure, stick it on the wall for decoration, what else would you do with it?) Little did we know!

The Hard Rock Cafe went from success to success and is now a global brand worth billions, but when it originally opened in London's Piccadilly in June 1971, the building was due for demolition after six months. The surrounding area at the south end of Park Lane was destined to become another ghastly tower block of ritzy apartments. The restaurateur Peter Morton had opened the Great American Disaster in 1970, a successful but small hamburger joint on the Fulham Road. Teaming up with Isaac, they both began to think bigger. I first heard the expression 'location, location, location' from them, and that's what they proved when the Hard Rock was established right at the bottom of Piccadilly where the traffic thunders past.

I'd first come to know Isaac through Nick Smallwood, who had been a chef for my brother in the small basement kitchen at 48 Cheyne Walk in Chelsea. (Apparently, Bianca would come down to check what was going on and add Tabasco sauce, to make sure the dishes were spicy enough.) Nick was recruited by Isaac to run the Hard Rock and it was probably the smartest move he made, because it was Nick who made the place tick. Nick knew who to hire and how to keep the staff happy, creating the atmosphere, the friendliness and service, good burgers and excellent music – not something much in evidence at that time.

Isaac's favourite track was 'Going Down' by Freddie King, played at high volume, while he flipped the pinball machines on a raised area looking out across the joint; Peter Christian

was in charge of compiling the cassette tapes and he did a good job. London wasn't used to loud rednecks, but they lined up devoutly for the experience.

The Hard Rock became a home from home for our friend and mentor John Uribe. He would hang there, eat there, meet friends there, and take calls there, sitting up at the bar, chatting to the waitresses and having the occasional drink. Isaac would often take the table next to the entrance and hold court with his pals, Rok Brynner, the artist Alan Aldridge (who designed Isaac's logo for peanuts), and many an American muso in town. They all loved the place. Isaac once challenged me to a drinking contest, the only time that has ever happened to me. I lost, and struggled to reach the downstairs loo to be sick, most likely after Jack Daniel's.

It was 'the Jack' that Isaac claimed was the cause of some severely rowdy acts when he was arrested in the West End and thrown into Bow Street jail for the night. A large piece of hash was also involved, and the following day, after he'd been hauled in front of the beak, Isaac asked the police if he could have it back but they politely declined. When the magistrate enquired what had caused his violent behaviour, Isaac apparently replied, 'Sir, it was the Jack Daniel's,' and he duly received a fine.

Along with my band, I was the first musician ever to play the Hard Rock Cafe, on top of a makeshift stage laid on the bench tables. After that, Nick asked me if Paul McCartney and Wings might do a gig. We went to his St John's Wood house to ask, but the gate was locked, so we climbed over the wall and knocked on the door. He did play there in the end.

I had many friends who worked at the Hard Rock as busboys and waiters. At one stage, my old travelling companion from India, Rick Watson, ran the bar, mixing the drinks, while Vivian ran the till, an important job.

My last involvement with the place was in the Eighties. Every Christmas, a huge tree was erected in front of the building and one year I offered to design the decorations, likely carried away by my theatrical experiences and the desperate need for some seasonal cash. With the designer Pat Townshend, of whom more later (see Chapter 18), we sculpted separate dishes to imitate split hamburger buns, had a number of them vacuum-formed and then spray-painted them, placing lights inside and gluing them together in pairs. The light emitted from the holes represented the sesame seeds: what could possibly go wrong?

I was given the job of dressing the tree, too, so on a fine December morning, I rose above the fumes of Piccadilly on a cherry-picker to adorn the branches. Luckily I don't get vertigo, but it was a bit hair-raising as the thing must have been 40 feet high. In the end, the tree looked fabulous, resplendent in all its ribbons and whatnots. However, Isaac had disappeared to India to see the guru Sai Baba, leaving a bossy subordinate in charge, and she started complaining about things, not least the colour of some of the ribbons – a lovely purple – which she said was unsuitable because it was associated with Easter and death! We had to hurriedly change all this, to our extra cost and effort. And as we were working on redecorating, an American girl passed by and commented: 'Look, hamburger lights, how tacky!' We'd thought they were pop art masterpieces.

Isaac launched a branch of the Hard Rock in NYC and carted across there wooden tables adorned with carved names, which were suitably 'distressed' on arrival; when the joint opened up, it looked like it had always been there. He had resold hamburgers to the USA! In the same spirit, when he started his first House of Blues in LA, the exterior was clad in corrugated iron so that it was hardly noticeable from the Sunset Strip; all very original at the time.

DIARY

Just returned from Penzance, Cornwall, where I played a one-nighter with pianist Ben Waters at the Acorn Centre, which was fun. I like to just get out and sing; it's like a glorified jam. Perhaps I can do more if it works out. I stayed with fellow musician Demelza Val Baker. My Cornish antiques friend Trader Gray, from Shiver Me Timbers salvage yard, is still in India, and I heard about his mountain bikes appeal; it seems he has shipped some 300 over to this small village where the kids have nothing, so he must be a hero there.

Dad was fitted with a pacemaker today and will be back home tomorrow. Mick is about, and I spoke with him but he was a little distracted. I organized a gig at Glastonbury Festival, too. Amazing that a festival that generates upwards of £40 million in ticket sales alone should have no money to pay little bands like ours, not even expenses. It's embarrassing. I wonder where it's all going?

Sad news, too: the 14-year-old next door, who had mild Down's syndrome and went to the same school as Kari-Ann's niece Rosie, had a heart attack early this morning and died. I have to write this piece on the Citizens Theatre but can't quite get my head around it. You need quiet and concentration to write. And no interruptions.

SOHO

Music manager Billy Gaff had an office on Wardour Street, Soho, and it was a hive of activity. The Faces often dropped in to talk and draw cash, their roadie, Pete the Fish, worked from a room there as well as the American road manager Chuc McGann. Among the Gaff stable was singer-songwriter Lesley Duncan, a protégée of the arranger Jimmy Horowitz, who worked with Elton John, and David Bowie recorded a tune of hers. Other names on the roster included Strider, a solid rock band, and Andy Bown, a solo artist before he joined Status Quo, who were also signed to Gaff.

Andy had worked with Peter Frampton and The Herd, and I came to know Peter a little, with him playing guitar on a track of mine. When at Eltham College, I had dated the same pretty girl as him – Mary Lovett, later to be Mrs Frampton – sometimes picking her up in her navy uniform from the gates of Beckenham Grammar School for Girls.

Long John Baldry, a stalwart of the music scene, was signed to Billy's label. His earlier band Steampacket had featured the young Rod Stewart and Julie Driscoll as backing singers behind his gruff baritone, all embellished by Brian Auger's Hammond organ lines. After they disbanded, a young Elton John played the piano with Baldry, so it was all entwined – musically, socially and probably sexually. Long John later recorded 'Like a Dog', a tune that Andy Bown and I wrote, with lyrics by Rick Watson and arrangement by Jimmy Horowitz.

The American folk singer Tim Hardin was in London, and also signed to GM. (His song 'Reason to Believe' became a big hit for Rod many years after it was written and was the B-side to 'Maggie May'.) Tim was a heroin casualty, who had developed his habit as a US Marine while serving in South-East Asia. Gaff tried to help him straighten out but Tim just couldn't kick it, dying before he reached the age of 40. Maybe that's one reason he wrote such melancholic tunes.

Everyone drank in the Ship, down the street, or the Intrepid Fox, close to the Marquee Club where everyone performed – though, alas, not myself. (Gaff even bought the place for a while and it's a shame it was allowed to close and become just another Soho restaurant.) My songs were pretty ragged in 1972 and my playing basic – and that probably counted against me at a time when everyone was trying to emulate an American sound and standard. Had I been born a few years later, it might not have mattered, as I

could have fitted into the punk era and been as crass as I liked.

Gaff licensed my recordings to David Geffen and Asylum Records in the USA, thus making an instant return on his investment, and as John Uribe had gone back to LA, Dave Pierce and I decided to follow him there and finish what we had begun on the Truck. Violinist extraordinaire Tony Selvage met us in a limo at the airport and guided us across the city to Santa Monica and a comfy apartment that Dave had found for rent in Pacific Palisades, at the end of Sunset Boulevard and close to the ocean. It belonged to the elderly Clara Bartlett, heiress to the tinned pear fortune, who lived downstairs, and I can't recall her complaining about the noise too much, though we had some good parties there.

Desi Arnez Jnr., son of Lucille Ball, once the biggest TV star in the USA, came over one night with his drum kit to jam. There was also a Steinway grand there – once owned by Judy Garland's musical director – and Dave had it restored in order to bang out some rock & roll. Cher popped by one day and was very friendly; she picked up a book of Native American verses that I had and told me it wasn't a very good one, but she must have clocked my interest.

COMMITTED TO ASYLUM

David Geffen was accommodating and we got on well enough but, as I was Asylum's only artist from the other side of the pond, it was a long shot to sign me; he should have really suggested I move out to LA for good, which was probably the only way it might have worked. I was never going to be another Jackson Browne, his very first signing, but David had enough money not to really worry about it.

Competing with the likes of the Eagles and Joni Mitchell was a tough call. Dave Pierce and I hired Devonshire Sound Studios to finish the existing tracks, and cut a few more with John

Uribe's Topanga Canyon crew and the Elijah Horns, bringing in P.P. Arnold and Claudia Linear for back-up vocals. I made the mistake of counting out the dollars for Pat's session and her eyes lit up on seeing the cash, pushing me for some extra bucks. Glyn Johns was in town and agreed to mix the record for me, and did a good job.

Tony Toon, who worked with Billy Gaff on PR, dreamed up the first album's title, *You Know the Name But Not the Face*. It was a cute idea – but of course brothers' faces are quite similar, so maybe it didn't have much mileage in it. For the cover, I took a photographer to the studio off Melrose Avenue that belonged to my good friend, the artist Kenneth Kendall, who I'd first met in London as a friend of filmmaker Kenneth Anger. His LA house, crammed with art deco lamps, sculptures and all manner of wonders, proved to be an inspired choice. I was photographed under a Spanish arch, adorned by Japanese Noh masks, and I couldn't resist holding one up to my face, and that single frame became the cover shot. If people bring it to me now to sign I say, 'Ah, that was when I was young and good looking.'

It was all very well making a record but now I had to sell it. That was another matter entirely, and I was a bit slow to realize it.

CHAPTER 14

YOU KNOW THE NAME BUT NOT THE FACE

Once the record was finished, I plodded around the UK to do promotion, but I really needed to get out on the road and play seriously, as stablemates Status Quo did – and it paid off for them. I had little experience of this, and Billy Gaff was concentrating on his management of Rod Stewart and signing other pretty-boy acts, so I was largely ignored. The record did show up in the lower reaches of the US *Billboard* Top 200, just above *No Secrets* by Carly Simon, an altogether more successful album.

I was offered a US tour, opening for Frank Zappa, which everyone told me was the kiss of death, but nonetheless, I was keen to go. Andy Bown suggested we recruit Chris Stainton on piano and Bruce Rowland on drums, which would have made a pretty good band, and we had one try-out. But they backed off, likely preferring to hold off for a better offer than play with someone as inexperienced as me.

I appeared on the *Russell Harty Show*, the equivalent of the top-rated *Graham Norton Show* today. For the band, I brought together Sammy Mitchell on guitar and Dave Pierce on piano with Pete Sears on bass, an excellent player who subsequently left for the USA to play with Jefferson Airplane. I asked Micky Waller to play drums and had to hire him a kit, as he didn't own one at the time. Nicknamed 'Sticky Wallet' by Sam, Micky later successfully took Rod Stewart to court for non-payment of royalties on 'Maggie May', even studying law for the chance to get his own back. Vivian and I were then living in St John's Wood under the roof of an American clothes designer, who had made a long fur tunic with fox tails hanging down like a shaman's coat, and I borrowed it for the occasion. It was open at the front, and with nothing under-

neath, it revealed my not-too-developed chest. I guess I wanted to be noticed.

The show included the veteran comic Jimmy Edwards, who I had watched many times on TV as a teenager. He actually had a kids' weekly series called *Whack-O!* about a black-gowned schoolmaster not averse to handing out 'six of the best', which was revived in the early Seventies. A silhouette of the comedian blowing a couple of notes on the tuba was shown before the softly spoken Harty announced Edwards. Being somewhat inebriated, he grabbed a cleaner's mop from a nearby bucket and ran onto the stage crying, 'Charge!' The floor manager shouted 'Cut!', and they began again. Just as well it wasn't live. Our performance was good and I had a brief interview with Harty, though it didn't attract as much attention as a later one when Grace Jones slapped him.

In the hospitality room afterwards, a large spread was laid out and for no reason at all a food fight started, which naturally annoyed the authorities – but not as much as the drummer's Boxer hound. When I'd asked Mickey along, he'd said that he would have to bring his Boxer to the studio, as there was nobody else to look after it. Alone in a strange room, it shat on the carpet and we were billed for a new one, at some cost.

VALENTINE VOX

A year after the first album, I started writing songs for another and decided to record at Rockfield studio in Chepstow, on the Welsh border. I knew Alan Spenner, who played bass with the funky band Kokomo, so I wanted to use him and the guitarist Neil Hubbard, both of whom had been in Joe Cocker's Grease Band and appear in the footage of Cocker's Woodstock set. My friend Steve Smith, who'd worked a lot with Chris Blackwell at

Island Records and was another American habitué of the Hard Rock Cafe, came to produce, along with engineer Phil Brown.

By now, Demetri, Viv and myself were living on the ground floor in Bramerton Street in Chelsea and renting from Catherine Tennant. Right before I was due to leave for Wales, I went to a party with my pal the Russian icon expert Johnny Stuart, and it turned out to be a big mistake. A Welsh guy who I knew by sight, aptly known as 'Taffy', came up to me, put a grape in my mouth – and it was spiked with acid. Not knowing what was happening freaked me out, and I wanted to leave the party as my mind was racing. Johnny took me home on the back of his old Norton bike, which blew my head off. Once back there, I lay on the bed with Vivian and Demetri and my lurcher, Sarah, convinced I was about to die. Whatever was given to me was some bad stuff, and if I ever catch up with Taffy again, I would like to stand on his head.

I got to Rockfield only to find out that the drummer I'd booked, Gerry Conway, hadn't made it and Terry Stannard from Kokomo was there instead. This would have been fine, until I realized that the band wouldn't get out of bed until three in the afternoon because they partied too late. We cut a couple of tracks, then fired the band and luckily Andy Bown came to the rescue. We wrote some tunes pretty fast and he lifted the tempo on the sessions, as he was a positive guy. On drums, we brought in Pick Withers, who has a great feel – he later joined Dire Straits – and on guitar, the American session player Jim Ryan, with Andy playing bass and some piano, and Dave Pierce alongside. But while there was a much better atmosphere, unfortunately we had already blown most of the budget. Consequently, the album might have been a lot better – but then, you can always say that.

The guitarist Dave Edmunds lived nearby so I went to visit him and see if he could overdub some slide guitar on 'Like a Dog'.

Dave was sitting on the floor of his living room with his vintage Gibson semi-acoustic, surrounded by old LPs that he was playing along to, copping the licks off Scotty Moore. (I would later get to meet Scotty, who is a massive influence on guitarists for his work on the early Elvis records.) Dave was interested in the short solos and, as soon as each ended, he scrunched the needle back to repeat the performance. His contributions to 'Like a Dog' were very tasty, but he could not understand why it wasn't a 12-bar.

I wrote 'Yesterday's Sun' with Dave, all about running out of oil, which remains relevant to this day – though at the time, it was prompted by an oil embargo: 'She's the jewel of the sheikdom's rule/ but so cruel to Neptune's world./ How long can you, go on/ living on the strength of yesterday's sun?/ That underground pool/ of fossilized fuel will soon be gone.' Seems now we are not quite running out of oil, but the fossilized fuel carbon problem remains.

The keyboardist Jean Roussel, a fine musician originally from Mauritius, also came down. Riding on his success with Cat Stevens, he was a heavyweight player in more ways than one, and made a big deal of returning to London to play with Joe Cocker. The guitarist Jim Ryan (who played on Carly Simon's 'You're So Vain') was also going back to town, so he agreed to take Jean. Jim pulled his old Porsche up in front of the studio, we stood there to say goodbye, Jean climbed in – and the springs dropped right down to the wheels, so he had to take the train instead.

The guitarist Neil Hubbard, who appeared on the first few tracks, came to play on my latest record, so we can laugh about those times now, but for one reason or another his band Kokomo never fulfilled their promise. I heard one story that they were taken over to the USA to provide the backing for a new Bob Dylan album, *Desire*, but he kept them waiting over many days with nothing to do, so they became bored, and when the great

poet finally showed, Jim Mullen, the band's Scottish guitarist, said something blunt like 'So you finally made it then?', whereupon Dylan turned around, never to be seen again, and Kokomo were left holding a one-way ticket back home.

For the album sleeve I was lucky enough to have Peter Blake as the creative force. I had picked up a curious Victorian novel – Henry Cockton's comedy, *Valentine Vox* – and liked both the name and the story, in which the hero throws his voice around in social circles, creating havoc. All this music-hall stuff appealed to Peter as well, and he produced an ancient dummy with which I posed in a photo taken in his studio in Wellow, Somerset. Peter had bought the old railway station building in the village for a paltry sum after Dr Beeching was brought in by the Labour government to close all the charming branch lines, and he would sit contentedly there on the platform – the old track now covered with a fine lawn – looking out onto rolling swathes of countryside. Peering out from the converted waiting room of the station was a life-sized figure of Sonny Liston in a white silk dressing gown, created by Peter's partner, pop artist Jann Haworth, and seen on the famous *Sgt. Pepper* cover. Peter reckoned it kept the burglars away.

Peter agreed to do the artwork, so long as he owned the copyright; which was understandable after his *Sgt. Pepper* debacle. He has always been very friendly, since the Robert Fraser times, when I first knew him. He was also a great mate of Ian Dury's – particularly as he had been Ian's art teacher at Walthamstow College, and that later led to one of Dury's songs, 'Peter the Painter'.

FIND A BAND, YOUNG MAN

It had been complicated enough putting together musicians for the recording. Now I needed to take the album on the road and I was on the lookout for a band. I heard Paul McCartney was

recruiting a drummer for Wings, so I went along to a London theatre where he had a kit set up for the candidates to play. Although Paul let me sit in the circle to watch, my eventual choice, John Halsey, actually came on the recommendation of bassist Steve York. Steve was a founder member of Vinegar Joe, a band set up by a school friend of mine, Pete Gage, together with singer Elkie Brooks – who shared the vocals with Robert Palmer. Robert had taken over the rental of Chris Blackwell's house in Theale from Mike Kellie, and we would sometimes jam there; he always taped it, so you never knew when your idea might get recycled.

On stage with Steve York on bass and cigarillo.

Steve York recalls getting off a plane at Heathrow after a Vinegar Joe tour to be met by a limo driver who brought him straight down to Stargroves, where we did some recording together. One track had a good reggae feel, and when we later played it in the USA,

some fans came up to ask what the weird beat was, as they had never heard reggae before. Steve is a dynamic bassist and combined the solid foundation that you need to hold the groove with a lively musical brain, allowing him to make a big contribution to any outfit he joined. Already a veteran, having played with organist Graham Bond and Manfred Mann, he went on to work with such top artists as Dr. John, Pete Townshend and Marianne Faithfull, before moving to the USA to play with singer-songwriter Laura Branigan. Not only that, but he could blow the harmonica and perform a knee-slide on stage.

Drummer John Halsey was known as 'the Admiral' and had kept time with a lot of good bands, his main gig being with Mike Patto. Apparently, Patto actually played cricket on stage on one US tour, and I later inherited the band's cricket bag, with 'The Rotters' written on the side. John is probably best known for being the beat-keeper in *The Rutles* – Eric Idle's Beatles spoof – and he has the deadpan humour typical of his native Bethnal Green, in east London; some of his family were in music hall and way back they were blacksmiths, so he was admirably equipped to play drums.

I'd originally met the Admiral at the Fender Soundhouse in Tottenham Court Road, where guitar player extraordinaire Colin Pincott worked and which had a rehearsal space and a vast array of instruments and accessories. One scam there was to bring an empty guitar case into the shop and put it down on the floor; on leaving, hey presto, it was miraculously heavier. The large premises caught fire one night, so no one was the wiser re the inventory. Not that I was ever the recipient of stolen goods, your honour.

Halsey struggled to support his family throughout his drumming career, taking extra work to pay the mortgage. For a time he ran a wet-fish van-round, rising at 4am to go to market – so if there was a late gig, he might be seen nodding off over the snare.

With the Admiral and Yorkie, I had a good band, complemented by Dave Thompson on piano and a 22-year-old Canadian on guitar, Bob Cohen.

Many years later, Halsey had a head-on collision after leaving a Joe Brown gig in the early hours, when a car appeared on the wrong side of the street. Eventually, he recovered, though his walking was a bit wobbly – but Clive, the bass player at the same gig, received brain damage and was never the same again. I organized a benefit at Dingwalls in north London to raise some cash, and we had a good turnout to hear disparate acts – including his old pal Roy Harper, who made the audience all sit down to listen!

DIARY

Back at base after a couple of days in London. On Sunday, we celebrated Dad's 90th birthday again – this time for more people – at Cambridge Cottage in Kew, neither in that town nor in any way a cottage. All Mum's family were there but not a Jagger in sight, bar Mick, me and our families, who admittedly do number a few: Elizabeth en route from Paris to New York; James, Gabriel and Georgia; my sons John, Robert, Demetri, and Julian with his wife Jo, plus Viv, too.

After champagne, there was a sit-down meal of lamb chops and mash, and Mick and I both said a few words. John Disley spoke, as did Uncle Horace, who is still having breathing problems. Mick chatted a bit to Horace's son Roy, who'd lent him some records back in the day, such as The Diamonds and Frankie Lymon. Roy was a rocker and had a greasy quiff. He would push his motorbike some distance off from his parents' house so the roar of the engine didn't annoy their neighbours.

Also there was Auntie Eve, our former neighbour from Denver Road. She was smartly dressed, too, retaining her style. Her son William brought her – he was best friends with Mick when they were at Wentworth Primary. I introduced Eve to Edna Chance, who lived

across the road at Wilmington. They were both friendly with Mum but, really, they are chalk and cheese. The day – the 18th – marked the third anniversary of Mum's passing, in fact.

On Monday, Atcha Acoustic trio played at the Bull's Head in Barnes and drew some 100 people, a good crowd for a Monday night. The gig went pretty well, with Ben rocking out on the grand piano there – a rare thing these days – and Charlie and me filling the spaces between on the ample stage. A girl came up to sing and play piano, and I understand Mick Fleetwood is investing in her career so maybe that's one for the future? Kari-Ann and I stayed at Dad's later. He came to the gig in his smart blazer and enjoyed himself, I think.

STATESIDE

After a few shows and festivals around the UK, we set out for the USA; breaking there is always the aspiration for British musicians. As soon as we reached New York, the Admiral made a beeline for Manny's Music, the legendary family-run business on 48th Street, where the walls were covered with photos of every famous musician ever to have shopped there, a *Who's Who* of the biz. The reason for this dash was that, just before we left, our van had been in a bad crash; all the band kit had been trashed, though luckily our road crew escaped unhurt. John bought a yellow Ludwig kit at Manny's and still has it to this day.

We began the tour at the Bottom Line club, a great place, alas now closed, and received a good review in *Variety* magazine. Yorkie knew a jazz drummer who was working with Salvador Dali and one time he picked us up in Dali's limo, the interior of which was covered in his artwork (every time the master travelled in it, he would draw something). Then we flew out west to small towns and joints that wouldn't have known us from Adam and the Ants and couldn't have cared less.

Pianist Dave Thompson was busted at the airport coming into Baton Rouge, Louisiana – just like in the song 'Me and Bobby McGee' – and was hauled off to jail. That night, the band sounded tighter than ever, and we realized Dave hadn't been playing the right chords on some of the numbers. We had a whip-round to raise his bail money – which meant we were locked out of our hotel rooms the following night, as we didn't have enough in the kitty to pay the bill.

We appeared at Mother Earth in Austin, Texas, as well as in Florida and in a football stadium in Charlotte, North Carolina. This was an all-day event featuring Billy Preston, Leon Russell, Elvin Bishop, Lynyrd Skynyrd and ZZ Top. We were the opening act, so when they told us to begin, I pointed out the stadium was empty. 'They'll come as soon as they hear you,' I was told – and sure enough, as soon as the first guitar chords were struck, fans poured over the rim of the stadium like ants in the distance, hooting and hollering. So it was as auspicious to begin the show as close it – or that's what I told myself.

Proceeding to Atlanta with Billy Preston and his band, we played with him for three shows, which were great, though following his set wasn't easy. He took us to Mrs Hull's soul food eatery on the edge of town; in fact, the dining-room table of her own house, where she cooked all the food you could wish for – greens, roast, biscuits and gravy – all for a few bucks.

We criss-crossed the USA, frequently bumping into Bad Company, who were just breaking out then, and were on the same bill a couple of times. That was fun for John and Steve, who were friends with the band's bassist Boz Burrell and drummer Simon Kirke.

One night, we played on the same bill as Edgar Winter, brother of Johnny, and he had a very funky band. His roadies ran a

'Clap-ometer' on the stage to monitor the crowd's response, and at his finale the cheering sent it into the red before it blew up. On the East Coast we opened for the New York Dolls, who had a reputation for being outrageous. Trying to outdo them, I climbed onto a large speaker – which was a bit mad – and then had trouble getting down. As it happened, the Dolls were well out of it and largely stumbled through their set.

We came to Los Angeles and were due to play the famed Whisky a Go Go – but thanks to too many late nights and early flights, I'd lost my voice. David Geffen sent me to see a top doc in Hollywood and, when I went in for the steam treatment, Alfred Hitchcock was sitting there with a towel over his head. (At the time, I didn't even realize until the road manager waiting in the lobby told me that Hitchcock had plonked himself down next to him. He was speechless.) I still wasn't right, but we had to play the show or we wouldn't be paid, so we sent out an SOS and the night turned into one long, mad jam.

The all-girl band Fanny showed up and their pianist climbed high up to a side section where Dave Thompson had fallen asleep over the keyboard. We hauled him to one side and the show continued. Guitarist Henry McCullough appeared and played some great licks but he was also the worse for wear. Someone had picked up a stripper in the Midwest and she came on stage – but since she wasn't doing the full monty, Henry took a hopeless lunge in an attempt to remove some clothes and ended up flat on his face, his Gibson guitar flying free in front of him. It was that kind of a night. Keith Moon came and was trying to get Steve York in a headlock but he was such a pain that we had him chucked out. That remains the only gig at which I lost my voice, so I learned my lesson.

We were booked for a couple of TV shows and the first of them got us into more trouble. This was the famed institution *American Bandstand*, hosted by the clean-cut Dick Clark. We were shown to our dressing rooms, which had recently been repainted and were still wet and smelly. Dave was getting his wardrobe together and brushed his coat on the door, smearing it with paint. As revenge, he wrote on the wall 'Fuck you, Dick Clark', and after the show we received a letter banning us forever more, citing 'lewd words with accompanying musical notes'. As I said, we would have done well enough in the punk era.

The second TV slot was better as it was live – unlike *American Bandstand*, where we had to mime. (This is actually quite hard to do and makes musicians look like idiots, but of course it's much easier for the technical staff.) *Midnight Special* was more akin to the BBC's 'progressive' *Old Grey Whistle Test* and I was quite nervous about it; we were up against The O'Jays and Flash Cadillac & The Continental Kids, who had an amazing dance routine and snazzy suits, very American and professional. The TV people insisted I change some lyrics, as they were too suggestive, and banned us from playing 'Everybody's Got a Finger in Your Pie (but I had all the gravy long ago)', and changing the words for 'I'm Just Another Little Cat Like You' – in which 'fish' is rhymed with 'lick out your dish' – declaring, 'Anything to do with seafood is out!' The show was taped and went out later in the week, so I was able to watch it. We appeared at the end and I was pleased to find that our songs and performance looked quite natural and fun; we weren't really pretending anything, while the other acts looked like pastiches of rock and soul.

I read one of the last interviews that John Lennon did from the Dakota building in New York before his horrible death, and his

attention turned from the journalist because he was waiting to see my appearance on that TV show. He was sympathizing, saying how hard it must be for me, but actually appreciating the music at the same time. The interviewer suggested that I could change my name, but John countered with: 'Ah, then they might not have asked him in the first place!' And that might be true. Or not.

Unfortunately, that was practically our last shot in LA; we were due to return home so couldn't take advantage of any interest. Bands that did well there ended up staying on and living there: you have to be available at all times for shows and media, and that's always been the case. As it was, we struggled to leave our hotel on Sunset Strip, the Continental Hyatt House (more affectionately known as the Continental 'Riot' House). The bill hadn't been paid, as Billy Gaff had disappeared after promising Rod Stewart's album to two different record companies, which proved rather complicated.

My pal Rick Watson was then in Hawaii, where his space-scientist father had retired, and I took a flight out there to meet up. It's a long way but it was worth it. When I arrived, Mona Loa on the big island was erupting and there was great interest. We managed to gain access to a closed-off area around the volcano through Rick's father, who knew some geologists taking measurements there and assisted them in a small way. We reached the caldera and gazed down as fire and molten rock was propelled into the air, producing amounts of foul-smelling sulphur that penetrated our masks. It was very exciting walking over the warm lava flows, where escaping gases were causing small explosions. We explored – a little dangerously – and after retreating from one edge, we saw the ground on which we'd been standing plummet into the fiery mass below. Apart from being very exciting, it was strangely creative, witnessing the earth very much alive and roaring, Madame Pele, the goddess of the volcanoes.

There are two types of lava flow on the island, one smooth and the other broken up, 'Pahoehoe' and 'Aa' respectively, so I couldn't resist a Lear-style limerick:

A geologist came from afar,
Hoping to raise up his star.
But with one great mistake,
He sealed his own fate,
Mistaking Pahoehoe for Aa.

AFTER-TOUR BLUES

Returning from the USA was a sobering process. While there, I had one offer to stay and form a band in Cleveland, Ohio, an industrial sprawl of a place that didn't appeal too much, so I passed. In London, when I had a meeting with Billy Gaff, I discovered that all the money from Asylum Records had been appropriated for the tour expenses and I was skint. It was my fault; I hadn't used the advance to buy a house for Vivian and me – and I had been looking around before I left, but always some complications got in the way.

Property was relatively cheap then, not that we realized it, but you could buy a house in a pleasant part of London for £20,000. Practically all the solvent musicians I know have made their money from property, achieving home ownership at the right time and moving up the ladder, but I was not going to be one of them. Viv found a good flat to rent in Maida Vale through a kind friend of Mark Palmer's, Penny Cuthbertson. (Lucian Freud had lived close by and had painted Penny in the flat.) Another previous tenant had been Marc Bolan. By a twist of fate, Kari-Ann had just moved out from the next-door flat and was off to join her partner in the Dorset countryside, as she

didn't see the point of working all day as a model and paying for someone else to look after her son. Vivian went off to study at the Chelsea Physic Garden to learn about herbs and gardening, as you could in those days.

My local watering hole was The Warwick Castle, where I met Tom Newman, who had worked as sound engineer for Mike Oldfield, the man who kick-started the Virgin empire with his ground-breaking *Tubular Bells*. (Branson had a couple of boats on the nearby canal: one serving as an office, the other as a studio.) The drummer Willie Wilson, who had been in a band with David Gilmour, also drank there, as did other musos looking for a break. I worked there for a while behind the bar but the money was crap; £4 an evening shift, which included cleaning up after the drinkers had left. As a special 'gesture' we could have an after-hours drink with the landlord, Harry, providing we paid for it, which I never did. Before computers we would tot up the cost in our head as the drinks were ordered, then ring up the total and hand out the change, so it was much faster than the current system where every peanut is accounted for. Harry didn't fully appreciate us, though, and announced he was hiring an ex-squaddie from Northern Ireland to manage the place. It went okay till Harry disappeared for a break and the squaddie did too with the week's takings, so it was back to us part-timers.

A guitarist called Steve drank there and ran a decorating operation and press-ganged me into joining him, slapping emulsion onto walls to keep the wolf from the door. It's fine to do this work casually, but you soon realize that you need ladders, overalls, brushes and a van, so it becomes a proper business before you can say Pablo Picasso. One commission was David Hockney's old Notting Hill apartment, which had been bought by the architect Tchaik Chassay, co-founder of the Zanzibar and The Groucho

Club. Another was a Kensington restaurant fronted by the well-known transsexual pioneer April Ashley.

Pubs were important back then as they had a phone, and it wasn't unusual to call in to track people down. If you wanted, say, a plasterer, you might be informed he drank at The Red Lion, so you'd call him there at 7pm to book him for a job! You often popped in there of an evening, too, while walking the dog; people weren't so uptight then and it was a good excuse to get out of the house.

Meanwhile, as per usual, I touted various musical projects round. Derek Taylor, who was the famous press officer for the Fab Four, liked me, and arranged a session through Guy Stevens to cut some tracks. I put a great band together, with drummer Charlie Charles, who played with Ian Dury, plus Steve York on bass, Pete Gage on guitar and a keyboard player – I think it might have been Mickey Gallagher. Guy, being a mad Bob Dylan fan, wanted to cut an obscure song of his, 'I'll Keep It With Mine', and brought in Jo Ann Kelly to sing it with me. I also recorded 'Mistaken Identity', a tune for which Rick Watson had written the words. It was like a Dashiell Hammett thriller in three and a half minutes, and would have made a good video at a time when they were only just being considered. Later, I foolishly left the tapes in a phone box and they never reappeared.

I also hooked up with the songwriter Paul Kennerley, who was developing a concept album about the American South called *White Mansions*, and was working tirelessly towards his dream, researching the background behind the stories and all the characters. He asked me and Sammy Mitchell, who played beautiful Dobro, to assist on the demos from his studio in west London. It was all done on a shoestring budget, but Paul was always a gentleman so we were glad to oblige. He then took the idea to the USA and engaged stars such as Waylon Jennings, Bernie Leadon and

Eric Clapton on the project – and we didn't get a mention when the album was released. In fact, I thought a couple of the demos Sam and I did were better than the studio productions, but that's just my opinion.

I knocked about London like this for a couple of years but things were going from bad to worse, and Vivian and I were not getting along either, mostly my fault. Thinking that the grass might be greener back in LA, I planned to escape there and make a record. I had in mind a country album as I had some songs that fitted well in that genre, so I sold my Revox and my recording gear and left for LA in 1976. That meant splitting up with Vivian. In hindsight, I was a coward to leave her and Demetri in the lurch – but I thought I might have a better chance in the USA.

CHAPTER 15

LA HOMBRE

On arrival in Los Angeles, the first question at immigration was: 'Do you have a return ticket?' I knew I could resell the return half because they didn't check the names back then. They did want ID when you checked in, so the scam was to check in the guy yourself, as after that nobody looked at it!

My plan was to make a record with The Flying Burrito Brothers and I was set to stay with their bassist, Chris Ethridge. He was really supportive and I lodged with him and his family briefly: madly generous of him, but he had a heart of gold. We ran through tunes and made a few demos, but LA was a place where a quick turnaround is needed. I went to some of the Burritos Brothers' rehearsals with pedal-steel-player extraordinaire 'Sneaky Pete' Kleinow and drummer Gene Parsons, who along with Clarence White invented the 'B' bender device for guitars. The Eagles were then kings of the Strip, with their clever harmonies and soft-rock sound – all too safe for me. Irving Azoff was their manager and I went to see him in his low-rise office on Sunset, but there was nothing doing and no money available to go into a studio.

In London, I'd met an American pianist called Virgil, a pal of Steve York's, and we got on well: he was always trying to tune in to the British sense of humour. After meeting up, he offered me his couch in Eagle Rock, then a largely Mexican area some way out of town and quite unfashionable (hence a cheap rent). Virgil often stayed with his girlfriend, and consequently I was left in his small adobe apartment alone, mulling things over and getting fairly depressed. I could walk down to the market and shop for groceries – I learned from the Mexican women how to

pick good avocados and lived on them, splattered on toast – but otherwise I was dependent on rides to get about town, and in the days before Uber, you could die without a car in LA. I bashed away on Virgil's old piano, writing a tune: 'I'm out on a limb and I ain't got a friend/Please Mary D'Courtney, won't ya pick me up again?' The name D'Courtney came from Alfred Bester's sci-fi novel *The Demolished Man*, which I was reading. I hadn't yet got on to Philip K. Dick.

Virgil came back one day to find me in a rather confused state. He decided we should go out and meet some people, so we took off to catch a band, employing a ruse that we devised for getting into clubs without paying. Jamming his Fender Rhodes piano into the back seat of his second-hand Porsche – bought with the proceeds from his session on the Village People's 'Y.M.C.A.' – we arrived at the chosen venue, knocked on the side door and told security that we had brought it for the band. 'Okay, bring it in,' they told us. We then parked the piano out of the way and enjoyed the show for free. Later, we refined the scheme, first telling the staff that we would 'check' with the band if they still wanted the piano – thus alleviating the need to physically carry it in. Musicians never like to pay to watch each other.

I saw Paul McCartney was in town one night, and went to the gig sans ticket. I headed to the stage entrance and began weaving a tale for them – essentially true, that I had met someone from the crew who'd said to come along. Progressing from one security guy to another, I reached the auditorium and duly watched Paul and Wings play their show, which was really good. The curtain came down and the stewards began clearing out the punters, but I told one that I was heading backstage. 'Let me see your ticket,' he said, but I told him I didn't have one and began my spiel. He finally scratched his

head and declared, 'Your story is so fantastic, I'm gonna have to let you through.' I then progressed steadily through the various backstage levels until I was finally in the inner sanctum – and there was Paul, chatting to another guy and smoking a Senior Service fag. I sat down with Denny Laine and began chatting when Paul came over to say hello, and that was that regarding backstage excitement, drugs and girls. Still, it was a cheap night out for a broke musician in LA.

I went to some other good gigs in town, too, one time seeing Little Feat at the Troubadour, an intimate venue where the band played a great set. The red curtains closed with the applause ringing out, and they remained closed until the clapping became a solid beat. The band took up the time and the curtains opened with everyone locked in as they launched into their final number. I loved Lowell George and his playing, and we had a chat; he wasn't best pleased that Robert Palmer had achieved such success on his debut solo album, *Sneakin' Sally Though the Alley*, by recruiting George and his band's sound, all produced by Steve Smith for Island Records. I ran into George one time afterwards in a studio and he was heavily into coke; he died aged just 34.

I also caught Dr. John – 'Mac' to his friends – in a small club soon after the release of *Right Place, Wrong Time*, his best-selling record. He sauntered onto the stage by himself and began tapping on the congas, soon joined by the others, a super-funky unit. He was one of my all-time favourite musicians. Another gig I caught was B.B. King recording live in a club with Bobby Bland. I always loved Bobby's great singing – so soulful, with a beautiful timbre. Occasionally, I do a version of 'Woke Up Screaming' and think of him; an inspiration, as was B.B.

Outside Tower Records on Sunset Strip LA. Carinthia West took the photo and is also the long tall model in the window!

DIARY

Back at the rancho after a gig at the Old Hall, a commune in Suffolk that has been running for almost 30 years. It's an interesting place, where residents buy into the vast edifice, formerly a monastery, with gardens, 70 acres and even cows to milk by hand. We played in an echoing hall that wasn't too pleasant, especially as I was bushed after chasing up from town.

Went to see some cricket at Lord's in the company of Dad and my chef friend Nick Smallwood, in a box used by Simon Tindall, who made his dough publishing trade mags with Michael 'Tarzan' Heseltine. I even managed to get Mick there. He'd cancelled going

to France until the next day so we enjoyed a few hours together, which was nice. Dived in to Paul Getty's box, too; John Michell was there, and the cricketer Raman Subba Row at his usual mischievous best, and Colin Ingolsby McKenzie, who runs a team for Getty at Wormsley. He has the ruddy face of a drinker and Mick told me that he had an enormous row with him some years ago. No sign of Paul's wife, Victoria Getty, and we left smartly.

TOPANGA CANYON

Rod Stewart, who had moved permanently out to LA, was supportive in a strange way. He checked out some of my songs and quite liked them, but he was very careful about what he recorded. I went to the studio where he was working with producer Tom Dowd, and Rod asked me to double-track what he was singing, a difficult thing to do. I entered the booth and did my best, but it was a struggle and I couldn't hit the same notes. All I remember is Rod sitting in the control room congratulating himself that he could hit higher notes than me, while my hopes of a session fee were dashed.

Rod was a mad football fan, and a motley band of British ex-pats and Mexicans would meet on Sunday mornings for a kickabout in Topanga Canyon. The guys from Ace, who had a huge hit with 'How Long', were often there, as were some of the Average White Band, and others like me, looking for a break. Robert Plant enjoyed a game when in town. He once arrived after Led Zep had cancelled a coast-to-coast tour because he'd broken his arm, bravely going in goal before deciding against it: if discovered, the band would probably have had their multi-million-dollar insurance policy cancelled. Eric Clapton came along to watch, around the time he had a hit with 'I Shot the Sherriff', generally the first reggae tune anyone in the USA

had heard. Eric introduced the Americans to Bob Marley with that song.

Afterwards, we would retire to the pub for the all-important libations, which in Hollywood weren't cheap. Rod once decided to stand a round but didn't have any cash, so he borrowed $20 from a fellow player. A week later, after another match, I was with the guy who'd lent the money, in Rod's Beverly Hills mansion. Standing by the fireplace in a set you might see in the movies, my pal uneasily asked for the $20 back, whereupon Rod shuffled a little, then called out to Britt Ekland, who was just swishing up the staircase, 'Hey Britt, have you got 20 bucks?' The famous blonde Bond girl, who'd earlier appeared on the arm of Peter Sellers, briefly looked round and then was gone, along with any hopes of a refund.

I hadn't really played football since I was about 12 years old and was gratified to discover that I still had some talent for it. Scoring a goal gives you confidence, knowing that you can knock the ball past the goalie at the final touch. One day, I showed up to discover we had proper shirts and a referee, plus some new guy called Tony to whom everyone was being super-nice. In the starting line-up Rod picked Tony for his team, while overlooking me with the remark, 'You'll get a game in the second half.' I hadn't come to watch from the sidelines and, by the second half, it transpired that Rod didn't need me – so I offered my services to the other team, who were now a player down and 2–0 up. Rod was quite peeved when I ran on for the opposition. I tackled him and, as we hit the ground together, he swung a punch at me, but happily it didn't connect and the ref let it go. That was the last time I saw Rod.

I knew Sabrina Guinness from the social scene in London and she was out in LA working for the writer Ian La Frenais. He was great company and welcomed me into his house in the Hollywood

Hills. Each morning his partner in crime, Dick Clement, would arrive and they would craft the scripts of what was to become the TV series *Porridge*, starring Ronnie Barker. This was in the middle of a heat wave, but they loved the freedom of working on the West Coast among the ex-pat community, many of whom were escaping from the high levels of tax being demanded by the Labour government across the pond.

SHANGRI-LA

Freddy Sessler, a massive Stones fan, came to my rescue and offered me a room in his house in Hollywood. He was a generous and crazy Jewish businessman who would rise at 5am to sell light bulbs to customers in New York, where it was already mid-morning. I would wake to hear him on the phone, doing his fast-talking business patter, quite unlike anything heard in England, with phrases coming out like 'D'ya think I'm sitting here with my dick in my hand to listen to this bullshit?' before slamming down the phone.

Ronnie Wood was a pal of Freddy's and called me one evening, suggesting I come down to the studio where he was recording with Eric Clapton. I borrowed a car and drove out along the winding Sunset Boulevard to where it meets the ocean, turned right past Malibu and finally found a shack-like studio up above Zuma Beach. Shangri-La was a down-home, friendly joint and owned by The Band, whose records we had listened to endlessly in London. Eric had his regular outfit of Jamie Oldaker on drums, Carl Radle on bass and George Terry on guitar. The session went on late and I returned bleary-eyed around 5am. The following afternoon a repeat call came from Ronnie: 'Are you coming again tonight?', he asked. 'I wasn't thinking of it...', I replied – to which, after a pause, he said, 'Well, Eric would

like you to.' I took a breath, wondering why old Slowhand was requesting me. (Incidentally, I heard that the nickname came from Eric changing bust strings at gigs, during which the audience would slow-handclap him until he was tuned up!)

After a long drive, I found myself sitting in the control room alongside the engineer, listening to Eric and his band and watching through the plate-glass window. There was no producer as such, and during the chat after each take I found myself pressing the talkback button and offering my humble opinion. Of course, they hadn't asked me but – what the hell – I reckoned my ears were as good as anyone else's; and when you are not actually playing, you probably have a clearer perspective. A deafening silence ensued, and perhaps a sarcastic remark – this was, after all, the Monty Python/Eric Idle period – and then things moved on.

My role wasn't defined so I was unsure of myself. And if you don't actually have much to do in a studio, then you're likely to get into trouble – which is what happened one time with The Band's pianist Richard Manuel. He gave me some Ritalin, which I've never come across before or since, and it made us both very hyperactive, at one point jumping onto a coffee table which promptly collapsed under our joint weight. The din attracted the others, who came in to see what was going on and found us looking rather foolish, surrounded by bits of wood and table legs. I did like Richard. I was amazed, too, at his colleague Garth Hudson's organ playing; he is a multi-instrumentalist and a master musician.

I returned on Eric's birthday to see a mass turnout of guitar players: Ronnie, Eric, George Terry and Robbie Robertson, along with the rest of The Band, Levon Helm and Garth, plus Van Morrison and Bob Dylan. Bob brought along a song to record – which is

what you do, I guess – and it started, 'You speak to me in sign language, while I'm eating a sandwich in a small café.' I said hello to him as he slouched in a chair – in a room on his own – and he gave me the limp handshake treatment.

Afterwards, a jam began and all the guitarists were too polite to take the lead – until Jesse Ed Davis turned up and played every standard lick in the book. Then Van the Man did a neck-tingling version of 'Stormy Monday', I think the best thing I have ever heard him sing. Dylan had a crush on a well-proportioned lass with a broken arm, which was in a plaster cast, and he erected a tent so he could spend the night with her in the garden. A day or two later, I played a gentle game of tennis with her, as there was a court, and couldn't help thinking of a Bonzo Dog song that went: 'I want to get you in my tent, tent, tent…'.

I sang on the chorus of 'One of Us Must Know' with Eric, a track from Dylan's *Blonde on Blonde*, but I don't think it has ever been released. Still, Eric did have the courtesy to mention me on the liner notes of *No Reason to Cry*, and years later I even received some money for my contributions, which was gentlemanly of him.

I was hoping to record a couple of songs I'd written with the famous Stax backing band – the legendary guitarist Steve Cropper, bassist Duck Dunn and producer Willie Mitchell. They offered to take me into their studio to record and mix the two tracks for $1000, all-in. But who would stump up the cash?

Bill Oakes from the Robert Stigwood camp, Eric's manager, liked the idea and arranged a deal, and when he was unexpectedly moved from the music side to film, to work on *Saturday Night Fever*, he assured me the money would be no problem. Before I'd started, though, his boss arrived at the studio one night and offered me a ride back to LA in his limo. Along the way Stigwood started breaking poppers and offered some to me – but amyl

nitrate always made me feel really sick, especially since he was fondling his crotch at the same time. The signs were that if I wanted the money I would have to earn it; so not being inclined that way, I made a quick exit somewhere en route.

I never did get to cut those tracks, which would have been good to have in my bottom drawer even if nobody else in the world ever came to hear them. I tried a few other people to raise the cash but – as this was way before The Blues Brothers or Bowie recording 'Knock on Wood' – Stax was completely out of fashion. When I approached one LA record man, he commented: 'Steve Cropper? What did he do for me TODAY?'

I met Chaka Khan with her manager and had a pop at her recording a tune of mine. She liked the opening lines: 'I trampled on dirt, I trampled on clay/ I got behind the wind in a blind alleyway/I thought it was love I found in the glass/ but I found I'd come face-to-face with myself...'. It also had a nice phrase about 'the queen of amnesia' – but it didn't happen. I was just another hopeful looking for a break.

ARTIST-IN-RESIDENCE

One dear friend in LA was Kenneth Kendall, and we took my first album cover photo at his house. Ken actually came from LA, a rare thing; his uncle had been an agent in the silent movie era and knew the legendary director Erich von Stroheim, so he was steeped in the history of the town. Never an actor, he had, however, taken walk-on parts, being on the set of *Julius Caesar* with Marlon Brando in the title role – and that was love at first sight. Kenneth was an artist and collector, and later modelled a head of Brando as Caesar, which was much admired by the up-and-coming star James Dean. In 1955, Dean visited Kenneth to discuss having a bust made of himself

– but within weeks, he was tragically killed in his Porsche 550 Spyder on the way to a race in Salinas. For Kenneth, it was the beginning of a lifelong obsession. He always had good one-liners, such as 'You can't be disappointed by dead movie stars,' and he thought that, had Dean lived, Brando would have upped his game to compete.

Ken was also present on the set of Dean's last picture, *Giant*, and heard the director make an arrogant speech about this 'George Stevens film,' failing to recognize Dean's significance. Later, Kenneth went round buying all the Dean memorabilia he could – including his tuxedo and identical sets of the blue jeans he had worn – and painted him in his various roles.

Kenneth lived in an old-style single-storey place, in a street of duplex apartments, while his next-door house served as his studio. This was a treasure trove of beautiful objects, half-finished projects and piled-up junk for which he'd yet to find a use. You would knock on the door of his spookily overgrown porch in the dead of night and finally he would open a small iron grille and peer through before letting you in. Then you would inch your way to the back, carefully avoiding the delicate art deco lamps, cabinets of curiosities and objects hanging from the ceiling. (Kenneth maintained, 'No matter how crowded it is, there's still room for more.') He worked at the back, where a pipe would sometimes be produced and the customary Mexican weed to be partaken of.

It was usual to visit Kenneth around midnight as he was a late riser, restoring antiques for various Hollywood dealers and finishing up his own projects, like moulding a porcelain penis for a set of garden ornaments or restoring a Joshua Reynolds painting. Among his own works were a fake Toulouse Lautrec, painted onto old cardboard that he had picked up in Paris; a set of dinner plates with ants crawling across them in procession; and a fake 'Jasper

Johns' aluminium slice of 'toast', displayed in a rack with a suitably fake high-price tag.

He was both obsessed and disgusted by Hollywood stars that remain nameless for legal reasons, who had purchased items from him but been tardy in payment. Mae West came to his studio, and he had met Marilyn Monroe at an exhibition where he was showing (she saw one of his pieces and declared, 'Oh, sculpture! That's art!'). His stories might be recounted over an old cylinder recording of Dame Nellie Melba, for he was an opera buff, too. When his work was done for the night, we could take off for a late, late snack at a transvestite sandwich-bar downtown full of colourful characters and bitchy chat.

Kenneth refused to drive on freeways, however. So if we went out to the Huntingdon Library, with its wonderful gardens and paintings by Lawrence and Gainsborough, or to the J. Paul Getty museum, with its Titians and Reubens, it was a long ride. Still, I had a good education in fine art from him. When doing restorations, he would explain to me the intricacies and details of the alchemical transformations, and he encouraged me to assist him, but I was pretty hopeless with my hands.

DIARY

On Saturday, I had to blearily rush down to the BBC, and after running the security gauntlet, found out that the show didn't start until 11am. (It's recorded now.) Ned Sherrin swept in, clad in a cream summer jacket, and various acolytes were assembled around him. He spent rather a long time talking to Mark Rylance, who wears a trilby pushed back all the time – so I take it he is losing his hair, like me.

Charlie Hart, Ben Waters and I played 'Stand Up for the Foot'. This is a paean to the duodecimal system, and in fact John Michell coined the phrase back in the Seventies, when he ran an anti-metrification group.

As he pointed out, the foot and the inch were sacred measurements. Twelve is a highly composite number, which can be divided by 2, 3, 4 and 6, whereas 10 can only be divided by 5, itself a prime number, and 2, which is too small to be of general use. Hence carpenters divided the ruler into 12, and bakers used dozens; a gross (144) was a handy number for everyday use; and circles are still divided into 360 degrees, or 30 sets of 12. But all this was summarily cast aside for a slavish adoption of the decimal system. Although people didn't like it, they were told it was good for them. The Americans had better sense and stuck to what they knew, which worked for them. I wrote the song while soaking in the bath, after pouring the water in gallons.

However, the tune was introduced as 'Stand Up for a Foot' by Ned, so I don't know whether anyone really got it. But to be honest, they were more into the tales of Gertrude Lawrence and Cole Porter, amply furnished by the celebs who sat on Ned's right and took his attention.

Afterwards, we went to the pub for sandwiches. I'd brought Ned a bottle of Wilkins cider that, when initially presented, he put down on the studio floor without a murmur. Now he asked for it and, as I had picked it back up for myself, I re-presented him with it. Ned's brother lives up the road here in Ham, Somerset, but somehow Ned isn't too keen on displaying his rustic roots.

Apparently, in the late Fifties, he had produced Seeing Sport, which Dad did, and that surprised me. I do remember Ned auditioning me for a musical he directed of Lieber & Stoller songs. I went on stage to sing 'Jenny, Jenny, Jenny' by Little Richard and was stopped after 30 seconds, before I was even in my stride. I'd been hanging out with Steven Berkoff, who believes, like Little Richard, that you have to build a sweat up before your aura shines, but with Ned all I got was an early 'thank you'. Still, he did teach me a quote – 'Look after your diary and one day it will look after you' – so I'd better take that to heart.

'TO ACT IS TO DO' – Stella Adler

In LA, I ran into filmmaker Donald Cammell, who had made *Performance*, and we went out for a meal with his actress girlfriend China Kong and her photographer sister Stephani. The latter had a great sense of humour – we hit it off and began a relationship. She was a little younger than me but, as an LA gal, knew the scene really well. Her mother, Anita, lived luxuriously in Beverly Hills with her rich husband, who I barely saw because he had health issues. He also had in his library a copy of the life of the Tibetan yogi Milarepa, translated by the aforementioned Evans-Wentz (see Chapter 10), that I borrowed.

Anita had a male friend called Stefan, formerly a principal dancer in the Warsaw Ballet, now running classes downtown, and he invited me to take part. My movements weren't quite in Baryshnikov's league, and Stefan once told me, 'You are dancing like a tin man!' But it was a serious workout: you might be standing with one leg up on the barre when Stefan would walk by and squeeze your head down in a pincer movement. It was torture, but you felt better for it. After the class, we would retire to a nearby Mexican bar where they made delicious margaritas, and undo all the good work.

The Stigwood incident had led me to thinking of abandoning my musical ambitions, and Anita suggested that I should look at acting instead. The doyenne of acting coaches was Stella Adler, a fierce, independent Jewish woman with a reputation for helping those she adored and scorning those she disliked. She came to LA once a year to give classes, and Anita prompted me to enlist.

Hailing from a large New York theatrical family, Stella started performing in Yiddish plays as a child. Meeting the great Konstantin Stanislavski when he toured the USA, she

later studied with him in Paris, and founded her own studio in 1949, going on to teach, among others, Marlon Brando, Warren Beatty, Harvey Keitel, Elizabeth Taylor and Robert De Niro. And who could argue with that list? Anita told me that she was once having dinner with Stella and Liz Taylor when the movie star admired a ring Stella was wearing. Stella told her where she'd bought it, and Liz replied in amazement: 'You actually buy your own jewellery?'

Stella liked to emphasize the use of the imagination, and went through numerous notes outlining her approach. Above all, she wanted a strong commitment; otherwise, there was no hope. One female student delivered a rather tepid speech, whereupon Stella asked her age and, learning she was in her twenties, said: 'Then why are you acting like you're 14?' As the girl ran out of the studio sobbing, Stella continued, 'That'll save her the trouble of trying to be an actress.' We all cowered a little more in our seats.

Stella knew little of Shakespeare – Tennessee Williams was more her bag. In one class a male student was reciting a passage from *Julius Caesar*, which left her cold. Waving her arms about and quoting 'blow wind, come wrack' from the Scottish play, Stella explained that Shakespeare was 'big stuff', so the student intensified his efforts only to be shouted down again: 'No, no, now you're like a New York taxi driver!' It was funny so long as you weren't on the receiving end.

She didn't like me too much and thought that, being British, I was in some way to blame for the British post-war 'protection' of Palestine. Although the course lasted but a few weeks, it was the only real dramatic training I've ever had and provided me with an insight into what was required. When we parted, Stella shook my hand and said, 'You'll never become an actor.' I smiled back and answered, 'I shall have to prove you wrong.' But Stella was right to

test everything all the time, particularly your desire, which is at the heart of everything.

I also had lessons of a more conventional kind from a retired actor who Kenneth knew, John Abbott. He'd started his career in amateur dramatics in Britain and appeared at The Old Vic in London, alongside the likes of Gielgud and Olivier. He then found his way to Hollywood during the war and stayed put, subsequently making a living by appearing in such TV shows as *Star Trek*, *The Munsters* and *Perry Mason*. He told me he had never done an audition in his life: he was seen in other roles and it always went from there. John was charming and loved me reciting Yeats, Wilde and Shakespeare sonnets to him. But he despaired of my 'estuary' vowels – it literally hurt his fine sensibilities – so I became his Eliza Doolittle.

At the same time, Stephani encouraged me in my acting by taking me to see such movies as *Missouri Breaks* with Marlon Brando, on which she'd taken the location stills. We caught Bowie, too: on celluloid in *The Man Who Fell to Earth*, and in the flesh at the Universal Amphitheatre during his *Diamond Dogs* tour. The set by Mark Ravitz was based on the work of a German artist and very ambitious, with Bowie hanging high above the audience on a cherry-picker to sing 'Space Oddity'. Bowie encouraged us out of our seats to dance, but zealous security men shoved us back, telling us to sit down. Stephanie and her sisters made up a noisy household and , as the Chinese say, a noisy house is a happy house – they love playing tricks and having fun and eating good food.

I met a helpful agent called Maggie, and she took me to a couple of those LA parties where actors and producers all mingle; she knew everyone and would give you a running commentary on who was chatting up whom and why, all behind their backs while you tried to look nonchalant. She knew Gore Vidal and we went out

to dinner a couple of times with him, which was very entertaining, as he held forth on most subjects under the sun.

Although I didn't have a working visa, I did go for a few castings out in LA. One was a 'cattle call', which involved a long line of hopefuls for a part in – believe it or not – a Mae West picture. She owned a script called *Sextet*, and was aiming to produce and finance it, as she was too old to be insured in the lead role. I was the only man not dressed in pastels, the LA standard of the day, and stood out in a stripy green shirt and black velvet jacket. Some 50 guys were assembled on a huge lot, as if for a school photo. We were then told that Mae was about to come through the door opposite, at which we were to burst into spontaneous applause. That done, she shuffled across the floor in a long Thirties gown and was led to a small box, onto which she was elevated. 'There ain't no steps, is there?' I heard her say, as by then I was standing next to her, partly holding her up. She looked like Miss Havisham in *Great Expectations*, with thick foundation and hair like straw; and one eyelash was hanging loose. The photographer took a few snaps then she rolled her eyes a little. 'That was great, Mae, what you did with your eyes right then?' he complimented her. 'What, like this?' she said, and did the same thing she'd been doing on screen for the past 60 years. If I'd been on the ball, I might have fed her a W.C. Fields line. She did get to make the movie a few years later and, needless to say, it flopped.

One weekend, Anita took Stephani, me and two other friends on a trip to Las Vegas. I'd been there before, but she really knew the ropes. First, she taught us to how to play blackjack and then gave us a stake. (I got lucky, later using the money to help fund my classes with Stella.) Since the run of the cards is affected by the sequence of dealing, Anita would pack the table with us as her allies so that no intruders could squeeze in and upset her schemes.

Then she would ask the dealers their names. 'Okay, Frank,' she would say, 'here's a side bet for you.' Then she would lay out a stake for the dealer to play – a means of 'tipping', which is otherwise not allowed. As the cards were dealt, she'd give a running commentary: 'Okay, Frank, give me a low card. Okay, another. Okay, I'll stick.' If he was showing, say, a picture card and a five, she would announce 'Okay, Frank, you're gonna bust.' Then, just as he turned over the card, she would stand up and shout 'B-U-S-T!' before, likely as not, exploding with laughter as he went over 21. This routine would alert the pit bosses in the casino, who would hover round. They liked people to enjoy themselves and win a little, but not too much; so then they would send in a 'shill' to muscle between us at the table and break up the run of cards. Now I play blackjack with my grandchildren and they love it; it's good for their maths, too!

Anita had one superstition that she would announce to dealers – 'Don't touch the cards!' – indicating that, when dealing additional cards, they shouldn't spin them out freely so that they collided with those she already had laid out on the table. One of her pet jokes was to secretly tell a waiter in the restaurant where we were eating that it was the birthday of someone on our table, and have them bring in a cake. When it arrived with candles and everyone singing, she would hoot with laughter as the victim protested.

Anita was a one-time lover of Marlon Brando, and he sometimes came around to her house for dinner or to take her out. Marlon gave me a lesson one time when we were waiting for the women to get ready and had time to kill. Picking up a pump-action air gun, he loaded it up and, after he had compressed the spring to the limit, took aim at a wastepaper basket in the corner of the room. Just before squeezing the trigger, he turned his head and narrowed his eyes in the expression of disdain that you can see in many a movie. After firing, he went to pick up the

basket, shaking his head and expressing surprise that the pellet had penetrated it. 'What did you expect?' I asked him. In truth, the whole thing was a demonstration of the actor's art, done almost in slow motion.

Once, I was telling Marlon about an incident that happened to me in the Himalayas, when a crazed buffalo had come around a bend, crashing into the fields below as we swiftly took evasive action. 'You can act,' Marlon later told me. 'How do you know, when you've never seen me doing anything?' I asked. 'You just did it,' he replied in his soft-spoken way. 'That's what acting is, telling a story.'

But Marlon seldom hung out with actors himself: he would rather chat to a plumber than deal with the ego of a big-name star, and musicians were the same deal to him. Anita told me about Marlon being at dinner with Bob Dylan, among others. They all sat down, and Dylan said nothing. The food was served, but still no conversation or pleasantries from Bob. Finally, Marlon took him on. 'I know why you don't speak,' he said. 'Because you might open your mouth and say something really ordinary like "Pass the butter".' Dylan rose and left.

The last time we met was at Shepperton Studios, near London, when Marlon was making a cameo appearance in *Superman*, and Stephanie was shooting the stills. I watched from a distance as he stood alone on a gigantic stage and spoke his lines into thin air, waiting for the imaginary reply. (Amazingly, it looks great on the screen, and his timing is incredible.) Afterwards, we sat around in his rented apartment and he played some congas that he'd set up there. I wish I had played with him, but I was too shy. Stephanie went on to the Philippines, where Marlon was shooting *Apocalypse Now* with Francis Ford Coppola, and she asked me to come along – but I felt I needed to find my own way and so our relationship came to an end. I shall never forget the friendship and kindness of

her and her family, however, and the insights they gave me into the Chinese way of life.

Stephani, right, and Shirlee Kong in LA.

FAREWELL USA

I was on a six-month tourist visa in the USA that I wanted to extend, so I was scratching my head over reasons I could give to do so. It was 1976 and the nation was celebrating its 200th year since breaking away from Britain. As chance would have it, England were due to play a one-off soccer match against Brazil at the LA Coliseum and there was a warm-up 'celebrity' game, in which I'd been invited to participate. On the visa form I wrote 'Taking part in official USA bicentennial celebrations', which looked kosher, and I got my extension.

Come the match, an ex-Sunderland player was on hand to give us some coaching, so that we wouldn't look like total idiots. I walked onto the pitch and gazed round to see a fair few spectators, 99 per cent of them Brazilian. All I can remember is passing a through-ball to Davy Jones, formerly of The Monkees, who was 'on

goal' – but, unlike Jamie Vardy today, he failed to slot the ball home and wheel away to celebrate. In that, he was similar to the English team, who couldn't manage a goal either. Messrs Keegan, Brooking and Francis lost 1–0 or, as the Americans would say, one-to-zero.

REUNION

Before I left the USA, Vivian came over with our son Demetri, so that we might spend some time together. Meeting in Portland, Oregon, we headed north to tour Washington state, camping there, which was beautiful, and we got along as well as we could. Later, in San Francisco, we met with our friend Jane Rose and her artist husband Michael. Jane ran a natural-beauty mail-order business, New Age Creations, using all-natural ingredients, and Vivian trained with her, learning to mix and craft the oils and potions. After returning to the UK, Vivian set up her own business, but at that time few Brits were hip to the products and most just thought them too expensive. The UK was far behind the West Coast in that respect.

However, I needed to find work – for which I would have to return home – and in trying to find the cheapest route, I became involved in a marathon trip (this, remember, is before flight deregulation). I drove from Seattle to San Francisco, around 800 miles, boarding the red-eye via Dallas to New York. Landing there, I met up with our former tour manager, Pat, and we toured some bars before another night flight, this time to Brussels. I made friends with some English guys on the plane, which was just as well as it turned out I needed their help to carry my cases. At Brussels airport, there were no baggage carts but I found a tea trolley instead and pushed it through customs calling, 'Tea, sausage rolls, teacakes...'. By then, I was pretty far gone.

We boarded a morning rush-hour train to Ostend to catch a boat and, after a choppy crossing, finally landed on British soil, where we were treated to the slowest train possible, halting at every village on the line to London Victoria. At one sleepy halt, nobody got off or on, so I opened then slammed a carriage door and – hey presto – the train took off again. Someone else tried the same trick at the next stop, but we stood still until the driver came through the carriages saying, 'If that happens again, we won't move for the rest of the day.' So good to be home at last.

I was numb by the time I reached London and took a cab to the Zanzibar cocktail place in Covent Garden, where Rick Watson, my friend from the Indian travels, was working as barman, waiting for his shift to end before I could get some well-earned sleep.

UPPER-CLASS ROCK & ROLL

The following day, Rick drove me in his Land Rover to Knebworth House, a grand pile an hour north of London, where the Stones were to perform. There was a massive crowd assembled to be entertained by 10cc, Hot Tuna, Todd Rundgren and then Lynyrd Skynyrd, with whom I later hung out – all good ol' boys but soon to be hit with a series of accidents in cars and planes that blighted their progress. The actor Jack Nicholson was on site and he took a shine to an ex-girlfriend I'd met up with – so that was the last I saw of her.

There were extensive delays before the Stones finally appeared on stage to play a fabulous and extensive set that went on well after the scheduled curfew. After the show, we had refreshments in the house with the lord of the manor, as you do, and I asked if we could see around the place because Edwin Lutyens had modelled most of the interior. The owner,

David Cobbold, kindly showed us a small museum that included Lord Byron's pen, whereupon I offered him Mick's gold backstage pass to add to the collection. Mick had earlier told me off for not having one and given me his. ('But then you won't have one,' I'd remarked.) Cobbold laughed at my offer and failed to see the connection.

NO FUTURE

London was at that time lifting off on a high-octane punk curve and to play any other type of music meant you were a dinosaur and should be taken out and shot. (I was 28 years old and completely over the hill, so there was no hope for me as a musician anyway.) Some changed their spots. The guitarist Sammy Mitchell told me that he had run into fellow strummer Andy Summers, who had cut his hair short and dyed it blond. 'What's happening?' Sammy asked him. 'I joined a punk band,' said Andy. 'What's their name?' 'The Police,' Andy replied, and Sammy fell about laughing, saying 'You'll never make it with a name like that.'

Elsewhere, the sax player Davey Payne joined Ian Dury and they crossed over from the pub-rock scene to find success. The drummer Mike Kellie joined The Only Ones, and other bands speeded up their numbers to stay abreast of the game, but many musicians I knew gave up or just bided their time.

DIARY

I did the Andy Kershaw radio show: four numbers in all, plus chat. Extended 'Stand Up for the Foot' and 'Manyatela' – the Spokes Mashiyane township number – to a proper set-length, so we really got rocking. Afterwards, we retired to the pub for a pint. AK seems partial to such refreshment and, after the

producers left, I remained with him. But two pints is my limit, especially at lunchtime.

Interesting that Andy went to Hulme Grammar School in Oldham, where Dad had been all those years before. AK had seen his name on the alumni board and had joked about it being Mick's father.

Driving home on the Thursday night, I listened to the show while crossing Salisbury Plain and had to stop to get reception. It sounded quite good in the night air, after the engineer had twiddled a few knobs.

I also played the Mind Body Spirit show in Victoria, London, – the most relaxed gig I have ever done, I think.

CHAPTER 16

IN BLACK AND WHITE

I'd known actor Rufus Collins for some time (last encountered in these pages with the Bauls of Bengal in Chapter 12) and we forged a closer friendship. He had a huge smile, a roaring, infectious laugh and a great zest for life. He was also gay, a fact he had to keep secret from the West Indian community. I went to see a play he directed called *Light Days, Dark Nights* by Jamal Ali at the Institute of Contemporary Arts (ICA) in central London. It was a production from the Black Theatre of Brixton, so of course all the actors were black – save for one beautiful white woman, and instinctively my eye was drawn to her. I admired her spirit as much as her looks and her acting. She had long legs, Scandinavian cheekbones, beautiful eyes and red hair.

In the front row, Rufus was looking after, and wrestling with, the actress's two small children – Julian, three, and Arthur, six – who were attempting to climb onto the stage to rescue their mother from imminent danger. Rufus was brilliant with kids and they all loved him, but he had his hands full; Kari played the white girlfriend, who the black female characters in the play, jealously resented, hence the distress of the children. Although they'd seen the production before, somehow it was too real for them.

This was, of course, my future wife, Kari-Ann Muller, back from Dorset, now separated from her husband and living in Paddington, west London. After the show ended, I was waiting for Rufus in the hall when I heard her voice asking, 'Where are you?' I playfully called, 'Over here!' She was busy rounding up her children, so I just said the corny line, 'Carry on, Kari-Ann' – which no doubt she had heard before. But we were due to meet again before long.

LIFE'S A STAGE, WE'RE ALL GOING THROUGH

With perfect timing, Rufus was about to produce a two-handed play, *The Jolly Green Soldier*, written by Steve Wilmer, an American author, who had spent time in Zambia and Tanzania and had taken as his subject the civil war then raging in Angola. It tells the story of a white mercenary in Africa confronting harsh realities, and was inspired by British soldiers who had travelled to Angola for adventure and pay; they were later captured and one was executed. Rufus was keen to produce new plays, so it was a good combination. We had a read-through; I mentioned to Steve that I sang and played guitar, and he went away and produced some lyrics, for which I later wrote the music.

We began rehearsing and were due to open at the ICA, but I needed an Equity union card to comply with regulations. My time spent at Hampstead was taken into account and I was granted one without too much fuss – also acquiring an agent, the rather camp David White – so I was all set within a matter of weeks. Naturally, I was broke, but found a cheap room in the same house as Rufus.

At rehearsals in Lambeth Town Hall, I got to see more of Kari-Ann, who sometimes came to the weekly workshops held there. She and I were the only white people in the place and many of the theatre members were rude to white members – to the women in particular – but she held her head up and didn't concern herself with it, being too occupied with the children and struggling to make ends meet.

One evening, Kari-Ann dropped round to see Rufus and, when she came up to my room, the outcome was inevitable. I'd never held such a beautiful and vulnerable woman in my arms before. Had we been more cautious, it might have been a one-night stand: neither of us really had the means to support the other, and she thought I would be trouble (she was probably

right). But the magnetism was too strong to resist, and I fell in love right then and there.

'Where both deliberate, the love is slight, who ever loved that loved not at first sight?' – Kit Marlowe

THREE'S COMPANY

Our little theatre company comprised Steve Wilmer, the author; Rufus Collins, as actor-director and lighting man; and yours truly, acting and supplying the audio requirements. The play was set in the jungle so, with minimum knowledge of the subject, I set out to record a soundscape largely from my imagination. I had fun making a background tape in a small studio, running loops from library recordings of birds, monkeys and frogs on to a super-long cassette that could run continuously without repetition and hopefully not break.

With Rufus Collins at the ICA London in Jolly Green Soldier *by Steve Wilmer.*

In the closing scene of the play, I went crazy on stage, shooting a machine-gun at shadows into the 'bush', aka the audience, as Rufus would be 'hiding' among them, and when he 'reappeared' I would open up with more rapid firing. I thought the standard

machine-gun recordings on sound-effect LPs dull, so I went to visit the synth-music pioneer David Vorhaus, known for his ground-breaking electronic work and the 'white noise' series of albums. On a DX7 synthesizer, Dave produced some quick-fire rapid bursts and we doctored them so that they sounded as close as possible to the real thing. On stage, I concealed a Fender Twin amp under the gun with a switch, so as I could open up and fire at will: it was so authentic people jumped out of their seats.

My son Demetri, then aged about six, would come to rehearsals too and likely got the theatre bug there, as he later attended the Anna Scher Theatre school in Islington, spending some time as an actor before moving into film work. One time he tugged at Rufus's trousers in rehearsals, suggesting a certain move would be best, upon which Rufus picked him up, roaring with laughter.

The play ran for a week at the ICA and was pretty well received for a debut, funnily enough getting a more favourable review in the stuffy *Financial Times* than the then-trendy *Time Out*, whose interpretation was near incomprehensible. We later toured in Amsterdam and Germany, and there was a good chemistry between Rufus and me, whatever my shortcomings. I had faith in Rufus as a director and actor, and he knew how to get the best out of me.

Meanwhile, Kari-Ann called me up and offered to rent me a room in the palatial duplex she was renting in Westbourne Terrace, a wide tree-lined avenue with tall Nash-style terraces, just around the corner from Paddington Station. On the phone she gave me first refusal and I was unsure – thinking what would happen if we started going steady – but I said yes.

I occupied a comfortable room painted a peaceful dark green on the third floor, up a rather grand, dilapidated staircase; and as Kari-Ann had two small and lovely boys, I soon became involved

with them, too, going to the swings in Kensington Gardens and picking them up from the school if need be. As I wasn't living with my own son, perhaps I tried to compensate with Kari's boys. This was not altogether easy, as they naturally resented me not being their father, coming unannounced into their lives and competing for their mother's attention, and it took many years for them to completely accept me.

Kari-Ann, the boys and I would travel down to Brixton each week on the Tube – sometimes bunking the barriers, as we were skint – and on to the classes in the town hall that Rufus held, mostly for the disaffected youth in Brixton. The young West Indians had reservations about this theatre game, and were often reluctant to do what they were asked as they couldn't see the point. Rufus understood but they sorely tried his patience.

Kari-Ann and I got by on the meagre funds we could muster, her child benefits and what income I could generate, but we were lucky to have a roof over our heads. She had left a glamorous and high-flying life as a model to look after her children but never resented the fact that I couldn't provide her a luxurious lifestyle. She could have had a rich husband and a more comfortable life-style but instead she got an out-of-work actor, with a guitar and a beat-up car.

A year after *The Green Soldier*, Steve wrote *Mzilikazi* – 'Trail of Blood' – another two-hander in which I played a missionary, with Rufus as my African assistant. This also opened at the ICA, and then moved to the Oval House in south London. I particularly remember the first night there because, when I sang 'Nkosi Sikelel' iAfrika' ('God Bless Africa') in the performance, the mostly black audience stood up as one to accompany me, with their hands on their hearts. This was the anthem of the anti-apartheid movement and their strength of feeling was palpable. It was very moving and

– given that I'd been to a school founded for the sons of mission-aries – rather bizarre, as I was versed in the history of their work in the developing world.

At that time in the late Seventies, 'fringe' theatre was still con-sidered, as the name suggests, marginal. I remember my agent suggesting, when booking me for one audition, that I didn't men-tion the fringe I had appeared in! I wrote a story for *Cosmopolitan*, the monthly magazine, explaining what 'fringe' actually was, but why people were snooty about it I don't know. Some casting and theatre people were dubious about my involvement at all, due to my 'history in rock & roll' and the famous brother; perhaps they regarded me as an opportunist and not serious. There was a lot of criticism from the punk faction directed at The Rolling Stones, and some of that rebounded onto me. Acting-wise, it was proba-bly a disadvantage having a famous brother.

'THE TROUBLE WITH FREUD IS THAT HE NEVER PLAYED THE GLASGOW EMPIRE SATURDAY NIGHT'
– comedian Ken Dodd

I went to an audition for the Citizens Theatre in Glasgow, Scotland, in front of its three directors – Philip Prowse, David MacDonald and Giles Havergal – in a Notting Hill cinema one afternoon. This was a hugely prestigious company for young aspiring actors, and a long list of alumni learned their craft there – among them Rupert Everett, Tim Roth, Celia Imrie, Mark Rylance and Glenda Jackson. I recited a Shakespeare sonnet, which took a couple of minutes, and they liked it. I think they were relieved I didn't subject them to a long, involved speech, as they probably made their minds up in about 45 seconds flat anyhow.

Winning a place in the company was great, but it did mean abandoning my work with Rufus and our little group. Steve had

written a third play, *Scenes from Soweto*, which had parallels with the South African political activist Wellington Tshazibane, a former Oxford graduate who was beaten up and killed while under arrest during the apartheid regime. The play was booked in for New York's Lincoln Center, which I would have dearly loved to be part of, but you can't be in two places at the same time. The 'Citz' was fantastic, except no London agents or casting directors ventured there, so you might as well be appearing on Mars. Apart from Kari-Ann, the only friend who came to see me there was Robert Fraser, bless him.

'TRUST YOUR INSTINCTS' – Noël Coward

The Citizens is housed in an old Victorian theatre situated in the Gorbals area of Glasgow, once famous for its tenement buildings and rough and tough, hard-drinking men. The rain came off the River Clyde in horizontal sheets, and a thick overcoat and alcohol would keep out the cold. Perhaps not the obvious spot for a load of fancy actors in make-up – but, hey, that was what made it risqué.

The first play I rehearsed there was the world premiere of Noël Coward's *Semi-Monde* – actually written in 1926, so it had taken 50 years to see the light of day, and something of a niche subject, for they loved discovering obscure pieces and re-presenting them. Coward had realized back then that it would be too sexually explicit for the censors – all of which delighted the director, Philip Prowse, who went all Busby Berkeley with it, pulling in a cast of some 32 actors, though no dancing girls.

Coward had written: 'The characters, all jagged with sophistication…shared their lives with members of the opposite or same sex and no wife dreamed for one instant of doing anything so banal as living with her husband.' The original stage directions included many scene-changes during which an orchestra popped up to play

string arrangements, but Philip rolled the whole thing into a long party, the set evoking the Paris Ritz, with a pink carpet and huge Mirroflex panels reflecting the grand piano and tables.

The first words I spoke on stage in what they called 'legit' theatre were to actor Pierce Brosnan – the banal 'How are you, Harry?' – as I casually opened a cigarette case, tapped the end and lit one up, a singularly unnerving thing to do in front of a full house. The 'previews' were free to all-comers and were usually full of local lorry drivers and their wives, attracted by a free night out. This sophisticated period piece was received in silence until, at the close of the first half, when a wronged husband pulled a revolver and shot his rival, the audience all stood up applauding, with a 'Good on yer, Jimmy!'

Once, during the interval, my elegant lurcher Sarah – who I'd had to bring with me for a spell – escaped from the dressing room and wandered across the stage to mild applause. Philip duly noted this, saying, 'I hear she looked wonderful, darling…but see that it doesn't happen again.' After the run ended, the set was chucked onto the vacant lot behind the building where the local tramps lit it up for a good bonfire while enjoying their meths, perched on banquettes from our 'Paris Ritz'.

As my previous acting had been limited to two-handers with Rufus, it was daunting to be in a cast of 32, all knowing what to do and when. I wondered how they chose the actors, and Philip told me they were less bothered about experience than what you brought with you and how interesting you were. That way – so long as you could pass the basic test of 'Can you be heard at the back of the stalls?' – you should carry the audience into the narrative. The Citz directors had an eye for interesting people and it happened that I was one of them. I did find some of the cast sceptical of my abilities, as I hadn't been to drama school, but that

didn't faze Philip too much. He apparently commented, 'Give him an audience, and he'll be fine.'

Pierce Brosnan pretty much kept to himself and I wouldn't have picked him out for the future success that he achieved through dedication and hard work. I remember he laced his hair with egg whites to keep it in place if we had two shows on the one day, and that was the source of a few jokes.

After first renting rooms, three of us actors – Ciarán Hinds, Garry Cooper and I – moved to a flat in Sauchiehall Street in the centre of town, buying cheap furniture at Paddy's Market or the Barrows on Sundays. They had signs there such as 'Junk bought, antiques sold' and 'as advertised on *Crimewatch UK*'. 'Big Dennis', a former driver for the Kray twins in London, sometimes assisted us; 'Anything you want, see Big Dennis,' was the advice, and he was a diamond geezer, so long as you stayed on the right side of him. One Saturday afternoon, he took me and designer Geoff Rose to his Fenian club in town. There was a sealed lobby where you were frisked down and vetted, but once inside it was a great place. Drinks were forced on you as if it was your birthday, and a game of pool was offered while bets were placed, everyone having an eye on the racing on the TV. I loved the vibrancy of Glasgow and the humour of the people, despite their animosity to the English, and who can blame them for that? You had to watch your step, and the first thing I learned was that if you hear, 'Wait a minute Jimmy' in the street, just keep walking. Sauchiehall Street was jammed with pubs and, of a weekend, lads would cram in there before the bars shut and order two or three jars for themselves with chasers, propping them on the narrow shelves as they stood up to sink the pints standing in a row. Then the shutters would come down at 10.30 sharp and hordes of drunken Glaswegians would totter onto the pavements and street with some falling through plate-glass

windows, as sirens sounded and the police attempted to deal with the mayhem. Then, the only refuge for a drink was a curry house. I once ordered a half pint in one of these, only to be informed by the waiter that they only served beers in pint glasses!

This was in the period just before the IRA situation deteriorated, but the Catholic–Protestant animosity was always there. I also went with Big Dennis to an 'old firm' game, Rangers v Celtic. The organization was military and we travelled with other Celtic fans, as it was an away fixture. All went well, at half-time Celtic were two up, so what could possibly go wrong? Then Rangers scored and, scaling a wooden barrier, the home fans started to hurl expletives our way, seemingly wanting to kill us. It was war. One Rangers fan had to be rescued by the St John's Ambulance men and was carried on a stretcher along the perimeter of the pitch; when he reached the Celtic end, awash with Irish flags, he managed to raise himself up six inches and V-sign the entire terrace! Celtic lost 3–2 in the end, and on the way back nobody spoke a word. The theatre electrician who took us would apparently go home and his wife, who already knew the result, wouldn't bother to speak to him apart from 'There's yer tea.'

PRICK UP YOUR EARS

After Coward, the next play was a rambling Balzac story that the author of *La Comédie Humaine* had apparently concocted in a weekend for a bet, as he was broke. There had been one previous performance in Paris in the 19th century but it was taken off rapido, as it contained a portrayal of Louis Napoléon, then still alive, and this was seditious. I had a minor part and remember little of the epic apart from Ciarán Hinds' make-up becoming yellower each night before it turned a strange green colour, much to our amusement. They liked make-up at the Citz – but you had

to do your own, something I didn't know much about. The theatrical Leichner stuff came in large doses and was expensive, so there was a lot of cadging backstage. We also went to Boots, in town and, while one of us was checking out some rouge, to the amusement of the young shop girls, another might be slyly snitching eyeliner to deposit in their pockets.

With Garry Cooper at Citizens theatre, Glasgow in Loot *by Joe Orton.*

The final play of the season was Joe Orton's *Loot*, with Siân Thomas as the attractive nurse and Garry Cooper as my fellow undertaker. Garry upstaged the 'inspector' one night by applying eyeliner during a scene, just as the latter was halfway through a monologue. Being a matinee, a few hundred schoolgirls were in and they all shrieked with laughter. Pat Hanaway, the diminutive and balding 'inspector', wasn't so enamoured, adding 'Are you quite finished?', before he gave out the next line. *Loot* is a classic farce and

went down well in Glasgow, where they got the Catholic jokes about death.

With Christmas approaching, I was asked to stay for the panto season, but I was anxious to return south to be with Kari-Ann. In retrospect, of course, I wish I'd done it; there's nothing quite like a theatre full of people hooting with laughter while you have to keep a straight face. I did 'corpse' once in *Loot* and the audience laughed the louder for it, but it will put you on the naughty step.

DIARY

On Saturday, Kari-Ann and I read for filmmaker Julien Temple at the Engine House, as part of a multi-media project in Bridgwater that he is helping with. He is aiming to produce a film on Kit Marlowe and I read the script from the page, though the director's instructions kept cutting across the action. Stephen Frears came down, too, to introduce his film Pretty Things, *which they showed in the weekend programme.*

I was due to interview Ronnie Wood, but it fell through, as he spent the night signing 4000 prints that he's flogging off to coincide with the Stones' summer tour.

MACKIE MESSER

I returned to the Citizens to appear in Bertolt Brecht's *The Threepenny Opera*, with music by Kurt Weill, performed as ever in their inimitable style. There was one set serving for all the scenes: a decadent French-style salon, with a grand piano centre-stage, beneath a huge chandelier. Director David MacDonald, complete with cigarette holder and dressed in tails, played the piano as the sole musical accompaniment.

David was a gifted linguist and had translated the original German text, retaining some *spiel Deutsch* – bits of it quite rude – so even with my limited knowledge of German I was comfort-

able with it. Kurt Weill's music intrigued me, as it was far from what I was familiar with, first coming to my attention via The Doors' version of 'Whiskey Bar'. The show opened after blackout with 'Mack the Knife', which Philip had me sing, one of my characters being 'The Mouth'. It was delivered nonchalantly, while slowly crossing the stage, and without a microphone, you really had to project to the back of what was then quite a large theatre. It helped if the audience was quiet, but on one particular evening there were a few rowdies in, and in frustration I kicked an empty champagne bottle that hit another one and smashed. Following the performance we retreated as usual to the pub next door, and a Glaswegian approached me to say he'd liked the play and had a 'souvenir'; it turned out to be a thick triangular piece of rather sharp, dark green glass. I didn't ask him what he might use it for.

Philip's adaptation was quite anarchic, the storyline being that the cast had broken into a smart house in Paris and tied up the 'madame' (Giles, another director, in drag). As Giles was surplus to requirements in the second half, he was unceremoniously hanged from the chandelier. We had a lot of fun up there!

Sunday was our one day off, so excursions might take in Loch Lomond, partly because you could get a drink at the hotels there (pubs back then were closed on the Sabbath) – and the scenery wasn't too shabby either. Ciarán, Garry and I took the ferry over to visit the Isle of Bute and the house that the famous actor Edmund Kean had built for himself in the 1800s; the current owner kindly invited us in for a wee dram. The boundary walls were mounted with busts of Shakespeare, the actor Garrick and the playwright Massinger, whose *A New Way to Pay Old Debts* had been brought to the stage by Kean himself and was a big success for him.

Apparently, Kean liked to be applauded if appearing in, say, a King Lear costume at his own party. He once treated his Bute

housekeeper to a trip over to Glasgow, to see him play the hunch-back Richard III. When later asked how she liked it, she replied, 'Och what a terrible man! I looked at everyone in the play, Mr Kean, but I could'nae see yer!'

I imagine that Kean brought a degree of 'realism' to the theatre as he astonished the audience by following the ghost while play-ing Hamlet, whereas others had drawn away. It was the norm then that to play the major tragic parts you had to be a 'gentleman', and as a bastard born in Charing Cross, who had started off as a trav-elling tumbler and harlequin, Kean certainly wasn't that. Byron befriended him and once threw a lavish dinner for Kean, but was affronted that he departed from the proceedings to join his low-life drinking cronies in Charing Cross.

For my part I found that, in delivering the text and trusting the playwright, you are doing part of your job as an actor: telling the story. There may be levels of meaning that you don't understand, but do you need to become too contorted with that? There's always much analysis and talk of motivation while rehearsing a play, but as Noël Coward once observed, 'Don't bump into the furniture and remember your lines.'

Towards the end of my time in Scotland, I boosted my wages by buying up junk and old coats in the Glasgow flea markets and bringing them to sell in the slightly more upmarket Portobello Road when I came down to London for the weekend. I some-times had a stall next to Pete Overend Watts, who had played bass with Mott the Hoople. He was a lovely character and we wrote and recorded a couple of songs together, but he was pretty disillu-sioned with the music biz after his experiences with Mott and the lack of funds he received; the same old story.

A SEA OF TROUBLES

Juggling life between London and Glasgow wasn't easy for Kari-Ann or me, and girlfriends can become jealous of the actresses in the theatre playing opposite to you. It was a long, rumbling train ride and expensive too; and if I brought my lurcher, I had to hide her on the train or pay half-price from my slender wages. I usually tucked her under the table and, lurchers being good at keeping schtum, she knew when to be unobtrusive. I would take her collar off when leaving through the barriers and move quickly, knowing she would track me. One time I heard the ticket collector shout 'Whose dog is that?', but we were gone.

Kari-Ann announced that we were going to have a child, which dramatically changed our relationship. John was born in St Mary's Hospital, Paddington, around the corner from our home. He was a beautiful baby, but it was a difficult birth for Kari-Ann. When the two elder boys went to their father after Christmas, the three of us travelled to North Wales to visit musician Dave Pierce. The weather was freezing and our car broke down on the way back, so we traded it in at a local garage for an old yellow Ford Capri, and continued to London. On our return to Westbourne Terrace, the place was pitch-black, there were no lights and the staircase was dripping with water. The entire building had been flooded after the water tank had burst in the flat above us, where the tenant had been evicted. (The landlord was trying to empty the block and only we had successfully resisted an eviction order because we had children.)

As night came on, the water froze inside and out, leaving the entire rear of the building with an icicle top to bottom, which split the brickwork in half over five storeys. Everything in our flat was ruined, including my vintage Martin and Gibson 'mandocello' guitar, bought years before from Fred Walecki in his music store in Westwood Village, Los Angeles.

Our only recourse was to apply to the council for temporary accommodation and take whatever was offered. After staying in a cheap hotel, we were moved into two bedrooms in St Stephen's Gardens, Notting Hill, and for six months shared a bathroom and an upstairs kitchen with other homeless couples.

A benevolent council officer guided me through all the hoops to make a housing application. He asked about my income and, when he heard it was practically zero, insisted that I sign on to the dole, as no one in authority would otherwise believe me. I had never before been in such a position and was glad there was a social security system as a safety net. I wrote a script about our experience, a real 'kitchen sink drama' dealing with the issues of the day, and had the temerity to send it off to the well-known playwright and later filmmaker Mike Leigh, who kindly returned it with comments.

We were finally offered a council flat in a basement close to the Westway flyover in Paddington, which I was ready to take. My father came up to see us and I took him there – but when I opened the door to the place, it too was flooded with recent rain and a good helping of sewage. This didn't throw me too much, after what we'd been through, but Dad was unimpressed. With help from my brother, he soon organized funds towards the purchase – for £28,000 – of a small Victorian terraced house in West Hampstead, near Kilburn. Kari-Ann had also been left some money when her mother died tragically young, so she added that to the pot. And behold, we were on the property ladder!

I'M YOUR HANDY MAN

Our tiny backyard was about 30 feet from the boys' school entrance, so we only had to open the door in the morning for them to go to classes. It was a friendly neighbourhood. I did some basic repairs

on our new place and one time re-pointed the crumbling chimney on the roof, lashing myself to it with a rope. After cleaning out the joints, I applied water so the cement would stick, but that made the sloping surface so slippery that I was losing my footing. You really need two hands to perform that task, and I was shaking like a leaf when I finally descended. You're supposed to erect scaffolding for those sorts of jobs.

Kari-Ann pictured on Hampstead Heath 1982. She could swing into action and strike poses effortlessly so you had to be quick on the draw. I tried my best but I am no real photographer.

With my pal Jimmy O'Neill, a colourful Scottish character and sometime-roadie for Motörhead, we repainted the front of the house and made such a good job we had requests from round the neighbourhood for more of the same. On Kari-Ann's instructions, we chose pink and grey for the interior, quite unusual at the time.

CHAPTER 17

"DRESS SMART CASUAL"

Ron Cass had previously been in the record business and even fired by Beatles manager Alan Klein, and now, having married the actress Joan Collins, was producing a film to resurrect her career. Joan was a Hollywood star way back, having appeared in numerous films, including Howard Hawks' epic *Land of the Pharaohs* in 1954. This outing was a little less lavish. Penned by Joan's sister Jackie, *The Stud* was intended to be a risqué romp – and to make money. Ron paid for my flight from Glasgow to London, rather than the plodding train, and told me he wanted me to appear alongside Joan in the film. I pointed out that I was under contract in Glasgow. In the end, I was given a small part – blink and you luckily miss it.

Oliver Tobias landed the male lead, and the picture's subsequent notoriety made it a huge earner for Joan, even if it didn't win any Oscars. It was the beginning of the video age and she and Ron cashed in, as, with Oliver, everything was a buy-out, no royalties. Some of the movie was shot at Tramp nightclub as the owner, Johnny Gold, was a big pal of Joan's. One shoot there was made out to happen on New Year's Eve and we were all jammed into the club to 'celebrate'. The gag was the usual countdown to midnight and the crowd was supposed to go bonkers, blow whistles and the rest. Balloons were released from the ceiling and a male stripper ran on – all terribly exciting. As with most movies, there were the usual hitches, so the scene was re-run, then again, by which time any initial enthusiasm had evaporated into the hot lights.

I could hardly face New Year's Eve again after that, or descend into Tramp, where Kari-Ann liked to go if we were up late, and dance away. There were usually celebs around the club, though not often my type. But I do remember a drunken night with George

Best there, meeting author William Burroughs, and a hilarious evening with Mel Brooks and Marty Feldman. Never bumped into Prince Andrew, though.

Joan followed up with the equally masterfully titled *The Bitch*, polishing the role later in *Dynasty*. Keith Moon and I appeared together – we hit it off well, improvising the lines – and I thought he was a good actor, but the scene ended up on the cutting-room floor. I got on pretty well with Joan; she didn't take herself too seriously and liked a joke. When I mentioned something about the below-par dialogue, she just said, 'I make it up on the set.' Kari-Ann was taken on for an outside location scene, her only previous movie outing being in *Casino Royale* in 1967.

I became quite friendly with the co-scriptwriter Dave Humphries and took Kari-Ann down to Cornwall to visit him there. She had grown up in Cornwall and it was our first time together there, which was rather special. We toured around Penzance, where she had been at school, and to the tiny and picturesque Mullion Cove on the Lizard peninsula, where she had been raised by her grandparents, roaming all summer long on the rocks and beaches and not bothering about shoes – an idyllic childhood in many ways.

Some TV work came along: a sitcom with comedian Maureen Lipman in front of a live audience; another with Bill Nighy; and an episode of the detective series *Shoestring*, which featured Gary Holton playing himself as a wide boy and the flame-haired singer Toyah Wilcox. I became quite good friends with Gary, a rock & roller and one-time frontman for the Heavy Metal Kids, and went on to appear in episodes of Ian La Frenais' *Auf Wiedersehen, Pet*. He was very funny, an archetypal Londoner with a marked penchant for drugs and drink, and he looked a bit like Ronnie Wood with his spiky black hair. I got on well with *Shoestring* direc-

tor Marek Kanievska and liked his work, as well as his fellow Pole Stephen Poliakoff, for whom I read a part in his *City Sugar* play for BBC radio.

The best money came from adverts, something coach Stella Adler had counselled against. The director Nick Lewin asked me to perform in one as a busking one-man-band and I agreed, so long as I didn't have to audition (because that would involve hiring all the gear specially). On a freezing morning, I had to walk up and down a cinema queue, coordinating the guitar playing with the bass drum, kazoo and whatnot. It's not easy: if the length of the string isn't right, each time you yank your foot up to engage the bass drum, your back gets a twinge – but you have to suffer for your art. An ad for Lee Cooper jeans was the best earner, and I even had my own 'stand-in' bottom, as apparently mine wasn't big enough for the rear shot.

Although I had avoided modelling, I was offered a shoot in an airport with a bit of acting thrown in. I was supposed to have one girl on my arm while another walked past to catch my attention. The two girls were Jo Howard (later Wood) and Jerry Hall, who at the time was dating Bryan Ferry. This was before either had encountered The Rolling Stones. Jerry had a very broad Texan accent then and remarked, 'The maid has been away, and I had to do the dishes.' She would have died if she'd seen my kitchen.

THE WALK

In 1978, Rick Watson passed a Hilaire Belloc book to me called *The Four Men* and it inspired a walk retracing his route across Sussex, a tradition that I continue to this day, always beginning – as in the original story – on 29 October. Walking cross-country was more unusual then, as the rambling craze hadn't acquired the popularity it has today.

Belloc tells the tale of a journey on foot, on a whim, made in the early 1900s, before the motorcar destroyed the leafy lanes and hidden haunts of Old England. He encounters three other characters on the way, each an aspect of himself: an impecunious poet, a sailor – Belloc was keen on sailing – and Grizzlebeard, the older, wiser spirit. Together with the narrator, they tell tales, sing songs and drink beer in the old pubs cherished by Belloc in his inimitable manner.

When I was a Londoner myself, the walks were an important event in my calendar and represented an escape from the daily routine. Friends might sometimes ask to join me and I was suitably vague until I was convinced that they were committed, as it didn't suit everybody. The trick was to take a train to a suitable rural location and walk on from there, travelling in one direction and avoiding the dreaded circular walk that you are forced to perform if you return to a car. Our later walks took us across Hampshire, Dorset and Wales, and once we repeated the original trek across Sussex – though this is now difficult, as the place is overrun by developers and BMWs haring down the narrow lanes.

I couldn't guarantee a comfy bed or a fine dinner, but when I took some of my boys, they loved the freedom of it, sleeping out and building a fire to cook a pheasant that the dog had caught in a hedge. We might stew it up with some mushrooms picked along the way and throw in a splash of cognac for an extra kick. Occasionally, we were thrown off private land, or the dogs strayed off into a game thicket to have some fun. And when we reached a good pub, we would likely lie to other drinkers about our exact mission, to divert them from the scent – because when you don't arrive by car, people question where the hell you are going in the darkness when you leave.

It's great to test yourself against the elements, read maps and explore the countryside. Walking quietly through rural villages, you witness small daily routines with minimal disturbance. After a couple of days, you get into your stride and enjoy the exercise, and we often detoured to see places of interest, such as ancient monuments or fine churches. We were never in a hurry and refused to walk in the rain – so more time might be spent in the pub than was advisable. As an antidote to sleeping out, it's good to find a rock star's country pile and help them to drink their vintage brandy.

Steve Wilmoth, my architect friend from San Francisco, loved our rambles so much that he would regularly fly over to join me, Johnny Sheriff and the dogs. It was always an adventure, and probably the last week in the year when you could still sleep out without being too cold. As Halloween approached, we wandered through autumn woodland with leaves and chestnuts falling to the ground – surrounded by all shades of brown and red – and often the walks would provide me with the inspiration for a song or poem.

At night, we would drift off to sleep with owls hooting, a deer sometimes appearing to sniff us, or a fox passing by. We might find the warm fire of an old country friend and partake of his cellar. Before the age of the mobile phone, we would just appear – which was more fun because, once on the road, you were out of reach.

One year, we walked along the Hampshire Downs and, knowing an old thatched inn on the way, waited in the dark outside for it to open, our thirst growing. However, the place had changed. The manor house had been taken over by a rich Arab, and an ex-copper had replaced the old RAF landlord at the pub. A fight almost started, so I called a local taxi man I knew, and he took us to another village inn made famous by the writer and radical William Cobbett. We had a good evening but were now off our

route, so I called the taxi again and he drove us along country lanes to a large old barn beneath a hill, where we had a most luxurious sleep on many layers of hay.

In 1997, five of us set out across Somerset and the Quantocks to mark 200 years since Coleridge had written 'Kubla Khan', ending up on the coast path to the Valley of the Rocks, which provided the inspiration for his epic 'Rime of the Ancient Mariner'. As we walked, we recited his verses, because poetry always works best when spoken aloud.

The autumn walk, 1997; in Lynmouth, Somerset, 200 years after S.T. Coleridge wrote 'Kubla Khan'. Myself in white hat, son John facing camera in hat, Josh Marcuson with lurcher.

DIARY

Glastonbury Festival. Played on Sunday afternoon in the Avalon tea tent. We were pretty good, so it was a workout, and a few friends came along. No pay, plus no mention of the tea tent or its stage in the programme. Afterwards, went to see the Russian mime in the Circus tent, which was pretty amazing and very dramatic. Kari-Ann and I drank some cider and tried to get into the Lost Vagueness tent but you had to be dressed up – like it's Mayfair? We hung about until 2am then made our way back to base. Demetri was there, filming for Julien Temple, and returned on the Tuesday after the festival, so that was that for another year.

NEXT, PLEASE

In London, I attended this and that audition but it was hard to keep your pecker up: it took a lot of time and Tube fares, and you had to look smart. The psychology of it is also weird, because, although you want the part, you don't wish to appear too keen and set yourself up for disappointment; yet if you act too offhand, you won't get the nod. After the scrutiny of the audition, you must bide your time for an answer, but then you might get a 'recall' and your hopes rise again. It can really fuck your head up – as can your agent losing patience with you and asking: 'What did you do there?' At one audition the casting person said, 'I remember you from before, you were quite rude,' which was a bit of a shock but better to be remembered, I guess.

Besides, during that punk period, almost everyone was rude – it was standard. I went to one audition in Wardour Street for an advert, and the brief was to play air-guitar to a track and at a certain point go nuts. Apparently, after my audition, a serious punk guy had followed their instructions too well and gone completely berserk, crashing into the lights and cameras, and

causing a few thousand pounds' worth of damage. Well, they asked for it, literally.

Nick Lewin also used me in a Foster Grant sunglasses ad, where I played a French gendarme. When someone on the set said 'He doesn't look anything like a gendarme,' Nick replied: 'Who cares? This is an advert.' One time I went for the role of a 'groom' and, according to Marlon Brando, you should walk in 'looking the part'. But I picked the wrong part and dressed all horsey; they wanted a wedding groom!

Being an actor actually involves a lot of time not being an actor. Unlike musicians – who are always hanging with mates, jamming and writing songs – actors don't pop over to rehearse a scene from *Hamlet* on a rainy Thursday. When you're working together, the cast members send each other loving cards on the opening night of a play, wishing every success, but once it's done and dusted you might not meet again except by chance.

Without trying to run down actors, musicians bond and are more supportive of each other, which is endearing. Also, as an actor it's tough to generate your own work because you are relying on agents and casting people, who you have to schmooze if you want to go places. That is true to an extent of musoids, but at least they can go to the local bar and ask for a gig on a Friday night; if people come in, they'll get the door money, which is somewhat different from finding $12 million for a movie.

And what do you do when you're not acting? At an audition, when you're asked 'What have you been doing recently?', you're not expected to reply 'Painting Mrs Jones's' bathroom in Ealing.' You're meant to lie about some supposed project or pretend you've been attending a course on sword fighting. I was never very good at this type of deceit. Once I went for a part in the musical *Tommy*,

but I didn't mention that, it being the pre-Christmas season, I was a 'temp' at Paddington Post Office.

The Christmas mail was a big thing in those days. Most of the temps were undergraduates, and aroused the indignation of the regular 'posties', all strictly unionized and with their own singular 'demarcation lines' (that is, things they would or wouldn't do). I was usually on the local collections at 10am, 12pm and 2.15pm, then on the heavier ones running through until 6pm; not really that strenuous. The drivers' approach was to remain in the canteen as late as possible – the white British posties generally playing rummy while the West Indians favoured dominoes, banging down their pieces in the echoing room. If the collection was at, say, 2.15pm, they would continue their games until 2.12pm. Then we would all leap into action, jumping into the Leyland Sherpa vans – the sliding doors left open – and to a soundtrack of screeching tyres, in a cloud of diesel fumes, we would be off on an assault course round the narrow streets of Paddington.

Brakes would be slammed on next to the red post boxes – skipping some if we were late – and I would empty Christmas cards and packages into the grey bags sewn up by some poor jailbird. Back at the depot, the post was thrown onto the 'facing table' for sorting; the drivers would leisurely rejoin their gambling schools and I would pass the time reading the paper, until it was time to repeat the performance.

But back to *Tommy*. One December afternoon, I asked my driver if I could 'skip the 2.15' and then dived down the Tube to Covent Garden, where Pete Townshend and backers were holding auditions for a stage production of *Tommy* above a pub. I might still have had my Post Office armband on while waiting to come in on the opening bars of 'Pinball Wizard'. My head was spinning as the introduction went round and round, the notes from the job-

bing pianist echoing through the empty rehearsal space. Needless to say, I didn't get the part; they hired someone with a high voice and curly locks who resembled Roger Daltrey. Like Frank Zappa says, 'To make it in music you either have to have a high voice or sing the blues.'

I was a musician and I liked serious plays, but I found musicals were usually watered-down mush. They required your voice to have as high a range as possible and to hit notes dreamed up by the composer in his bath. This may make the score sound fantastic, but I reckon they would have turned down Elvis if he'd auditioned.

ON SONG

Everyone has a voice and is capable of singing. Developing your voice is a matter of training and technique. Of course, some have a high degree of natural ability, but there are still many aspects to take into account, such as the timing and rhythmic flavour that you impart (and how you use that depends a lot on who you are playing with, and the style of music they're playing). Being in tune helps, naturally, but you can also go flat if you know what you're doing: some African singing is deliberately so. Then there are the *shruti* quartertones of Indian music, which are quite hard to identify unless you have excellent hearing.

Singers usually have favourites who they take as role models and copy. There's nothing wrong with that. Ray Charles sounded very similar to Nat King Cole, until he found his own voice, and then success with his own style. Mick always loved Muddy Waters – powerful and with a great delivery. He had a big influence on both of us. He laid it on the line and his timing was everything. James Brown was unsurpassed for rhythmic skill.

In English church choirs, the most valued voices belong to young boys whose voices have yet to break. They are pure and

high and that's fine, but personally I find a well-worn throat more interesting, and the growls of Johnny Cash, Leonard Cohen or Al Green come across as more infused with feeling and experience. When I first listened to blues players such as Jimmy Reed or Howlin' Wolf, they were already quite old, but I never thought about that; I was drawn in by the amount of living they had done.

I started to understand a little about singing in India, when I learned to breathe. To hold a single note for several seconds without wavering, you must have strong lungs pushing out a steady stream of pressurized air; it's that simple. But singing is so beneficial for the throat, lungs and entire body. It's only recently that more people have discovered this and started joining choirs. So don't ever be ashamed to sing in public – or the street – if you feel like it. It's only natural!

NOTTINGHAM PLAYHOUSE

I did get hired for a musical play called *Teeth 'n' Smiles*, which I'd already seen when it opened at the Royal Court (starring Helen Mirren, who was a friend of a friend at the time). Our production was slated for the provincial town of Nottingham and featured a live band on stage. This involved switching from acting to playing instruments without pause, something the esteemed writer David Hare hadn't considered too difficult; but then, he wasn't a musician and didn't need to check the tuning.

Following a blackout after one scene, we would climb onto the separate 'band stage' and it would lumber on wheels towards the front, carrying the 'group', complete with drums, amps and microphones, a proper set-up. It felt risky to be so high on a moving platform, and it was tricky to pull off. The play had as its female lead Linda Marlowe – who was great even if she couldn't sing too well – and also featured Anthony Head, later to become famous

for a sexy Gold Blend coffee ad. We rearranged the music as best we could to make it more 'rock & roll', and had as much fun as we might in sleepy Nottingham.

The actor and drummer Don Hawkins knew of a rambling Victorian vicarage outside town where we could stay, so we bought a clapped-out Vauxhall Viva that shuddered like a wet dog if it went above 40mph and drove out there every night after the show. It looked like a location from the film *Withnail & I* – which in a sense it was. An actor that Don knew, called Vivian, had lived there, apparently the inspiration for the black comedy that later became famous to thespians everywhere. I took great pleasure in mentioning this to Richard E. Grant once when I ran into him at a party, but he wasn't too interested. I guess he had heard it all before.

NOT SO LYRICAL BALLADS

I was chosen for a part in a musical at the prestigious Hammersmith Lyric Theatre; and though its director, Toby Robertson, was highly regarded having run the Prospect Theatre Company, it proved a dismal experience for me. The production was *The Beggar's Opera*, written by John Gay in 1728 and the basis for Brecht's *Threepenny Opera*. The director obviously liked the Citizens Theatre's idea of doubling some of us in different parts, so we had to play pickpockets and harlots as well. I had one solo number to sing , which was my minimum requirement to appear – but during a dress rehearsal, the director casually announced in front of the entire cast that he was giving my song to another actor, without any explanation. That was very demeaning, not least because I was one of the very few in the company who could actually hold a tune.

After this, I lost interest in the production and was seriously marked down by the management. One actor stood up for me,

however: Harold Innocent, who was quite famous, hammed it up on stage like it really was the 18th century. One night, the waistband of his trousers came apart on stage and he desperately turned to me in panic. I somehow contrived to fasten them up, after which, if someone complained about me, he replied: 'I won't hear a word said against the boy!'

The Lyric's studio theatre was simultaneously running a production of *Loot*, directed by none other than the raconteur Kenneth Williams, who had famously holidayed with Joe Orton and his partner Kenneth Halliwell in Morocco. Right before the opening night, in true Ortonesque fashion, the lead player had been beaten up in the street – so Williams himself stepped in to deputize, reading from the text. I called my brother and left him two tickets for that performance, and he went along with Jerry Hall; but for some reason I never invited him to watch me. In fact, he has never witnessed me perform in the theatre.

'TWO HOUSES, BOTH ALIKE IN DIGNITY'
– Will Shakespeare

These were the first lines I spoke from the Bard as I appeared in *Romeo and Juliet*, in Plymouth, over 200 miles west of London. The play was moved to the Fifties, with Citizens friend Garry Cooper cast as Romeo, so we had some fun together. I was both 'the prince' and Mercutio; and for the latter role I took my cue from Henry Winkler's role as 'The Fonz', playing as Romeo's hip sidekick, with a lot of chat and lines that I sometimes struggled to remember.

As usual, the money was the Equity minimum, so to save on outlay, I arranged to stay with (Lord) Peregrine Eliot at St Germans, his extensive Elizabethan pad in Port Eliot, across the Tamar from Plymouth and just inside Cornwall. Buckets

were strategically placed along some corridors to catch drips from the roof, which enhanced the air of damp decadence. Still, he generously let me occupy one of his 125 rooms and, when I was rehearsing, we would often eat dinner together in the fine panelled dining room, complete with a Rembrandt on the wall – not a very good one, but nonetheless worth a bomb. Perry liked home cooking, served on silver plates to keep the food hot; these, John the butler would collect, disappearing backwards with them through a concealed door.

Peregrine was fond of theatre gossip – after all, he was rattling round that enormous house with little company – so perhaps having me there was enjoyable for him. He also liked a good smoke of hash, which was part of his undoing, as he later developed emphysema and even had a lung transplant before living out his days in Hawaii. He was a real gentleman. Kari-Ann once came to visit and at dinner Perry sensed that his keen appetite took her aback. 'Well, you do eat rather fast,' she said. 'I wolf it down, that's what I do,' Perry unashamedly replied.

I'd visited Port Eliot a few years before when I was with Vivian, and John Michell, a great friend of the Lord's, had asked us. At dinner, an American woman enquired how Perry heated the place and he came back, 'With fires and the grand invention of the cardigan.' 'Pardon me, but what's a cardigan?' she then asked, obviously feeling the chill. It was May Day when we went to the north coast to watch the 'Hobby 'Oss' parade along the narrow roads of Padstow, an ancient spring fertility rite, the main point of which seems to be getting drunk and dancing in the street.

While I was at Port Eliot, the Polish painter – and character – Robert Lenkiewicz, a true friend of the vagrant, painted me onto the wall of St Germans' enormous round room along with hundreds of other faces. Notoriously, Robert once faked his own

demise to draw attention to the council's neglect of a large mural he had painted on the side of a house in Plymouth. Inserting a death notice in the local paper, he then disappeared and the obituaries had come out before anyone asked where the body was. A manhunt ensued and he finally came out of hiding, but it was a good spoof.

DON'T CRY FOR ME, SIR TIM RICE

A call came from my agent to audition for a replacement part – as Che Guevara in *Evita* – admittedly a fill-in, but it was a West End show. I learned the songs, practised hard and on the appointed day presented myself at the Prince Edward Theatre in Shaftesbury Avenue. Kari-Ann had recently begun Iyengar yoga and I did a little in the morning, so that I'd feel centred to deliver 'Oh, What a Circus'. I thought I did pretty well, emulating the laid-back performance that David Essex gave in the role. But perhaps the yoga had worked all too well as, when they did call my agent, they asked 'Was he was on drugs?' After all my attention to detail and the effort I had put in, I felt insulted by the comment. I was trying to support my family and myself and decided to have no more to do with the world of theatre. I left the boards behind!

DIARY

Jerry's birthday was next up in the calendar and we were to play, with Ben Waters on piano, in the ballroom at Richmond. Mick didn't make it over from France, where his band had a few days off. He must be fed up with parties and people – I would be! Spoke to good ol' Ian La Frenais, as well as Pete Townshend and Bob Geldof, who got up and sang a couple of tunes with us, which was nice. (At first, Bob was skulking at the back of the room, unnoticed – which is tough when you are 6 foot 2, and

*wearing a white hat and suit.) He played guitar, then we did 'My Babe'
with him on harmonica.*

*I think Jerry had a good time. I carried the cake into the main room as
we all sang 'Happy Birthday'. Dad came in a kimono and looked great!
The dress code was 'Oriental' and the garden looked fantastic – all decked
out with a beautiful tent, low divans, cushions and candles – while a sitar
twinkled in the background. In the end, only James and his friends were
still there when I left – almost the last to do so; it takes me ages to load up
the gear for some reason.*

CHAPTER 18

GUITAR INTERLUDE

In 1983, I met a clever engineer and designer called Pat Townshend, an affable character with lots of ideas, who had previously developed a fibreglass drum kit, with a weird trouser-shaped bass drum, called the 'Staccato Drum Kit'. This had already been sold on, but he was keen on developing a guitar with the neck cast from magnesium alloy, the concept being that the neck could slide out from its casing, so you could replace it with another, a 12-string or a bass.

It looked swish and super-clever but in hindsight was something one might make as a one-off project at engineering school and not seek to produce commercially. Pat was driven, though, and sought my help, which initially I gave freely. Naturally, he also wanted finance, so we went along to see Bill Wyman, who very generously offered some seed capital, which kept Pat going for a while. The project started sprouting wings, however, and we then approached Mick, who saw it as a chance to assist me in something that might be successful, and so made an investment.

I really didn't have a clear idea of how the business might work, but the musical instrument industry is littered with ideas that fanatics have tried their best to develop, and this was another in that crowded field. We showed prototypes at trade fairs and there was a great deal of interest from the press, always eager to write about something new. (Like those products you might see on *Dragon's Den*, the samples cost a fortune to develop, in the expectation that costs would drop with mass production.) We went to the famous Music Fair in Frankfurt, sharing a corner of fellow UK manufacturer Rotosound strings' stand, and with assistance from *Sounds* magazine; lots of people came by and encouraged us, but

I soon realized the manufacturing costs were way too high and I didn't see a future in it. I reported this back to my brother but he felt I was giving up too easily and should stick with it.

At the time, there was a resurgence of interest in the bass guitar, and thumb popping (as practised in particular by Mark King of Level 42) was a big thing. Hence, Pat developed a Staccato bass guitar, with a fixed neck, still made of magnesium alloy – which is light and strong, but expensive too. Since this material was widely used in the racing car industry, we went to Kent Castings, who made parts for Formula One cars. We put all our effort into these basses, complete with LED lights, a touch volume-control and special pick-ups wound by American Kent Armstrong.

Surprisingly, the musical instrument field can be very traditional: many players just wanted to stick with their old Fender basses, and who could blame them? Part of our system was a fine-tuning mechanism with a screw tension set behind the bridge, which was very accurate and alleviated the need for heavy tuning-cogs on the head of the neck, where their weight can make the instrument unbalanced. Our friends at Fender Guitars, the biggest player in the field, were interested in licensing these tuners, which could be retrofitted onto their existing basses, and if they took off, we could be looking at high sales. It appeared we were going ahead – the contracts were drawn up, the supply chain organized for production – and we just needed the nod from Fender. I flew to California to seal the deal, but at the last minute it all fell through, one reason being the high value of sterling at the time, which made UK manufacture just too uneconomic.

Gene Simmons from Kiss bought one of the bass guitars and used it in a video – but maybe there it was more of an accessory than anything else. Otherwise, all the time, effort and money that went into Staccato Guitars resulted in little more than a shed-

load of unwanted parts and fading leaflets. As anyone who has attempted a start-up knows, the odds are stacked against success and ours was no different.

Designer and builder Pat Townsend at a guitar show in London with legendary guitar maker Jim Burns. Note Staccato bass on the wall.

This was quite a painful period for me as I had worked hard and Mick had been kind and invested. Pat was driven to the point of exhaustion and it affected him more than me. He went on to design motorcycle panniers – moulded fibreglass containers that fitted neatly onto the back of bikes – which he sold to the courier company Addison Lee, and he was also involved in making parts for Ducati, the stylish Italian bikes that Pat raced around tracks like a madman.

THE SCRIBE

One good thing to come from the Staccato episode for me was meeting Luk Michaels, who ran a music magazine in Antwerp, Belgium, and whom I had met at the Frankfurt Music Fair. He asked me for a monthly column and this arduous task involved obtaining free tickets to gigs, free records, and interviews with

musicians who were usually only too pleased for the publicity. I also picked up another publication based in New York, imaginatively called the *Music Paper*, so I began a small monthly syndication deal. Other commissions came my way, including those from the American *Guitarist* magazine and *Rolling Stone*, run by Jann Wenner. He was a great friend of my brother's, and I had met him in Montauk one time. I was returning to England from Chicago and stopped to visit Mick in Long Island and we spent a wonderful few days with nothing on the agenda as his business meeting was cancelled. We toured round and went for beers and played pool in bars – all very low-key. I played tennis with the other Rolling Stone, Jann; I can't recall who won but I remember he was very competitive, as some business people become on court. One time, I played cricket with a bunch of musos and Virgin boss Richard Branson, and I believe the singer who bowled him out failed to land a record deal with Virgin! A dropped catch could mean the difference between success and failure.

In my incarnation as a journalist, I began to take snaps of the bands to keep myself occupied. This was the era of The Cult, That Petrol Emotion and various indie shoe-gazers in such venues as the Hammersmith Odeon and The Forum in Kentish Town. John Paul Jones from Led Zeppelin looked down his nose at me when I interviewed both him and his daughter, who was launching her career. 'What kind of job is that?' he asked me somewhat sarcastically. I took his point and ended up telling more stories; after all, why should anybody care if I really liked Killing Joke's second set or not? I hadn't even paid to get in! I wrote one piece entitled 'Critics Don't Dance' about miserable writers and how to spot them at gigs. The period encapsulates that time in London, and I was intending to include the best of those stories in this

volume, but I was talked out of it as it was something of a diversion – something I personally enjoy in books!

At first, I wrote on an old IBM typewriter, a huge clunky thing, and was useless at correcting mistakes with Tipp-Ex. Soon, however, I graduated to an Amstrad word-processor with an eerie green screen, a great technological leap forward from business magnate Alan ('You're fired…and you're fired!') Sugar. Once the articles were printed, I would pop over to the house of my friend and neighbour Sue Lloyd-Roberts and send them off by fax. Funnily enough, I think that Stella Adler's acting lessons had helped me with my articles: she emphasized observation and paying attention to details to help recreate a character or event.

Jerry Hall in her dressing room at The Palace Theatre, Watford, appearing in 'Bus Stop'. It was her first play so I was trying to show her as an actress rather than a model, but she didn't think much of my photographic efforts!

FOR BETTER OR VERSE

Mick asked me to assist in writing a few lyrics for *Dirty Work*, which the Stones were recording at the Marconi Studios in Paris, a roomy old place with lots of character that they subsequently 'improved' after the band had been there, thus losing much of its charm which had made it attractive in the first place. I was only too glad to help, seeing how much he always does for me. He sent over cassettes and lyrics scribbled onto scraps of paper and I added what I could and sent them back. It's best to have a wide choice so that you can edit down to what you really want to use on the record, and quite a lot was discarded, but that's fine. I also contributed the opening lines to 'One Hit to the Body', and when I came to hear the record in the studio, we argued about who wrote what; it was quite competitive! Mick gave me a rather strange credit, as 'literary editor' – but the main thing I took from it was that I must have done okay or he wouldn't have used it; so I had more confidence in my writing. One ballad he had was 'Blinded by Love', which went on to appear on 1989's *Steel Wheels*; remembering my English A-Levels, I thought of Mark Antony and his infatuation for Cleopatra, and stuck in a verse using that idea (after all, Shakespeare had borrowed a lot of stuff from Plutarch).

Once *Dirty Work* was finished, Mick wanted a break so he suggested a trip to India. I hadn't been there since the heady days of the Sixties, so I was only too pleased.

We were met at Delhi airport and the driver, seeking to impress us, pushed in a cassette to pound out 'Get Off My Cloud', which we politely asked him to eject! 'I drove Mr John Elton once,' he proudly recounted. After sleeping off the haze of the Paris sessions, Mick and I toured Rajasthan and had great fun together, hanging out and seeing such sights as the Taj Mahal.

Wary that we might be hassled, I had visited Charles Fox, the theatrical make-up company based in Covent Garden, London, and bought a couple of moustaches plus glue, so as to wander round incognito. Before we visited the Taj, we stuck these on – amid much laughter because they looked ridiculous – and then took the tour with our guide. The only effect they appeared to have was to frighten young women there.

The following morning we were due to drive to Fatehpur Sikri, the famous city built by Akbar the Great as his capital, but which was later abandoned, probably due to a lack of water. The same driver as the previous day turned up, and must have wondered why these two Englishmen now arrived without moustaches, and why they had them in the first place? Like many a guide, he was a mine of information on the number of pillars on the road that Akbar had built, the length of the surrounding wall, and so forth, so I began asking daft questions – such as 'How many bicycles are there in India, and how many punctures per day?' – until my brother told me to shut up. Mick and I both love travelling to India, the people, the places, the food and the cricket, even though there is such grinding poverty everywhere. Akbar had built a room with niches in which would sit the various proponents of religious faiths, a Sikh, Jesuit, Buddhist, Zoroastrian, and so on, and he would sit in the centre listening to the dissertations and merits of the different points of view. In Europe they had the Inquisition. Ha!

THE FAME GAME

It's been interesting over many years to view the concept of fame and how people react to it because – when meeting someone famous – people, me included, can change their manner; and instead of being considered and relaxed, they blurt out stupid things, ask for autographs (more recently selfies) and generally

drive the famous person away, which is often the opposite of their intentions. Some of this depends on how the famous person behaves, of course. I was impressed many years ago when I saw Pete Townshend appearing at the side of the stage after a concert, chatting to fans and really listening to what they had to say; he probably learned a lot. And as a lad, when I'd met famous footballers and asked for their autographs, I'd seen that, off the pitch, they were no different from anybody else. On the field of play they were gods but, back then on a salary of 20 quid a week, they would jump on the bus and go home or have a pint with their mates.

The traditional Indian way of dealing with fame is *darshan* (or 'seeing') and is also a kind of 'thank you'. If you listen to a concert by a favourite musician or *ustad* (master), then the correct behaviour is to approach him if he remains on the stage after the show and touch his feet. In turn, he might touch your head in recognition, but no one expects to have a conversation. (Obviously, there are limits to this personal contact; you can't do that for 10,000 people individually.)

I once heard the Dalai Lama speak at the Gandhi Institute in London, and after the talk he made his way slowly across the floor, surrounded by admirers, of whom I was one. He finally came towards me and, as we had previously met, took my hand and held it for some minutes, while Tibetan advisors were talking in his ear. Then with a smile he moved on. Words were not necessary. The only other person to have held my hand for that long was Stevie Wonder, while he asked me various questions about my star sign. That was probably to hear my voice: he couldn't see me, but was nevertheless building up a picture in his mind's eye.

Walking along the street with my brother, it's interesting to witness people's reactions. They look up from maybe 30 feet away and their faces change with the realization that Mick is walking

towards them. First, they might register surprise, or perhaps their mouths drop, then comes the reaction. They're thinking of what to do in that split-second – perhaps say hello, say something, but what? – and then the moment passes and he's gone. Some might turn and follow, to ask for an autograph, but that's to be avoided because – if Mick stops – he'll be noticed and a queue will form. Once we were in a London theatre with our parents to see Oliver Tobias in *The Pirates of Penzance,* and during the interval were standing together chatting when an American girl approached and timidly asked perhaps if he was Mick Jagger? 'No,' he blankly lied, and the poor girl turned away in disappointment. It's a well-known maxim that you shouldn't meet your heroes as you will ultimately be disappointed, and there's truth in that. Better to admire from a distance.

"Yes I can hear you okay"

Sometimes, an avid Stones fan might approach me, and I find myself confronting their projections of the band and my brother in particular – but really they're exposing their own fantasies to me. This is hard to deal with and very little to do with me, as I point out. But when drawing comparisons, one likes to look for

similarities in people – you often hear the words 'She's so like her mother' when you spot a family resemblance, but differences are not so obvious. It's a big issue when it comes to famous people having a private life. Being a movie star is fine and good, but some things you still want to keep private. Demi Moore told me that while shopping in Amsterdam with her children, she was spotted on entering a store and photographed and hassled. She had retired from acting but obviously couldn't retire from being a celebrity. In the Sixties, when the Stones were already a big UK act, the people in Chelsea where Mick lived were more relaxed. If a cab driver saw him in the street, he was more likely to shout out of his open window 'Like your latest one, Mick!' in a chummy way, which was more fun.

FIRST TIME I MET THE BLUES

I went to Dingwalls Dance Hall in north London one night to see Buddy Guy and Junior Wells and to write a story. I arrived there early in the hope of having time to meet up properly, and they were interested in who might come along that night. Mick? Bill Wyman? Eric? They were hoping these names would appear at this small but well-known club as we sat in a cave of a dressing room shooting the breeze.

I had been blown away as a mere lad by Buddy Guy's mesmeric and speedy guitar style and high-pitched vocals. For this gig he had a borrowed amp and a pickup group, like when he was starting out. He passed me his cognac bottle and, it being around 6.30pm, I declined – at which Junior 'twigged' that I wanted some of the gin that he was drinking neat. Hard-living dudes! The show began as I sat in the dressing room by the stage and when Buddy motioned for a drink, I took him the bottle, acting as his roadie, yeah! They played a great set and I was impressed at how Junior, already quite

an old chap, drew in the girls with his charm, his harp playing and a wicked smile revealing his gold teeth. It was practically voodoo.

Buddy was looking to Eric Clapton to help him make a record, and a while later, meeting Eric at a charity cricket match in which I was playing, I asked about his plans, but Eric wasn't too keen to discuss them. So, maybe nine months later, Buddy and Junior played Dingwalls again – and this time Eric was there with the cricketer Ian Botham, puffing on a smoke, and there was a throng of stars packed into the dressing room door, in contrast to the previous gig.

In the dressing room at Dingwalls, Camden, London. Buddy Guy with guitar and Junior Wells in hat. They had a kind of magic that they generously shared with me.

I already knew Buddy's bass player Greg and, remembering how tedious hotels and touring can be, I thought he might want a change of air so invited him to my house nearby, for tea and to see the family. Buddy hadn't had an album out for ten years, his career was languishing and I suggested that Greg meet the producer John Porter about recording. I duly introduced the two and out of that came the comeback album *Damn Right, I've Got the Blues*, which sold well and put Buddy back on the map. I had also arranged for the Stones' Truck to record Buddy at a bigger gig he

later played at the Town & Country Club, but his then-manager turned it down. A pity, as it was one of the finest shows I'd ever heard him play.

I only wish Junior could have shared in the action, as he was a generous and lovely guy, but by then he had stopped touring. Junior had given me his mother's number in Chicago as a contact and I couldn't help wondering how long she would be around. I wrote one blues tune on *Atcha*, my 1994 comeback CD, and dedicated it to him, as I felt his spirit running right through it. I later saw Buddy play at an Albert Hall gig with Eric, and Buddy gave me a warm thank you.

THE FAMILY WAY

An interesting aspect to all those blues guys is that they are very family-oriented, and Buddy's brother Phil also played guitar. When Buddy and Junior looked at Mick and I, they got the whole picture and treated me with equal respect. One brother, all brothers!

People occasionally ask the rather limp question, 'Why didn't you play with the Stones?' Apart from the age gap making that unlikely, there have been many bands of brothers and it usually ends in tears. Look at The Kinks, Dire Straits and latterly Oasis. Usually one is the dominant force, the other plays second fiddle and jealousies arise. In any case, Mick had his brother in Keith; they were the Glimmer Twins, who wrote the tunes and steered the band's direction, particularly after the death of Brian Jones. Keith didn't have a brother – he's an only child – so that role fell to Mick.

But as I say, many black American musical outfits have a different approach; for them, it's normal to share the family business. Take The Staple Singers, one of my all-time favourite groups. In 2000, I went to see Mavis Staples at the Jazz Cafe in Camden

and I was sitting on the stairs close to the stage when a woman passed me, saying 'I know who you are!' It was Mavis's cousin, and she had told Mavis I was there. So during a long introduction to one number, in which she thanked everybody – particularly the chef, Sue Miles – she announced that I was there and wondered if I would join her to sing. Since we had never met, she added, 'I don't even know if he does sing?'

I was then thrust onto the stage and attempted to accompany Mavis and her strong voice, even though I was a little overawed. Later, I joined her in the dressing room and we sang some old gospel tunes together – but the point is they expected me to sing, it was a family thing! Still, as someone remarked of actress Elizabeth Whitlock, sister of the much more famous 18th-century actress Sarah Siddons, 'She is very good, but will always be Sarah's sister.'

I COULD DO THAT!

I attempted to find permanent employment and applied for a post at the BBC, but I didn't have the necessary qualifications. I tried *Time Out* but they thought I wasn't clever enough with paper clips or something. I asked at the *Evening Standard* if there was something full-time I might do, such as write about theatre? 'No,' was the reply. 'Milton Shulman does that, he's been here for 40 years.' (I thought he might need a rest.) I later wrote stories on the environment for *The Guardian*, as well as cricket and travel articles. But the funny thing was, only when I returned to playing music were publications more inclined to take my calls.

For a while, I had a temporary job with a market research firm, filling in questionnaires. One day in leafy Hampstead, I was on the rounds and knocked on a rustic front door – and Sting answered. Taken aback, I blathered something out, and stepped into his hallway. He naturally wondered where I was going, for in those more

innocent days, people usually asked me inside to answer the questions. I ignored the form-filling – I could do that later and make it up – but we got chatting and he invited me to his upcoming birthday party, full of Hampstead types, musicians and actors and even a hero of mine, the satirist Peter Cook.

SWEET SOUL MUSIC

Since my twenties, I'd knocked around with a few line-ups and one I had was pretty damn good. It included 'Admiral' John Halsey on drums, Charlie Hart on bass, John Porter on guitar and Davey Payne on sax. Davey and Charlie had known each other for years and played free jazz, among other styles, but ours was more soulful blues. We had one memorable gig at Dingwalls that included the Irish guitarist Ed Deane, with Vicky and Sam Brown as backing singers. We played covers such as 'Unchain My Heart' by Ray Charles (before Joe Cocker recorded it) and before The Commitments came along with the Alan Parker film, which reintroduced audiences to that great style of music.

At one point, we rehearsed in a partly demolished house in Maida Vale, owned by Richard Branson. It was basically a hole in the ground; there was no proper floor, or walls either. The other place we used, as it was free, was the basement of an Indian greengrocer's in Kilburn High Road, and it had a good spicy smell.

I played a few gigs around town, one at Morton's on Berkeley Square. I previously had a regular spot at the Zanzibar cocktail joint in Covent Garden in the Seventies with guitarist-singer Phil Ram, until he made a full swing into the punk scene. I named us the 'Clumsy Brothers' and we were there to entertain the chattering classes, battling with machines churning out the cocktails. Chef Nick Smallwood had run the place and, after his time at the Hard Rock, went on to Peter Morton's upmarket bar and

restaurant. There was a white grand piano next to the huge window overlooking the square and the bright young things would flock in after work to fill the bar and the booths. Keyboard player Mike Deacon, a regular player with Kiki Dee, would tickle the ivories while I added guitar and vocals. We had some good nights there, joined with regulars like guitarist Isaac Guillory and bassist Steve York, who might stop by late. Before opening night I was there with Nick and Peter, sampling cocktails, and I remarked the place was a bit too pristine, so Peter began chucking the drinks at the wall and we all followed suit. Nick Smallwood told me that Peter had once called him up when he was at the Hard Rock and instructed all the staff to come outside, which they did, and Peter appeared in a brand-new Dino Ferrari, but then he left the door open and a passing cab knocked it off. Peter Christian (who was his go-to man) was dispatched the following day to Milan, to pick up a new door!

Morton sold the place on and at one point it was taken over by gangsters, who liked you to sit with them at the bar when you weren't playing, so I knew my time was up. I was finally fired after Mike and I did a rendition of the Professor Longhair number 'Ball the Wall'.

The other music I got turned on to was Forties swing. Ian 'Stu' Stewart was a fan of this stuff and had an extensive collection in his house outside Weybridge, so I went there to check through all his old favourites on vinyl. I also found some reissued albums and decided to have a stab at creating a musical around the genre. I wrote a story outline of a young black girl with a talent for singing; it followed the ups and downs of her coming to town and trying to realize her dream, the usual framework on which to hang the singing and dancing. One song I liked a lot was called 'It Ain't What You Do, It's the Way That You Do It'. I borrowed its title for my

own project and included it on a cassette of swing tunes, which I circulated to try to arouse interest.

Stu told me that he could get some of the original jazz players – who were still alive and had grown up with swing – to record the music on the Truck. So I went to see a couple of West End impresarios, including Robert Fox, who was interested but didn't want to take a punt. Richard Branson had the Victoria Theatre and offered me a week's try-out and £5,000, but I knew that wouldn't be enough. In retrospect, I wish I'd gone ahead but I lacked confidence. Some six months later, Bananarama covered 'It Ain't What You Do' and had a huge hit with it, then singer-songwriter Joe Jackson came along with an album in the swing style, so I was definitely on the right track but didn't push it hard enough.

I was in and out of work, claiming the dole and then signing off, which was a tricky thing to do. I was once called in for an interview at the office and, thinking I might be up for a grilling, was trying to recall what misdemeanours I might have committed. To my surprise, they offered me a job working for them – in the very office where I had to sign on! Although I demurred, I did manage to incorporate the experience into a song I later wrote, called 'Rock & Roll on the Dole', which had Ed Deane playing some great guitar.

DIARY

To London and the V&A show for Ossie Clark. I got there late in sweaty travelling clothes and changed in the loo, never my favourite. Kari came with Dad from Richmond. When I went in, I felt a great sadness, like I was expecting Ossie to meet me. I saw Celia Birtwell, (the ex Mrs) who was chatting to people, then Ulla Larson – and as I embraced her, I just burst into tears. 'Don't cry, don't cry,' she said. Then she started, too, and people came round taking pictures; all very

emotional. Ossie once told me that he had offered the V&A some clothes years back, on the proviso that they were displayed, but they didn't want to know. Now he's safely dead, everyone can say how great he was, even though so many turned their backs on him when he was in need. Sure, he could be a liability and his own worst enemy, but he was great too and always such a friend and fan of Kari-Ann's. There she was in the old newsreel shots, looking like it was a hundred years ago. The dresses were displayed in glass cases with no movement, obviously. Rather tame. They might have used a dummy or two – of Kari-Ann, even.

I was one of the last to leave and on such a balmy evening felt like getting the guitar out on the steps, there with hairdresser Keith from Smile, Lynne Franks and Celia. Demetri had found a pic of Kari-Ann earlier that day, in a classic motorcycle magazine when she was but 20 years old – wearing shoes by Manolo on a bike! Demetri's godfather Johnny Stuart had died a couple of days before and he was very sad about that. Johnny was a pal I'd met through my school friend Ricky Hopper. He was a motorcycling, Russian-icon-loving, gay, erudite fellow. Vivian and I rented his basement in Kensington Park Gardens once, and he was ever so kind. Dear John.

TAXI DRIVER

Living in West Hampstead, I resorted to driving a minicab around. My old Ford Escort had died and I knew it was time to take it to the scrapyard the day two female police officers on horseback stopped me for not having a valid tax disc. Luckily, my brother had an old Renault 16 – with a front bench-seat and a gearbox mounted on the steering wheel – and as he deemed it surplus to requirements, I obtained it from his long-time driver and assistant Alan Dunn.

Near Kingsgate Road was a minicab office, on the busy corner of Willesden Lane and Kilburn High Road and, as they charged

a small fortune for the rental of a two-way radio, they were only too happy to have me sign on with them. The income was sporadic to say the least. You hung around in a dingy room furnished with sagging sofas above the fume-filled street, and waited for a fare. A Chinese-Jamaican, Mr Chang, ran the joint and his speech was fairly indecipherable, especially if he got on the radio to issue commands; if you asked him to repeat them, he would just shout the same thing, only louder. Insurance was never asked for.

Kilburn was sometimes known as 'County Kilburn', thanks to its large Irish population. I banked with the Allied Irish Bank, which was friendly enough to me. (I joked that you only needed a crate of Guinness to open an account there.) And behind the taxi office stood the National, an Irish dance hall that at weekends featured show bands playing all the famous old Irish tunes.

Eager Irish lads would arrive on a Saturday night, dressed in Terylene suits and ties with brown lace-up shoes and, after a few beers in Biddy Mulligan's opposite, would join the fray for the big night out. Around 1am, most would emerge; ties pulled to one side, and walking the tangle-foot twist, they would navigate crossing the busy high road to the KFC. Then, smelling of booze, fags and greasy chicken, they would look for a ride home to Willesden, Dollis Hill or Neasden. The springs in the motor would drop half a foot, and then came the complicated business of weaving round the suburbs of north London to drop off two or three different parties, because it was hard to control who actually got into the car. The passengers would give advice on the best routes, and there was seldom any agreement. They usually told you directions via pubs: 'Take the main road past Cricklewood station and turn right at The Red Lion, go along till you reach The Prince of Wales, turn left and it's along there,

just past The Rose and Crown.' Occasionally, the punters would doze off before arrival and more than once I had to fish out their door keys, find their wallets and remove the fares. Just as well I was an honest chap.

All the drivers were Jamaican, apart from me, and there was one black woman called Gloria who didn't take any nonsense from fellow cabbies. 'What a perfect cover for drug distribution,' I thought to myself, and some years later I learned that the controller had indeed been arrested for running just such an enterprise. I didn't make much from the minicab, though, and driving around Willesden in the rain, peering at the tiny type in the *A-to-Z* street guide, was a tough way to make a living.

Many of the Irish lads worked on building sites and were paid on Thursdays, burning up their cash in the few pubs that remained illegally open for late-lunchtime 'afters'. I was once sent to The Alliance in Mill Lane around 4pm and the fare in question was busy drinking up a few before departing. 'Have one yourself,' he gallantly offered, but I politely declined: it didn't really mix with the driving. Then, as I was casually standing at the end of the bar, he toppled over backwards, in slow motion, collapsing onto the floor. His fellow drinkers carried on regardless and, as I unobtrusively made for the door, the last words I heard were: 'Where's that cabbie?'

Biddy Mulligan's pub was the only place for miles around that had an extension for drinking until midnight every night of the week, while everywhere else shut at 11pm. Naturally, it was a busy place and, being close to home, offered me a last chance to get a drink after work. To reach the bar might take ten minutes, as you had to shoulder your way past the throng of packed drinkers. Finally there, I would request 'A pint of Guinness', as the punters turned around to note there was an Englishman in their midst. This was during the time of The Troubles, and many English

people were jumpy about Provisional IRA bombs. In fact, a bomb was detonated at Biddy Mulligan's – later claimed by the Protestant Ulster Freedom Fighters – and caused much havoc. One drinker playing pool that night was blown out through a window, but his comeback was: 'I'll be back in tomorrow night if it's open.'

WHAT A WASTE

The killing of John Lennon in 1980 affected my brother, as he looked on John as a close friend and colleague, someone who could understand where he was coming from. Around this time, when I was resident in Kilburn, I visited Mick as he was overdubbing tracks at Air Studios off Oxford Street in central London. I left the well-appointed studio pretty late to catch the last bus home, and as I walked down a narrow alleyway, I realized that if anyone was waiting to attack my brother, they might mistake me for him. It was a chilling thought that I had to process before I could move on. Fortunately, in Britain it's hard to get hold of shooters. I can't understand the common American argument that the answer to gun attacks is more guns.

I DO

After five years together, I proposed to Kari-Ann and we decided to get married. As she was a 'divorcee', shock horror, the Church of England declined to host our nuptials, so we arranged a simple ceremony at Marylebone Registry Office. This was followed by a blessing at nearby Paddington Green, where the vicar had salted away the compensation money for land taken in the construction of the nearby flyover, and redecorated his church very finely – as befits the place where the actress Sarah Siddons was buried.

My 'stag do' had comprised a few beers with my friend Hugh Achilles in Dingwalls, hardly the extravagance that people

engage in now. The following day, we met at the registry office: Kari-Ann in a shimmering blue silk Antony Price suit, her coloured and coiffured hair adorned with a flower; me in more conservative attire. The designer Ossie Clarke was best man, and we had to ask a passer-by to sign the register, too. Later, in the church, Kari was led up the aisle by my father, as at that time she had not met her own (this was to come years later). Just my parents, a few friends and the children were there, looking uncomfortable in their smart clothes.

We had a church hall reception, with fiddle player Robin McKidd, Steve York on bass and some of his band 'Alive and Picking' all playing great music with everyone dancing. Robin said it was supposed to be unlucky to have a bluegrass band at your wedding, but experience suggests otherwise. Right after, we flew on honeymoon to Puerto Vallarta on the west coast of Mexico – for which Mick very kindly paid, as he was working in the USA at the time and couldn't come to the wedding. Kari-Ann was feeling queasy during the wedding and, when this continued, she put it down to the travelling and food. We soon discovered, however, that she was pregnant with our second son, Robert.

LOCAL HEROES

There was a small park around the back of Kingsgate Road where it was pretty safe for the kids to go. I used to play football with them there until Arthur, Kari-Ann's eldest, announced one day 'We don't want you to play with us anymore,' so I was confined to the bench. Kari-Ann did some trial modelling shots with a local photographer but there were few jobs for beautiful women of her age, as the media was totally youth-oriented. Meanwhile, I did a lot of shopping and cooking in between any little jobs in hand.

Kari-Ann became pregnant with her fourth child (and my third) and of course by then she knew what to expect. Not wishing to be inside the Royal Free Hospital on Hampstead Heath any longer than necessary, I drove her up there and we walked on the Heath right up until the time she knew that labour was imminent. An hour later, Robert was born and, with Demetri, there were five boys in all. They even played a game with Robert while he was tiny, called 'superbaby' taking him on adventures and even changed his nappies, the old-style ones that you washed and held fast with a safety pin. All our boys always got on with each other, any arguments only ever being temporary, and I have been so happy about that

I became a school governor at the headmistress' suggestion and went to all the meetings. Opposite our house there was also an old community hall that had been shut for many years and I joined the committee to oversee its reopening and different functions. I asked Philip Prowse, the Citizens Theatre director, to advise on the colour scheme and it came out red and green with gold outlines, which looked really smart.

Next door were workshops, including a typical greasy garage-with-tow-truck. The large West Indian guy who worked there would leave his pick-up lorry running outside my door, belching smoke, so one time I just went and switched it off. He went ballistic. However, as I was running a part-time cricket team with a few mates and we were a man short, I asked him if he would like a game. He appeared at the ground on the Sunday, immaculately dressed in whites, with all the gear, and put us to shame. The Indian greengrocer on the high street also joined our team and we had some fun games around Regent's Park and Paddington 'Rec'. Cricket brings people together.

CHAPTER 19

MUSICAL REBIRTH

I went to catch a Stones' show in Düsseldorf and met German singer Nena; she invited me to open some shows for her on her tour and we got on really well.

During the Nineties, I continued to play music and did the occasional tour, but as my brilliant left-handed guitarist Ed Deane pointed out, if I was to be taken seriously I needed to cut a record. It had been 19 years since my last release, *Valentine Vox* on vinyl. In the interim, CDs had brought about an expansion of interest in a wide range of music – from John Lee Hooker to the Cajun tunes of the Balfa Brothers – and music lovers were restocking their shelves with the new format. Jon Newey, then working for the music paper *Sounds*, introduced me to Bob Fisher, who ran a small label called Sequel, and he was interested in my recording for him.

I had been playing a regular slot at Roberto's, a club on the King's Road, where the boss gave me Tuesday nights from 11pm to around 1am. Different people dropped in to play – Steve Laffy and Malcolm Mortimore on drums, Robin McKidd on fiddle, Jon Newey on congas and, of course, Ed Deane on guitar – so we had a chance to put ideas together and jam around. We were sometimes joined by a teenage pianist called Ben Waters, brought up from Dorset by his parents and whose enthusiasm was infectious, while Hal Lindes, from Dire Straits, and Charlie Hart would also pop by.

Mick had been recording in Los Angeles with Rick Rubin, using a blues outfit called The Red Devils, who sounded like they came from Chicago's South Side. The band flew over to the UK to tour with Lynyrd Skynyrd but they cancelled at the last minute and the Devils were left kicking their heels, with only a small gig at the Borderline in the West End. Mick and I went along and he was lined up to join them for a jam but, as we watched on, he decided to give it a miss. Afterwards, in the dressing room, I asked what the band were doing the following Tuesday – usually a good evening to hijack musicians – and they agreed to join me at Roberto's.

We had a great night there, with the Devils knocking out their well-worked blues set and Mick joining in on vocals. The customers at the front, who had only paid a couple of quid, were so close they couldn't even take photos. My band played and were joined by the diminutive Scotsman Stan Greg on Wurlitzer. (Stan had always tuned the studio pianos for the Stones, was a friend of Stu's and a great boogie player, too.) The club generally attracted girls from the suburbs for a night on the town in its basement disco, and I heard one coming down the stairs remarking, "Ere, it's a bit loud innit?…Is that Mick Jagger singing? What do ya like, vodka tonic?'

As the live music drew to a close, the owner Roberto approached me and I thought he was about to say 'That was the most amazing night I ever had here,' but instead, the more banal 'Shall we go to the disco after the next number?' came forth from his lips.

SWEET CHARITY

I first met the fashion entrepreneur Peter Golding through guitarist and producer John Porter. Peter was then organizing a grand show at London's Albert Hall – the Valentine's Ball – and needed a little help from his friends. At his own expense, he had gathered an all-star band to rehearse and play the gig, with the proceeds going to various charities. I agreed to join in and was soon pulling together arrangements for the five numbers that I was to sing, mostly old rock & roll tunes – among them Elvis's 'Let's Have a Party', Chuck Berry's 'Sweet Little Sixteen' and the evergreen 'What'd I Say'. Peter had flown guest artistes over from the USA, including Shuggie Otis, son of bluesman Johnny; Buster Cherry Jones, who had played on my second album; and trombonist Gene 'The Mighty Flea' Connors, who had co-written the instrumental hit 'Tequila'. That was recorded as an afterthought at the downtime of someone's session.

This was way before performers such as Jools Holland were putting together their big bands – a difficult and expensive undertaking – and it was a great luxury to have a line-up that included a full horn section, piano, organ and three female backing singers. The girls were a little casual about rehearsing their parts and one song I'd chosen was 'Tramp', originally sung by Otis Redding and Carla Thomas. I decided to take a theatrical approach.

On the day of the gig, I brought along an old greatcoat to the show, one that my son Arthur had worn when he worked for the local fishmonger. The thing stunk badly, so had been exiled to our

basement. I stashed it at the back of the Albert Hall stage, ready for the 'Tramp' number, and when I pulled it out it had the desired effect, and my co-singer spat out the words for the song. Good method acting. I did this, as the words are largely improvised and it proved hard to rehearse. At the end, I threw off the greatcoat to reveal a purple Jasper Conran silk jacket and lit up a cigar with the line, 'I think you mean Trump, the richest man in New York!' Back then it was supposed to be a joke.

Kari-Ann danced on stage to 'Tequila' – a photo of her can-canning in a frilly red dress filled up some space in the next day's papers – and my son John came on for the last number, 'All You Need is Love', along with the full cast.

PLAYING WITH THE BAND

One of my favourite London bands in the Nineties were the Balham Alligators, who played a spicy mix of American styles including Cajun, zydeco and rock & roll, throwing in the odd Scottish tune when Robin McKidd was on the fiddle. Robin had long been a friend and could regularly be found playing at the Hare & Hounds in Islington, and many other spots around town. I didn't wish to play covers, so thought to come up with some of my own songs in a similar vein. I borrowed an old Revox tape machine and sat at the large dining table that had come from an Oxford college to record a couple of tunes I'd composed. 'Whispering Wind' was one – something the crooning Bing Crosby might have recorded – and I was helped by my neighbour, the talented guitarist Pete Ridley, with whom I had taken some guitar lessons.

Another was about a woman I'd met in Land's End, Cornwall. 'She's Got a Green Thumb' described her life on a small plot of land, growing vegetables, milking goats, making cheese and keep-ing bees with her partner and four children; it was amazing to see

what they achieved without wasting their time watching TV. This earth-mother was originally from the Bronx, which made it all the more unusual. When the album came out, ideas like that struck a chord with some radio producers. They caught a different mood from your average pop song.

GET IT ON TAPE

I looked to use the old Rolling Stones Truck again. It had been out on the road discovering unknowns, roaming the countryside spotting musical talent, mostly bands, and recording them for free for the AIMS Project, which was initiated and run by Bill Wyman, Through AIMS, Bill was way ahead of his time and he was a trailblazer for shows like *The X Factor*.

The Truck was parked up at a spare lot at Shepperton Film Studios, outside London, where the evergreen sound engineer Mick McKenna was overhauling the beast. So I scraped some funds together to pay for musicians, and invested in a couple of rolls of two-inch tape – then around £100 each – which we intended to spin at 15 inches per second to save on costs.

Mine was destined to be the last album ever recorded on the Truck – afterwards it was unceremoniously auctioned off and now rests in a museum in Canada – and it was fantastic to be back in such a familiar environment, supported by friends all wishing the best for the project. Ed played brilliant guitar and stuck with me, fixing things when we had problems; Robin was on fiddle, and the American Constance Redgrave took bass and harmonies. There were a couple of drummers: Irishman Fran Byrne, who swung really well; and Malcolm Mortimore, with whom I was to play over the next 20 years. Meanwhile, the legendary Dick Heckstall-Smith, who had survived bands that included Ginger Baker and Jack Bruce, added some sax. When leaving the session,

he said, 'Give my best to your brother.' I asked when he had last seen him, and he replied 'Around 1964.' Bless him; he wrote a great autobiography, which I recommend.

Geraint Watkins and Charlie Hart came down to play on a couple of tracks, one being 'Stand Up For the Foot'. Leo Sayer had become a friend and came to sing excellent back-up vocals, doing all the parts on one track. We had some Cajun influence in the tunes written with Charlie, including 'Allons Joujette', which included some cod schoolboy French lyrics I had penned.

Once I had turned the grand old age of 40 I somehow seemed to change my disposition. I just determined to do what I liked and didn't really care what others might think. Perhaps I had been too defensive in covering up my inadequacies and wary of criticism in the past. You might seek to justify your actions too much. What people write or say in the newspapers can be quite hurtful if you let it get to you. I just thought, 'To hell with it' and proceeded playing the music I wanted even if it wasn't commercial. Perhaps others might come around to it. One thing about Cajun music, I thought, was that it won't go out of fashion as it's never been in fashion, it was more like folk music, always there for people to enjoy if they discover it.

MY VERSION OF A FISHY CAJUN STEW RECIPE

I like improvising in cooking as well as music, so here's one way to go about a fish stew. First, arrive late at the fishmonger if you can, and ask for heads, bones, etc., which they will readily give you if you're a good customer. Then pick out whatever might be left on the counter – a tail of tuna, pieces of white fish, some prawns and shellfish too. Make the stock, adding onion – and fennel stalks from the garden if you have them – along with whatever veg you have that needs using up. Simmer away for a couple of hours before straining. Then go ahead as if you are

making a vegetable soup: fry up onions, celery, peppers, chopped pota-
toes, fennel seeds, a tomato or two and veggie powder – plus mustard
and a cut-up chilli, depending whether you are cooking for kids. If you
were in Louisiana you would then add the ground-up leaf of sassafras,
but you can't get it in England, so another thickener – even just some
flour – is okay. Once it's stewing well, add your vegetables, broccoli,
cauliflower, whatever, along with the washed fish, cut into pieces. That
doesn't need much cooking but keep checking the taste and add lemon
juice, salt and pepper, parsley, dill, Tabasco sauce, all the usual suspects.
It makes me hungry just writing this.

COMING ATCHA!

I called the album *Atcha* ('Okay' in Hindi), which then became the
name of our band. When it was released, it garnered good reviews,
the most prominent by Tony Palmer of the *Daily Telegraph*, who
gave me the bulk of his page, with Sting's new release confined
to the bottom. What I hadn't figured, though, was how hard it
would be to get live bookings. I'd been away so long that I was
classed as a 'new act', despite being 46 years old! So I had to start
again at the bottom.

We played shows in Spain, France and Holland – and
Scandinavia, where we had a great time. The top booker in Norway
was an Inuit called Uve who, though difficult to deal with, secured
the best venues and festivals. The last we saw of him, though, he
was departing the hotel via the kitchen exit with all the loot from
the last gig, leading to the moniker 'Eskimo on the Run'.

One gig was in a small village hall in Saetervik, north of
Trondheim, and we took a boat across after a long drive. A wel-
coming party stood on the jetty, holding cola bottles full of clear
moonshine. It was a wild night and during the interval we went
outside for some fresh air and saw the Northern Lights.

As it was so tough to book fee-paying shows for a five-piece band, I thought to have an acoustic version – Robin, Ben and me – and soon gigs came our way without any bother. Atcha Acoustic was thus formed. Later, Charlie Hart came in to replace Robin and we toured extensively across Europe, playing parties and small venues with the new material and some covers. One regular date was at the tiny Soho blues bar Ain't Nothin' But, on a stage where you could barely turn around. It was so packed that, during the breaks between sets, it wasn't worth the time spent to reach the front door and breathe some air, a vital requirement in the days when everyone smoked indoors.

BACK IN THE USA

Through a contact, Clive Hines, Curb Records in Nashville bought up the album – but they insisted on having the rights for all eternity, never a good idea. I reluctantly signed the contract and went over to promote it, later organizing some gigs there with the help of my old bassist Steve York. We took a six-piece band – Ben, Ed, Charlie on fiddle and accordion, Malcolm on drums and Camille on bass. We played the New Daisy Theatre in Memphis and the Mardi Gras procession in St. Louis, where we were on the back of a moving truck; it was so cold that it actually snowed, and all the while the enthusiastic crowd was throwing beads at us.

We appeared again at the Bottom Line in NYC – where my brother came with Jerry and Jann Wenner – and were then given a coast-to-coast TV slot on *The Tonight Show with Conan O'Brien*. All went well but, as before, the tour lost money and I ended up owing more to Curb Records than they owed me. It was hard reaching them on the phone, so I wrote a country song for them called 'He's in a Meeting', as that was always the case.

DIARY

Ode to the current climate change conference.

(NB: Dunwich, on the coast of East Anglia, was swept away by a series of storms over 300 years ago and declined from the principal town of that region to a small village. There were once some 16 churches, and legend has it that during low tides you can hear their bells ring.)

The postman drops his letters off
In Dunwich-under-Sea.
At times he even stops in
For a watery cup of tea.
You have to lick the stamps down well,
It's very hard to read,
With fishes swimming all around
The watery green seaweed.

The vicar gives his sermon out
In Dunwich-under-Sea:
The jumble sale is at the hall,
He needs some volunteers,
But his request not to drive
Falls upon deaf ears.

The sunshine doesn't shine too well,
There's bad visibility,
So don't you bother going there
For your summer holiday.
The deckchairs have all floated off,
There are no more ice creams
And Mrs Moore's general stores
Are now a memory.

So please take care
When going there
To hold the children's hands,
Or else, like all the houses there,
They'll sink into the sand.

A GIRL NAMED SUE

Our back garden in Muswell Hill, north London, was steep, with a fence at the top separating it from the garden of the place opposite. One afternoon, I heard the sound of splintering wood and went outside to investigate. A young lad was smashing up our party fence with a hammer and I heard his well-spoken mother calmly saying, 'I wouldn't do that, George, if I were you.'

The voice belonged to Sue Lloyd-Roberts, a Cambridge-educated TV reporter who went round the world documenting human rights abuses. We became friends and she soon viewed me as her co-conspirator. We had a gate inserted between our gardens, and I could pop over and use her fax machine even if she was out, as she left the back door unlocked. At Christmas she would ask Charlie, Ben and me to play at her parties, which were always full of interesting people, such as the writer Douglas Adams and the newsman Jon Snow. There was noisy chat, drinking and dancing on her hardwood floor, as Ben pounded the ivories of the old upright joanna and Charlie Hart and I complemented on fiddle and guitar.

Sue said she was off to Albania – then, in the Nineties, still a secretive communist state. I had read a famous travel book by Edith Durham called *High Albania* written at the beginning of the 20th century and knew a little about their medieval law based around the *Canon of Lek* (see Ismail Kadare's *Broken April*), so I suggested to Jann Wenner that I write a piece for *Rolling Stone* in the Hunter S. Thompson mode. In the end, the magazine was less interested

in the repressive country than I had imagined, but I still got the commission. I applied for an Albanian visa, along with others, such as the BBC's Stephen Sackur, now well known for his face-to-face TV interviews, and Charles Maclean, son of Fitzroy, the SAS man and author of *Eastern Approaches*, who had lived rough with Tito during the Second World War. I was to share a room with the photographer Barry Lewis and we became good friends. The rest of the organized group was mostly communist sympathizers, supporters of the regime that was soon to be overthrown.

We flew from London via Zurich to Tirana, Albania's capital, thus going from Europe's richest country to its poorest. Before landing, we were given strict orders not to take any photos of planes, so we immediately started snapping out of the windows at the few ailing MiG jets that couldn't fly anyway because they lacked spare parts. (Albania managed to fall out with every communist country bar Cuba.)

On the bus from the airport, we stopped to allow a few geese to cross the road and watched women in the fields digging the soil with spades. The tour took in such exciting venues as an ancient steel works and the museum of atheism. Our guides knew we were journalists but pretended they didn't, while we knew they knew but still pretended to be ordinary tourists. It was like spy vs spy.

Barry took pictures of the main square in the capital, amazed there were no cars, just a few bicycles with pedestrians milling about. Our guide claimed that Albania produced everything it needed itself and its people were happy. We asked why so many men in ragged apparel were hanging about the streets, and the answer came that they were waiting to clock on to their next shift. (In fact, there had been demonstrations in Shkodër in the north but they had been hushed up and – as nobody had any photos – they didn't really happen, did they?) Most all of the shops had

nothing to sell. The place was filthy, everything a dull brown, and the people looked miserable. Barry taught me what was a bad photo and I got to see how he worked: he befriended his intended subjects and was never threatening. He had a lot of technical skills, too, but it was the interaction that was vital.

We stopped off for lunch in a roadhouse that Mussolini had used and a bus appeared from nowhere with a band of happy gypsies shaking tambourines and dancing gaily. An argument ensued as to whether this was staged or for real, the socialists believing the latter of course. On our last evening in the 'luxury' hotel, a small band were playing in the basement and I joined them, making up the 'Sigurimi Blues', a reference to the feared secret police that had ruled the country for so many years. I also met the famous author Ismail Kadare, who has written so strikingly about his country and many other stories well worth reading. *Chronicle of Stone* is a good one.

WAR CHILD

During the 1994 Bosnian conflict, Sue suggested a fundraising event for the charity War Child – which worked out there supporting kids – so I assisted with the music. It took place in Studio One at the BBC, and after Sue had given a speech in front of a large graphic screen (where we learned that it cost £12,000 to fill a lorry with medical supplies), the auction commenced, always the best way to raise funds. The first lot appeared and Dave Stewart raised his hand in a casual way and bid the whole 12 grand to the surprise of the auctioneer. We later assembled on stage: me, Simon Kirke of Free on drums, David Gilmour and Dave Stewart on guitars, Ben Waters on piano and Charlie Hart on bass, Jon Newey on congas with Leo Sayer joining in – a great end to the evening.

I also started sending faxes around in 1988 after the ghastly gassing of the Kurds that year, as nobody seemed to take much notice at the time. Finally, a movement gathered pace and I wasn't a part of that, though later I was asked to play at a big Kurdish rally at the Feyenoord football stadium in Rotterdam.

THE ROOF OF THE WORLD

After our Albanian journey, Sue organized a more adventurous trip to Tibet and asked me to come. This involved more outlay and, although I was pretty broke, I didn't want to pass up the opportunity; at least *The Guardian* had commissioned me to write on the Tibetans' plight.

We flew to Kathmandu via Delhi and boarded a minibus bound for Lhasa, the capital of Tibet around a thousand bumpy miles away. The first part of the journey was on the very same road I had taken in vain back in 1968. After crossing the emerald green of the beautiful Nepalese countryside, we came to a steep ascent before the border, where we were told to disembark and take jeeps. This was supposed to be an all-in trip but the Chinese organizers wanted to charge extra, so Sue and I said we were happy to walk, and started up the mountain to the bewilderment of our handlers. Marching towards us on the terraced mountain track, a party of Chinese soldiers appeared in rank, so Sue lifted her video camera to film them. In the Nineties, these cameras were still quite bulky and obvious, and the leader of the troop wagged his finger, telling us to desist – so we could have been in trouble before even entering the country.

At the border, our baggage was examined but I smuggled in pictures of the Dalai Lama to distribute later. The smartly dressed and 'modern' Chinese military looked down their noses at the beautiful Tibetan women there, with their long braids, turquoise and

coral necklaces and flowing gowns. If these women had wandered through Camden Market in London on a Sunday, people would have been full of admiration, but not there. Our watches were forwarded by over two hours to Beijing time, some 1200 miles away, a time difference that forced the Tibetans to rise at dawn. I wandered down a street full of the military in the evening light and entered a small lamasery, not quite a temple, where Tibetans were circling and chanting prayers, while turning the brass wheels. While Sue looked on, I joined them and, as the weight of their oppression overwhelmed me, I burst into tears. 'What's the matter?' Sue asked, but I couldn't explain, it was just a feeling.

In the days of Tibet's independence, their policy was to exclude all foreigners, as they feared the British with their missionaries and trade – and it worked, up to a point. During the Raj, China didn't present much danger, but once the British departed India in 1947, all they had to do was march in on any pretext, as the Nazis had in the Sudetenland, and declare it their territory, job done.

Most travellers on the bus shied away from politics, a tricky subject to broach, as the guide was a well-vetted Chinese party member and spoke no Tibetan. Once, an elderly, destitute, peasant woman was crossing the road in front of our bus. 'What did the Chinese Communist Party ever do for her?' I asked innocently. 'In the springtime, she will be given seeds to plant,' he replied, as if they didn't have seeds before that. There had never been a famine in Tibet before the Chinese arrived, but there was afterwards. Some of the passengers on the bus, Americans among them, told me off for giving the guide a hard time, as they just wanted to take nice snaps of the scenery. I had brought along coloured pens and lighters to hand out to the kids and at one place a crowd surrounded me as I was dishing them out. One American rebuked me and said I was 'encouraging begging', so I asked how they

would behave if they lived there. We stopped by the cave where the famous yogi Milarepa had meditated; apparently the conditions in his spartan monastery were too soft for his liking. (His life and songs are famous to all Tibetans.)

We once ate in a Chinese restaurant in a provincial town but, as we didn't understand what we were ordering, they brought us way too much. When we tried to stop them, they insisted that's what we'd asked for – so Sue smiled and said okay. Then we gave the extra food to the waiting Tibetan beggars in the street, to the horror of the Chinese waiters and the appreciation of the beggars.

Sue knew the ropes and had inside information. In one town, Shigatse, she arranged a meeting with some dissidents but it was risky, particularly for them. Together with the ITN journalist Tom Bradby, we lost the secret police following us and silently followed our contacts down alleyways and round corners, doubling back, finally reaching a 'safe' house. There we sat in silence fort ten minutes while the surrounding area was checked, and only then were they free to discuss the situation. They were literally prisoners in their own country, crying for help from the outside world. But what could we do against the might of the Chinese Empire?

An elderly Tibetan man later told me, when we toured the Summer Palace in Lhasa, 'They have taken our country, our religion and our language away.' Checking nobody was watching, he pulled a curtain aside to reveal a fresco of a figure with a Union Jack, a reminder of when the British arrived in 1908 under the adventurer Younghusband.

They retain 'show Buddhism', which is strictly controlled to demonstrate how tolerant the administration really is and we visited Sera monastery near to Lhasa, where the tour group was led down a long corridor full of the usual stuffy images and insipid smelling yak-butter lamps. I had caught sight of monks chat-

ting away outside, so I peeled off from the back of the group and went to look for myself. The large courtyard contained groups of young novices, sitting under the trees, debating religious issues or texts, one standing up to explain the teachings, the others seated around to listen and comment. I watched for a while, then some of the lads motioned to me; they were delighted when I joined them.

By this time I had acquired a few trinkets around my neck and wrists as they provide a good basis for communication. They examined them one by one; then a young monk wagged his finger at one bracelet, meaning he didn't care for it. I knew it was from Kam, in eastern Tibet, renowned in days past for the fierce warriors who fought the Chinese. 'Kam no good?' I asked, and they all fell about laughing. I clapped my hands in the way Tibetans do after a point has been made. I felt as if I had definitely been there before, that this place was familiar to me. Just then our party of tourists came round the perimeter of the courtyard and the Chinese guide was horrified that I had infiltrated the enemy and made myself at home, but I didn't care what he thought.

In the middle of the old town in Lhasa, near the famous Jokhang temple, groups of young Sherpa and Khampa lads were hanging around with little to do, bar a few ancient street entertainers plucking away with an elderly woman dancing. I would have loved to have brought out a guitar and sang a few songs – I know they would have loved it. They are so repressed, it's a crying shame the people are cut off from the rest of the world, especially when you consider what Tibet would have to offer if it were a free independent state, in the way of eco-tourism, spiritual retreats and instruction and the amazing mountain scenery. Instead, they are overrun with ethnic Han Chinese who take

all the best work and business, leaving only menial tasks for the people who call Tibet home.

After we returned to London, Tom Bradby – then a fresh-faced lad, now a big deal at ITN news – interviewed the Dalai Lama, and I was there, too. 'What do you think of the Chinese?' was Tom's first innocent question. His Holiness paused for a moment and replied, 'Chinese, you see, missing one organ…'. We waited, wondering at his meaning. Then he added, 'Missing ear organ. They always want to lecture, but never want to listen.'

Two young Tibetan nuns who had escaped over the high mountains to Nepal, a feat in itself. They had been imprisoned and horribly tortured by the Chinese for refusing to denounce the Dalai Lama. Their aim was to see him in Dharamshala, India.

Since our visit, times have become far harder for the Tibetans, and nobody outside dares to raise a word against the Chinese for political or economic reasons. (Further north, the Uighurs are now repressed in a similar manner.) The Chinese see Tibetans as inferior and barbarians, their culture worthless and their

religion irrelevant. Yet Buddhist theories of respect for all sentient beings, animals and the environment are crucial if we can ever hope to save our planet. I have met Tibetans who managed to walk across the high mountains in winter, running the gauntlet of Chinese patrols that will shoot them if they don't get frostbite, yet could still joke, 'I slept on top of the others, so I didn't feel the cold so much!' Once in India – for Nepal, too, is practically Chinese-run these days – the refugees travel to see the Dalai Lama, and he has devoted his life to his people in a hopeless cause but still maintains that dialogue and peaceful means are the only ways of reconciliation. After all, he too is a refugee. The Tibetan's one dream is that, before he dies, he might return to Lhasa; a wonderful thought, if only the Chinese could see that co-operation is the best way forward. The Chinese line is that anyone saying anything against their 'motherland' is a 'splittist' and must be removed. One Chinese soldier helpfully illustrated the extent of their territory that included westwards into Ladakh, where they have been fighting, Nepal, and towards Darjeeling. The Chinese, and particularly the Han, had never been mountain people; they are a breed apart, but of course Tibet represents huge mineral and water resources.

Sue returned to Tibet on other occasions, once with the dissident Harry Wu, who had spent 19 years in a remote Chinese prison camp. The two even went to revisit it, a dangerous undertaking. Later, Sue made a film for the BBC, which included allegations of body parts being taken from living prisoners for high-ranking officials. The Chinese went ballistic and she was high up on their blacklist. Even some of the BBC management admonished her, because the Chinese cancelled various films the corporation wanted to make that involved travel in China, so she ruffled a few feathers.

350

After our trip, Sue and I, with much support from friends, went on to organize a number of fundraising events for Tibet: in a tent in Battersea Park, at the Floral Hall in Covent Garden, the Roof Garden in Kensington and – the largest – at the Alexandra Palace in north London, on 20 July 1996. The Dalai Lama was booked to speak to an assembly of Buddhists in the great hall there, so we planned to hold a concert afterwards in the park. We ran into numerous obstacles from Haringey Council and they tried to cancel at the last minute, but we saw it through. There was a great line-up: a youth jazz band, Tibetan dancers, Andy Summer and John Etheridge on guitars, Trilok Gurtu and friends on percussion. David Gilmour brought a trio specially formed for the occasion and played his version of the Syd Barrett song 'Terrapin' for the first time ever. Sinead O'Connor and her band performed, as, of course, did Atcha!

The field in front of the stage was filled with stalls selling Tibetan *momo* delicacies – as well as beads, robes and conch shells – and Tibetan dancers performed in their voluminous robes and face masks to the sound of the long trumpets. Everyone was dressed gaily in the summer sun. His Holiness then made an unscheduled appearance and gave a short speech. There was no way he would miss this, though his minders were wary of possible snipers hiding in the woods close by. They had guards with shooters standing by in the bushes. Haringey Council took great pains to limit our numbers but, after it proved such a success, they appeared and had their pictures taken with the Dalai Lama and fed it into their PR machine.

Sue died prematurely in 2015 and I still miss her.

CHAPTER 20

MUSWELL HILLBILLIES

We had moved to the more middle-class surroundings of Muswell Hill in 1982, as with five boys on weekends and our niece, we needed more room. Deciding it had the most green and open space in the area, I found an Edwardian house in Woodland Rise, with a south-facing rear garden and five bedrooms. The boys had all made friends, as they do, and one of their friend's fathers was an architect with whom I got along well. Polish builders were just arriving in London then and were willing to take on jobs and complete them without fuss, so we took them on to bring the house up to date.

I had a great friend in Cornwall, Terry 'Trader' Gray, who introduced me to reclamation and to recycling wood and stone from old buildings rather than ordering all-new stuff. Trader had a marvellous rambling shack called Shiver Me Timbers, close to the beach at Long Rock, near Marazion and St Michael's Mount. From here he would dispense wisdom, jokes, stories, and anything he could trade. The sign outside advertised 'Purpose-built antiques, like Mother used to make', as he had invented what he called the art of 'mackeling' – that is, recycling old pine boards he had stripped clean in a caustic tank into useful furniture. Travellers and vagrants showed up on his doorstep, so he would put them to work, building the wood into corner cabinets or bookcases, sometimes adding painted scenes or faces to the 'new' antiques.

The first time my brother became a grandfather, Trader took an old grandfather clock, substituted a Rolling Stones picture LP onto the clock face and rested the base on rockers, creating, as he said, the 'first grandfather rock-clock'. He loaned it to a store in Penzance and put a price tag of £1 million on as a joke. Trader had assembled a huge collection of old jazz 78s and delighted in playing obscure

songs or the pianist Earl Hines on his old radiogram, while telling stories, brewing up tea or drinking something stronger.

I decided to re-lay our ground floor in Muswell Hill and travelled down to a reclamation yard near the Cardiff Docks, long since gentrified, where my old musical partner Dave Pierce had spotted some Welsh flagstones from the Preseli Mountains. I brought them back in an old truck and the Polish builders didn't blink an eye, the main man declaring, 'All stone good!' In an East End yard, I found a large, old-fashioned gas range made by Stott's of Oldham and bolted a gas grill on top; all blue enamel and quite industrial. (When Dad came round, he told me that he was at school with a Stott in Oldham in the Twenties!)

The original Dingwalls Dance Hall in Camden had been demolished and I picked up a load of bricks there, London stock, to rebuild the front wall, took out our naff front door and generally made the place more period. I'd picked up a little practical knowledge from the theatre world, as I liked to hang out with the carpenters building sets, the painters creating the right colour schemes, and the set designers designing for each play's period. When a friend of Kari-Ann's came around, she didn't get what I'd done and asked, 'When are you modernizing it, then?'

We had a great party for our young chef, Arthur, when he reached 21. The house was so crowded that you could barely move, and the food and drink were outstanding – which was just as well with so many experts from his trade there. A band played in the front hall and in the garden Arthur's 'real' dad, Rufus, roasted a sheep, as you do in suburbia. (Arthur often refers to me as his father, which is a nice compliment – but at 6 foot 4, he doesn't really look like me.) Through Nick Smallwood, Arthur initially went to work at Kensington Place, then Notting Hill's most fashionable brasserie, and on to apprenticing with the Roux Brothers.

Many other places followed, including the River Cafe, where Jamie Oliver was then a sous chef; a cheeky chappie in the kitchen until a TV crew spotted him on a video clip and drafted him in.

Arthur's brother Julian went to work with another friend, Lance Yates, who managed the Stones' licensed clothing range. Lance later made sure I wrote the notes and bios for the programme to the *Steel Wheels* tour – the first time there had been any, as previously there were only photos.

While our younger sons John and Robert were still at school, Kari-Ann's niece Louisa came to live with us – which can't have been easy for her in a house full of boys. Her mother could not care for her and we were forced into a protracted court battle with the local authority on the Welsh border, who wanted her adopted into a family of religious purists of the same church as the head of the social services, which really got my back up. I had no experience of bringing up a girl, but I did try a little pretend-ballet with her, putting some Mozart on the turntable and twirling around the room. Later, she was telling a woman about her dancing and was asked if she did it with her mother. 'No, with my uncle,' she lovingly replied. Many years later, Louisa's half-sister, Rosie, also came to live with us in Somerset, where she attended secondary school, and I realized how much I enjoyed the difference of having girls around. We're all still close.

NEIGHBOURS

Viv Stanshall from the Bonzo Dog Doo-Dah Band moved nearby and we became friends, sometimes playing snooker together in a local club. He was happy there after so much depression in his life, but tragically his flat caught fire one night and he went up in smoke with it. Dear old Viv. I maintain that the Bonzos were an inspiration for The Beatles, particularly for all that brass stuff

on *Sgt. Pepper*. Larry 'Legs' Smith was originally the tuba player and tap dancer with the Bonzos, then became the drummer, and was a great pal of George Harrison, who put him up in the gatehouse of his country pad in Henley. Geoff Stephens had been in the band and then departed and copied their style for the huge hit 'Winchester Cathedral', which didn't please Viv too much!

Two drummers were also resident at the bottom of my road, Steve Monti and Dylan Howe. I played with both of them and they both later played with Ian Dury, which was a funny coincidence. Dylan, who had grown up close by, is the son of Yes guitarist Steve Howe, so there's music in the family there. He's now playing on my latest record, released in September 2021.

I also came to meet Rik Mayall, then a huge TV star. He had married Barbara Robbin, who I had known from the Citizens Theatre, where she worked in the wardrobe department. I remember a get-together one night with Ben Elton, Alexei Sayle, Ade Edmondson and, the funniest of them all, Robbie Coltrane; it was impossible to get a word in edgeways. I said to Rik I needed a name for my band and, in typical fashion, he came up with 'Chris Jagger's Dick'.

Atcha! At the Gurten Festival, Bern, Switzerland 1994. From left, Camille Khan, bass, me, banana, Charlie Hart, keys, violin, accordion, Ed Deane, guitar, Malcolm Mortimore, drums.

The Kinks famously came from Muswell Hill, though I only ever met the drummer Mick Avory, a lovely guy who might have joined the Stones at one point, as he rehearsed with them in the very early days; and Ray Davies has a studio there called Konk. Meanwhile, in nearby Crouch End, Dave Stewart had taken over an old church and built a state-of-the-art recording studio, with a suitable tartan carpet throughout. *Sweet Dreams* was recorded there, and many famous musicians followed the Eurythmics to discover the charm of this out-of-the-way London village, among them Chrissie Hynde and Bob Dylan.

It was there that I recorded 'Lhasa Town', which appeared on the *Atcha* record. I'd played a sketch of it to Dave and he offered me the use of his studio. My band were running through the track when Dave appeared after his lunch and he freely confessed he had drunk a couple of bottles of wine and so suggested slowing it down to maximize the impact. We cut it live with Charlie Hart on double bass, Ed Deane on mandolin and Dave himself on acoustic guitar; what a generous guy – and I guess he was also supporting the cause. The idea of the song was to describe different scenes from the amazing country of Tibet, coming back to the line 'You won't see the Dalai Lama around', as he is an exile and one sight all Tibetans would dearly love to witness.

The broadcaster Andy Kershaw and his wife also lived in the area, and she had a small eatery called Banners, which unsurprisingly played great music. After an afternoon at Dave's place, Bob Dylan and a sidekick came by there, to play chess over a drink, and Andy was informed by phone, as he's a massive fan. Dylan sat down and ordered a drink but was told by the waitress that he must eat something too, to comply with the licence. He didn't want to eat so, instead of just ordering a sandwich, they upped and left. By the time Andy had arrived, the bard had departed.

At home in Muswell Hill 1983. From left, Kari-Ann holding John, Demetri, Arthur, me with Robert and Julian.

PARTY TRICKS

I had unashamedly asked George Harrison if he would come and play at the Ally Pally concert for Tibet. He didn't make it, though he did reply by letter, or rather fax, which was the mode of the day. I'd visited George in his quirky mansion near Henley, tagging along with Python man Eric Idle and photographer Carinthia West. George was a generous host and not at all put out by the invasion of his privacy, though he was in the process of making an album. I always got along well with him, as he was so down-to-earth, and we shared a love of Indian music, which we had both studied. (He even named his son Dhani, after the sixth note of the scale.)

The last time we spoke was at David Gilmour's 50th birthday party in Fulham Town Hall. I had suggested to the organizer that Charlie Hart and I might sing a tune especially for the occasion. She said thanks but no thanks; the entertainment was to be a surprise. This was in the early days of tribute bands – of which I'm not fond; I'd rather have musicians doing their own thing – and the Bootleg Beatles appeared, probably a daunting gig for them. I was

standing next to George and he watched the copycats in silence, adding laconically at one point, 'He's playing the wrong chord there.' The Australian Pink Floyd was the following act – but with so many great musicians around I was hoping for more of a lively jam rather than karaoke.

Kari-Ann dressed for the evening in an amazing, sparkling, long and very tight dress – assisted in the wardrobe department by designer Ossie Clark – and I think George liked that! His first wife, Patti Boyd, and Kari-Ann had been Ossie's favourite models at his Sixties fashion shows, which drew all the stars of the day, including The Beatles. I missed those events, only seeing a later one held in a King's Road cinema in 1974 – but yet again, I just missed Kari-Ann, who had recently given birth to Arthur and moved to the country. Funnily enough, Mr Gilmour had driven a van for Ossie in the very early days, delivering frocks around London!

On my brother's 50th, he threw a lavish party at Strawberry Hill House near Twickenham, which is now owned by St Mary's University College, where our father taught. (The original part of the building was created for Sir Horace Walpole in the style known as 'Strawberry Hill Gothic' and features an amazing long salon full of angled windows and mirrors.) The famous Irish band The Chieftains, with Paddy Malone, played that night, joined by Irish dancers from the *Riverdance* show, and were wonderful. The guests straggled round in various forms of fancy dress, some, like ours, homemade, and others with hired costumes, all evoking the French Revolution, which allowed for all kinds of fake blood and torn shirts.

Another of Mick's birthday parties took place at the Antibes home of Jean 'Johnny' Pigozzi in the South of France – and it fell at the same time as the Antibes Jazz Festival, where guitarist John McLaughlin was playing with his Mahavishnu group,

among them the tabla maestro Zakir Hussain, who I'd met years before when I had asked him to play at Keith Richards' house. We went to their sound check and asked Zakir to join the party later after his gig, then went on with Kari-Ann to Pigozzi's place on the promontory, where he resides in splendour in the pile that his industrialist father left him.

Guests were wined and dined outside on the ample terrace, as a chic Brazilian combo cha-cha'd away on a small bandstand. Word reached me that what the French really wanted was a 'rock & roll jam' (said with the correct accent) rather than the cute sounds of samba. I relayed this to my brother, who was contentedly ensconced among friends, not really wishing to be disturbed. 'We don't have a drummer,' he said, which was true, so I suggested Ronnie Wood, who was naturally there. For some reason musicians are quite snooty about what drummers they will play with – but Mick wasn't too keen on the prospect. Undaunted, I rounded up a few suspects, including Bono, who told me he didn't really jam, as he wasn't familiar with standards. Offering to join in with me and Ronnie was Microsoft's co-founder Paul Allen – a mad guitar freak – and Zakir, who had arrived in flowing robes, leading a bevy of sari-clad beauties.

One of the two songs Bono said he did know was 'Stand by Me', hence we began with that – quite appropriate under the moonlight – and everyone loved it. At one point in the number, the mic was passed to founder of Atlantic Records Ahmet Ertegun, at that point already in his eighties, and he crooned a verse – no surprise that he should know the words, as the song was Atlantic's very first hit, recorded by Ben E. King in 1961. After the ice was broken, others came up to jam, including the then-young guitar-slinger Jonny Lang – and Mick sang with Bono, which was nice. Bono was complimentary to me afterwards, which I appre-

ciated, and Zakir told me, 'That was the second time in my life I have played kit drums!' This was right before smartphones began recording such events, so there's no evidence.

DIARY

Another brilliant bright day. Kari-Ann is off to see our grandson Isaac in London. I took my bike out across the moors, over the reserve on the 'drove' [path], and saw the myriad starlings. The air was alive with the whirr and rustle of their wings as they swooped overhead – in separate flocks but coming together to roost. The backdrop was the evening sky and the bright sun over the lake. The birds came in from all directions, their sound mixing with the tall grasses waving and sighing in the wind. Black masses were creating beautiful 3D shapes, then peeling off to settle in the grasses for safety in numbers. Quite a miraculous sight.

A BREATH OF FRESH AIR

Kari-Ann completed a course as a preschool education teacher and took a part-time job in a local nursery school; she is so magical with children. She also followed the dancer and 5Rhythms creator Gabrielle Roth, taking her training courses and qualifying there as a teacher. I went to a few sessions and joined Gabrielle sweating away in large draughty halls, even writing a story for *The Independent* on the subject, but mostly it was women who found it so liberating. All the while, Kari-Ann was studying Iyengar yoga and in the end found that discipline more structured and rewarding – though she wasn't so keen on taking the complicated exams you must go through before qualifying to teach.

We sometimes had a stormy relationship and argued a lot, but there were never recriminations, she didn't bear a grudge so we made up right after, which sometimes baffled other people who

saw us going at it. As the old calypso song goes, 'if ya want to be happy for the rest of your life, never make a beautiful woman your wife' and I don't know really why she stuck with me when she might have had a much better lifestyle with a more eligible and wealthier suitor. But then she didn't care that much for money, even though it would have come in useful. People had fallen in love with her just from the cover of the Roxy Music album, which she did as a favour to the then unknown band.

At the top of our road in Muswell Hill, a disused railway track ran to Alexandra Park, passing across a high viaduct with distant views, and this served as the route to the primary school for Robert and John, while Julian and Arthur attended Fortismere School nearby. The area contained largely professional people commuting to and from the centre of town. But I wasn't one of them. In reality, I was leading a country life in the suburbs – dressing in old tweed jackets from charity stores and walking my lurcher, Spas, across Alexandra Park or Highgate Woods, and sometimes further to Hampstead Heath. Queen's Woods were once the site of a 17th-century plague pit and supposedly haunted; I would go through there at night, picking up logs to burn in the open fire at home.

Below these woods lies a large expanse of recreational ground, rare in London, enclosing cricket squares and tennis clubs, all bequeathed years before by a benevolent spinster. I joined North London Cricket Club and turned out for the lower teams rather than run my own outfit, as it was much easier. I still arranged some entertaining mid-week games, sometimes against Nick Smallwood's Kensington Place restaurant; you were always assured a good teatime spread as well as some hostile bowling from his Pakistani sous chefs. Mick might come over to play if he was in town, bringing with him his man Quentin – who, being

from the West Indies, could swing a bat too. When our parents came along, it was a real family affair.

I assisted with coaching the kids' under-11's teams. After school on a summer Wednesday evening, six or seven lads would pile into my old Volvo estate (no seat belts then) and drive up to Hampstead or Brondesbury to contest a needle match against the local rivals. The actor Peter O'Toole had a son in the Brondesbury team and he was often on hand to help out and give support, so we became quite friendly. I would buy juice and biscuits for my team, as they were hungry after a day at school and welcomed a pick-me-up in their energy levels. We had some great times and, in contrast, I found adults rather staid and boring. There is a lot to learn in cricket – batting, bowling, fielding, and quite a few rules. My own boys were playing, of course, and cricket is above all a social event with long summer evenings that give city kids the chance to have freedom, run around and devour lemonade and crisps.

One game I remember was my team against a Post Office one that mostly comprised West Indian players. When Mick came in to bat, all the opposition were anxious to claim his scalp, bowling as fast as they could. (We didn't have helmets then either.) Mick invariably reacted well and preferred these matches to the 'celebrity' ones that he was often asked to join; they are, after all, rather artificial. I played in some of those matches with, among others, Eric Clapton, Bill Wyman and Dave Gilmour. On one occasion, Gilmour bowled me a 'sit up and hit me' lollipop ball and I smashed it clean over his head. As it sped past, he tentatively raised a hand to stop it, exposing his delicate guitar-playing fingers; not a good idea.

The Fairport Convention guitarist Richard Thompson loved cricket and assembled a team in which I played, alongside guitarist John Etheridge and double bass man Danny Thompson. Luckily,

we also had our sons on the field, so when the ball whizzed past the slips, the young ones could chase it while the old-timers nursed their heart bypasses and bad knees. We had a lot of laughs, and as a result, Danny and John accepted my invitation to play on my album *The Ridge*. They were musicians of a high calibre and I'm proud to have worked with them.

Women were included, too. One year, I visited my brother in France and a cricket match was arranged there. Anna, married to my youngest, Robert, played, as well as Kari-Ann – though she wasn't that conversant with the rules. Mick was bowling to her and the fielders came in close – but she knocked his ball for a four. And why not? Two of her maternal forebears had played cricket for Surrey years back.

PAUL'S CONVERSION

In the Seventies my brother had turned (Sir) Paul Getty on to cricket while he was cooped up in his Cheyne Walk house, addicted to heroin and passing time watching Britain's dull day-time TV. As test matches run all day for five days, they provided good plots to follow, and Paul got hooked on them instead of soaps. (I once visited him there and had tea served by his butler.) Later, Paul donated funds to the rebuilding of the Mound Stand at Lord's and retained a box there. I was a sometime-visitor and the company was always terrific – mostly ex-cricketers and actors, as businessmen were barred. Usually with a can of Tennent's lager in one hand, Paul would entertain royally, with nibbles and champagne on tap. You might be sitting opposite Spike Milligan and between Peter O'Toole and the legendary sportsman Dennis Compton – who both liked a drink – so there was never a dull moment. And, occasionally, you watched the cricket.

Paul had his own ground laid out at his country manor, Wormsley House in Buckinghamshire, where he welcomed guests with the most amazing spreads. He liked to invite groups, such as the Burma Veterans, as well as cricketers from an earlier era who had been neglected – say, the fast bowler Brian Statham, who lived modestly in a council house in Lancashire. I once played on Getty's ground and it was like a billiard table, better than most county ones. Christopher Gibbs even designed a score box with a thatched roof.

One summer, the Australian test team were touring England and Paul invited them to play at Wormsley, quite a coup. Mick and I were asked along, and the beautifully manicured grounds were busy with guests and friends sipping champagne and nibbling sumptuous delicacies, while the locals tucked in to free ice cream. It was a beautiful day, just a few clouds floated gently in the July sky, and at the tea interval a military band – chosen by Christopher Gibbs for their fancy red uniforms and spiked helmets – paraded across the greensward. I stood next to Paul, watching the spectacle, when the company wheeled and began marching towards us. 'Wouldn't it suit this perfect day if he took the salute,' I thought to myself. But just at that moment his wife, Victoria, rushed up, telling Paul to go find his straw hat and protect his head from the sun; which proves that, no matter your disposable income, your wife knows best.

HEY, KARI-ANN

Back in 1984, Kari-Ann and I had organized a fundraiser for Broadreach House, an addiction centre in Plymouth, Devon. At the time, less was understood about the subject and one tabloid paper put us down for it. Kari-Ann conceived the event as a 'tea dance', and Richard Branson allowed us free use of the roof

garden on top of the old Derry and Tom's store in Kensington. Kari led a fashion show featuring many Ossie Clark dresses and I put together a band that included drummer John Halsey and saxophonist Davey Payne. A journalist who picked up on the event was Astrid Gunnestan from Norway, where alcoholism is a big problem, and she interviewed Kari-Ann. But her report took on a whole new dimension when she realized that Kari-Ann was half-Norwegian and hadn't seen her Norwegian father for 35 years. Astrid had a magazine cover story. With her picture splashed all over Oslo's newsstands, Kari-Ann's father rang into the magazine within an hour of its appearance.

Lief Muller had been in the Norwegian air force, and when the Germans invaded in 1940, he had flown over to fight alongside the RAF. In Plymouth he met a pretty young nurse named Jean Knill, and before you could say 'smorgasbord' they had fallen in love. They later returned to Norway, and Kari-Ann was born in Arendal on the south coast, two days before me, in 1947. But the couple didn't stay together and Jean came back to Britain, never to return; in fact, Kari-Ann had never seen a photo of her dad.

The magazine flew our whole family over to Oslo for a reunion, and it was with some trepidation that Kari-Ann first saw her father coming towards her down a long corridor at the airport, separated by glass doors. She was shaking as she came closer, then the doors opened and she was swept off her feet in an avalanche of emotions; all those years of separation dissolved in a sea of tears. It was also a wonderful moment when Lief bent down to greet three-year-old Robert, who we'd thought of naming Lief and who shared the same birthday as his Norwegian grandfather.

Lief was something of a character. In his youth, he'd done ski-jumping, a daredevil sport, and later bred trotting horses – 'cold bloods', as they're known there. (Naturally, we went to the

track for a spin.) By this happy coincidence, Kari-Ann came to share some special years with her father, which was particularly important to her because her mother had died young, and she was able to feel love of the closest kind from her own father, something she had never previously experienced.

Kari-Ann is often asked about The Hollies' 1967 song of the same sound as her name, if not spelling. Many years later, she was told by a record producer that he remembered seeing her at the flat of one Hollies member, rather out of it at the time and dancing around his cat in a quite magical way – and you would remember it, as she is a singularly beautiful woman. Apparently, the band had already written the song but didn't have a title, so used her name in the hit that it became. I have heard a different version of this story – Graham Nash wrote the song for Marianne Faithfull but was too shy to call her out and used a rhyme instead – but I prefer our story, even if they did use a 'C', not a 'K'.

GOLDEN YEARS

We had a wonderful celebration for my parents' 50th wedding anniversary in 1990. Uncle Horace was the instigator, noting, 'We can't let this one just slip by.' Meanwhile, my mother, realizing that something was afoot, asked 'Have you been speaking to Uncle Horace?', before adding 'I don't want a big fuss made.' We tried not to involve her but of course she got in on the act, and relatives and old friends came from far and wide to the Nayland Rock Hotel on the seafront at Margate. I think we took over the entire place and Mick kindly footed the bill. A band was hired for the occasion, with clarinet, piano, bass drums, sax – the works – in order to run through the old-time favourites: swing, foxtrot and whatnot. After a wonderful spread, Mick presented Mum and Dad with a fine plain gold dish that my mum playfully put on her head to make

a crown. There were speeches by Dad's old colleagues, and I was impressed by the quality they displayed in addressing everyone – making jokes and being serious, too – but then again, as teachers, they were used to talking to their university students and had a lifetime of experience.

Mum clowning around with golden bowl at golden wedding celebrations in Margate 1990.

I was the MC and spouted off about the environment and looking after the planet at one point, and my brother waved at me to desist from the sidelines. I told him, 'Come here if you want to say something, no speeches from the floor.' So he did. It must be one of the first times I'd admonished him in public, because older brothers always like to rule it over their siblings.

The band played numbers like the 'Snowball Waltz', where, after a few minutes, couples split and each brings a fresh partner onto the dance floor, until it is full. They must have played tunes by Al Bowlly, a favourite of my mother's, and many years later for her funeral, I chose his song 'Love Is the Sweetest Thing' to be played as I, with my sons and nephews, carried her out from the church. When there are six of you, you must take small mincing steps and

I realized, 'We are dancing off with her. How appropriate!' I am so glad we did that; and that Mick and I sang 'Will the Circle be Unbroken?' at the service: far better to be involved yourself no matter if you are cut up inside.

READY FOR THE COUNTRY

Despite a comfortable life in leafy London N10, we were taking off for the countryside whenever possible. With the children and our friends, the Marcuson family, from down the road, who had three boys all of similar ages, we would take ourselves off yearly to the Glastonbury Festival and we had some great times there, mostly staying in the children's area, where Kari held dance or yoga sessions in return for free tickets. Like many others, that was how we first came to know and love Somerset.

Our son John was getting into trouble at school and we thought he might do better as a boarder somewhere. Since he was an excellent sportsman and my brother had offered help with the fees, we decided to send him to Millfield in Somerset. Robert later followed him and, as Kari-Ann had now decided she wasn't keen on him boarding, we took a mortgage on a small terraced house at the top of Glastonbury High Street. With her there during term times, Robert could go to Millfield as a day boy and come home to his mum.

Glastonbury is a very social town, with people dropping in all the time, which can be demanding. It is also a magnet for eccentrics, and I maintain that you could walk down the High Street in your pyjamas and no one would bat an eyelid. Traditionally, it relied on agriculture and associated industries like shoe making and wool, but these went into decline, so the 50-year influx of hippies and New Age shops has been a lifeline, and gradually local resentment of incomers has declined. The place has attracted more

than its share of soap dodgers, spiritual seekers and misfits, but they don't cause that much trouble. Some arrive because they're disenchanted with the materialistic lifestyle their parents have relentlessly pursued; others because they are seeking a more rural existence, or they just don't fit in to modern life. There's an attitude of live-and-let-live and an appreciation of music, art, dance and crafts often absent from other towns.

Skittles is a popular pastime in Somerset among the locals, and one invited me to join his pub's team. The game is the ancestor of ten-pin bowling, only there are nine pins and no automation, so you employ a lad as a 'sticker upper'. The neighbour told me that his team was bottom of the league. 'There's also a knock-out cup,' he added brightly. 'Only trouble is, we've already been knocked out.' I rose to the challenge and played for a time, but I found I was drinking more than was good for me. One night, I was unable to drill the wooden ball straight down the long alley and admitted it to another player. 'Don't worry,' he replied. 'If you were any good, you wouldn't be playing for our team.'

I met up with other musicians in the area, as it was tough to rehearse with my regular guys living so far away. That way we had a nice acoustic trio consisting of Dave Hatfield on the double bass and Elliet Mackrell on violin, ready to tour around the country and throughout Europe, where we were well received, particularly in the intimate venues and clubs where people mingle easily and drink and eat together. One club in Münster, Germany, we would play twice a year, always to a packed and enthusiastic audience, while the host, Wolfgang, cooked excellent food and provided the best wines, as he was a Francophile and travelled around France visiting the best wine cellars. These are my favourite places to play; there is no contract, it's all done on trust between friends. Alas, that venue, like many others, has closed now.

With so many friends across Europe, it was galling that the ridiculous policy of 'Brexit' went ahead. My Dutch friends and others could not understand what we were about, and the cultural aspect of work such as we do is never mentioned. When I first toured in Eastern Europe after the Berlin Wall came down, they were almost ecstatic to have the freedom and experience of bands like ours coming along. We had so much in common. Now it is all so much more complicated and expensive and thus more expensive to tour. For the individual folk singer, playing a show in the USA is a prohibitively high cost and the visa form-filling so extensive, you might as well just go down and play in your local pub. It might be okay for the big boys, but musicians love meeting other players, they thrive on it; instead, many will just go 'under the radar' and play without permits, which makes criminals out of ordinary people who just enjoy music without boundaries.

To explore the Somerset area, I would cycle out from Glastonbury, and one afternoon as the sun was setting, I rode across the flat expanse suitably known as 'the Levels'. Reaching a hill after some miles, I followed the ridge and arrived at a hamlet called Mudgley, where sheep were grazing on a south-facing slope and dappled light danced between the apple trees; the Isle of Avalon indeed. I told Kari-Ann about my discovery and a short while later a yoga friend of hers, Sarah, from the same area, mentioned a house would be coming up for sale near by. An old woman was still living there, but was likely to move away sooner rather than later, and we went along to have a peek. It was an old farmhouse, lodged beneath the hill, with a view across the Levels towards Glastonbury Tor. An ancient yew tree stood outside the front door, guardian and sentinel against malevolent spirits.

Soon it came on the market, but the sellers wanted to maximize their investment and split the property into lots. The planners

turned this scheme down and eventually it was auctioned by sealed bids. The house required complete renovation top to bottom, and it was impossible to know how much this might cost. But I duly submitted my bid – all based on the number three and as magical as I could conjure up – then waited for the fates to decide.

Three days later, I was in London on a fine Saturday morning and had a ticket for the cricket at Lord's, where England were facing the West Indies, a team who had crushed us continually since the Seventies. (It was now the year 2000.) A call came from my solicitor to say our bid had been successful! So I went off to Lord's and, buoyed by my success, watched England finally beat the 'Windies', with the Somerset bowler Andrew Caddick taking five wickets to win the game. It was a great day.

London may be far away now, but it's always there if I need to visit – although so many friends my age have moved out, it isn't always easy to find a comfortable bed. Each time I go, I turn a corner to see an old store where I once bought books or hardware has closed down, and I feel disoriented. There are few gigs left for musicians like me and it's near impossible to bring equipment into town because of parking restrictions and congestion charges; one fine is the equivalent of your fee for the night. It makes you envious of Austin, Texas, where there are signs all over saying 'Loading for musicians only'.

The Arts Council, banks and international sponsors have ploughed millions into opera, ballet and even horseracing – because they are seen as 'prestigious' events, attracting champagne drinkers and high flyers – but folk music and rock & roll are expected to stand on their own commercial feet. That would be fine if bands had anywhere to play but, thanks to local government cuts, the arts centres and halls are being closed. It's definitely a class thing in Britain. I could take you to the theatre where David

Garrick played Hamlet, but not the clubs where Hendrix or the Stones performed. Likely as not, they have been converted into restaurants or demolished.

For the album *Act of Faith*, released in 2006, I wrote a song called 'It's Amazing What People Throw Away', and while it was aimed at needless consumption, it was also meant to make people think about the concept of 'progress'; the tendency to presume anything new is automatically good and to jettison what came before.

A mass of wires runs across the stage; it's a wonder that anything works. At the Dublin Castle, Camden, 2010. Such venues don't cost a bomb to enter, you can hear great bands, drink a decent pint if you're lucky and dance across the floor with your partner, and nobody cares if you make a fool of yourself. From left: Elliet Mackrell, violin, Steve Laffy, drums, me, Kit Morgan, guitar; Charlie Hart & Dave Hatfield out of shot!

TRICKS OF THE TRADE

People often ask me about the process of songwriting. It fascinates them – and it fascinates musicians, too. Most hardly know what they're doing themselves, and are often just following their noses or unconsciously retrieving forgotten ideas from the backs of their brains. I have an old envelope, a rare thing these days, inscribed with notes on the subject from an interview I did with my brother

some years ago, so I can share them with you if you like (though they might not apply to rap).

First, a great melody is vital, and working it out on a piano is probably easiest. Second, always write down and record your ideas, as they can be very fleeting. Your environment is very important, too; you need peace and quiet. Other points include: overwrite because you can later edit what you don't need; composing words and melody at the same time is best; make the phrasing meaningful; listen to the melody not the chord sequence, but don't get stuck on it; better to start on the groove. Finally, you can't do it all in your head.

NO PLACE LIKE HOME

We sold our small Glastonbury High Street terrace and the London house, which had increased dramatically in value, and headed for the rural backwater of Mudgley. I managed all the removals, with my sons helping – clearing all the junk accumulated over the years in the Muswell Hill basement and attic – and the final vanload left the metropolis around 2am one summer morning. I reached the narrow lane above the old farmhouse just as the sun came up, so I opened the truck door for our two dogs, Orca the lurcher and Mudger the staffie cross, to jump out and run alongside for the final 200 yards. I felt exhilaration and exhaustion at the same time. I had finally quit town life. And I couldn't understand why it had taken me so long.

All I had to do is to renovate a 16th-century farmhouse with damp walls that had hardly been touched since the Twenties and in which any building work done had been amateur. What could be simpler? John Edmonds' firm helped to do all the renovations and he gave me some good advice before I bought the place: 'If

you're not going to enjoy doing it, then there's no point in taking it on in the first place.'

But that's another story.

DIARY, 2020

This book has been a labour of love over a long period; and to coincide with this, the rain has stopped briefly and a rainbow has appeared over Roger's cider barn in the orchard above, so it would seem the perfect time to retreat there for a glass. The early 'Morgan Sweet' is just fresh – but as an old boy there once remarked to me, 'Trouble is, it do go down far too easy.'

Unfortunately, I can't picture all the grand-children but here are (from front) Naja, Tristan and Brandon on the Victorian Pier in Clevedon, Somerset. We went to a butterfly farm, the beach, a music shop, and the pub, so it was a fun day.

ACKNOWLEDGMENTS

2021

I would like to express my thanks in the completion of this project, first off to Hartwig Masuch at BMG who gave the go-ahead and had the confidence in me to deliver; to Sherry Daly for all her able assistance and endless consultations and patience. To family who have had to live with me during the process, particularly Kari-Ann for her patience and allowing me to spread myself all over the house; to Julian Dawson for his scanning, Jon Newey for encouraging me in the first place, and for his proofreading and comments; to my brother, Mick, for checking there wasn't anything too litigious contained therein. To various old pals for their comments, including Oliver Tobias, John Halsey, Rick Watson, Charlie Hart, John Newbigin, Martin Wilkinson and Jasper Newsome for his notes in the India chapters. To Barry Lewis for all his fine photographs; to Chris Black at the Zig Zag Building where we shot the cover, and to 'pupsicle' who posed with me so well. To Tim Willis who assisted with the edit; to Steve Redmond for coordination, as well as Christoph Schulze from BMG and Dave Evely and his brother. Apologies for any omissions!

CREDITS

www.chrisjaggeronline.com

Management: Sherry Daly

Sherry@sdalyassociates.com